REMINGTON & RUSSELL

The Sid Richardson Collection

Remington & Russell

Revised Edition by Brian W. Dippie

Publication of this book was made possible by a grant from the Sid W. Richardson Foundation.

Copyright © 1994 by the University of Texas Press All rights reserved Printed in the United States of America

Revised edition, 1994 (First edition published in 1982)

Requests for permission to reproduce material from this work should be sent to Permissions, University of Texas Press, Box 7819, Austin, TX 78713-7819.

® The paper used in this publication meets the minimum requirements of American National Standard for Information Sciences—Permanence of Paper for Printed Library Materials, ANSI Z39.48-1984.

LIBRARY OF CONGRESS CATALOGING-IN-PUBLICATION DATA

Dippie, Brian W. Remington & Russell: The Sid Richardson Collection / by Brian W. Dippie. — Rev. ed. Includes bibliographical references and index. ISBN 0-292-71569-2. — ISBN 0-292-71568-4 (pbk.)

1. Remington, Frederic, 1861-1909-Catalogs. 2. Russell, Charles M. (Charles Marion), 1864-1926—Catalogs. 3. West (U.S.) in art—Catalogs. 4. Richardson, Sid, 1891–1959—Art collections—Catalogs. 5. Art—Private collections—Catalogs. I. Title. ND237.R36A4 1994 758′.9978—dc20

93-21260

For my grandmother NORA BRANDER in celebration of her hundredth birthday, and to the memory of my grandmother MARGARET DIPPIE and my grandfathers
THOMAS DIPPIE and WILLIAM BRANDER

CONTENTS

INTRODUCTION I

ACKNOWLEDGMENTS 14

SELECTED BIBLIOGRAPHY 201

INDEX 205

Frederic S. Remington

The Way Post 16

The Riderless Horse 18

The Ambushed Picket 20

The Sentinel 22

Self-Portrait on a Horse 24

His Last Stand 26

The Courrier du Bois and the Savage 28

The Thunder-Fighters Would Take Their Bows and Arrows, Their Guns,

Their Magic Drum 30

In a Stiff Current 32

The Puncher 34

Captured 36

He Rushed the Pony

Right to the Barricade 38

Rounded-Up 40

The Cow Puncher 42

A Sioux Chief 44

A Taint on the Wind 46

The Dry Camp 48

A Figure of the Night 50

Scare in a Pack Train 52

The Unknown Explorers 54

Apache Medicine Song 56

Among the Led Horses 58

Buffalo Runners—Big Horn Basin 60

The Luckless Hunter 62

Charles M. Russell

Roping the Renegade 66

Western Scene 68

Cowpunching Sometimes

Spells Trouble 70

Cowboy Sport—Roping a Wolf 72

Grubpile 74

Seeking New Hunting Grounds 76

The Brave's Return 78

The Buffalo Runners 80

Caught in the Circle 82

There May Be Danger Ahead 84

Plunder on the Horizon 86

Trouble on the Horizon 88

Indians Hunting Buffalo 90

Attack on the Mule Train 92

The Marriage Ceremony 94

Bringing Up the Trail 96

The Defiant Culprit 98

Big Nose George

and the Road Agents 100

The Ambush 102

Sighting the Herd 104

The Snow Trail 106

Three Generations 108

Captain William Clark of the

Lewis and Clark Expedition Meeting with the Indians of the Northwest 110

Guardian of the Herd 112

The Buffalo Hunt 114

Wild Man's Meat 116

When Cowboys Get in Trouble 118

Bear Claw 120

Breaking Up the Ring 122

The Tenderfoot 124

On the Attack 126 Buffalo Hunt 128 Returning to Camp 130 Counting Coup 132 Trouble Hunters 134 Indian Head 136 The Bucker 138 He Snaked Old Texas Pete Right Out of His Wicky-up, Gun and All 140 Utica 142 The Scout 144 First Wagon Trail 146 When Blackfeet and Sioux Meet 148 Wounded 150 Maney Snows Have Fallen 152 He Tripped and Fell into a Den on a Mother Bear and Her Cubs 154 His Wealth 156 A Bad One 158 Man's Weapons Are Useless When Nature Goes Armed 160 Deer in Forest 162 Buffalo Bill's Duel with Yellowhand 164 When White Men Turn Red 166

Roping 168

Other Western Painters

Indian Encampment 172 by Peter Moran

The Pow-Wow 174 by William Gilbert Gaul

Naí-U-Chi: Chief of the Bow, Zuni 1895 176 by Charles Francis Browne

Indians 178 by Edwin Willard Deming

Attack on the Herd 180 by Charles Schreyvogel

The Hold Up 182 by William Robinson Leigh

Bears in the Path 184 by William Robinson Leigh

Trouble on the Pony Express 186 by Frank Tenney Johnson

Contrabandista a la Frontera 188 by Frank Tenney Johnson

The Forty-niners 190 by Oscar E. Berninghaus

Ten Indian Studies 192 by Herbert M. Herget

Portrait of Sid Richardson 198 by Peter Hurd

INTRODUCTION

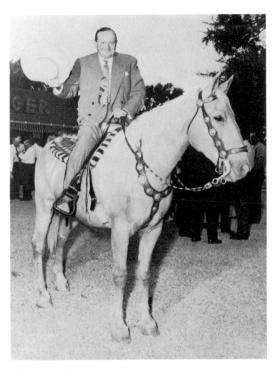

Sid W. Richardson (1891-1959).

SID WILLIAMS RICHARDSON, oilman, cattleman, and financier, sought respite from the pressures of his many business activities in a peculiarly western form of recreation: he collected western art. That he collected wisely and well is evident to the thousands of visitors who since November 1982 have enjoyed the Frederic Remington and Charles M. Russell paintings on permanent display in downtown Fort Worth, the city Richardson made the base for his wideranging operations.¹

Born in Athens, Texas, on April 25, 1891, Sid Richardson was trading cattle and making money before he graduated from high school. He had a knack for making deals and, according to an acquaintance, relished the chase. After attending college at Waco and Abilene, he entered the oil business in 1912, scouting for new fields, drilling wells, swapping leases, and still making—and losing-money. His personal fortune followed that of the boom-and-bust petroleum industry in Texas through the turbulent 1920s; in 1930, along with the nation's economy, he crashed. But with luck, perseverance and willing friends, Richardson started over, wildcatting in West Texas until he struck it big in the Keystone Field and never looked back again. Richardson subsequently diversified his operations, but always oil, cattle, and land were the bedrock.

With his fortune secure, Richardson in 1942 decided to collect Western art, startling Bertram M. Newhouse, president of the Newhouse Galleries in New York City, with a question and an offer: Could the Newhouse Galleries form a collection of western pictures for him? If so, get them and he

would pay the price. Bert Newhouse cherished the memory of the trust that Richardson, "the finest natural gentleman I ever knew," reposed in him. Richardson operated on loyalty, and Newhouse Galleries remained his principal dealer from 1942 to 1950, when he acquired the majority of his paintings. For him, it was another kind of oil game. He liked the pictures he understood, his nephew recalls, and had "a quick eye." Clyde Newhouse, who was sent by his father into the field to scout out what was available, remembered Richardson's excitement when he "took up the chase." Collecting Western art was a gamble when it was not the established activity it is today, and this added zest to the pursuit. As oilmen like Richardson, Frank Phillips, Thomas Gilcrease, R. W. Norton, and Amon Carter won the twentieth-century West, Clyde Newhouse hypothesized, the paintings showing the earlier winning of the West became important to them. Themselves part of the western legend of freewheeling enterprise, through their collections they established a link to the romantic legends of an older West.

Certainly Sid Richardson enjoyed his Western paintings. "I get a kick out of seein' 'em around me," he quipped, and he meant it literally. In his rooms at the Fort Worth Club and his home on San José Island, off Rockport, Texas, he was surrounded by the works of Remington and Russell, often displaying them with a touch of sly humor. Remington's 1889 Sentinel was hung at the end of one hall to create a trompe l'oeil effect, as though one were gazing out a window onto Old Mexico. Russell's painting of skunks ransacking a hunters' camp, Man's Weapons Are Useless When Nature Goes Armed, graced the dining room on the island because it "bugged" Richardson's older sister. Visitors to his Fort Worth office confronted Richardson at his desk and on the wall behind him Russell's aptly titled The Tenderfoot. "Anybody can paint a horse on four

I. The discussion of Sid Richardson that follows is based on telephone conversations with Clyde and Bert Newhouse, September 14 and 18, 1981; conversations with Mr. and Mrs. Perry Bass and Clyde Newhouse, January 17, 1983; an interview with Perry Bass on July 15, 1992; as well as on clippings and miscellaneous materials in the Sid Richardson Collection of Western Art files.

legs, but it takes a real eye to paint them in violent motion," he once told his nephew. "All parts of the horse must be in proper position, and Remington and Russell are the fellows who can do it." His affinity for their work is easily explained. Richardson had trailed cattle in his youth, camping out under the stars with his saddle for a pillow. A plain-spoken, unpretentious man, he was "more at home with cowboys in a country cafe than . . . in a fine restaurant in New York," John Connally observed, and, as a lifelong bachelor, he was certainly as fiddlefooted as any cowboy around. Most summers found him in La Jolla at the race track. A lover of fine horses, he raised registered quarter horses on one of his ranches. His personal favorite was Dude, a big paint that came at the call of his name and would go through his paces on command. Richardson was also an avid outdoorsman who enjoyed hunting (he was a good shot) and fishing. Little wonder, then, that he responded to Remington and Russell's depictions of "men with the bark on." Russell was his particular favorite. He shared his earthy sense of humor, and thus treasured pictures like The Tenderfoot, Utica, and Man's Weapons Are Useless When Nature Goes Armed.

Sid Richardson did not confine his collecting to Remington and Russell. He showed no interest in Western landscapists (Albert Bierstadt, Thomas Moran) or the pre-Civil War documentarians (George Catlin, Karl Bodmer, Alfred Jacob Miller, Paul Kane, and Charles Wimar, for example), but he did acquire works by such relatively unknown late nineteenth-century artists as Gilbert Gaul, Peter Moran, and Charles F. Browne. Though he liked Russell's paintings of Indian domestic life and kept The Marriage Ceremony over his bed, the tranquil Indian scenes characteristic of the southwestern school centered in Taos and Santa Fe did not attract him-perhaps for the same reasons Remington expressed when he wrote

his wife from Santa Fe in 1900: "I dont want to do pueblos—too tame . . . They dont appeal to me—too decorative—and too easily in reach of every tenderfoot." Richardson did acquire paintings with action or suspense by Charles Schreyvogel, Oscar E. Berninghaus, Frank Tenney Johnson, William R. Leigh and Edwin W. Deming. But mostly he stuck to Remington and Russell, adding the occasional work until a few years before his death on September 30, 1959. Time has confirmed his wisdom. Remington and Russell remain today what they were in their own day, the "titans of Western art." 3

Frederic Sackrider Remington was born in the town of Canton in northern New York on October 4, 1861. His boyhood fostered a lifelong love of horses and the out-of-doors, while his father's tales of action as a cavalry officer in the Civil War filled his head with pictures and inspired a passion for things military that found a western focus with the annihilation of General George Armstrong Custer's command on the Little Bighorn River during the nation's Centennial Year, 1876. At the age of fourteen Remington was smitten with the urge to go west and see for himself the blue-clad cavalrymen, bronzeskinned Indians, and buckskin-garbed frontier scouts who peopled his fantasies and filled his school texts and sketchbooks.

But Remington's was a family of some prominence. His father owned the Canton newspaper and, a staunch Republican, had secured a patronage plum, U.S. collector of the port of Ogdensburg, New York, on the

^{2.} Frederic Remington to Eva Remington, November 6, 1900, in Allen P. Splete and Marilyn D. Splete, eds., *Frederic Remington—Selected Letters*, p. 318. I have cited this edition of the Remington letters for convenience, but have occasionally made modifications in the text based on the original. In those instances, I will cite the source of the original letter as well.

^{3.} J. Frank Dobie, "Titans of Western Art," *American Scene* 5, no. 4 (1964): 4–9.

St. Lawrence River. Naturally Frederic was expected to attend college and prepare himself for a business career. Instead, he passed a year and a half at Yale playing football and studying art. He never relinquished his youthful ambition to see the West, and when he came into a small advance on his inheritance after his father's death, was off to Montana in August 1881 for a few months' stay. Although he tried to settle into a clerkship in Albany on his return to New York, he remained restless and eager to see more of the West. His opportunity came in February 1883. With the balance of his inheritance in hand, he was off again, this time to Kansas, where he purchased a sheep ranch and, for the only time in his life, made the West his home. He did not stay long—about a year and was never keen thereafter to reveal that he had been a sheepman, not a cattleman. Thus a journalist in 1907 described him as a "stockman on a ranch" and spoke in glowing generalities about his experiences, lumping his Kansas sojourn with the many reportorial excursions he made to the West through the 1890s to fabricate a portrait of Remington, the complete Westerner:

. . . this blond, youngish giant who sat idly smoking a cigarette and looking as if he had led a sheltered existence between walls and amid refined surroundings all his life was once a ranger on the limitless prairies, a hard-riding, rough-living, freefighting cow-puncher,—for do not lose sight of the fact that Frederic Remington has put himself and his own experiences in very nearly every picture he has drawn or painted. "He rides like a Comanche," said one of his friends speaking of Remington's early career. "He knows as much about horses and cattle as any man alive. And so he should, for he spent most of his youth in the saddle, rounding up mavericks, chasing and being chased by red men and hobnobbing with scouts, pioneers, miners and the picturesque freebooters of the plains."4

Nonsense like this created the false impression that Remington's art always drew directly upon personal experience. In fact, his major easel paintings were tributes to the Wild West of fantasy. They drew on the artist's experiences for their sense of place and authentic details, but on his imagination for their subject matter. Remington's achievement was to fuse observation and imagination so seamlessly that his contemporaries assumed he had actually witnessed what he showed, and a journalist writing in 1892, at a time when Remington's reputation as the supreme illustrator of Western life was recent but already secure, was acute in remarking: "In his pictures of life on the plains, and of Indian fighting, he has almost created a new field in illustration, so fresh and novel are his characterizations . . . It is a fact that admits of no question that Eastern people have formed their conceptions of what the Far-Western life is like, more from what they have seen in Mr. Remington's pictures than from any other source, and if they went to the West or to Mexico they would expect to see men and places looking exactly as Mr. Remington has drawn them."5

Remington illustrated for the major periodicals of the day—Century Magazine, Harper's Weekly, Harper's New Monthly Magazine—and lesser journals as well. By the end of the century, as reproductive processes and photographic technology reached new sophistication, the illustrator's role as purveyor of information became obsolete, marooning those who were satisfied in the role but freeing others like Remington who found it too restrictive.⁶ Since 1888 he had been exhibiting in major art shows, seeking recognition as not just an illustrator,

^{4.} Perriton Maxwell, "Frederic Remington—Most Typical of American Artists," *Pearson's Magazine* 18 (October 1907): 403.

^{5.} William A. Coffin, "American Illustrations of Today" (Third Paper), *Scribner's Magazine* π (March

^{6.} Estelle Jussim, Visual Communication and the Graphic Arts: Photographic Technologies in the Nineteenth Century, pp. 211–214, 235–236; and Jussim, Frederic Remington, the Camera & the Old West.

but an artist in the recognized sense of the term. "The men who do things are the real people," he wrote. "The artists and novelists are the people who tell about them and the critics . . . are the coyotes who hang on the edge of the herd."7 Still, he courted the critics, while holding sales of his work and competing for prizes. In 1891 he was elected an associate of the National Academy of Design. But he never quite made the breakthrough he was seeking until he turned to sculpting in 1895 and discovered an unexpected talent. "I am to endure in bronze . . . —I am modeling—I find I do well—I am doing a cow boy on a bucking broncho and I am going to rattle down through all the ages," he wrote with characteristic enthusiasm.8 He was right to be pleased. The Bronco Buster is one of the defining masterpieces of the Western art tradition. Remington toyed with abandoning painting altogether to glory in the joys of "mud." His color sense, long under the sway of illustration's black and white imperative, was suspect, he readily conceded, while form was his forte. Sculpting seemed the answer, clay the medium in which he could express himself most fully while earning critical respect, though some dismissed his bronzes as illustrations in three dimensions.9

By 1900 the painter in Remington had also come out fighting. He would teach himself how to see all over again, letting his color sense develop naturally. 10 A contract with Collier's Weekly in 1903 gave him the freedom to paint what he wanted, with Collier's reserving exclusive reproduction rights. In effect, he would receive a salary of \$500 a month, subsequently bumped up to \$1,000 a month, for twelve paintings a year. This arrangement removed monetary worries and allowed Remington to experiment with his painting. His technique evolved dramatically during the last five years of his life as he rejected the crisp, linear style that had served him so well for two decades as an illustrator to concentrate on mood, color, and light sunlight, moonlight, and firelight. His later oils are consistent with his conclusion, flatly asserted, that his West was dead. "I mean just this: The West is no longer the West of picturesque and stirring events," he explained. "Romance and adventure have been beaten down in the rush of civilization; the country west of the Mississippi has become hopelessly commercialized, shackled in chains of business to its uttermost limits. The cowboy—the real thing, mark you . . . disappeared with the advent of the wire fence, and as for the Indian, there are so few of him he doesn't count . . . "11 So Remington painted impressionistic scenes in which the West, now entirely confined to memory, was invested with a poetry and mystery the present could not touch. The critics saw things his way at last. In 1909 his annual exhibition at New York's M. Knodler & Company opened to strong reviews, and Remington crowed in his diary: "The art critics have all 'come down'-I have received splendid notices

^{7.} Frederic Remington Notebook (New Rochelle), 71.812.11, Frederic Remington Art Museum, Ogdensburg, New York.

^{8.} Frederic Remington to Owen Wister, [January 1895], in Ben Merchant Vorpahl, *My Dear Wister—:* The Frederic Remington—Owen Wister Letters, p. 160.

^{9.} For Remington's astonishing development as a sculptor, see Michael Edward Shapiro, *Cast and Recast: The Sculpture of Frederic Remington;* and Shapiro, "Remington: The Sculptor," in Shapiro, Peter H. Hassrick, et al., *Frederic Remington: The Masterworks*, pp. 170–233.

^{10.} See Frederic Remington to Owen Wister [before February 1, 1896], to Howard Pyle, November 5, [1899], and to Eva Remington, November 4, 1900, in Splete and Splete, eds., *Frederic Remington—Selected Letters*, pp. 280, 291, 317–318. The date for the Wister letter may be too early.

II. Maxwell, "Frederic Remington—Most Typical of American Artists," pp. 396–397.

from all the papers. They ungrudgingly give me a high place as a 'mere painter.' I have been on their trail a long while and they never surrendered while they had a leg to stand on. The 'Illustrator' phase has become background." ¹²

Within a month Frederic Remington was dead—December 26, 1909—the victim of appendicitis and his own voracious appetite for food and drink. He had clambered on and off the water wagon so many times over the years that he must have lost count; what did not change was the upward curve of his weight. He weighed around three hundred pounds near the end and knew that he was tempting fate. "I can't plead age exactly," he had written frankly a few years before, "but I did most d—— faithfully burn the candle at both ends in the days of my youth and I got the high sign to slow down some little time since. Therefore I have cut out the 'boys' . . . I always loose my bridle and when I get going I never know when to stop. If there is anything in the world I love it is to sit 'round the mahogany with a bunch of good fellows and talk through my hat-I like it a lot better than it likes me and I greatly fear it will take more than a year of training to make a calm eyed philosopher out of me."13 A man of prodigious bulk, Remington had the energies and talent to match. In a career spanning less than twentyfive years he produced a huge body of work illustration, painting, sculpture, nonfiction, and fiction—the vast majority of it centered on the West. His influence in shaping the

West of the popular imagination cannot be overstated. "Buffalo Bill, Ned Buntline, and Frederic Remington—ah, . . . It is something to have created a region as large as the American west," Emerson Hough wrote, not without a touch of malice, "and lo! have not these three done that thing? Never mind about the facts. They are the story." ¹⁴ Remington's influence, like his sculpture, has proven "something that burglar won't have, moth eat, or time blacken." ¹⁵ It has endured.

Remington's was a West without much softness or subtlety. It was, instead, a grand theater for the testing of manhood. It was a throwback to pioneering days, the molding of the national character, and the setting for a great drama. The winning of the West was his theme, and he never outgrew it. He might find more pure enjoyment in the small, plein air landscapes he painted along the St. Lawrence, but he never turned his back on his bread and butter. In his last summer he drew a clear line between business and pleasure when he proposed giving his new neighbors "a small landscape—not the 'Grand Frontier' but a small intimate Eastern thing which will sit as a friend at their elbow."16 His final exhibition included a mixture—six landscapes and seventeen paintings, all but one on Western themes. As he confidently predicted a year or so before he died, "we fellows who are doing the 'old America' which is so fast passing will have an audiance in posterity whether we do at present or not."17

^{12.} Frederic Remington Diary, entry for December 9, 1909, Frederic Remington Art Museum, Ogdensburg, New York.

^{13.} Frederic Remington to Daniel Beard, undated, in the Daniel Beard Papers, General Correspondence, Box 103, Manuscript Division, Library of Congress, Washington, D.C. This is printed in Splete and Splete, eds., *Frederic Remington—Selected Letters*, pp. 393–394, where it is misidentified as to Owen Wister.

^{14.} Emerson Hough, unidentified clipping from *Putnam's*, back of the Frederic Remington Diary for 1909, Frederic Remington Art Museum, Ogdensburg, New York.

^{15.} William A. Coffin, "Remington's 'Bronco Buster," Century Magazine 52 (June 1896): 319.

Frederic Remington Diary, entry for July 30,
 Frederic Remington Art Museum, Ogdensburg,
 New York.

^{17.} Frederic Remington to Carl Rungius, [1908], in the Carl Rungius Papers, Glenbow Museum, Calgary, Alberta.

Like Frederic Remington, Charles Marion Russell was born to comfortable circumstances and would receive his first exposure to the West in Montana. His first job there would be as a lowly sheepherder rather than a lordly cowboy. But there the similarities end. For Russell, born in St. Louis on March 19, 1864, was so captivated by Montana when he visited in 1880 that he chose to stay, becoming in fact the Westerner that both men as boys had dreamed of being. Indeed, it was his persistence about that dream that induced Russell's parents to let him go West as a sixteenth-birthday present. He was to earn his keep tending sheep for a family acquaintance, but inattentiveness cost him his job and he got the reputation of being ornery and irresponsible. Ignoring advice to go home and grow up, he stayed on, assisting a professional hunter who taught him "nature's secrets," and eventually landing a position in 1882 wrangling horses on a cattle drive. He was still wrangling for a living eleven years later, and while he never claimed to be "a good roper nor rider" he was a genuine cowboy, proud of his profession and in love with Montana's wide open spaces. 18 But change was all about him. The bitter winter of 1886–1887 checked the booming, speculative cattle industry and marked the end of the cattleman's dominion on the northern plains. Railroads and settlers were altering the face of the land. The days of free grass and the unfenced range were ending, and for Russell the cowboy life was over by 1893.

Even while working as a wrangler, Russell established a local reputation as the affable (some said bone lazy) cowboy who loved to draw. His sketches were crude, but the earliest of them showed an observant eye, a feeling for animal and human anatomy, a sense of humor, and a flair for portraying action—all hallmarks of Russell's mature

art. Russell captured attention with a little watercolor depicting the devastation brought about by the winter of 1886–1887—Waiting for a Chinook (1887; Montana Stockgrowers Association, Helena)—and had a few works reproduced nationally before he quit the range to take up art full time. But fame and fortune did not prove synonymous, and it was uncertain he would ever make a real living from his painting when in 1896 he married a young woman named Nancy Cooper. She saw something in the rough-hewn Cowboy Artist that many of his contemporaries did not: the talent to be great.

Nancy Russell provided the business sense and drive that eventually made her unambitious husband one of America's most successful artists. This meant exerting control over his financial affairs, of course; but it also meant managing his time, limiting the hours he spent drinking and socializing with his old cowboy cronies, keeping him at his easel, and then marketing what he produced. Because she was his business manager, Nancy looms large in the Charlie Russell story, while Eva Remington remains discreetly obscure, overshadowed by the exclusively masculine concerns celebrated in her husband's art. Success did not come easily for Nancy. Montana offered few opportunities for sales, so beginning late in 1903 the Russells began branching out. They visited New York most years, established contacts with other artists interested in Western themes, secured illustrating assignments (at the very time Remington was getting out of illustration in order to concentrate on his painting), and gained exposure through exhibitions and press coverage. While critics may not have taken Russell's art too seriously in this period, they found the artist fascinating. Russell stoutly insisted upon his right to be himself. He dressed as he pleased—in cowboy boots and Stetson, with a woven sash to hold up his pants and, he believed, keep his stomach small. His talk, which was guarded

^{18.} Charles M. Russell, "A Few Words about Myself," in *Trails Plowed Under*, p. xix.

and laconic in the best Gary Cooper fashion when he was around strangers, flowed among friends, who regarded him as a master storyteller and delighted in his dry wit just as readers of his illustrated letters still do. Russell won people over without trying and made the idea of a Cowboy Artist as popular as his paintings. Finally, a one-man show at New York's Folsom Galleries in 1911, followed three years later by an exhibition at the Doré Galleries in London, marked Russell's emergence as a major figure in the big-time art world. Nancy made certain that his prices kept pace with his fame, and her efforts paid off with a jackpot of \$10,000 for a single oil in 1921 and a commission for \$30,000 for a mural finished a few months before his death on October 24, 1926.

Russell never let his success go to his head. Pomposity was foreign to him, and he always felt most comfortable at home in Great Falls, where he and Nancy lived from 1897 on. He stopped drinking by 1908, but still mixed with his "bunch" whenever he could, and downtown Great Falls' cigar stores and bars—notably the Mint and the Silver Dollar—were favorite haunts. He needed these contacts. Old friends kept his art vital, for Russell really had only one theme—"the west that has passed"—and they were his links to yesterday. "When the nester turned the West grass side down, he buried the trails we traveled," Russell commented to a former cowboy. "But he could not wipe from our memorys the life we loved. Man may lose a sweetheart but he dont forget her." 19 The same refrain informed his art. As much as Remington, Russell could do the wild, wild West; but his work expressed a consistent larger vision suggested by the buffalo skulls

that dotted his paintings from the beginning and became a part of his signature. He felt the passing of the West. Remington knew that his West, too, had vanished, and he took to lamenting it in prose and paint and bronze. But Russell's sense of loss touched him with an emotional immediacy. He was haunted not just by the youthful fantasies that first kindled both men's artistry, but by memories of what once was and by the evidence of change that surrounded him as an everyday reality. Thus his art speaks with an almost mystical passion of lost love, while Remington's tells with some detachment of boyhood dreams betrayed by the imperatives of advancing age.

Their separate visions are at the heart of their separate achievements. Remington knew the Southwest best and through the 1890s was more interested in the West as a minimalist stage for action—vellow ochre sands, powder blue skies—than in the land itself. "Remington was a painter and illustrator of men and horses," an obituary noted. "With him landscapes were always a minor objective."20 Russell, in contrast, elaborated setting in his paintings. Montana was home to him, as the Adirondacks and Chippewa Bay on the St. Lawrence were to Remington,²¹ and he cherished the landmarks that identified specific locales—the Judith Basin, the Great Falls area, Glacier Park. A glance at the paintings in the Richardson Collection establishes this obvious distinction. In their time, and especially after Remington's death in 1909, the two were often compared. The Eastern press regularly described Russell as Remington's successor; it was a way of indicating that his subject matter was Western but was not helpful in getting at the differ-

^{19.} Charles M. Russell inscription, 1922, in Harry T. Duckett's copy of *Rawhide Rawlins*, Nancy C. Russell typescript, in the Helen E. and Homer E. Britzman Collection, Taylor Museum for Southwestern Studies of the Colorado Springs Fine Arts Center.

^{20. &}quot;Remington," Cincinnati Times-Star, December 28, 1909; and see James K. Ballinger, Frederic Remington's Southwest.

^{21.} See David Tatham, "Frederic Remington: North Country Artist," in *The North Country Art of Frederic Remington: Artist in Residence*, pp. 10–12.

ences between them. The Western press, in turn, was more strident than analytical. "The effete east has her Remington," a Butte, Montana, paper observed in 1903, "but the glorious west has her Russell."22 A state official was more reasonable the next year in an address delivered at the World's Fair Grounds in St. Louis when he characterized the Russells on exhibit there as "some of the most captivating artistic work of the age" and their creator, "an ordinary cowboy from the City of Great Falls," as "the peer of Remington, and one of the artists destined to live in the history of art within the lines he has made his own."23 Pride mixed with pugnacity in such assessments. From them it becomes clear that the case for Russell's superiority rested on the fact that he actually lived in the West. "Some of Frederic Remington's illustrations are magnificent," a Texas cattleman explained in 1908, "but in certain of his pictures, in not a few of them, in fact, Mr. Remington has not been accurate. This is probably due to the fact that he doesn't know the men and the life with that thorough knowledge an artist who paints it should have. One must live among them to acquire it."24

That was the rub: "Remington never lived in the west, notwithstanding statements to the contrary," and thus "the knowledge of the western types he gained was superficial." ²⁵ Those who champion Russell continue to refer to his authenticity rather than his artistry—a position qualified by J. Frank

Dobie, who also admired Russell's warm humanism with its concern for the individual rather than the typical. Leave Remington to immortalize frontier "types"; Russell offered the "speaking details dear to any lover of western life."26 That said, it must be added that Remington's influence on Russell's art was pronounced—hardly surprising, given Remington's preeminence as a Western illustrator through the 1890s. Indeed, from 1887 to 1899, formative years for Russell, only eleven months passed without at least one Remington illustration appearing in such leading periodicals as Harper's Weekly, Century, Cosmopolitan, Collier's Weekly, or Harper's Monthly, and most were on Western themes. Russell borrowed Remington subjects, compositions, and figures as he worked out his own approach and defined his own turf. The Indian-fighting army was Remington's, but Russell claimed the open range cowboy, the old-time plains Indian, and Western wildlife.27 They were his West, and a reporter for the St. Louis Star was unusually perceptive when she wrote in 1910 that while Russell's work had been likened to Remington's,

it in no way resembles it other than that of subject... The treatment of the theme is entirely different. With Remington, the figure or group is the picture—the story; there is just a suggestion of landscape, after the manner of the illustrator, a background for the figure.

No doubt Russell was impressed by and learned something from Remington, some of his early work bearing this out, especially his drawings, but his strong personality soon asserted itself, both in conception and execution. . . .

^{22. &}quot;Charles Russell, Cowboy Artist," *Butte Miner*, October 11, 1903.

^{23. &}quot;Address by Hon. Thos. H. Carter, Helena, Mont., at the Dedication Exercises, Montana State Building, Louisiana Purchase Exposition, World's Fair Grounds, St. Louis, Mo., June 14, 1904," in *Contributions to the Historical Society of Montana* 5 (1904): 103.

^{24. &}quot;Artists and Western Life," *Great Falls Daily Tribune*, January 21, 1908, quoting Erwin E. Smith.

^{25. &}quot;Russell and Remington," Great Falls Daily Tribune, January 6, 1910.

^{26.} J. Frank Dobie, "The Conservatism of Charles M. Russell," *Montana, the Magazine of Western History* 8 (Autumn 1958): 63; see also Dobie's provocative introduction to Frederic Remington, *Pony Tracks*, pp. xix—xxi. Dobie for years seriously contemplated writing a biography of Russell and did extensive research, including many personal interviews, in preparation.

^{27.} See Brian W. Dippie, *Looking at Russell*, pp. 10–52; and Peter H. Hassrick, *Charles M. Russell*, passim.

Mr. Russell paints the landscape with as much fidelity as he does his figures. . . . he gives a graphic description of the country which creates the rugged, boisterous, fun-loving, life-loving, jolly men of the plains. . . .

... One can feel the alkali dust rising from the sun-baked earth, the dryness of the dead sage brush, and the refreshing green of the cacti growth, the grandeur of the distant mountains, and the light of the early morning sun, all telling a poetical story of the solitude of the plains and its people. . . .

The sentimentality of the poet ill suits a man like Russell, still, his pictures often affect the beholder as some great powerful poem, more epic than lyric, in which he glorifies Nature, the living and the lifeless.²⁸

Russell rarely went on record about Remington, though he obviously grew tired of being likened to him and, when pushed, remarked informally on inaccuracies in his work.²⁹ Since Remington, too, adhered to the canon of accuracy and was quick to cut down upstarts who challenged his supremacy in the field of Western art by declaring them uninformed, Russell's reservations were pertinent.

Did the two men ever meet? The evidence is slim—a passing comment by Russell in a newspaper interview, a cryptic reference by Remington in a letter 30—but it seems likely they were introduced to one another, probably on Russell's second trip to New York City over the winter of 1904–1905. Remington was not one to relish rivals, and Russell received friendly coverage in the Eastern papers and magazines and attention from New York's professional illustrators who, charmed by his frank manner and droll humor, welcomed him into their ranks. No Russell-Remington friendship followed, though the comparisons continued. A St. Louis journalist in 1901 wrote: "Remington is the idealist of the new western art culture. Russell is its realist."31 Yet just a few years later a more perceptive critic said of Russell: "he is not a painter of stern realism, but rather a delineator of the poetical."32 The poetical kept recurring because Russell was a romantic. He worked hard to satisfy the demand for authenticity, but recognized, as he wrote a friend about his Indian paintings, that he had "always studied the wild man from his picture side."33 Much the same could be said about Remington's work—he dismissed Indians as uninteresting once they had adopted white clothing.34 Even a casual acquaintance with the work of Remington and Russell is adequate to demonstrate that realism is too

^{28.} Anita Moore, "Life of the Plains and Its People Is Vividly Pictured by St. Louisan," *St. Louis Star*, March 12, 1910.

^{29. &}quot;Is He Remington's Successor?" St. Louis Republic, March 6, 1910; "Pays Tribute to Russell," Great Falls Daily Tribune, December 26, 1908, quoting Emerson Hough; James B. Rankin notebook, reporting an interview with William S. Hart, ca. 1938, in the James B. Rankin Papers, Montana Historical Society, Helena; and James W. Bollinger, Old Montana and Her Cowboy Artist: A Paper Read before the Contemporary Club, Davenport, Iowa, January Thirtieth, Nineteen Hundred Fifty, pp. 20-22. Bollinger first prepared his paper as "Charles Marion Russell, L.L.D.: Montana's Famous Cow Boy Artist," typescript, in 1926; see copy in the Helen E. and Homer E. Britzman Collection, Taylor Museum for Southwestern Studies of the Colorado Springs Fine Arts Center. Austin Russell, Charlie's nephew, noted that Charlie also defended Remington against the casually dismissive—C.M.R.: Charles M. Russell, Cowboy Artist, pp. 202-203.

^{30. &}quot;C. M. Russell Is Home Again," *Helena Independent*, March 18, 1905; and Frederic Remington to Joel Burdick, Sunday [1907?], in the Frederic Remington Art Museum, Ogdensburg, New York.

^{31. &}quot;Cowboy Artist St. Louis' Lion," *Helena Independent*, May 13, 1901, reprinting remarks from the *St. Louis Post Dispatch*.

^{32.} Marian A. White, "A Group of Clever and Original Painters in Montana," *Fine Arts Journal* 16 (February 1905): 87.

^{33.} Charles M. Russell to Harry P. Stanford, December 13, 1918, private collection.

^{34.} Maxwell, "Frederic Remington—Most Typical of American Artists," pp. 395–397.

restrictive a standard for evaluating their respective achievements. Nevertheless, there was Remington on the record remarking at the ripe old age of almost forty-three: "The youngster that attempted to portray the early West must get his material from older artists, since the typical figures of the plains are as much gone as the Civil War of the Paleozoic period." 35

The problem is that such comments by Remington or about Russell have been taken for gospel. After all, both men themselves had to rely on older artists—and their imaginations—in re-creating historical events preceding their experience. And both moved away from the documentary realism of their early years even as they became more technically proficient in the twentieth century. Ignoring subject matter, where there is obvious continuity, and relying on visual evidence alone, it would be difficult to believe that an 1889 and a 1909 Remington were by the same artist, so profound was the technical transformation as he self-consciously sloughed off the marks of the illustrator.³⁶ We are told that Remington—who was outspoken in his Americanism and, like Russell, thoroughly parochial when it came to venturing abroad and studying the Old World masters—responded to an initial encounter with Impressionist painting by blurting, "Say! I've got two maiden aunts in New Rochelle that can knit better pictures than

those!" ³⁷ But before long he was sitting at the knees of Claude Monet and learning from his American Impressionist contemporaries. ³⁸ Russell disclaimed any interest in "teck neque," mocked high-faluting artsy talk, and doubted that there was any more to Impressionism than a desire to hide "bum drawin"." ³⁹ But his own painting in the 1920s exhibits a bolder use of color and a painterly looseness that cannot be equated with Remington's Impressionist and Tonalist experiments but do indicate a similar evolution away from the linear and the literal toward an appreciation of light and the way we feel what we see.

It is an obvious point, but not all Remingtons and Russells are equally good. Dates aside—and the work of both artists changed markedly over the years—neither performed at an absolutely consistent level at any period in his career. Remington abandoned many paintings as failures, and consigned several others to the flames during his late-life drive for critical acceptance. "They will never

^{35.} Ibid., p. 399.

^{36.} See Brian W. Dippie, "Frederic Remington's West: Where History Meets Myth," in Chris Bruce et al., *Myth of the West*, pp. 111–119, for the thematic continuities in Remington's art; and, for continuities in Russell's art, Dippie, "Improving Right Along': Continuity and Change in Charles M. Russell's Art," *Montana, the Magazine of Western History* 38 (Summer 1988): 40–57. The continuities were critical to both artists' establishing their respective visions of the West in the public's mind.

^{37. &}quot;Remington's Frank Criticism," *Everybody's Magazine*, clipping in Frederic Remington Diary, entry for March 26, 1909, Frederic Remington Art Museum, Ogdensburg, New York.

^{38.} Giles Edgerton [Mary Fanton Roberts], "Frederic Remington, Painter and Sculptor: A Pioneer in Distinctive American Art," *Craftsman* 15 (March 1909): 669. Remington's earlier debt to certain European military artists—notably Alphonse de Neuville and Edouard Detaille—has been well-examined, the point to make being that it was their subject matter that attracted him, and not artistic considerations per se. The most thoughtful work on Remington's European links is Joan Carpenter, "Was Frederic Remington an Impressionist?" *Gilcrease* 10 (January 1988): 1–19; and "Frederic Remington's French Connection," *Gilcrease* 10 (November 1988): 1–26.

^{39.} Charles M. Russell to Joe De Yong, March 30, 1920, in Brian W. Dippie, ed., *Charles M. Russell, Word Painter: Letters, 1887–1926*, p. 295; and Frank Bird Linderman, *Recollections of Charley Russell*, ed. H. G. Meriam, p. 92. Also see Russell to William G. Krieghoff, May 4, 1914, and the accompanying commentary, in Dippie, ed., *Charles M. Russell, Word Painter*, p. 202.

confront me in the future," he wrote in his diary, "-tho' God knows I have left enough go that will."40 Russell, in an interview published two months before he died, claimed to have painted many great pictures in his mind but not yet one on canvas.⁴¹ Few things are more needed in Western art studies than critical discussion. Over twenty-five years ago John C. Ewers complained that "far too much" of the writing in the area "consists of biography interlarded with laudatory comments on the artist's work which are more akin to the unrestrained prose of the press agent than to the carefully weighed words of the serious scholar and critic. Too often writers have applied generalized slogans to the western artists—slogans such as 'he knew the horse,' or 'he knew the Indian,' or 'the Mountain Man,' or 'cowboy,' and such gross judgments have been offered in place of the much more difficult, scholarly criticisms of the individual works of the artists under consideration."42

A turn-around point in the writing on Remington and Russell was Peter Hassrick's catalog of the Amon Carter and Sid Richardson Remingtons, published in 19/3. It straightened out Remington's biography and dealt with his artistry in a serious way. With the Sid Richardson Collection again providing the occasion, *Remington & Russell*, first published in 1982, attempted a

comparative consideration of the two artists grounded in the specifics of individual works. The Richardson Collection reflects the Western art market of the 1940s. It is heavy in early Russells, including three from the 1880s. Two are mainly of historical importance, while the third, Cowpunching Sometimes Spells Trouble, is significant in understanding Russell's evolving artistry. The market also yielded up twenty-five paintings from the 1890s, including the collection of Robert Vaughn, a Montana pioneer and a neighbor of the Russells. This was Russell's most experimental period in subject matter, and an apprenticeship period for the full-time professional artist. He had much to learn, and these paintings show him going to school. The Richardson Collection is light in Russell's mature work, though there are three important oils from the years 1907-1909, and one of them, When Blackfeet and Sioux Meet (1908), is a Russell icon. Two paintings represent his work at his peak as a colorist—Man's Weapons Are Useless When Nature Goes Armed (1916) and Buffalo Bill's Duel with Yellowhand (1917), a superb action piece—and a single work, When White Men Turn Red (1922), vividly illustrates Russell's late life palette with its vibrant sunset tones. The Richardson Collection's Remingtons include strong examples from each stage of the artist's career, and a splendid selection from his last four years. Here, the market generously yielded up the Robert Winthrop collection (A Taint on the Wind [1906], Apache Medicine Song [1908] and The Unknown Explorers [1908]), as well as the luminous Buffalo Runners—Big Horn Basin (1909) and the moving *The Luckless Hunter* (1909). To this rich group the Sid W. Richardson Foundation added two more important pieces-The Dry Camp (1907) and Scare in a Pack Train (1908)—to mark the official opening of the Sid Richardson Collection in 1983, and another ten years later, Among the Led

^{40.} Frederic Remington Diary, entry for January 25, 1908, Frederic Remington Art Museum, Ogdensburg, New York; and see Peggy and Harold Samuels, *Frederic Remington: A Biography*, pp. 1–4.

^{41.} Frank M. Chapman, Jr., "The Man behind the Brush," *Country Life* 50 (August 1926): 37.

^{42.} John C. Ewers, "Fact and Fiction in the Documentary Art of the American West," in *The Frontier Re-examined*, ed. John Francis McDermott, p. 82.

^{43.} Peter H. Hassrick, Frederic Remington: Paintings, Drawings, and Sculpture in the Amon Carter Museum and the Sid W. Richardson Foundation Collections.

Horses (1909). The assemblage now is simply unequaled.

Since the first appearance of this catalog, there has been an efflorescence in the scholarship on Remington and Russell, and I have tried to reflect it in the commentaries. Some have been substantially revised. Titles have been corrected where possible, and provenances added for many of the Russells. The focus in Western art studies has shifted somewhat in the last decade. While there is still a great interest in the biographies of both Remington and Russell,44 their artistry in particular has come in for searching reexamination.45 Their documentary credentials have been challenged and a new stress placed on the imaginative, creative, visionary qualities of their work. They are no longer seen as literalists but rather as interpreters who shaped their own experiences in their art and in the process shaped the public's understanding of the West. There has also been an attempt to free Remington from the

shackles of subject matter and to consider his work from a purely artistic standpoint. The net effect would be to position Remington among his peers as an American artist instead of isolating him as a Western artist. It would also free him from the current judgment, based on its content, that his work can be dismissed as art because the values it upholds are no longer acceptable. Remington has been characterized as the champion of "triumphalism"—the white man's glorious winning of the West—and as a particularly nasty turn-of-the-century bigot. The foundation of his reputation—the subjects he painted and the way he portrayed them—is no longer secure; any attempt to defend his reputation must retreat to the higher ground of artistic excellence.

But Remington himself has proven refractory material. He was a man of his time, and his views were his own. He stood pretty much behind what his art showed. Moreover, he never apologized for his subjects.

include Jussim, Frederic Remington, the Camera & the Old West; Carpenter, "Was Frederic Remington an Impressionist?" and "Frederic Remington's French Connection"; Dippie, "Frederic Remington's West: Where History Meets Myth"; and Alex Nemerov, "Frederic Remington: Within and without the Past," American Art 5 (Winter/Spring 1991): 36-59. A catalogue raisonné moves toward completion at the Buffalo Bill Historical Center, Cody, Wyoming, and a catalog of the Frederic Remington Art Museum Collection at Ogdensburg, New York, is in preparation by Brian Dippie. Also useful is Peggy and Harold Samuels, Remington: The Complete Prints. For Russell's artistry, see Dippie, Looking at Russell, and "'Improving Right Along': Continuity and Change in Charles M. Russell's Art"; Hassrick, Charles M. Russell; Rick Stewart, Charles M. Russell: Masterpieces from the Amon Carter Museum, which anticipates a new full catalog of the museum's collection; and Stewart's impending comprehensive study of Russell's sculpture. Also see John C. Ewers, "Charlie Russell's Indians," Montana, the Magazine of Western History 37 (Summer 1987): 36-53; and Ginger Renner, A Limitless Sky: The Work of Charles M. Russell, the catalog of the Rockwell Museum Collection in Corning, New York.

^{44.} For Remington see Samuels and Samuels, Frederic Remington, an exhaustive biography; Splete and Splete, eds., Frederic Remington—Selected Letters; and Atwood Manley and Margaret Manley Mangum, Frederic Remington and the North Country. A useful—and, at times, properly provocative—overview of Remington's career and artistry is provided by James K. Ballinger, Frederic Remington, a volume in the Library of American Art, a new series that includes Hassrick's Charles M. Russell. There are currently three other Russell biographies in preparation, and a study of cowboy culture focused on Russell's own collection of gear. Useful for the artist's life are the Charles M. Russell special issue of Montana, the Magazine of Western History 34 (Summer 1984), and Hugh A. Dempsey, "Tracking C. M. Russell in Canada, 1888-1889," Montana, the Magazine of Western History 39 (Summer 1989): 2-15. A comprehensive edition of the Russell letters is Dippie, ed., Charles M. Russell, Word Painter.

^{45.} Important Remington exhibition catalogs include The North Country Art of Frederic Remington: Artist in Residence; Shapiro, Hassrick, et al., Frederic Remington: The Masterworks; Gerald Peters Gallery, Frederic Remington; and Ballinger, Frederic Remington's Southwest. Interpretive studies of Remington's artistry

"You see there is a wide fundamental split between myself and the school which holds that subject matter is of no importance in painting," he explained. "I believe it is. I was born wanting to do certain phases of life and I am going to die doing them. This school ought to forgive me for wanting to do man and horses and landscapes of the West and hold it of no importance. The school considers only my paint." Still, he was "willing to be judged from their small standpoint."46 Of course Remington's stature as an artist was no "small" thing. But his persistence in his themes is the source of his vast influence, and however unfashionable they may be today, they constitute his enduring claim to cultural importance.

No one has advanced a comparable case for Russell on purely artistic grounds, or argued that he be granted a high place in America's artistic pantheon. But his subject matter, superficially so similar, is acceptable, where Remington's is not. Russell's

treatment is the difference. He was dancing with wolves long before Kevin Costner was born. His West, unfenced and open, is a great space to ride across, and an invitation to dream. And it is irretrievably lost. Gone with the wind. Magic in memory. Russell's palpable nostalgia, his yearning and regret, make his vision feel modern. The core of his work is a sustained elegy in which time stands still. No triumphalism for him, no celebration of civilization's progress and savagery's defeat. No thundering charges by conquering boys in blue. No cheering them on. Just images of the "onley real American," proud Indian men and women riding across the land they owned.⁴⁷ And of cowboys in their careless youth, outside the imperatives of change, free never to grow old. And of wild animals, destined not for some hunter's trophy room but to grace the mountains and howl at the moon long after we have passed by. And of buttes and rivers, there for the duration, and of plains stretching to the limits of our imagination—and beyond. Through his art, Russell speaks to us in the present voice, and what he says constitutes his claim to greatness.

^{46.} Frederic Remington to Mr. McCormack, December 10 [1890], in Splete and Splete, eds., Frederic Remington—Selected Letters, p. 82. The 1890 date seems unlikely. The views expressed here accord closely to those Remington was advancing during his last few years—for example, in his letter to Albert S. Brolley written on December 8, 1909, just before he died. Ibid., p. 435.

^{47.} Charles M. Russell to Charles N. Pray, January 5, 1914, in Dippie, ed., *Charles M. Russell, Word Painter*, p. 188.

I wish to acknowledge the assistance of the following in the preparation of this book: Doris Fletcher, The Warner Collection of Gulf States Paper Corporation, Tuscaloosa, Alabama; Edward T. LeBlanc, Fall River, Massachusetts; Mary B. Palmer, National Geographic Society, Washington, D.C.; Bertram M. Newhouse and Clyde M. Newhouse of the Newhouse Galleries, New York City; Perry Bass, Fort Worth, Texas; Carol Clark, Amherst College, Amherst, Massachusetts; Ron Tyler, Texas State Historical Association, Austin; Don Reeves, National Cowboy Hall of Fame and Western Heritage Center, Oklahoma City, Oklahoma; Rick Stewart, Amon Carter Museum, Fort Worth, Texas; Elizabeth Dear, C. M. Russell Museum, Great Falls, Montana; Dale L. Johnson, Mansfield Library, University of Montana, Missoula; Dave Walter, Montana Historical Society, Helena; Paul Fees and Peter Hassrick, Buffalo Bill Historical Center, Cody; Lowell McAllister and Laura Foster, Frederic Remington Art Museum, Ogdensburg, New York; and Jan Brenneman, Sid Richardson Collection of Western Art, and my enthusiastic partner in this new edition of Remington & Russell. I also want to thank the following institutions and services: the Archives of American Art microfilm series, Smithsonian Institution, Washington, D.C.; the Bancroft Library, University of California, Berkeley; the Glenbow Museum, Calgary, Alberta; the Great Falls Public Library, Montana Collection, Great Falls, Montana; the Huntington Library, San Marino, California; the Library of Congress, Manuscript Division, Washington, D.C.; and the University of Victoria, Interlibrary Loan Service, Victoria, British Columbia. And I want to renew my thanks to Donna, Blake, and Scott for encouragement, patience, and love.

The Way Post

C. 1881 Watercolor and gouache on paper 7 x 9½" (17.8 x 24.1 cm.)

Signed lower right: F.R.

Frederic Remington's first trip west is veiled in mystery. Boyhood sketchbooks and marginal doodlings in his school texts reveal his obsession with military subjects—Civil War scenes and soldiers reflecting the experiences of his father and, beginning in 1876 with the news of Custer's Last Stand, Indian fighting.1 His brief stint at the Yale School of Fine Arts did not wean him from his youthful preoccupations, and when the opportunity presented itself he headed west in 1881. He was gone from August until mid-October. Where he went and how he passed his time are unknown, though he intended to visit the site of Custer's defeat in Montana five years before, and likely did.² He was singularly uninformative on the matter. "Remington has no gift of reminiscence," a journalist wrote in 1907. "His stories are best told with the brush." 3 But Remington did set down a few recollections in 1905 that place him in Montana at the age of nineteen sharing bacon and coffee with "an old wagon freighter" who told him that the West, so new and exciting to the boy, was already a thing of the past. "The old man had closed my very entrancing book almost at the first chapter," Remington remembered.4

It is possible, however, that we have one memento of that initial Western excursion. *The Way Post*, a simple watercolor study of a pioneer resting his horses at what appears to be a stage stop, may be a product of Remington's two months in Montana. Because the style is so unformed, the painting cannot be attributed to Remington, let alone dated, with any certainty. Other artists have been suggested, including the experienced Western illustrator William de la Montagne Cary (1840–1922). Still, *The Way Post* has the documentary ring of Remington's earliest authenticated Western scenes, while the signature—the initials "F.R."—is one he used around 1881 but rarely thereafter.

Ex-collection: Newhouse Galleries, New York City; William Griscom, Philadelphia.

- 1. There is a wealth of early Remington material in the collection of the Frederic Remington Art Museum, Ogdensburg, New York; also, Frederic Remington (1861–1909): Paintings, Drawings, and Sculpture in the Collection of the R. W. Norton Art Gallery, Shreveport, Louisiana, pp. 48–50.
- 2. Atwood Manley, Some of Frederic Remington's North Country Associations, pp. 22–23; Hassrick, Frederic Remington, pp. 18–20; Samuels and Samuels, Frederic Remington, pp. 32–36.
- 3. Perriton Maxwell, "Frederic Remington—Most Typical of American Artists," *Pearson's Magazine* 18 (October 1907): 404.
- 4. "A Few Words from Mr. Remington," *Collier's Weekly*, March 18, 1905, in Peggy and Harold Samuels, *The Collected Writings of Frederic Remington*, p. 551 (hereafter cited as *Collected Writings*).
- 5. See Mildred D. Ladner, William de la Montagne Cary: Artist on the Missouri River, for Cary's illustrative style.
- 6. See *Two Men on a Beach* in the R. W. Norton Art Gallery catalog *Frederic Remington* (1861–1909), p. 53.

The Riderless Horse

1886 Pencil, pen and ink, and watercolor on paper 87% x 117%" (22.5 x 30.2 cm.)

Signed lower left: Frederic Remington.—del.;

inscription upper left: No. 1.; lower left (below

Frederic Remington has been called "The Soldier Artist," and because he was responsible for so many vivid battle scenes involving troopers and Indians the impression persists that he actually witnessed what he showed.¹ In fact, he was in Arizona in 1886 as a correspondent for *Harper's Weekly* covering the Geronimo campaign and did patrol with Company K of the Tenth Cavalry, a black regiment, in the Santa Catalina Mountains north of Tucson that June.² But he saw no action, and such subjects as *The Riderless Horse* and the sketch that follows, *The Ambushed Picket*, were based upon imagination.

A few years later, Remington was on assignment in the Dakotas during the Sioux campaign of 1890–1891. "There is going to be a row," he told his editors upon arriving on the scene, but when the row came off he was conspicuous by his absence.³ He was *near* Wounded Knee Creek on December 29, 1890, but he missed both the battle and the burial of the dead there two days later. Since Wounded Knee proved to be the curtain ringer on almost three centuries of Indian warfare, it seems astonishing that Remington, who was so keen on the subject, did not choose to witness the denouement of that sad affair. Instead, he offered a string of limp excuses:

Two days after [the battle at Wounded Knee] I rode into the Pine Ridge agency, very hungry and nearly frozen to death having ridden . . . all night long. I had to look after a poor horse, and see that he was groomed and fed . . . Then came my breakfast. That struck me as a serious matter at the time. There were wagons and soldiers—the burial party going to the Wounded Knee to do its solemn duty. I wanted to go very much. I stopped to think; in short, I hesitated, and of course was "lost," for after breakfast they had gone. Why did I not follow them? Well, my natural prudence had been considerably strengthened a few days previously by a half-hour's interview with six painted Brule Sioux who seemed to be in command of the situation. To briefly end the matter, the burial party was fired on, and my confidence in my own good judgment was vindicated . . .

signature): sketch with K. Troop 10th Cav. / mesa near Santa Catilenas [Catalinas], Arizona 1886.—; below:—sand and dust.—; at left: —brown and sorrele horse.—; and titled lower right: "The riderless horse."—

Instead, Remington rode over to the camp of the Seventh Cavalry and listened to the officers and men recount their experiences "in that inimitable way which is studied art with warriors."⁴

Remington's close brush with reality did nothing to dampen his martial ardor. Through the 1890s he continued to hanker after a *real* war—in Europe, if need be, or in Cuba, where he hoped for "a big murdering" until it actually came to pass and he was on hand to see it.⁵ Sickened, he returned home aware of the distance between his heroic dreams and war's grim reality and content thereafter to let armies do their clashing on the field of his imagination.

The Riderless Horse figured as one of thirteen pen drawings collectively titled Types from Arizona and published in Harper's Weekly, August 21, 1886. In it, the cavalryman's head is slightly ducked, suggesting that he is escaping under fire.

Ex-collection: Newhouse Galleries, New York City; Samuel H. Rosenthal, Jr., Los Angeles.

- 1. Frederic Remington: The Soldier Artist. This label was anticipated by General Nelson A. Miles who in a letter of introduction for Remington on December 31, 1895, called him "a very good friend to the army" (Splete and Splete, eds., Frederic Remington—Selected Letters, p. 198).
 - 2. Hassrick, Frederic Remington, p. 43.
- 3. Frederic Remington to J. Henry Harper, December 17, [1890], in Splete and Splete, eds., *Frederic Remington—Selected Letters*, p. 110.
- 4. Frederic Remington, "The Sioux Outbreak in South Dakota," *Harper's Weekly*, January 24, 1891, in *Collected Writings*, p. 67. The entire episode did not redound to Remington's credit in army circles—see Samuels and Samuels, *Frederic Remington*, pp. 149–152.
- 5. Frederic Remington to Owen Wister, [June 1898], in Vorpahl, *My Dear Wister*—, p. 233.

Types from Arizona Harper's Weekly, August 21, 1886 Amon Carter Museum, Fort Worth

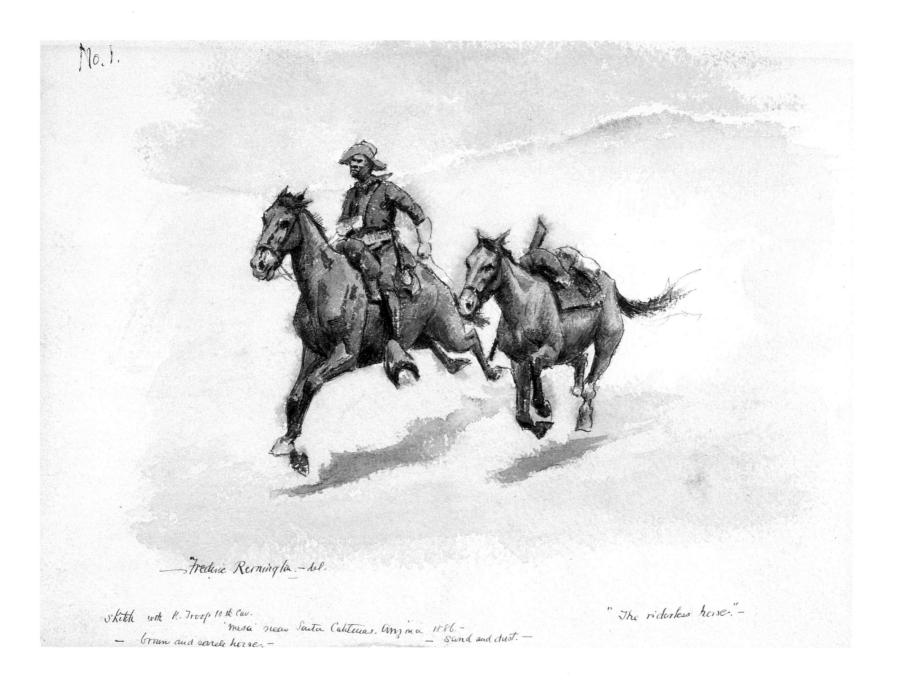

The Ambushed Picket

1886 Pencil, pen and ink, and watercolor on paper 9 x II⁷/₈" (22.8 x 30.2 cm.)

Signed lower left: Frederic Remington del—; inscription upper left: No. 2; lower left (below

The Ambushed Picket, like The Riderless Horse, illustrates the potential danger in Indian fighting, not an actual incident witnessed by Remington. In a note accompanying a related painting published in 1893, The Advance-Guard, or the Military Sacrifice, Remington wrote: "... when the vidette ranges out in front and flank he is at the mercy of his pot-hunting foe. . . . I remember to have seen two young negroes of the Ninth Cavalry go down a nasty defile commanded by a thousand points, when they had no more chance to escape than poor shooting would afford. The Sixth Cavalry did lots of 'Bad Land scouting' in the last Sioux outbreak, and from an impression I received there I got my picture, though I did not see a man killed."1 This statement suggests the kind of liberties that Remington, as an illustrator, routinely took with fact. He probably submitted several drawings to Harper's Weekly in 1886 similar to The Riderless Horse and The Ambushed Picket, representing dramatized moments in the Geronimo campaign. The Weekly for May 29 that year carried a major composition by Thure de Thulstrup, a staff artist, based on a Remington sketch. Titled Shot on Picket, it showed a party of cavalrymen and scouts galloping past the body of a trooper whose horse stands forlornly by. The Ambushed Picket was reworked—especially the fallen soldier—and published in the June 8, 1889, Weekly. Subjects such as these, full of violent, pounding action, captivated the public and established Remington as the premier Western illustrator of his day. He knew what he wanted to paint ("other things are irksome"2), and that it was already in the past. "D—— the future," he wrote an officer friend in 1890. "Soldiers by proffession deal with the future—artists deal with the past though. I dont care a d---- what you cavalrymen are going to do—its what you have done."3

signature): "The ambushed picket" / Arizona 1886—; and lower right: —please return the sketches—; below: dust—mesquit:—foot caught in stirrup—horse reins caught in saddle gear / carbine draggin from sling.—

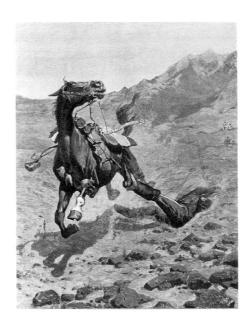

The Ambushed Picket Harper's Weekly, June 8, 1889 Amon Carter Museum, Fort Worth

Ex-collection: Newhouse Galleries, New York City; Samuel H. Rosenthal, Jr., Los Angeles.

- 1. Frederic Remington, "The Advance-Guard, or the Military Sacrifice," Harper's Weekly, September 16, 1893, in Collected Writings, p. 109; also Frederic Remington to Powhatan Clarke, June 20, [1891], in Splete and Splete, eds., Frederic Remington—Selected Letters, p. 119. In a letter of December 1, 1899, to the publisher of Harper's Weekly, Remington noted that he "faked" one of his Cuban war illustrations, "having lost my sketch book & having no photograph at the time"-an admission that raises not only the issue of invention in his illustrative work but also the whole, thorny issue of his reliance on photographs. Simply, only a portion and perhaps a small portion at that—of his entire artistic output was based on firsthand observation. See Jussim, Visual Communication and the Graphic Arts, Chapter 7, for the Remington letter to the Weekly and the argument that his career "was essentially that of an intermediary between photography from Nature and the printed page"; and Jussim, Frederic Remington, the Camera & the Old West, for an elaboration.
- 2. Frederic Remington to Powhatan Clarke, June 20, [1891], in Splete and Splete, eds., Frederic Remington—Selected Letters, p. 119.
- 3. Remington to Clarke, January 30, 1890, in ibid., p. 90.

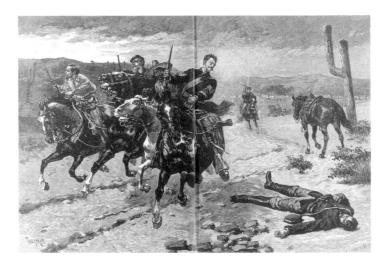

T. de Thulstrup, after Frederic Remington, *Shot on Picket Harper's Weekly*, May 29, 1886.

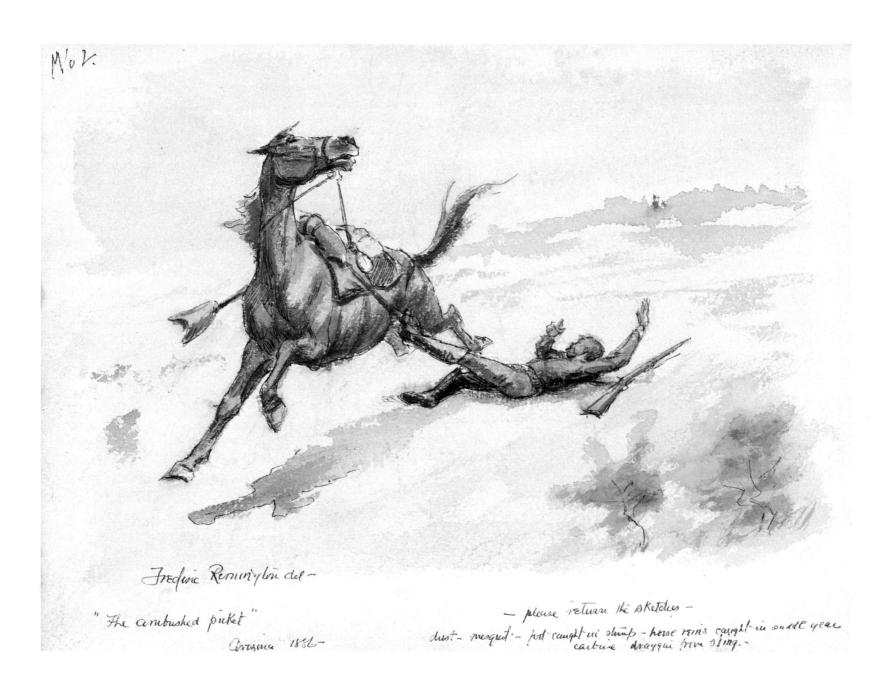

The Sentinel

1889 Oil on canvas 34 x 49" (86.3 x 124.4 cm.) Signed lower right: Frederic Remington. / '89 *Ex-collection:* Newhouse Galleries, New York City; John Levy, New York City.

In several of his major oil paintings, Remington pulled together elements from his field sketches. His early works were as literal and linear as the drawings themselves, though he occasionally made dramatic compositions out of fairly mundane materials. Routine camp scenes recorded while on patrol with the cavalry, for example, are charged with interest when Remington adds a scout delivering his report to the officers over breakfast. The viewer is left to conclude that a day that has begun like so many others for the cavalrymen in the picture will not end without some dramatic development. There is action in the offing.¹

The Sentinel was painted in 1889, a year in which Remington made one of his periodic forays into Mexico on assignment for Harper's Weekly. But its inspiration was a trip to the Southwest three years earlier that took him through Colorado, Arizona, and New Mexico into Mexico.² In the deserts of southern Arizona, Remington sketched the Papagos, a peaceful people long under the sway of the Spaniards and Mexicans. They had no enemies apart from the Apaches, who were a constant menace, and outside the mission at San Xavier a mounted Papago kept vigil. Remington published a sheet of twelve drawings, Sketches among the Papagos of San Xavier, in Harper's Weekly for April 2, 1887, and combined three of them—a Papago home, the mission proper, and the guard on lookout for Apaches—in this striking oil.

This may be the painting put up for auction at the American Art Galleries in New York on January 13, 1893—one of Remington's first important ventures in selling his work. If so, it was known at the time as *The Guard of the Rancheria*. The painting's surface has cracked over the years, a problem Remington commented on himself. "I never varnish paintings (except a spirit varnish)

until as long after wards as possible which gives the paint time to harden," he noted shortly before he died. "If varnished too soon they crack (the varnish shatters) . . . I used in my youth to varnish early with the result that some of my early things are cracked."3 Nevertheless, The Sentinel is a splendid example of Remington's early work in color in a period when he was self-consciously trying to master desert tones. On one of his trips to Mexico he jotted an appropriate "Description of an Effect" in his notebook: "yellow black plain foreground quite yellow with light warm purple shaddows-brown red blue middle distance of mesquit. deep blue mountain horizon and dark blue sky—troubled in streaks— . . . The ground of the south west has more burnt sienna in it than I had thought.-"4

- 1. The painting referred to is A Cavalryman's Breakfast on the Plains (c. 1891; Amon Carter Museum, Fort Worth); its sources are discussed, and one illustrated, in Dippie, "Frederic Remington's West: Where History Meets Myth," in Myth of the West, by Chris Bruce et al., pp. 115–117.
- 2. See Samuels and Samuels, *Frederic Remington*, Chapter 6.
- 3. Frederic Remington to Albert S. Brolley, [December 20, 1909], in Splete and Splete, eds., *Frederic Remington—Selected Letters*, pp. 436–437.
- 4. Frederic Remington Notebook, 71.812.8, Frederic Remington Art Museum, Ogdensburg, New York; and see Ballinger, *Frederic Remington's Southwest*, pp. 14–15.

Sketches among the Papagos of San Xavier Harper's Weekly, April 2, 1887 Amon Carter Museum, Fort Worth

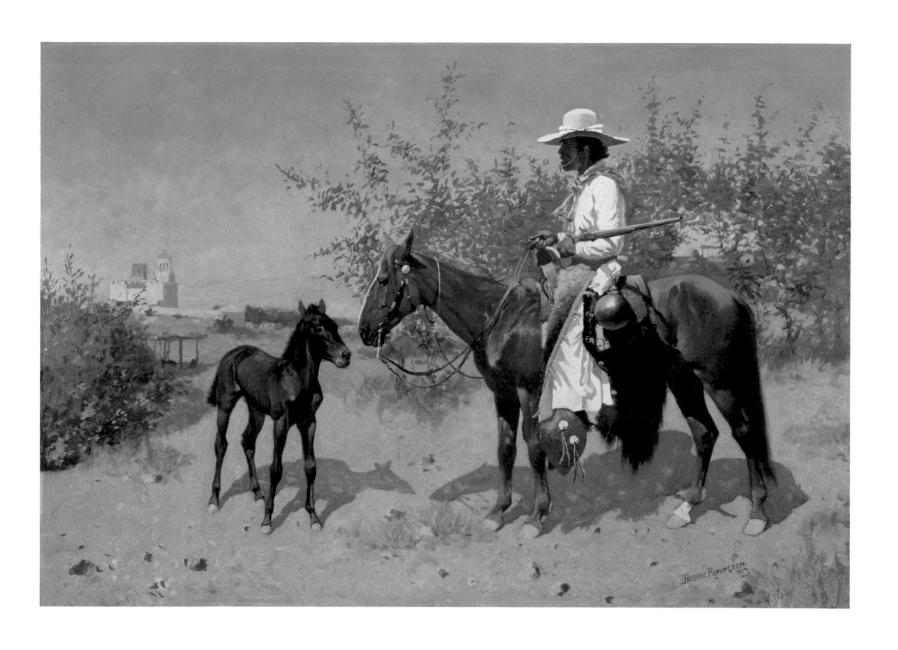

Self-Portrait on a Horse

C. 1890 Oil on canvas 29¾6 x 19¾8" (74 x 48.8 cm.) Signed lower left: Frederic Remington—

E. L. Dempsey, New York City.

Ex-collection: Newhouse Galleries, New York City;

In paint and prose Remington paid enduring tribute to his ideal, the wasp-waisted officers and men of the United States Army. He "loved the soldiers," a friend recalled, but was respectful of the distinction between a civilian like himself and the professional fighting man.1 While he rode with the cavalry, reported on military exercises, equipment, and trivia, and was proud to be an honorary member of several officers' messes—and while he noisily clamored for the sight and smell of real combat throughout the 1890s—he never forgot that soldiers wore uniforms and he did not. "My business in life, as a painter and illustrator is to give other fellows the credit that is due for gallantry— I desire no honors of this kind myself," he wrote an officer friend upon notification of his election as an honorary life member of the U.S. Cavalry Association in 1890. "In the public judgment of to day I am accorded the benefit of a doubt as to the heroism of my moral nature and I never want to get up very close to an evily disposed person with a gun for fear that the doubt may be dissapated."2 His Sioux War experiences later that year came near enough to proving his point. Anyway, Remington recognized that not being a professional soldier was what permitted him to romanticize the soldier's calling. Had he attended West Point himself, he said, he would merely have been disillusioned: "that awful West Point education might have spoiled it all—it might have paralyzed the sentiment of the thing—"3

Thus, when Remington came to paint himself into the West he was immortalizing, it was as a cowboy. He never worked as one, though some of his contemporaries thought he had. He did, however, claim to know "that gentleman to his characters end." 4 Cowboys "possess a quality of sturdy, sterling manhood which would be to the credit of men in any walk of life," he wrote in 1899, adding, "I wish that the manhood of the cow-boy might come more into fashion further East." 5 This feeling helps to explain the cowboy garb (a photograph from the same period shows him in ordinary civvies): his self-portrait is a study in self-fulfillment, the Easterner become hardy Westerner. Asked about the audience for his art, Remington replied in 1903: "Boys-boys between twelve and seventy . . . "6 Here, in his only full-fledged self-portrait, we have a boy of nearly thirty, dressed up as a cowboy on a white

horse under one of those skies that are not cloudy all day. The angle is heroic. Horse and rider tower over the viewer, who has no choice but to gaze up at them. Youthful fantasies, that smug face tells us, *can* be realized.

- I. Augustus Thomas, "Recollections of Frederic Remington," *Century Magazine* 86 (July 1913): 354.
- 2. Frederic Remington to Powhatan Clarke, March 25, 1890, in Splete and Splete, eds., Frederic Remington—Selected Letters, p. 92.
- 3. Frederic Remington Notebook (1890–1891), 71.812.9, Frederic Remington Art Museum, Ogdensburg, New York.
- 4. Frederic Remington to Francis Parkman, January 9, 1892, in Wilbur R. Jacobs, ed., *Letters of Francis Parkman* 2: 254.
- 5. Frederic Remington, "Life in the Cattle Country," *Collier's Weekly*, August 26, 1899, in *Collected Writings*, p. 388. Earlier, in "A Rodeo at Los Ojos," *Harper's New Monthly Magazine*, March 1894, he wrote of cowboys: "... these natural men possess minds which, though lacking all embellishment, are chaste and simple, and utterly devoid of a certain flippancy which passes for smartness in situations where life is not so real. ... They are not complicated, these children of nature, and they never think one thing and say another" (*Collected Writings*, pp. 136–137).
- 6. Edwin Wildman, "Frederic Remington, the Man," Outing 41 (March 1903): 716.

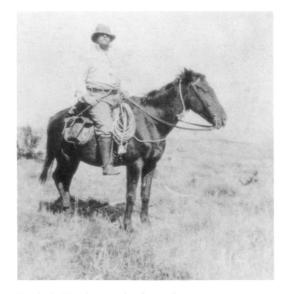

Frederic Remington in the early 1890s Kansas State Historical Society, Topeka

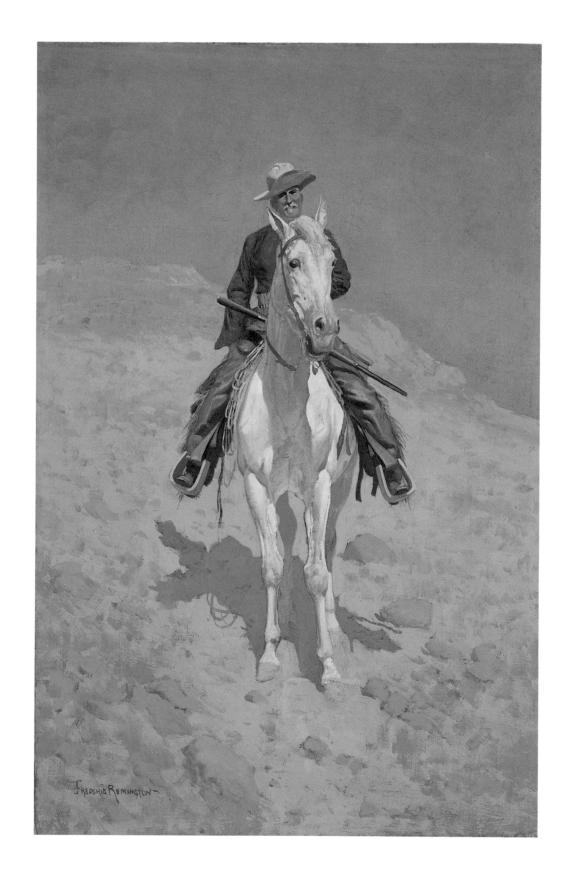

His Last Stand

C. 1890 Oil on canvas 25¹/₄ x 29¹/₄" (64.1 x 74.3 cm.) Signed lower right: Frederic Remington—

In a letter to Owen Wister, Remington confessed to some difficulty with an illustrating assignment involving a musk-ox. "I'm d- if you can imagine how little I know about musk-ox when you get down to brass tacks," he quipped.1 Indeed, animals apart from horses and wolves consistently gave Remington trouble; his illustration of a badger fight drew the criticism from Theodore Roosevelt in 1897 that "the badger's legs are too long and thin." After Remington died, the writer of an obituary got a bit carried away while reciting the standard litany ("He knew the Indian and fought him . . . He knew the cowboy, the United States cavalryman and the Mexican vaquero and rode with them") and ended up asserting that "the grizzlies Remington depicted were grizzlies he had known personally."3 In truth, bears also remained a mystery to him. He sketched and painted his share over the years, but never quite got the hang of bear anatomy. He was of the

His Last Stand shows the climax to a bear hunt on the range, and with its Indian wars analogy is appropriately titled. The swarming, yelping dogs have brought their exhausted quarry to bay, and the cowboys, with all due respect for the bear's fearsome reputation, are moving in for the kill. The foreground rider, his rifle at ready, his horse registering the tension of the moment, was distinctive enough to be singled out and repainted by John Scott for use in the Marlin Fire Arms Company's 1900 catalog. Known as Danger Ahead, Scott's copy still serves as Marlin's logo.⁵

opinion that "a grizzly can run downhill quicker than a horse," and his bruins were always built to gallop, with legs as long as a thoroughbred's. Ex-collection: Newhouse Galleries, New York City; John Douthitt, New York City.

- I. Frederic Remington to Owen Wister, [late October 1895], in Vorpahl, My Dear Wister—, p. 168. For those who would care to examine his effort, Remington's Musk-Ox at Bay appeared in Harper's New Monthly Magazine 92 (April 1896): 730.
- 2. Theodore Roosevelt to Frederic Remington, November II, 1897, in Splete and Splete, *Frederic Remington—Selected Letters*, p. 287.
- 3. "Remington, the Artist, Is Dead of Appendicitis," New York World, December 27, 1909.
- 4. Frederic Remington, "Bear-Chasing in the Rocky Mountains," *Harper's New Monthly Magazine*, July 1895, in *Collected Writings*, p. 202.
- 5. Marlin Guns for 1963, p. 19; Hassrick, Frederic Remington, p. 117, illustrates the Scott copy.

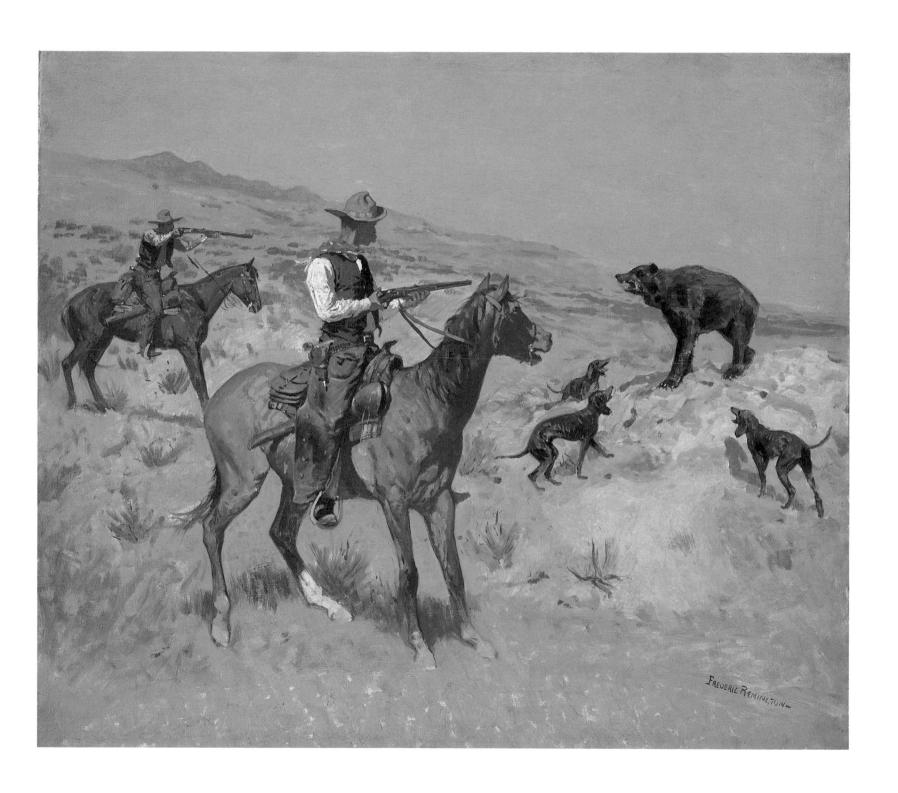

The Courrier du Bois and the Savage

1891 Oil (black and white) on canvas 23⁷/₈ x 35³/₄" (60.6 x 90.8 cm.) Signed lower right: Frederic Remington

Ex-collection: Newhouse Galleries, New York City; Arnold Seligman Ray & Company, New York City.

The fur trade was a business proposition. It involved Indian and white in what both considered a beneficial exchange, symbolized by the handshake that spans racial and cultural barriers in Remington's The Courrier du Bois and the Savage. This black-and-white oil illustrated an article by Julian Ralph narrating the early history of the Hudson's Bay Company in the Canadian Northwest. Ralph, a good friend who vigorously promoted Remington's work and apparently aided him with his prose,1 wrote that before the Bay men were "the French, from the Canadas," the coureurs des bois or "runners of the woods": "They were of hardy, adventurous stock, and they loved the free-roving life of the trapper and hunter. Fitted out by the merchants of Canada, they would pursue the waterways which there cut up the wilderness in every direction, their canoes laden with goods to tempt the savages, and their guns or traps forming part of their burden. They would be gone the greater part of a year, and always returned with a store of furs to be converted into money, which was, in turn, dissipated in the cities with devil-may-care jollity." The coureurs des bois, in short, were the precursors to America's storied mountain men.

There was no delicacy to Remington's touch in his illustration, just a thoroughly professional job of depicting something that antedated his personal Western experience (here by two centuries) but that always fascinated him, the fur trade. Remington in this period was known for his unsparing realism. It led to mixed results in his first major book assignment, a new edition of Henry Wadsworth Longfellow's beloved Indian epic *Hiawatha* in 1890. Remington was not in harmony with the poem's spirit, though contemporaries thought his illustrations a cut above the usual noble savage claptrap since they were a

compound of observation and imagination that appeared authentic. It was this same aura of knowing realism—nicely suggested in the details of costume and armament in The Courrier du Bois and the Savage—that first brought Remington's work to the attention of Francis Parkman and resulted in another, more satisfying commission to illustrate the 1892 edition of Parkman's classic account of Western life in 1846, The Oregon Trail. A letter that Remington wrote Parkman at the time not only defined the approach he would take but also concisely summed up his credo as an illustrator: "I desire to symbolize the period of the Oregon Trail and I do not hope for your approval since it is impossible but if the men you made do not corospond with the men I make, it [is] their fault, not mine."3

- 1. Julian Ralph, "Frederic Remington," *Harper's Weekly*, January 17, 1891, p. 3; Ralph, "Frederic Remington," *Harper's Weekly*, February 2, 1895, p. 688; Frederic Remington to Julian Ralph, May 23, [c. 1893], Theater, Music, Dance and Art Miscellany, Bancroft Library, University of California, Berkeley; and see Samuels and Samuels, *Frederic Remington*, Chapter 12.
- 2. Julian Ralph, "A Skin for a Skin," *Harper's New Monthly Magazine* 84 (February 1892): 374–375. *The Courrier du Bois and the Savage* was reproduced fullpage on p. 393.
- 3. Frederic Remington to Francis Parkman, January 9, 1892, in Jacobs, ed., *Letters of Francis Parkman* 2: 254–255.

The Thunder-Fighters Would Take Their Bows and Arrows, Their Guns, Their Magic Drum

1892 Oil on wood panel 30 x 18" (76.2 x 45.7 cm.) Signed lower left: Frederic Remington*Ex-collection:* Newhouse Galleries, New York City; Dr. R. Benson, New York City.

Remington regarded Indians as superstitious primitives who took all their cues from nature. Living in ignorance, they saw omens in the shape of a cloud, the roll of thunder, a flash of lightning. Here, in one of the paintings that illustrated the 1892 edition of Francis Parkman's The Oregon Trail, Remington shows Sioux "thunder-fighters" braving a storm and their own fears to chase off the huge black thunder bird whose beating wings filled the air with roaring. "Whenever a storm which they wished to avert was threatening," Parkman wrote, "the thunder-fighters would take their bows and arrows, their guns, their magic drum, and a sort of whistle made out of the wing-bone of the war-eagle, and, thus equipped, run out and fire at the rising cloud, whooping, yelling, whistling, and beating their drum, to frighten it down again."1

An army friend who visited Remington in 1892 found him at work on The Oregon Trail illustrations and commented, "hereafter the heroes of the plains whose memories live in those pages will be immortal in figure and form as well as in words. Occasionally he steals time to complete a canvas, but his profession properly forbids any work but black and white."2 This painting, however, is in color, and involves some changes in the published version that make the title inappropriate. Originally, there was a third warrior standing behind the other two discharging his musket into the sky. In his early attempts to market his work, Remington occasionally repainted finished pictures—notably an oil he entered in the 1888 exhibition of the National Academy of Design, Return of a Blackfoot War Party3—and the elimination of the background figure in The Thunder-Fighters does simplify the composition. Remington also added an embellishment: the design that decorates the drum was based on one in his own studio collection.4 Apparently the revised painting, along with many of Remington's lesser illustrations for The Oregon Trail, was offered at auction in New York in 1893 as The Storm Medicine.

- 1. Francis Parkman, The Oregon Trail: Sketches of Prairie and Rocky-Mountain Life, pp. 208–209.
- 2. Alvin R. Sydenham, "Frederic Remington," in Splete and Splete, eds., Frederic Remington—Selected Letters, p. 185.
- 3. George Schriever, "Russell-Remington," *Southwest Art* 6 (May 1977): 49, 51; and Samuels and Samuels, *Frederic Remington*, illustrations 27–29.
- 4. Peter H. Hassrick to Jan Brenneman, May 15, 1987, Sid W. Richardson Collection files.
- 5. Catalogue of A Collection of Paintings, Drawings and Water-colors by Frederic Remington, A.N.A., #37.

The Thunder-Fighters Would Take Their Bows and Arrows, Their Guns, Their Magic Drum Francis Parkman, The Oregon Trail: Sketches of Prairie and Rocky-Mountain Life (Boston: Little, Brown, and Company, 1892)

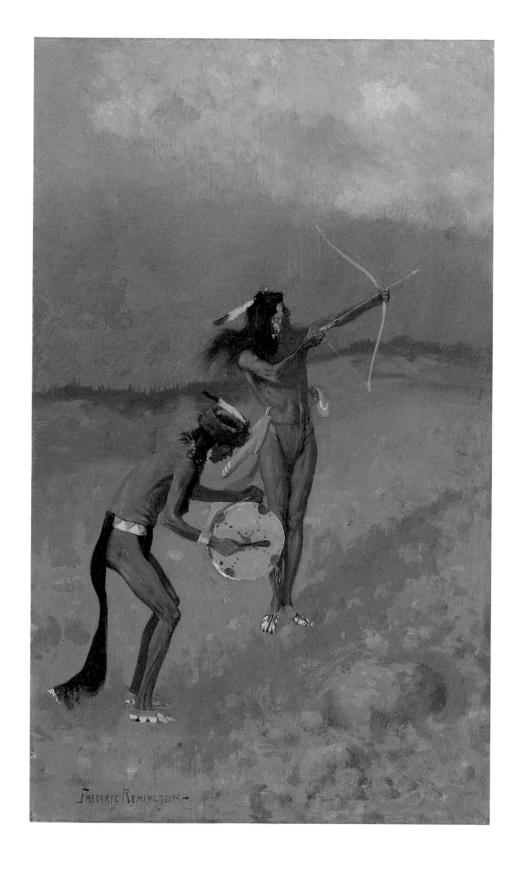

In a Stiff Current

1892 Oil (black and white) on canvas 24 x 36" (61 x 91.4 cm.) Signed lower right: REMINGTON Ex-collection: Newhouse Galleries, New York City; Thomas E. Finger, New York City.

Canoeing, Remington wrote in 1896, "is my religion."1 It was a passion that never lost its tang for him. Late in life, when his "elephantine bulk" ruled out horseback riding and made even a long hike taxing, Remington could still be found paddling his canoe near his summer home and studio, Ingleneuk, in Chippewa Bay on the St. Lawrence. The years and his excess poundage slipped away as he headed into the wind to tame the river's "white horses." 2 Canoeing was one of his last concessions to the "strenuous life" ethic, that masculine credo to which he had subscribed so noisily over the years. "Fie on this thing called contentment! . . . it properly only belongs to Florida negroes and house-dogs," he had asserted in 1895.3 Challenge was everything. "A real sportsman, of the nature-loving type, must go tramping or paddling or riding about over the waste places of the earth, with his dinner in his pocket. He is alive to the terrible strain of the 'carry' [portage], and to the quiet pipe when the day is done. . . . He is fighting a game battle with the elements, and they are remorseless. He may break his leg or lose his life in the tip-over which is imminent, but the fool is happy—let him die."4

Julian Ralph, a regular contributor to Harper's, was one of those who filled Remington's requirements for "a real sportsman," and their work frequently appeared together.5 In a Stiff Current is an excellent example of Remington's mature technique as an illustrator. A fluent black-and-white oil, it accompanied an article by Ralph on life in the Canadian north woods where the Hudson's Bay Company was into its third century in the fur trade, and "the countless lakes of all sizes, the innumerable small streams, and the many great rivers . . . make waterways the roads, as canoes are the wagons, of the region."6 Remington's picture shows a party of voyageurs, lineal descendants of the coureurs des bois according to Ralph, dressed in flannel shirts, corduroy trousers, and jaunty

touques, battling their way upstream. It also illustrates a theme that Remington put into words a year later in an essay of his own on canoeing: "The morning comes too soon, and after you are packed up and the boat loaded, if you are in a bad part of the river you do this: you put away your pipe, and with a grimace and a shudder you step out into the river up to your neck and get wet. The morning is cold, and I, for one, would not allow a man who was perfectly dry to get into my boat, for fear he might have some trepidation about getting out promptly if the boat was 'hung up' on a rock . . ." The professionals in *In a Stiff Current* are showing how it is done.

- 1. Frederic Remington, "The Strange Days That Came to Jimmie Friday," *Harper's New Monthly Magazine*, August 1896, in *Collected Writings*, p. 227.
- 2. Perriton Maxwell, "Frederic Remington—Most Typical of American Artists," *Pearson's Magazine* 18 (October 1907): 397; Manley, *Some of Frederic Remington's North Country Associations*, p. 31. A journalist in 1903 wrote: "Remington and his canoe are inseparable. 'Best exercise on earth, feel my arm,' he says to the skeptical inlander" (Edwin Wildman, "Frederic Remington, the Man," *Outing* 41 [March 1903]: 713).
- 3. Frederic Remington, "Getting Hunters in Horse-Show Form," *Harper's Weekly*, November 16, 1895, in *Collected Writings*, p. 217.
- 4. Frederic Remington, "Black Water and Shallows," Harper's New Monthly Magazine, August 1893, in Collected Writings, p. 105.
- 5. See Remington's tribute, "Julian Ralph," *Harper's Weekly*, February 24, 1894, in *Collected Writings*, pp. 130–131.
- 6. Julian Ralph, "Talking Musquash," *Harper's New Monthly Magazine* 84 (March 1892): 493. *In a Stiff Current* appeared as a full-page illustration, p. 499.
- 7. Remington, "Black Water and Shallows," in *Collected Writings*, pp. 107–108.

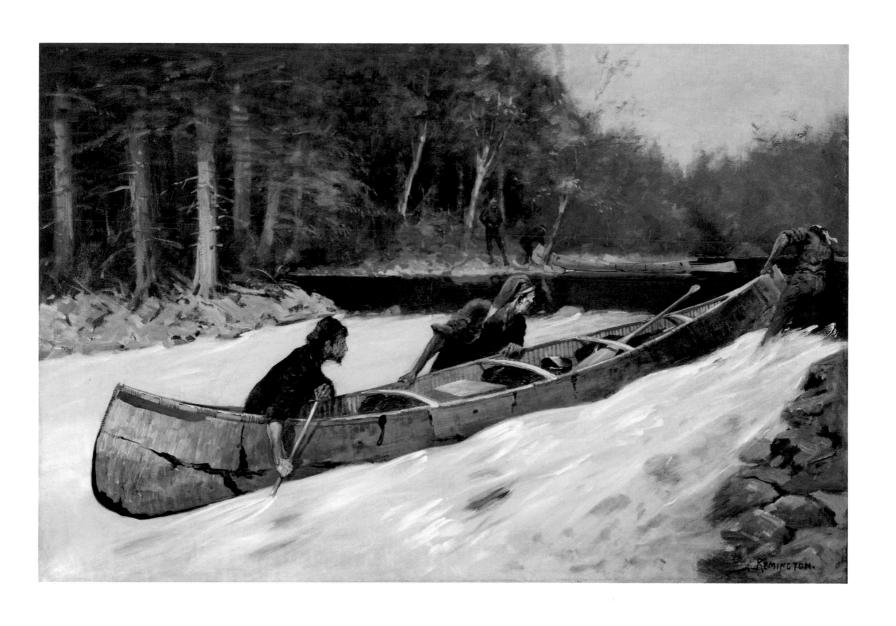

The Puncher

1895 Oil on canvas 24 x 201/8" (60.9 x 51.1 cm.) Signed lower right: Frederic Remington—; inscription lower left: To my friend / H. Pyle

This well-painted figure study was apparently executed as a return gift for the celebrated and highly influential illustrator Howard Pyle (1835–1911).1 A painting by Pyle titled Pirates Used to Do That to Their Captains Now and Then had appeared in the November 1894 issue of Harper's New Monthly Magazine, where it caught Remington's eve.2 He ignored Pyle's other illustrations, including one showing Captain Kidd's men burying a treasure chest, in his excitement over the somber depiction of a dead pirate chief sprawled on a beach, his sightless eyes staring at the sky. "If I get that I will worship you, it, and once more take stock in humanity," he wrote Pyle. "As for what you will get—anything I have. I have nothing which is good in oil . . . I shall probably not paint until spring, but whatever you see of mine which suits your fancy, is yours." They eventually agreed on a different exchange—Pyle's dead pirate for a Remington cowboy to be done at some future date. "That's fair trade if I paint it well enough," Remington remarked, and The Puncher indicates that he was sufficiently conscious of his own stature as a major American illustrator to be sure he was represented by one of his best efforts.3

The trade seems a satisfying one. If pirates were pearls to Pyle, cowboys were "gems" to Remington.⁴ "The cowboys of whome I meet—many are

Ex-collection: Newhouse Galleries, New York City; Walter Latendorf, New York City; Howard Pyle, Wilmington, Delaware.

quiet, determined and very courteous and pleasant to talk to," he wrote about his encounters in New Mexico and Arizona in 1888. "Their persons show wear and exposure and all together they look more as though they followed cattle than the persuit of pleasure. Such lined and grizzled and sun scorched faces are really quite unique."5 But undercut romanticism as he might, Remington could not help seeing "the puncher" as a heroic ideal. Like Pyle, he had lifted illustration in his chosen area to the level of art and had indelibly impressed his personality on the themes he made his own. Both men also seem to have experienced crises of a different kind around the turn of the century. Pyle detected in a letter from Remington an undercurrent indicating restlessness with his work and the limitations imposed by his reputation as a Western illustrator—fallout from his experiences in the Cuban war, no doubt, and an awareness of middle age that found expression in a settled conviction that the real West had vanished, as well as in a desire to be taken seriously as an artist as distinct from an illustrator. Pyle, in turn, felt the weight of his nearly sixty-five years, but was bothered not by his reputation as an illustrator, which he still stoutly affirmed, but by his keen sense of time running out on him before he accomplished a fraction of what he wanted to do.6 That was the difference between them.

- 1. The Puncher resembles one of the pastel drawings of Western types Remington made in 1901 and published as A Bunch of Buckskins, An Arizona Cowboy. This raises the possibility that The Puncher was actually the oil Remington exhibited in 1893 as An Arizona Cow-puncher. He often did not date his work through the 1890s—presumably so that it could be reproduced at any time as though it were brand new. Thus it is possible that he recycled his earlier oil for Pyle's benefit.
- 2. In the same year, 1894, Remington illustrated a minimum of one article in every number of *Harper's New Monthly Magazine*, suggesting just how preeminent he was among the illustrators of the day. Only Pyle and a select few others ranked with him.
- 3. Frederic Remington to Howard Pyle, January 15 and undated, 1895, in Hassrick, *Frederic Remington*, p. 108.
- 4. Frederic Remington, "Cracker Cowboys of Florida," *Harper's New Monthly Magazine*, August 1895, in *Collected Writings*, p. 208.
- 5. Frederic Remington, "Front[i]er" [1888?], in Splete and Splete, eds., Frederic Remington—Selected Letters, p. 55.
- 6. Howard Pyle to Frederic Remington, March 29, 1899, in ibid., pp. 290–291.

Pirates Used to Do That to Their Captains Now and Then by Howard Pyle Harper's New Monthly Magazine, November 1894

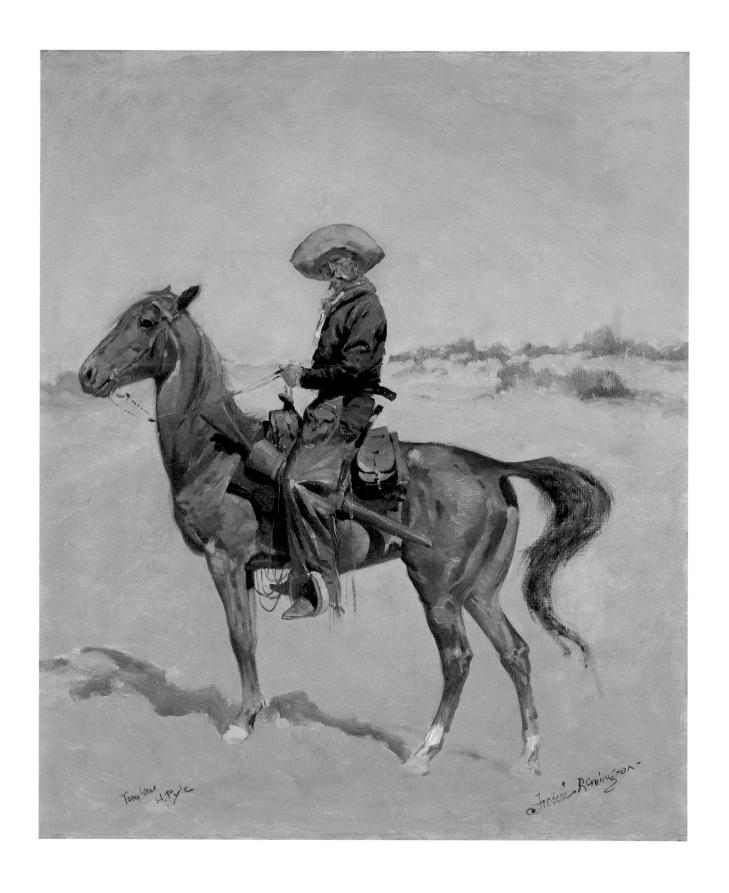

Captured

1899 Oil on canvas 27 x 401/8" (68.6 x 101.9 cm.) Signed lower left: Frederic Remington / '99

Indian captivity narratives constitute one of America's oldest literary genres. They were harrowing, first-person accounts of capture and sometimes torture, followed by escape (or, as the Puritans would have it, divine deliverance) and return to civil society. Artists were also captivated by the theme, and Remington was working in a venerable tradition when he painted Captured in 1899. It serves as a sequel to another oil done the same year, Missing (Gilcrease Museum, Tulsa), showing a party of plains Indians leading a soldier by a rope around his neck. His arms are bound behind him, and his captors' callousness is evident in the fact that he is afoot while they are riding. But the point of the picture is the trooper's stoicism. Faced with certain death, he is a model of the soldierly qualities that Remington most admired: "grim, no emotion," exhibiting "a perfect mental calm." Similarly, the prisoner in Captured, chin up, head held high, appears unafraid. Stripped to his underwear and seated away from the fire on a cold, blustery day, he knows exactly what to expect from his blanket-wrapped captors. They are pitiless, unfeeling, beyond civilized understanding. This, and related works like Henry F. Farny's The Captive (1885; The Cincinnati Art Museum) express a late-nineteenth century perception of the Western Indians that justified their defeat and displacement. Presumably Remington's warriors will torture their captive, though the lookout on the ledge behind and the still-saddled horses grazing on the slope indicate a close pursuit. If so, the deliberation around the fire and—if he is fortunate—the trooper as well will be short-lived. Remington's image of the Indian as unfathomable savage never found starker form.2

NOTES

- 1. Frederic Remington, "Chicago under the Mob," *Harper's Weekly*, July 21, 1894, in *Collected Writings*, p. 154.
- 2. Farny's *The Captive* was reproduced in the February 13, 1886, issue of *Harper's Weekly*. Remington broke into the *Weekly* in a big way that same year and doubtless saw and remembered Farny's striking picture.

Ex-collection: Newhouse Galleries, New York City; Scott & Fowles, New York City; Robert Winthrop, New York City; Beekman Winthrop, Old Westbury, Long Island; Robert Dudley Winthrop, Old Westbury, Long Island.

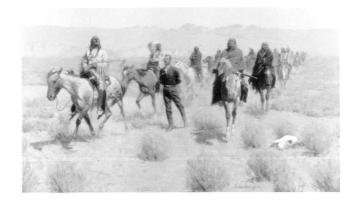

Missing (1899) Gilcrease Museum, Tulsa

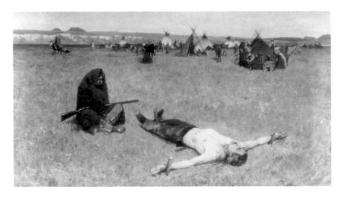

The Captive (1885) by Henry F. Farny The Cincinnati Art Museum, Ohio; gift of Mrs. Benjamin E. Tate and Julius Fleischmann in memory of their father, Julius Fleischmann

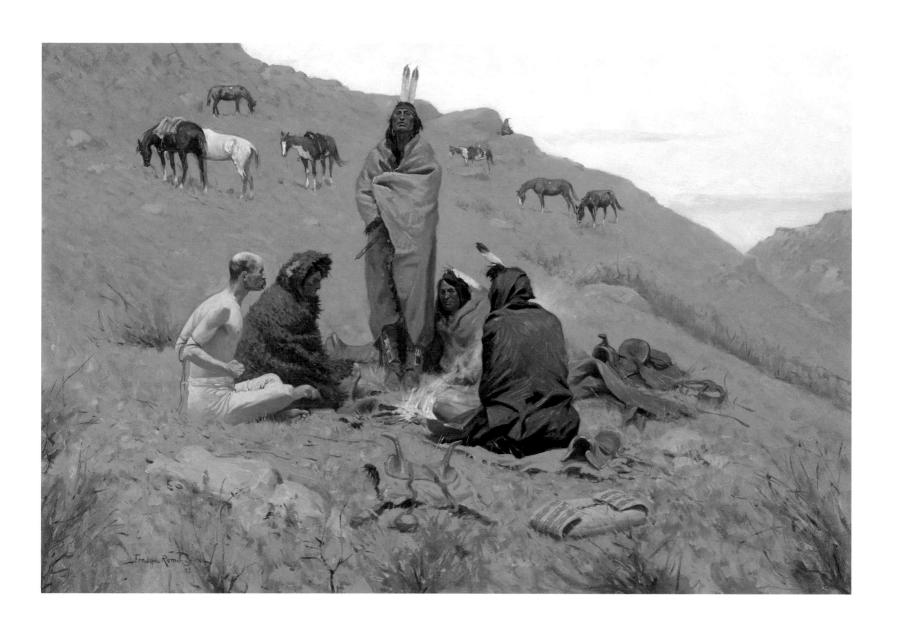

He Rushed the Pony Right to the Barricade

C. 1900 Oil on canvas 27½ x 40½" (68.9 x 101.9 cm.) Signed lower right: Frederic RemingtonEx-collection: Newhouse Galleries, New York City; John Douthitt, New York City.

At the end of 1897 Remington published a short story, "Massai's Crooked Trail," about a renegade Apache. It attracted favorable comment, and Theodore Roosevelt was particularly enthralled: "The whole account of that bronco Indian, atavistic down to his fire stick; a revival, in his stealthy, inconceivably lonely and bloodthirsty life, of a past so remote that the human being, as we know him, was but partially differentiated from the brute; seems to me to deserve characterization by that excellent but much-abused adjective, weird. Without stopping your work with the pencil, I do hope you will devote more and more time to the pen."1 With such praise still ringing in his ears, Remington in 1900 set out to write a full-length novel exploring what he elsewhere confessed was an impenetrable mystery to him, the mind of the Indian.2 He titled his story The Way of an Indian to underline his conviction, shared with Francis Parkman among others, that the Indian was a type, and the individual variations were insignificant compared to the essential uniformity. He portrayed his protagonist, a Cheyenne named Fire Eater, as a pure savage—ignorant, superstitious, fearless, ferocious, and pitiless. Roosevelt was enthralled again: "It may be true that no white man ever understood an Indian, but at any rate you convey the impression of understanding him!"3

He Rushed the Pony Right to the Barricade illustrates an episode in which Fire Eater, then known as the Bat, earns his name. A party of Cheyenne warriors have happened upon three trappers driving a string of heavily laden pack animals. The white men have had time to form a barricade out of their packs before the Cheyenne charge. They have also prepared a surprise for the on-rushing warriors:

In an instant when it seemed as if the Indians were about to trample the Yellow-Eyes, a thin trail of fire ran along the grass from the barricade and with a blinding flash a keg of powder exploded with terrific force right under the front feet of the rushing ponies. . . . Four ponies lay kicking on the grass together with six writhing men, all blackened, bleeding and scorched. The other ponies reeled away from the shock . . . All but one, for the Bat pulled desperately at his hairlariat . . . and, lashing fiercely, he rushed the pony right to the barricade. Firing his rifle into it swerving, he struck the bunch of trapper-horses which had already begun to trot away from the turbulent scene, and drove them off in triumph. He alone had risen superior to the shock of the white man's fire trap.

So he earned the name Fire Eater (or "The Man who eats the Flying Fire")—and sealed the fate of the three trappers.⁴

Remington's original illustration was done in black and white, as were the others for *The Way of an Indian*. The painting as it now exists has had a color coat applied to it, apparently by another hand. This may have been done to enhance the painting's resale value, though there is a possibility the color coat was related to the reproduction of the plates in color for distribution as separate prints. Ironically, *He Rushed the Pony Right to the Barricade* was one of the five plates, out of fourteen in the novel, *not* included in the color print series, while the original paintings of some of those that were are still in black and white.⁵

NOTES

- 1. Theodore Roosevelt to Frederic Remington, December 28, 1897, in Splete and Splete, eds., *Frederic Remington—Selected Letters*, pp. 288–289.
- 2. Frederic Remington, "On the Indian Reservations," *Century Magazine*, July 1889; *Collected Writings*, pp. 34–35.
- 3. Roosevelt to Remington, February 20, 1906, in Splete and Splete, eds., *Frederic Remington—Selected Letters*, p. 359.
- 4. Frederic Remington, *The Way of an Indian* (1906); *Collected Writings*, pp. 575–578. Peggy and Harold Samuels speculate that Remington drafted the novel by 1902 (ibid., pp. 625–626); there is strong evidence to

indicate that he actually finished the whole thing in 1900. The novel was not serialized for five years, the first installment appearing in the November 1905 issue of *Cosmopolitan* with a portion of one of Remington's illustrations emblazoned on the cover in color. This caused some discomfort at *Collier's Weekly*, which two years before had proudly announced "the exclusive publication . . . of all of Mr. Remington's work." Consequently, a short disclaimer appeared under the heading "Relics from the Past," with an explanatory letter from Remington dated October 16, 1905:

In reference to the articles now appearing in the magazine: You will remember that I told you when we made our exclusive arrangement that they were in existence and unpublished. They were written and illustrated and sold by myself five years ago to the "New Magazine" (which never eventuated) and have found their present destination.

(Frederic Remington to Julian Ralph, [Summer 1900], in Splete and Splete, eds., Frederic Remington—
Selected Letters, p. 313; Advertisement for "The Christmas Collier's," Collier's Weekly, November 21, 1903; and "Relics of the Past," ibid., November 4, 1905.) The Way of an Indian was Remington's swan song as a writer. "I shall never write another word," he told a journalist in 1907. "I only wrote those books of mine to introduce people to the subjects I was trying to draw, paint, and sculpt" (Perriton Maxwell, "Frederic Remington—Most Typical of American Artists," Pearson's Magazine 18 [October 1907]: 405). This could be seen as further evidence of Remington's determination to abandon illustration and make his mark as an artist.

5. Samuels and Samuels, *Remington: The Complete Prints*, nos. 52–60.

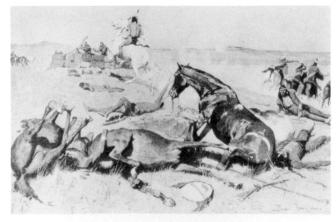

"He rushed the pony right to the barricade."

He Rushed the Pony Right to the Barricade Frederic Remington, The Way of an Indian (New York: Fox Duffield & Company, 1906)

Rounded-Up

1901 Oil on canvas 25 x 48" (63.5 x 121.9 cm.) Signed lower right: Frederic Remington— / 1901

Remington frequently returned to a theme that represented his version of grace under pressure: a group of cowboys, mountain men, or soldiers surrounded by circling Indians and confronting death without a hint of fear. Usually he showed a small party of men—five or six at the outside facing overwhelming odds. One exception was his 1890 oil The Last Stand (Woolaroc Museum, Bartlesville, Oklahoma), which depicts a contingent of troopers and one prominent scout ensconced on a rocky hill. Though not a single Indian is seen, the whole composition melodramatically underlines the point that none of those brave men will escape alive. Rounded-Up, painted eleven years later, is even more ambitious but somehow less satisfying. Full of action, it nevertheless seems placid. The colors are disconcertingly bright. Critics regularly complained about Remington's use of color, "a garishness not to be explained alone by the staccato effects of a landscape whelmed in a blaze of sunshine" that resulted in paintings "as hard as nails." 2 In Rounded-Up, the vibrant hues and grating light might have added poignancy to the scene—men desperately battling for their lives on such a perfect day—were it not for the troopers' unaccountably passive response to their predicament. One can understand the officer standing erect directing the defense, eyes shaded, face an emotionless mask, unperturbed by the bullets whizzing by. This was a Remington ideal. But why the scouts would expose themselves in such a fashion is as inexplicable as the action is difficult to comprehend. The breastwork of horses in the foreground does not extend around the troopers' formation indeed, the led horses in the center of the ring are just where they should be in a routine dismounted maneuver. Since the officer and the white scout are conferring, one can assume that they are pondering their options. But this is precisely where the painting falls down on a narrative level. For the Indian foe, despite the numbers implied by the bullets kicking up dirt in the foreground, appears distant and unmenacing. Surely a determined show of force on the part of the soldiers would be more than enough to lift the siege. The plain is flat, the enemy visible—and the path of honor open and obvious. Perhaps the explanation is simple: Remington meant to convey misgivings about the action shown. He had for some time pondered a painting of Major Marcus Reno's retreat and, to Remington's mind, virtual desertion of General Custer at the Little Bighorn.3

Ex-collection: Newhouse Galleries, New York City; Scott & Fowles, New York City; Robert Winthrop, New York City; Beekman Winthrop, Old Westbury, Long Island; Robert Dudley Winthrop, Old Westbury, Long Island.

Could this be the painting? If so, why such a calm performance by the officer? Or perhaps the ambivalence in *Rounded-Up* simply mirrors Remington's own following his first direct exposure to warfare in Cuba. It is difficult to say, since Remington painted other cavalry subjects in this period, including a painting of a cavalry column coming under fire, *Halt—Dismount!* (1901; Stark Museum of Art, Orange, Texas), which could serve as a prelude to *Rounded-Up.*⁴

Rounded-Up does evince the realism for which Remington was known, and both admired and reviled. N. C. Wyeth, as a young illustrator aspiring to capture the "sublime and mysterious quality" of the West, was initially appalled by Remington's concentration on "the brutal and gory side of it." But he soon modified his views. "Remington's show was fine," he wrote in 1904. "It was vital and powerful although most of his pictures were too gruesome to allow them to become living works of art. He's too insistent on showing mangled bodies, wounds, etc. Nevertheless the exhibition impresses you and convinces you that Remington had lived in that country and was telling something . . . "5 Over the next few years Remington would almost completely abandon the literalism that offended his critics, and set himself the task of capturing the West's "sublime and mysterious quality" in paint.

- I. Originally reproduced as a double-page spread in *Harper's Weekly*, January 10, 1891, pp. 24–25.
- 2. Royal Cortissoz, "Frederic Remington: A Painter of American Life," *Scribner's Magazine* 47 (February 1910): 186.
- 3. Frederic Remington to Owen Wister, September 1, 1899, in Vorpahl, *My Dear Wister*—, p. 279, and in his other references to the Custer Battle.
- 4. Remington before year's end painted another last stand, *Caught in the Circle*, that was published as a two-page color spread (his first) in *Collier's Weekly* for December 7, 1901. Sold separately as a print, it proved immensely popular. Its power resides in its simplicity: three troopers and a scout make a determined stand against circling Indians. This time there is no question of options. They are badly outnumbered, their horses are down, precluding escape, and all they can do is sell their lives dearly. The drama is clear-cut and convincing.
- 5. N. C. Wyeth to his mother, November 29, 1903, and March 25, 1904, in Betsy James Wyeth, ed., *The Wyeths: The Letters of N. C. Wyeth, 1901–1945*, pp. 65, 79.

The Last Stand (1890) Woolaroc Museum, Bartlesville, Oklahoma

I

The Cow Puncher

1901 Oil (black and white) on canvas 287% x 19" (73.3 x 48.3 cm.)

Signed lower right: Frederic Remington

Ex-collection: Newhouse Galleries, New York City.

By 1900 Remington was given to mourning the passing of his West. A trip to Colorado late that autumn brought only disappointment. "Shall never come west again," he wrote his wife. "It is all brick buildings—derby hats and blue overhauls—it spoils my early illusions—and they are my capital."1 It was in just such an elegiac mood that Remington painted his stirring black-andwhite study The Cow Puncher. Horse and rider make a blatant bid for the viewer's attention as they come to a skidding halt in a cloud of dust. The cowboy, lean and unsmiling, is a figure of myth, and when Collier's Weekly reproduced the painting on its cover for September 14, 1901, it was with an accompanying poem by Owen Wister:

No more he rides, yon waif of might, His was the song the eagle sings; Strong as the eagle's his delight, For like his rope, his heart had wings.

Remington was pleased—the poem was "a great help to the picture. Sort of puts the d—— public under the skin." Wister subsequently modified his verse to bring it into line with Remington's larger intentions. Instead of a eulogy, it becomes a tribute to the cowboy's enduring appeal:

He rides the earth with hoofs of might, His is the song the eagle sings; Strong as the eagle's, his delight, For like his rope, his heart hath wings.

And so the cowpuncher, a mythic figure from America's past, lingers on in the present.³

Peter Hassrick has commented on some of the flaws in this authentic-looking but fanciful portrayal of the cowboy: the floppy hat that has all but obscured his vision, the dragging loop, the awkward position of his left hand which ensures that his throwing hand will get tangled in the coil.4 This might seem like nitpicking, but Remington had always been a stickler for accuracy himself and was annoyed to read in the same Collier's Weekly in 1908 Charles M. Russell's laconic observation: "That fellow may be able to handle a rope with his quirt hanging on his right wrist while he's roping; but I never saw it done in real cow work myself." 5 "There is one thing a man who does anything in America can figure on—a - good pounding," Remington grumbled in his diary. "It seems to be one of the penalties of achievement."

- 1. Frederic Remington to Eva Remington, November 6, 1900, in Splete and Splete, eds., *Frederic Remington—Selected Letters*, p. 318.
- 2. Frederic Remington to Owen Wister, [October 18, 1901], in ibid., p. 299.
- 3. Vorpahl, My Dear Wister-, p. 326.
- 4. Hassrick, Frederic Remington, p. 128.
- 5. "Pays Tribute to Russell," *Great Falls Daily Tribune*, December 26, 1908, quoting Emerson Hough, "Wild West Faking," *Collier's Weekly*, December 19, 1908.
- 6. Frederic Remington Diary, entry for December 19, 1908, Frederic Remington Art Museum, Ogdensburg, New York.

Collier's Weekly, September 14, 1901

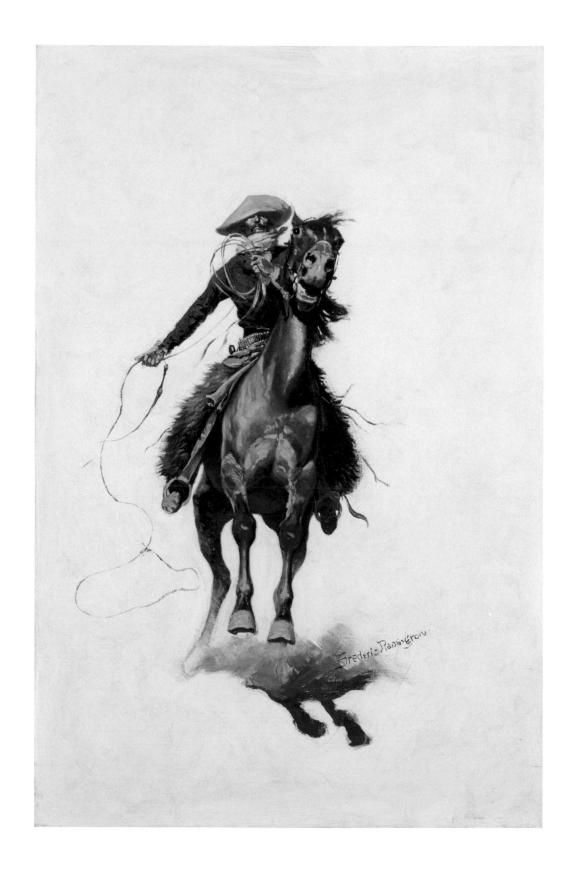

A Sioux Chief

1901 Pencil and pastel on composition board 317/8 x 227/8" (81 x 58.1 cm.)

Signed lower right: Frederic Remington

Ex-collection: Newhouse Galleries, New York City.

While covering the Sioux campaign of 1890-1891 for Harper's, Remington recorded a few observations typical of his attitude at the time: "I sat near the fire and looked intently at one human brute [a Brule Sioux] opposite, a perfect animal, so far as I could see. Never was there a face so replete with human depravity, stolid, ferocious, arrogant, and all the rest—ghost shirt, war-paint, feathers, and arms. As a picture, perfect; as a reality, horrible." But the soldiers whom Remington idolized expressed a "decided respect" for their plains Indian adversaries,² and conventional army wisdom, which he eagerly absorbed, held that they were "naturally the finest irregular cavalry on the face of the globe." The passage of time only confirmed him in the view that plains warriors were born to fight, not farm, and as the 1890s came to an end he was prepared to give them their due: "They were fighting for their land—they fought to the death—they never gave quarter, and they never asked it. There was a nobility of purpose about their resistance which commends itself now that it is passed."4

A Sioux Chief, one in a series of eight pastels of Western types that Remington published in 1901 as A Bunch of Buckskins, is his tribute to the fighting Sioux. He essayed the same pose in other single-figure studies—notably An Indian Trapper (1889; Amon Carter Museum, Fort Worth, Texas)—though here the twist of the torso and ungainly angle of neck and head create a rather awkward impression. It is compounded by the wind, which has flattened one side of the warbonnet worn by the Sioux. But the haughty arrogance that Remington detected a decade earlier is preserved intact, and this figure became one of the "types" that defined Remington's West.

- 1. Frederic Remington, "Lieutenant Casey's Last Scout," *Harper's Weekly*, January 31, 1891, in *Collected Writings*, p. 75.
- 2. Frederic Remington, "Indians as Irregular Cavalry," *Harper's Weekly*, December 27, 1890, in *Collected Writings*, p. 59.
- 3. Frederic Remington, "Artist Wanderings among the Cheyennes," *Century Magazine*, August 1889, in *Collected Writings*, p. 44. Also his "Indians as Irregular Cavalry" and *John Ermine of the Yellowstone* (1902), in *Collected Writings*, pp. 65, 512.
- 4. Frederic Remington, "How Stilwell Sold Out," *Collier's Weekly*, December 16, 1899, in *Collected Writings*, p. 397.

The Thrill That Comes Once in a Lifetime by H. P. Webster New York Herald-Tribune, June 20, 1942

A Taint on the Wind

1906 Oil on canvas 27½ x 40" (68.9 x 101.6 cm.) Signed lower right: Frederic Remington; and base center: copyright 1906 by Frederic Remington

In dealing with subjects he knew firsthand, Remington had always been a stickler for accuracy. When his novel John Ermine of the Yellowstone was being adapted for the stage in 1903, his voice was ever on the side of authenticity in costume and props.1 That same year he charged into public controversy by pronouncing a cavalry scene painted by New Jersey artist Charles Schreyvogel "half baked stuff" and listing his criticisms point by point.2 Remington "is the most conscientious of historians," a critic wrote as late as 1907. "He has never 'faked' an action, a costume or an episode."3 Of course this claim is absurd—even such early field sketches as The Riderless Horse and The Ambushed Picket were imaginary—but there is no doubt that Remington had always aimed at verisimilitude. However, as his artistry ripened in the twentieth century, he abandoned the illustrator's concern with form, precision of line, sharp tonal contrast, and accuracy of detail to concentrate on light and color in his painting. His goals had changed, in short, and his later work cannot be judged by the same criteria as his earlier illustrations. The Schreyvogel controversy was a last hurrah; thereafter, Remington, who had always made pictures that conformed to his personal vision of the West, broke away from the literal and gave his imagination free rein. He particularly loved night scenes. Darkness concealed the mundane, while moonlight and shadow created instant drama.

Ex-collection: Newhouse Galleries, New York City; Scott & Fowles, New York City; Robert Winthrop, New York City; Beekman Winthrop, Old Westbury,

A Taint on the Wind is redolent with tension as the spooked horses turn their heads toward some unseen peril lurking in the shadowy sagebrush outside the picture's borders. As an illustrator, Remington would have spelled out the cause of their panic—be it a road agent or a bicycle rider. As an artist, he wanted only to imply the cause. One could ask of Remington the illustrator why a coach traveling through dangerous country at night would have two lanterns lit, but Remington the artist had his reasons: he needed to build light sources into his night scenes white horses, white hats, moonlight on dirt or snow. Here, without the lanterns, one could not see the startled reactions of the men on the coach or, for that matter, the coach itself. Thus accuracy was sacrificed to aesthetic considerations, and the result is a carefully integrated work of art.

Remington enjoyed such success with his nocturnes that they made up perhaps half of his output during his later years. A friend noted that they were "keyed to the mute though not inglorious poet in him." His study of nighttime light convinced him that the appropriate color range was browns and black on a field of greens—jades, mints, no tone was too daring. While a friendly critic thought that Remington's stars looked stuck on, and while the lanterns are thick blobs of white pigment suggesting some difficulty in making them stand out naturally, A Taint on the Wind, along with the other nocturnes in the Richardson Collection, represents Remington at his painterly best.

Long Island; Robert Dudley Winthrop, Old Westbury, Long Island; Grant B. Schley, New York City.

- I. See Remington's letters to Louis Shipman, in Splete and Splete, eds., *Frederic Remington—Selected Letters*, pp. 339–343.
- 2. See James D. Horan, *The Life and Art of Charles Schreyvogel: Painter-Historian of the Indian-Fighting Army of the American West*, pp. 31–40; and Dippie, "Frederic Remington's West: Where History Meets Myth," in Chris Bruce, et al., *Myth of the West*, p. 119.
- 3. Perriton Maxwell, "Frederic Remington—Most Typical of American Artists," *Pearson's Magazine* 18 (October 1907): 399. Also Augustus Thomas, "Recollections of Frederic Remington," *Century Magazine* 86 (July 1913): 358: "Accuracy . . . was his religion. In his chosen field he abhored anachronisms."
 - 4. Hassrick, Frederic Remington, p. 41.
- 5. Thomas, "Recollections of Frederic Remington," b. 361.
- 6. Childe Hassam to Frederic Remington, December 20, [1906], in Splete and Splete, eds., Frederic Remington—Selected Letters, p. 361.

The Hold-Up (1902) Amon Carter Museum, Fort Worth

The Right of the Road (1900) Amon Carter Museum, Fort Worth

The Dry Camp

1907 Oil on canvas 27% x 40" (68.6 x 100 cm.) Signed lower left: Frederic Remington. / 1907. Ex-collection: Newhouse Galleries, New York City.

By 1907 light had become Remington's obsession as a painter—early morning light, midday glare, moonlight, firelight. After viewing his exhibition at M. Knoedler & Company in New York in December 1908, a critic remarked, "one grows . . . to look first for the light over the canvas, not for the detail or the color or the outline." 1 The Dry Camp is an attempt to capture the intense light at day's end as the setting sun bathes the land in an unreal, ruddy glow, transfixing the single figure of a pioneer with his outfit caught short of water at nightfall in a parched country. He could be an actor upon a spotlit stage, his shadow projected against the props of horses and wagon, which cast their own shadows on the desert backdrop. Having removed a broad-brimmed hat that would have done the trick, the man shades his eyes with a hand and, standing front and center, stares back at the audience. It is all such a theatrical performance that it seems rooted in Remington's own experiences when his novel John Ermine of the Yellowstone was dramatized and put on the stage in the fall of 1903. A disappointment, the play opened and quickly closed in Boston, Chicago, and New York. But it gave the "stagestruck" Remington a thrill along the way, and may have influenced paintings like The Dry Camp and a nocturne done the same year, The Sentinel (Frederic Remington Art Museum, Ogdensburg, New York), with their limited scope, implied drama, and stagev lighting.2

Despite the static subject matter, Collier's Weekly published The Dry Camp as Benighted for a Dry Camp at the front of its issue for March 4, 1911, more than a year after Remington's death, and included it in a 1912 portfolio of Remington's Four Best Paintings. With its pervasive sense of psychological isolation, The Dry Camp could now be seen to represent Everyman at the sunset of life confronting mortality.³

- I. Giles Edgerton [Mary Fanton Roberts], "Frederic Remington, Painter and Sculptor: A Pioneer in Distinctive American Art," *Craftsman* 15 (March 1909): 669.
- 2. Samuels and Samuels, Frederic Remington, pp. 338–339, 346–350. Remington used similar lighting effects in The Sign of the Buffalo Scouts (1907; National Cowboy Hall of Fame and Western Heritage Center, Oklahoma City) and The Long Horn Cattle Sign (1908; Amon Carter Museum, Fort Worth, Texas).
- 3. Samuels and Samuels, Remington: The Complete Prints, no. 143; and see Jussim, Frederic Remington, the Camera & the Old West, pp. 102–103. This sense of closure, and perhaps of enervation or exhaustion, is the particular theme of Ben Merchant Vorpahl, Frederic Remington and the West: With the Eye of the Mind; while Christine Bold, Selling the Wild West: Popular Western Fiction, 1860–1960, pp. 52–64, on the awareness of limits and the claustrophobic qualities in Remington's work, is relevant to The Dry Camp.

The Sentinel (1907)
Frederic Remington Art Museum, Ogdensburg,
New York

A Figure of the Night [The Sentinel]

1908 Oil on canvas 30 x 211/8" (76.2 x 53.6 cm.)

On January 14, 1908, Remington finished an oil of an Indian in moonlight. Likely it was the painting he copyrighted a week later as A Figure of the Night and exhibited that February at Henry Reinhardt's Annex Gallery in Chicago.1 "Big art is a process of elimination," Remington explained to a friend in 1902. "Cut down and out-do your hardest work outside the picture, and let your audience take away something to think about—to imagine. . . . What you want to do is to just create the thought—materialize the spirit of a thing, and the small bronze—or the impressionist's picture—does that; then your audience discovers the thing you held back, and that's skill."2 It was a long statement for a man not usually given to overt analysis of his craft, but it reflected the selfconscious direction that Remington's art had taken after 1900. At one time it had seemed to him enough to "observe the things in nature which captivate your fancy and above all draw draw—draw—and always from nature. Do not try to make pictures. When you are studying-do the thing simply and just as you see it—use india ink—crayon or some broad medium at firstthen color either water or oil . . . "3 But as he experimented with his own technique, his naturalistic credo faded. Commenting on Remington's 1908 exhibition at Knoedler's, Mary Fanton Roberts observed that to his "perfected knowledge" of Western detail Remington had added "the extraordinary and intangible quality which suggests the actual mystery of life itself." 4 Instead of a direct statement, Remington's art had become an enticement, drawing the viewer into the search

A Figure of the Night is a case in point. It shares similarities with another nocturne, The Outlier (1909; The Brooklyn Museum, New York), though the mood is very different. The Indian in The Outlier rises well above the horizon line and dominates the picture space; 5 the Indian in A Figure of the Night blends into his environment. Its narrative is so cryptic that one can see him as a lookout, camouflaged by the trees behind, or as a forerunner to the "luckless hunter" Remington portrayed the next year, returning home after a wearying day with nothing to show for his efforts. He is not a typical Remington warrior. His face wears a worried, even timorous expression. Perhaps he is a boy doing a man's job. The shadows on the snow in front of him and the dark woods behind encircle him like the jaws of a giant Signed lower right: Frederic Remington / 1908—; and base center: copyright 1908 by Frederic Remington—

trap. Remington used the foreground to good narrative effect as early as 1889 in A Dash for the Timber (p. 126). A few scattered tree branches in the path of his onrushing riders and the shadows of trees on the left indicate that they have reached the sanctuary of the timber and will be able to make a stand against the Indians galloping after them. More tellingly, he used foreground shadows in His First Lesson (1903; Amon Carter Museum, Fort Worth, Texas) to enclose the drama of two men and an unridden horse; the shadows tell us they are inside a corral, and the viewer is a spectator awaiting what will follow. The foreground shadows in A Figure of the Night are more ominous. There is imminent danger here, and it is up to the viewer looking out from the woods to guess what it might be. The story, in short, is in the viewer's head, not in the picture, and by 1908 Remington thought that the distinction was everything.

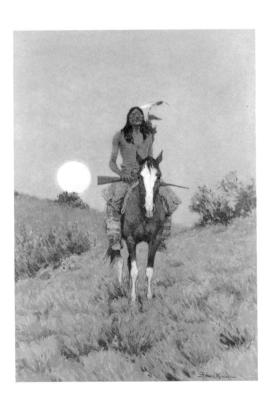

The Outlier (1909)
The Brooklyn Museum 55.43; bequest of Miss Charlotte
R. Stillman

Ex-collection: Newhouse Galleries, New York City; John Douthitt, New York City.

- 1. Frederic Remington Diary, January 14, 22, 1908, Frederic Remington Art Museum, Ogdensburg, New York; Recent Paintings by Frederic Remington and Portraits by A. de Ferraris of Vienna, no. 12.
- 2. Edwin Wildman, "Frederic Remington, the Man," Outing 41 (March 1903): 715–716.
- 3. Frederic Remington to Maynard Dixon, September 3, 1891, in Wesley M. Burnside, *Maynard Dixon:*Artist of the West, p. 215.
- 4. Giles Edgerton [Mary Fanton Roberts], "Frederic Remington, Painter and Sculptor: A Pioneer in Distinctive American Art," *Craftsman* 15 (March 1909): 670.
- 5. In a variant on *The Outlier* (1909; Frederic Remington Art Museum, Ogdensburg, New York), Remington set the Indian lower in the picture space and the heroic impression is correspondingly reduced. Both versions are illustrated in Shapiro, Hassrick, et al., *Frederic Remington: The Masterworks*, pp. 168–169.

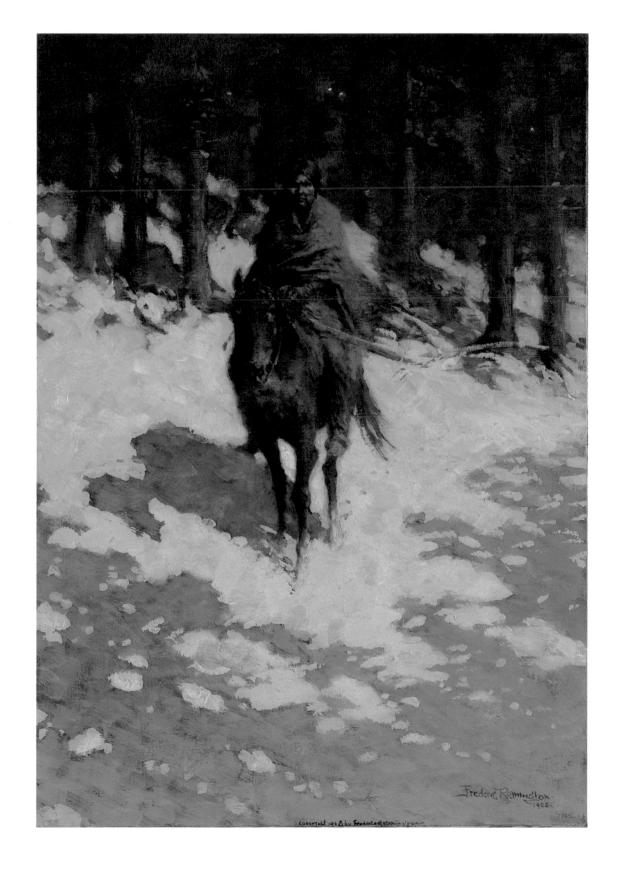

Scare in a Pack Train

1908 Oil on canvas 27 x 40" (68.6 x 101.6 cm.) Signed lower left: Frederic Remington / 1908

Scare in a Pack Train was an experiment for Remington, and his most daring nocturne to date. He began it on a snowy day in February, and started over a few weeks later when he acquired a new "Rough Smoothe" canvas that promised good results for his "moonlights." With his usual efficiency, he finished the painting in four days, though he returned to it periodically for further work. Peter Hassrick has observed that "whereas Remington had once used impasto to capture ambient light and accentuate certain elements of his compositions, he now explored the rough texture of canvas, washed with a thin surface of paint."1 Remington noted that color loosened "readily from the heavy mesh canvas," and continued to rework Scare in a Pack Train. But though it took "a world of monkeying," the effort was worth it when a friend pronounced the oil "wonderful"—a "ghost painting." 2 Remington, who had exacting standards and was hard to please, agreed. Scare in a Pack Train was unusually dark, and with so few sources of reflected light its tension more than ever had to be implied. The painting found a buyer when Remington exhibited it at Knoedler's that December, and he provided her with a description of the content but only a hint at the technique:

Ex-collection: Newhouse Galleries, New York City; Lauder Greenway, Greenwich, Connecticut; Mrs. James C. Greenway, Greenwich.

... it represents a U.S. government Train in Arizona during the days of the Apache campaigns. Mules have highly wrought sensabilities and are particularly nervous at night. The scent of indians—old indian fires, wild animals or a sudden commotion makes them stop and their ears go up—whereat the packers get busy—Something is due to happen muy pronto.

I consider the Pack Train my best attempt so far at that very elusive thing moonlight and have great faith that the picture will help my reputation as a painter in the time to come. I also thank you for your patronage and hope that you will never be able quite to penetrate the mysteries of the technique which is the greatest charm of all painting.³

Ghost paintings must keep their secrets to themselves.

- 1. Peter H. Hassrick, Frederic Remington: The Late Years, p. 40.
- 2. Frederic Remington Diary, entries for February 6, 22, 24, 27, March 9, 17, 26, December 4, 1908, Frederic Remington Art Museum, Ogdensburg, New York.
- 3. Frederic Remington to Mrs. James C. Greenway, December 11, 1908, Sid W. Richardson Collection, Fort Worth.

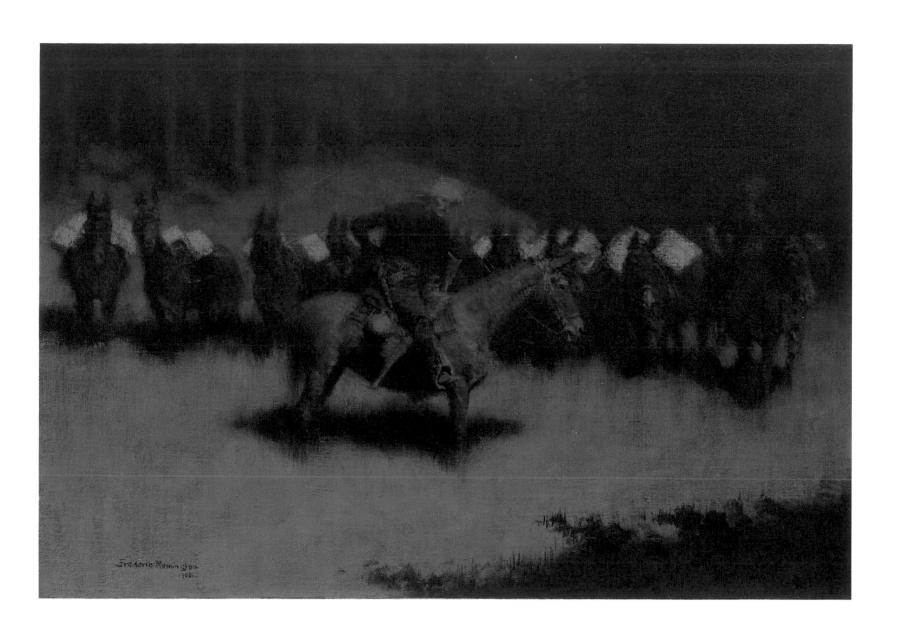

The Unknown Explorers

1908 Oil on canvas 30 x 27¹/4" (76.2 x 69.2 cm.) Signed lower right: Frederic Remington / 1908—

Because mountain men carried such a burden of the West's romantic tradition for Remington, he always thought of them as grey-bearded oldtimers. But trapping was a young man's occupation, a high-risk first career for those who survived. (The violent mortality rate among one sample of 446 mountain men active between 1805 and 1845 was 40 percent!) 1 Jedediah Smith was a retired veteran who had survived two major Indian fights, explored routes from Salt Lake to Los Angeles and from the Sacramento to the Columbia, and been in business himself when he was killed by Comanches in 1831 while guiding a wagon train to Santa Fe. Smith was only thirty-two years old.² So much living crammed into so few years—then, like the frontier, the mountain men had vanished in a twinkling. Remington confessed that they were "passé" before he ever went West, but he was sure they all looked much alike.3 A photograph of Jim Bridger elicited this response: "I had thought there could be no such thing in existence. He was the real old mountain type however by his picture. Those fellows all had a strong family resemblance—didnt they."4 When Francis Parkman disappointed his expectations by sending him a photograph of a young, smoothfaced trapper of his acquaintance in 1846, Henry Chatillon, to aid in preparing the illustrations for The Oregon Trail, Remington replied: "H.C.does not look at all as he should according to my mind—people never do. He looks like a Boston fisherman and not like a wild horseman of the American desert—I take it he did not shave in the mountains. I shall take liberties with H.C. which the good soul would resent were he alive." 5 Remington was given to painting "types" anyway—a standard army officer, a standard cowboy—so it was natural that in dealing with one he had never seen he would draw upon his imagination. This tendency did not escape notice. "I don't like him or his illustrations," Hamlin Garland wrote. "His red men and trappers are all drawn from one model. All his trappers have close-set eyes and bushy beards, and his red men are savages without being graceful. He does not see the Western men and Indians as I see them."6

But in *The Unknown Explorers* Remington rose above stereotyping. A few years before he had painted an oil of identical title which he destroyed after redoing the subject for a patron. The figures were similar, but the lighting was not, and therein lay the difference. "Above and beyond all

Ex-collection: Newhouse Galleries, New York City; Scott & Fowles, New York City; Robert Winthrop, New York City; Beekman Winthrop, Old Westbury,

his extraordinary presentation of the people and their picturesque existence is the absolute quality of the West itself,—the bronze of the day, the green of the twilight, the wind that stifles, the sun that blinds, the prairies that glisten and quiver with thirst, water that is a mockery, and storms that are born and vanish in the sky," Mary Fanton Roberts wrote of Remington's 1908 exhibition. "And each phase of this marvelous country expressed through a medium so fluid, so flexible, so finally sympathetic that you become unconscious of it as was the artist himself when he painted."7 The Unknown Explorers is itself an exploration in sunlight and shadow. During the 1890-1891 winter campaign against the Sioux in Dakota, Remington described "the tangled masses of the famous Bad Lands—seamed and serrated, gray here, the golden sunset flashing there, with dark recesses giving back a frightful gloom—a place for stratagem and murder . . . "8 In this painting, the point of view is reversed: the men emerge from a shadowy defile into dazzling sunlight. But the emotion of riding into the unknown is effec-

The Unknown Explorers
Collier's Weekly, October 11, 1906

Long Island; Robert Dudley Winthrop, Old Westbury, Long Island.

tively conveyed by the very glare of the sun, so harsh that it temporarily blinds the mountain men. A world of unseen perils is opening up before them. In an 1897 letter to a pioneer who, unlike him, "dated back," Remington made some relevant comments: "I read your passage of the desert with gusto and have often wondered in riding New Mex. & Arizona how the devil the pioneers ever got over that country having no knowledge of the water. I suppose lots of them didn't as a matter of fact." From the alert posture and self-assured expressions on the faces of his "unknown explorers," one can conclude that locating the next waterhole will be the least of their worries.

- I. William H. Goetzmann, "The Mountain Man as Jacksonian Man," *American Quarterly* 15 (Fall 1963): 408–409.
- 2. Remington did an oil painting titled *Jedediah Smith*, which appeared in *Collier's Weekly* for July 14, 1906. It showed Smith as one of his typical bearded mountain men of indeterminate but presumably advanced age.
- 3. Frederic Remington to Francis Parkman, January 9, 1892, in Jacobs, ed., *Letters of Francis Parkman* 2:
- 4. Frederic Remington to John B. Colton, December II, 1899, in the Huntington Library, San Marino, California. Colton also supplied Remington with photographs of Kit Carson and Jim Baker ("He was a great type—wasn't he?" Remington replied on December 26, 1899). When Remington sketched Bridger (*Outing*, November 1887), he showed him as the usual buckskin-clad, white-bearded old mountain type; it is unlikely that any photograph would change his impression.
- 5. Remington to Parkman, January 13, 1892, in Jacobs, ed., *Letters of Francis Parkman* 2: 255. Parkman, it should be noted, approved the liberties that Remington took, writing him on February 23, 1892: "The pictures are admirable. You have rendered the 'Mountain Man' type perfectly. . . H. Chatillon, if he were alive, would have every reason to be pleased with his image" (p. 256).
 - 6. Hamlin Garland, Roadside Meetings, p. 394.
- 7. Giles Edgerton [Mary Fanton Roberts], "Frederic Remington, Painter and Sculptor: A Pioneer in Distinctive American Art," *Craftsman* 15 (March 1909): 669.
- 8. Frederic Remington, "Lieutenant Casey's Last Scout," *Harper's Weekly*, January 31, 1891, in *Collected Writings*, p. 171.
- 9. Remington to Colton, April 22, 1897, Huntington Library.

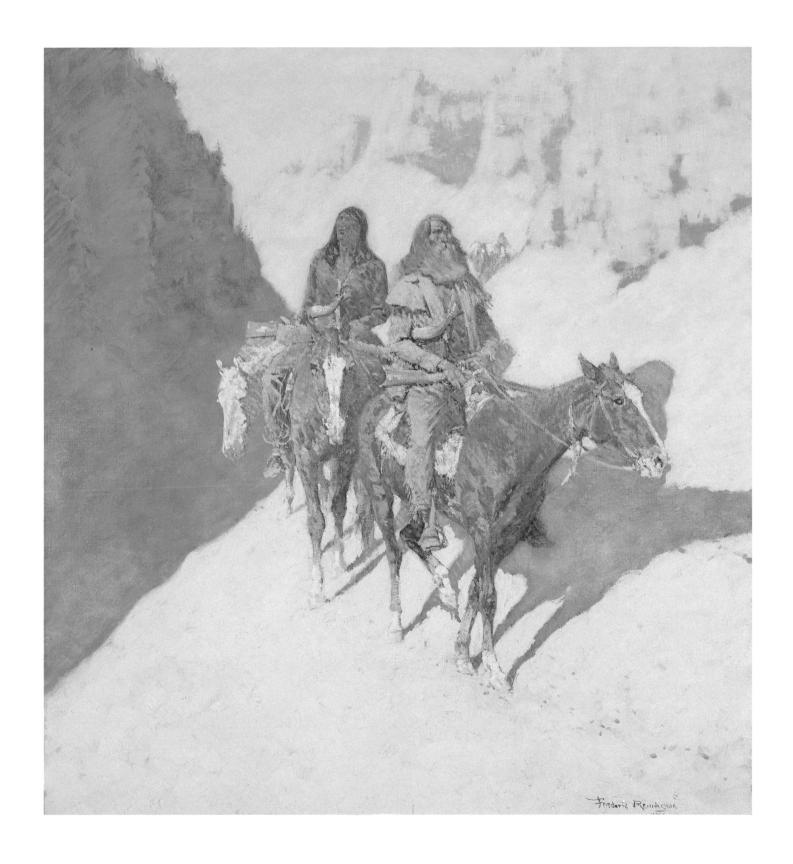

Apache Medicine Song

1908 Oil on canvas 271/8 x 297/8" (68.9 x 75.9 cm.) Signed lower right: Frederic Remington / 1908

In Apache Medicine Song the campfire's glow provides orange highlights in a sea of greens and browns, while deep shadows fringe the picture. The flickering light plays over the faces of the chanting warriors, distorting their features. The effect is demonlike, chilling, as though the men are congregated about the fire to cast an evil spell. Back in 1888, on a journalistic assignment for Century Magazine, Remington had witnessed this scene on the San Carlos Reservation:

It grew dark . . . Presently, as though to complete the strangeness of the situation, the measured "thump, thump, thump" of the tom-tom came from the vicinity of a fire some short distance away. One wild voice raised itself in strange discordant sounds, dropped low, and then rose again, swelling into shrill yelps, in which others joined. . . . We drew nearer, and by the little flickering light of the fire discerned half-naked forms huddled with uplifted faces in a small circle around the tom-tom. The fire cut queer lights on their rugged outlines, the waves of sound rose and fell, and the "thump, thump, thump, thump" of the tom-tom kept a binding time. We grew in sympathy with the strange concert, and sat down some distance off and listened for hours. . . .

The performers were engaged in making medicine for the growing crops, and the concert was a religious rite, which, however crude to us, was entered into with a faith that was attested by the vigor of the performance.¹

As an illustrator Remington had always been attracted to campfire scenes. (The compositional precedent for *Apache Medicine Song*, oddly enough, was a sketch he made during the 1890–1891 Sioux campaign, *Troopers Singing the Indian*

Ex-collection: Newhouse Galleries, New York City; Scott & Fowles, New York City; Robert Winthrop, New York City;

Medicine Song, which appeared in the December 6, 1890, issue of Harper's Weekly.) But it was in his late, impressionistic phase that he fully realized the dramatic potential of firelight. Mary Fanton Roberts, who wrote the most perceptive critical commentary on Remington's later work (at least he deemed it "very much all right . . . the best statement of actualities I have seen as yet"2), struck by the "extraordinary variation . . . of light flooding canvas after canvas" in his 1908 show at Knoedler's, singled out for praise an oil "in which the flaunting wind-blown camp fire breaks the blackness of night and opens spaces in the dark for fear, or sorrow, or revenge to show on the faces of the men about the fire." This effect was only one of several that Remington perfected in the burst of creative energy that marked the last years of his life.

Beekman Winthrop, Old Westbury, Long Island; Robert Dudley Winthrop, Old Westbury, Long Island.

- 1. Frederic Remington, "On the Indian Reservations," *Century Magazine*, July 1889, in *Collected Writings*, pp. 34–35. Interestingly, Remington did not illustrate this vivid passage in his *Century* essay but instead showed a group of Apaches playing Monte by the light of a lantern! However, he did do a sketch a few years later, *Apache Signal Fire* (*Century Magazine* 41 [March 1891]: 655) that includes a squatting figure much like the warrior seated second from the right in *Apache Medicine Song*.
- 2. Frederic Remington to Mary Fanton Roberts, [c. January 1909], Mary Fanton Roberts Papers, Archives of American Art: Roll D 163.
- 3. Giles Edgerton [Mary Fanton Roberts], "Frederic Remington, Painter and Sculptor: A Pioneer in Distinctive American Art," *Craftsman* 15 (March 1909): 669.

Troopers Singing the Indian Medicine Song Harper's Weekly, December 6, 1890 Amon Carter Museum, Fort Worth

Among the Led Horses

1909 Oil on canvas 27 x 40" (69.2 x 102.6 cm.) Signed lower left: Frederic Remington / 1909 *Ex-collection:* Gerald Peters Gallery, Santa Fe, William Foxley, Denver.

During a dry, often sweltering July in 1909, as the Remingtons settled into their imposing new home in Ridgefield, Connecticut—a mansion on a hill crowning a thirty-acre country estate— Frederic Remington worked away on Among the Led Horses. The contrast between his prosperous circumstances and his gritty Western subject matter must have struck him: between luncheons at his club in New York City, automobile rides to his neighbors' to admire a swimming pool, telephone conversations with his stock broker, and inspection tours of his own property, he was still creating in paint life and death encounters on the distant plains.1 Indeed, he was at his peak as an artist, reveling in his powers. "I worked on my paintings and am bringing them all up to my standard," he observed at the time. "I let no picture get past me now until I cannot see a flaw."2 And important critics like Royal Cortissoz agreed. After viewing Remington's exhibition of oil paintings that December, he wrote directly to the artist: "So full of life they are, so chock full of interest, and oh! so rippingly painted!"3 In his published review, Cortissoz grouped Among the Led Horses with those pictures filled "with keen, dry air and dazzling light,"4 and though he preferred the nocturnes, explained elsewhere that the day scenes were "in the key" Remington had "first made familiar in his work, paintings in which sharp and glittering contrasts of color bring out the potency of light and air on the plains and contribute as by a kind of nervous emphasis to the effect of violent action which seems inseparable from many of his themes."5

Many of Remington's late works were reaction pieces. The reason for the reaction is unspecified in a nocturne like *Scare in a Pack Train*, where tension is conveyed by the rigid, alert pose of a trooper staring into the darkness toward *something*. The trooper in *Among the Led Horses*

strikes a similar pose, but here that unseen something is spelled out. He has come under fire. Bullets kick up the dirt in the foreground, and one of the horses he has been assigned to lead is already down. In specifying the reason for the reaction, Among the Led Horses closely resembles another night scene, Fired On (1907; National Museum of American Art, Smithsonian Institution, Washington, D.C.), though Remington's narrative strategy is transformed by daylight. In Fired On the troopers have descended a river bank and have been caught in the open by an unseen enemy concealed by the dark; in Among the Led Horses an enemy close enough to ambush troops in open country would have to be visible, but has achieved the element of surprise by catching the soldiers just as they top a rise.

- 1. See Samuels and Samuels, *Frederic Remington*, pp. 379–380, Chap. 36; and Frederic Remington Diary for 1909, Frederic Remington Art Museum, Ogdensburg, New York.
- 2. Remington Diary, entry for August 21, 1909.
- 3. Royal Cortissoz to Frederic Remington, December 2, [1909], in Splete and Splete, eds., *Frederic Remington—Selected Letters*, p. 358, where it is misdated 1904.
- 4. Royal Cortissoz, "Frederic Remington: A Painter of American Life," *Scribner's Magazine* 47 (February 1910): 192
- 5. Royal Cortissoz, untitled clipping from the *New York Tribune* [December 1909], back of the Remington Diary for 1909.

Fired On (1907) National Museum of American Art, Smithsonian Institution; gift of William T. Evans

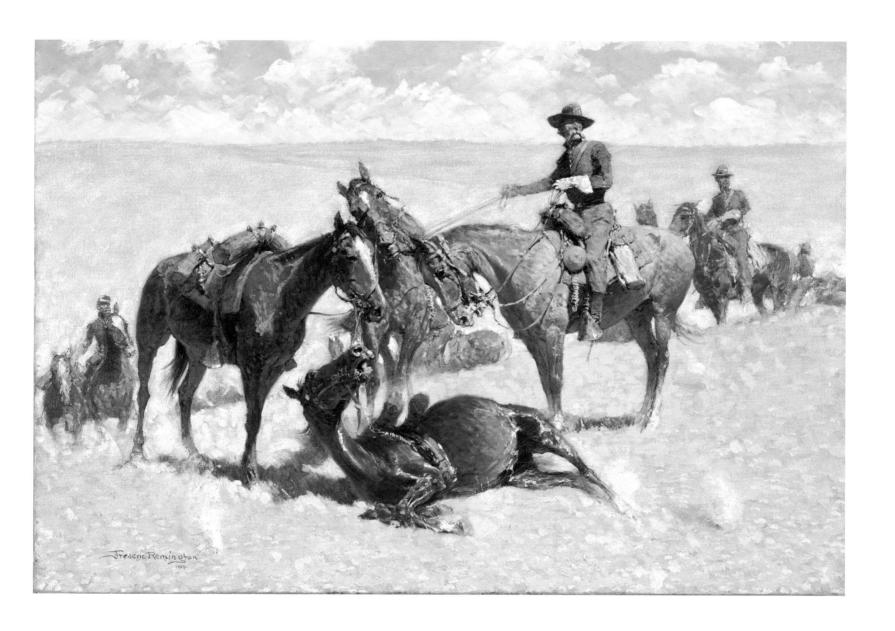

Buffalo Runners—Big Horn Basin

1909 Oil on canvas 30½ x 51½" (76.5 x 127.3 cm.) Signed lower left: Frederic Remington / 1909; with additional inscription: "Bighorn Basin" *Ex-collection:* Newhouse Galleries, New York City; Mary McClennen Hospital, Cambridge, New York.

This stunning explosion of light, color, and sinewy action seems a flawless reflection of the sunny, boyish side of Remington's nature. He could be curmudgeonly in the extreme. But Buffalo Runners—Big Horn Basin, painted in his last year of life, is a throwback to his earliest Western experiences and the emotions they generated. It is a testament in paint to his love of horses, "men with the bark on," and "the grand silent country." In his first published article (1887) Remington told of a morning's gallop across the Kansas prairie on a horse whose "stride was steel springs under me as she swept along, brushing the dew from the grass of the range and taking the bit smartly in her teeth as though to say, 'Come on, let's have a run' . . ." Other riders joined them in a

On over the smiling reach of grass, grown dry and sere in the August suns and hot winds, we galloped four abreast. . . . The rise and fall of the perfect lope peculiar to the American broncho was observable in all its ease and beauty. . . .

The horses tore along, blowing great lung-fulls of fresh morning air out in snorts. Our sombreros blew up in front from the rush of air, and our blood leaped with excitement.²

The contagious enthusiasm of such prose remained a challenge for the artist. "I have always wanted to be able to paint running horses so you would feel the details and not see them," Remington confided to his diary in 1908, and in *Buffalo Runners—Big Horn Basin* he achieved that goal. He started the painting on December 12, 1908 ("Charge of the Buffalo Runners," he called it), found it "a hard one," tamed it on July 6, 1909 ("I worked to great advantage—the color vibrated for me. . . . pulled 'The buffalo runners' into harmony"), and offered it for sale that December. Though it did not sell at the time, it is a highpoint in Remington's hard-earned transformation into an American Impressionist of sorts.³

Remington (and most of his critics) had always doubted his color sense. In 1895, in the throes of his newly discovered abilities at sculpting, he renounced painting as "fooling my time away-I can't tell a red blanket from a grey overcoat for color."4 But in the process of making himself over into an artist after 1900 he also discovered the joys of applying paint freely, stroking more boldly, and allowing his own sense of light and shadow to dictate his palette. In 1898 he wrote that "a fine green" came over the sky from the east just before dawn, but "no one of the painter guild would have admitted it was green, even on the rack . . . "5 At the time, he was as stodgy as his peers. But when he did acknowledge his perception and use green in his own work, he did it with a vengeance in his celebrated succession of nocturnes. Similarly, he had despaired of ever capturing the intense, dazzling glare of Western sunlight. Buffalo Runners—Big Horn Basin is a riot of sunstruck hues-yellow ochres, warm browns, rusts, and reds—sweeping across the canvas with an abandon to match that of the racing riders. It was Renoir who said, "I want a red to ring clearly like a bell. If it doesn't turn out that way, I add more reds until I get it. . . . I have no rules and no methods."6 And it was Remington who, according to a contemporary critic, "under a burning sun . . . has worked out an impressionism of his own."7 Around the time he painted Buffalo Runners he imparted one secret of his new-found success to a fellow artist. "If you will permit me to observe," he wrote Carl Rungius, a gifted wildlife painter, "I will say I think the lighting in your studio is too cold. I have found the same trouble and two years ago I painted or stained both my studio here and my summer one a rich red which had the effect of warming up my paint immediately. Why dont you try it. In most galleries your paintings go against hot backgrounds and one should try to get the same environment."8 The results of his experimentation speak for themselves.

In an oft-quoted personal statement written in 1905, Remington said: "I knew the wild riders and the vacant land were about to vanish forever, and the more I considered the subject the bigger the Forever loomed." Buffalo Runners—Big Horn Basin is one encounter with the Forever in which the artist emerged clear victor.

- 1. "A Few Words from Mr. Remington," Collier's Weekly, March 18, 1905, in Collected Writings, p. 551.
- 2. Frederic Remington, "Coursing Rabbits on the Plains," *Outing*, May 1887, in ibid., pp. 3–5.
- 3. Frederic Remington Diary, entries for October 3, December 12, 22, 1908, July 6, December 18, 1909, Frederic Remington Art Museum, Ogdensburg, New York.
- 4. Frederic Remington to Owen Wister, [January 1895], in Vorpahl, My Dear Wister—, p. 158. In a revealing letter to Wister—possibly written before his sketching trip to southern Colorado and New Mexico in the fall of 1900—Remington expressed a renewed determination to establish himself as a painter. "The thing to which I am going to devote two months is 'color' I have studied form so much that I never had a chance to 'let go' and find if I can see with the wide open eyes of a child what I know has been pounded into me I had to know it—now I am going to see—" (Remington to Wister, dated before February I, 1896, in Splete and Splete, eds., Frederic Remington—Selected Letters, pp. 280–281, though this date seems too early).
- 5. Frederic Remington, "The Essentials at Fort Adobe," *Harper's New Monthly Magazine*, April 1898, in *Collected Writings*, p. 288.
- 6. Hereward Lester Cooke, Jr., "Great Masters of a Brave Era in Art," *National Geographic* 119 (May 1961): 686.
- 7. Royal Cortissoz, "Frederic Remington: A Painter of American Life," *Scribner's Magazine* 47 (February 1910): 192.
- 8. Frederic Remington to Carl Rungius, [1908–1909], in the Carl Rungius Papers, Glenbow Museum, Calgary, Alberta.
- 9. "A Few Words from Mr. Remington," in *Collected Writings*, p. 551.

The Luckless Hunter

1909 Oil on canvas 267/s x 287/s" (68.3 x 73.3 cm.) Signed lower right: Frederic Remington / 1909

For all his boyishness, there was a darker side to Remington as well. Late in life he frequently painted pictures without clear victories, and scholars recently have taken to probing the sobered, even chastened man who, back from his long-awaited confrontation with real war in Cuba in 1898, could no longer glamorize combat as he once had.1 Much of his youthful exuberance had vanished, replaced by an uneasy recognition of his physical decline as he passed his fortieth birthday and a growing sense of loss over the Wild West that had once nurtured his artistry and was now a fading memory. Even as he turned away from the kind of illustrating that had made his reputation and disayowed the contemporary West and modern soldiering as dreary, he embraced the old West with renewed passion. An artist who had been a master of action, a storyteller in line and paint, became a student of mood, and some of his paintings were infused with a brooding intensity.

Contemporaries recognized this new direction in oils like *The Hungry Moon* (1906; Gilcrease Museum, Tulsa) and The Luckless Hunter with its almost palpable aura of despair. Instead of being conquered by heroic boys in blue in equal combat on a sun-drenched battlefield, the Indian is shown reduced to helplessness by hunger. The night air is brittle, the sky speckled with frozen stars, the snow-covered landscape as barren as the moon that washes it in pale light. There is nothing here to sustain the will to resist, or even to go on. Speaking of this "masterpiece of expression," a contemporary wrote: "In all Remington's pictures the shadow of death seems not far away. If the actors in his vivid scenes are not threatened by death in terrible combat, they are menaced by it in the form of famine, thirst or cold. One sees the death's-head through the skin of the lean faces of his Indians, cowboys and soldiers. . . . The presence in Mr. Remington's characteristic work, of a great central motive like this . . . is an indication of power, and the ability to express the motive in a hundred vivid forms is a proof of genius."2

On November 29, 1909, *The Luckless Hunter* went on display with twenty-two other oils at Knoedler's in New York. Less than a month later Frederic Remington was dead at the age of forty-eight.

Ex-collection: Newhouse Galleries, New York City; John Nicholson, New York City; Robert Woods Bliss, Dumbarton Oaks, Georgetown, Washington, D.C.; William H. Bliss, New York City.

- 1. See Ben Merchant Vorpahl, My Dear Wister—: The Frederic Remington—Owen Wister Letters, and Frederic Remington and the West: With the Eye of the Mind; also Hassrick, Frederic Remington, pp. 38–40; the notes to Collected Writings, pp. 604, 617–619; and Samuels and Samuels, Frederic Remington.
- 2. Unidentified clipping inserted in Frederic Remington Diary, entry for December II, 1909, Frederic Remington Art Museum, Ogdensburg, New York; also "The Art of Frederic Remington," *Mail & Express* (New York), December 27, 1909.

The Hungry Moon (1906) Gilcrease Museum, Tulsa

Roping the Renegade

C. 1883 Pencil, watercolor, and gouache on paper 12½ x 165/8" (31.7 x 42.2 cm.) Signed lower right: CMR

Ex-collection: Newhouse Galleries, New York City; Wenzell Smith, New York City.

This painting was done as early as 1883, at a time when "Kid Russell" was still learning the ropes both as cowboy and artist. He first worked as a horse wrangler with the Judith Roundup in the spring of 1882, and the next year as a cowpuncher on the Shonkin range, in the southern extremity of Choteau County below Fort Benton.1 With watercolors and brushes that he carried rolled up in a pair of socks, Russell recorded what he saw. Most of his later roping scenes depict moments of high drama and danger—saddles slipping, horses falling, mad cows charging, ropes getting hopelessly tangled, guns being drawn for selfprotection. But in 1883 the typical still engrossed Russell because it was still novel to him. Roping the Renegade, like another watercolor of the same vintage, Roping 'Em (c. 1883; Amon Carter Museum, Fort Worth), shows an everyday occurrence on the range. The cowboy on the left, decked out in California fashion, has lassoed a bolter, taken his dallie-welts (that is, wrapped his rope around his saddle horn), and is shown bracing to hold the steer while his partner rides up to drop a second loop.2 It would not take Russell long to turn this scene into high drama. An 1889 oil, The Judith Basin Roundup (or Scene Near Utica, Montana) (private collection),3 showed the virtually identical figure on the left, but he has caught the cow by its leg, and it is charging at three other cowboys who scatter before it.

Both early watercolors are notable for showing riders head-on. Foreshortening was something Russell essayed only rarely through the 1890s; perhaps he was influenced by published illustrations like Rufus F. Zogbaum's A Refractory Steer, which appeared in Harper's New Monthly Magazine in July 1885.4 If so, it could be that both watercolors were actually done in the mid-1880s, and not in 1883. At a time when Russell's skills were evolving rapidly, it is hard to fix a precise date for any of his works.

- I. Al. J. Noyes (Ajax), In the Land of Chinook; or, the Story of Blaine County, p. 120.
- 2. See Russell, "The Story of the Cowpuncher," in Trails Plowed Under, pp. 2-3, for his distinction between California- and Texas-influenced cowboy styles. Based on circumstantial evidence, the cowboy shown here may be Jasper McFry (Frankie M. Taylor, "Russell Watercolors Found!" True West 17 [November-December 1969]: 17, 62); and for what appears to be a portrait of the same individual, see the sketches accompanying Charles M. Russell to Friend Pony [William W. (Pony Bill) Davis], May 14, [1889], in Dippie, ed., Charles M. Russell, Word Painter, pp. 16-17.
- 3. See Hassrick, Charles M. Russell, p. 34; and, for the painting in color, The Connoisseur 204 (June
- 4. Rufus Fairchild Zogbaum, "A Day's 'Drive' with Montana Cow-boys," Harper's New Monthly Magazine 71 (July 1885): 192.

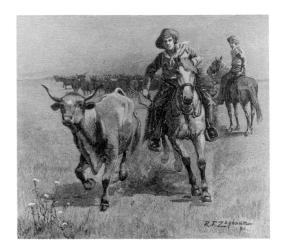

A Refractory Steer by Rufus F. Zogbaum Harper's New Monthly Magazine, July 1885

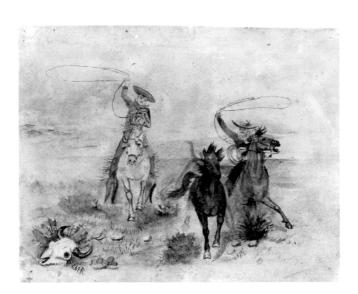

Roping 'Em (C. 1883) Amon Carter Museum, Fort Worth

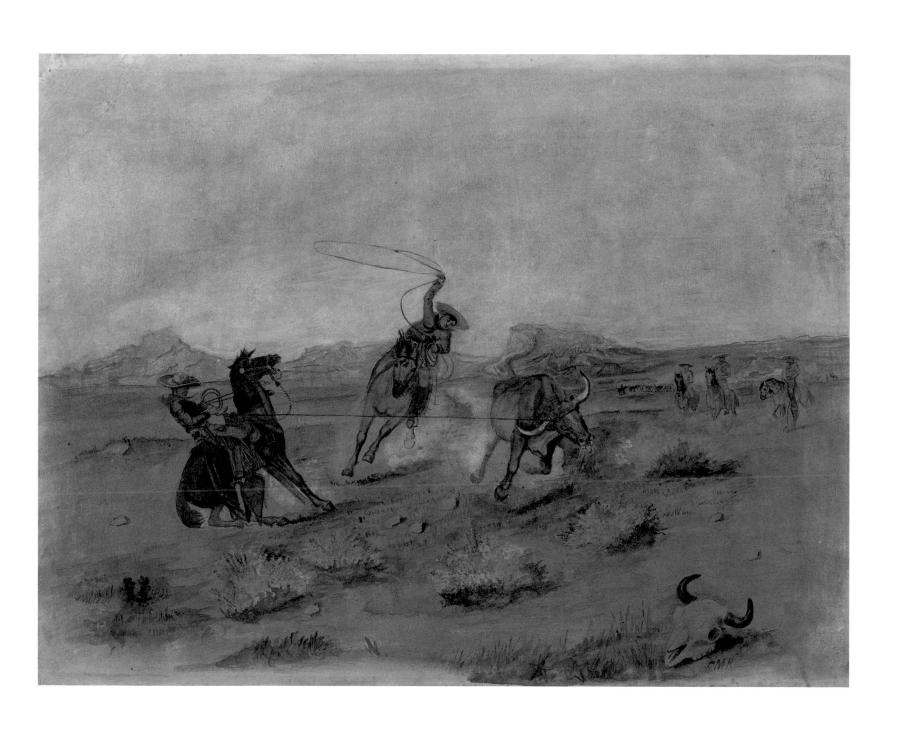

Western Scene [The Shelton Saloon Painting]

C. 1885 Oil on wood panel 17¹/₂ x 69" (44.5 x 175.3 cm.) Signed lower left: C M RUSSELL

Frederic G. Renner described this painting as Russell's "first formal commission." 1 His patron was James R. Shelton, proprietor of the original saloon-hotel in Utica, the little town founded in 1881 in Montana's Judith Basin.2 A saloon without some artwork was a sorry spectacle indeed, and Shelton turned to the Cowboy Artist for a muralsized painting to hang above his bar. Russell had neither oil paints nor artist's canvas so he settled for house paints and a pine board one and onehalf feet wide and nearly six feet long, with screw eyes in the back to suspend it from a rope. Western Scene is an obviously amateurish effort. Its crudeness and raw color can be accounted for in part by the circumstances, but mostly by the fact that in 1885 Russell was still more cowboy than

The three subjects included in the mural are all ones that Russell returned to: the wagon train drawn up in a defensive circle and the attacking Indians keeping a respectful though inadequate distance, judging from the dead horse and dying warrior; the herd of elk in Yogo Canyon, presaging his superb 1912 oil The Exalted Ruler (B.P.O. Elks, Great Falls, Montana); and the curious pronghorn antelope being flagged by the hunters on the ridge to the right, a theme he subsequently handled from the viewpoint of the hunters. Russell did introduce an interesting twist into his mural by presenting reverse perspectives in the side paintings. In the one, the attackers fire at distant targets; in the other, the targets—that is, the antelope—occupy the foreground. There is another point of interest as well. At a date when Russell had not even worked out a signature, he included a buffalo skull in the composition (as he did in Roping the Renegade). The skull became such a fixture in his work that by 1887 he was describing it as his "trade mark." 3 He chose it as his personal insignia and eventually incorporated a stylized version of it in his signature because, on a literal level, buffalo bones were omnipresent in the Montana of his youth. Moreover, they symbolized the theme that would be his lifelong preoccupation, the West that has passed. They gain a particular poignancy in his cowboy scenes showing the "white man's buffalo" grazing over the remnants of "nature's cattle," unaware they too will soon be replaced by the newer order represented by the farmer's plow.

Ex-collection: Newhouse Galleries, New York City; Zella M. Cowan, Great Falls, Montana; Martin Messner, Utica, Montana; James R. Shelton, Utica.

- 1. Frederic G. Renner, Charles M. Russell: Paintings, Drawings, and Sculpture in the Amon G. Carter Collection, p. 6.
- 2. Mildred Taurman et al., Utica, Montana, p. 9. A photograph of Shelton's saloon appears in Ramon F. Adams and Homer E. Britzman, Charles M. Russell, the Cowboy Artist: A Biography, p. 83, where it is described as Russell's "first studio." Mrs. M. C. Goodell, who came to the Judith Basin in 1880, the same year as Russell, recalled him painting the mural in Shelton's saloon. Shelton gave the painting to a friend, Martin Messner, when he left Utica in 1891, and Messner passed it on to his daughter, onetime postmistress of Utica, Zella Cowan. She stored the painting with Mrs. Goodell at her home in Hobson, Montana, for many years, and Mrs. Goodell retained a one-third interest in any sale. See Utica Book II, pp. 66-68; Mrs. M. C. Goodell to Will Rogers, October 2, 1929, in the Helen E. and Homer E. Britzman Collection, Taylor Museum of Southwestern Studies of the Colorado Springs Fine Arts Center; Mrs. Goodell to James B. Rankin, October 26, 1937 and March 21, September 28, 1938, in the James B. Rankin Papers, Montana Historical Society, Helena.
- 3. "Life on the Range," Helena Daily Independent, July 1, 1887.

Cowpunching Sometimes Spells Trouble

1889 Oil on canvas 26 x 41" (66.1 x 104.1 cm.) Signed lower right: C M Russell / 1889 Ex-collection: Newhouse Galleries, New York City; George J. Heckroth, Detroit.

Everyone agrees that Russell was no great shakes as a cowpuncher himself. His range pals said as much, and he was quick to concur, noting: "Although I worked for many years on the range, I am not what the people think a cowboy should be. I was neither a good roper nor rider. I was a night wrangler." But Russell admired the work of the top hands he associated with, and he watched them during the day as they matter-offactly went about their business and demonstrated their skills. Riding and roping scenes became staples for him. Bronc busting was an individual activity, and Russell's paintings often isolate the cowboy and the horse in an elemental contest, man against animal, that was a test of nerve, stamina, and will. Roping scenes, in contrast, were usually more complicated, story-telling pictures with several figures involved in the action unfolding before the viewer.

In Cowpunching Sometimes Spells Trouble the roper on the right has heeled the cow but has been unable to prevent its charging the other riders. One horse has bolted out of the way; the other, less fortunate, has been sent to the ground, pinning its rider and likely breaking his leg. Amidst the tangle of his rope he desperately claws for his revolver. There are still signs of awkwardness in this early oil. The horse on the right appears to have given Russell trouble, and the pigment is applied in such a way that it resembles coloring with paint. But the red bandanas, yellow slickers, and clear blue sky lend brightness to the scene in a period when Russell's tones were frequently muddy. The action is convincingly rendered. And Russell was pleased enough with the composition to repeat much of it in his popular 1901 oil The Strenuous Life (Gilcrease Museum, Tulsa). Indeed, Cowpunching Sometimes Spells Trouble anticipates many of Russell's major roping pictures, and stands on its own as a significant transitional achievement.

NOTE

I. Charles M. Russell, "A Few Words about Myself," in *Trails Plowed Under*, p. xix.

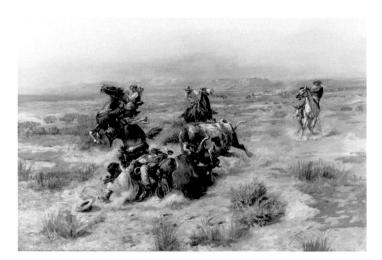

The Strenuous Life (1901) Gilcrease Museum, Tulsa

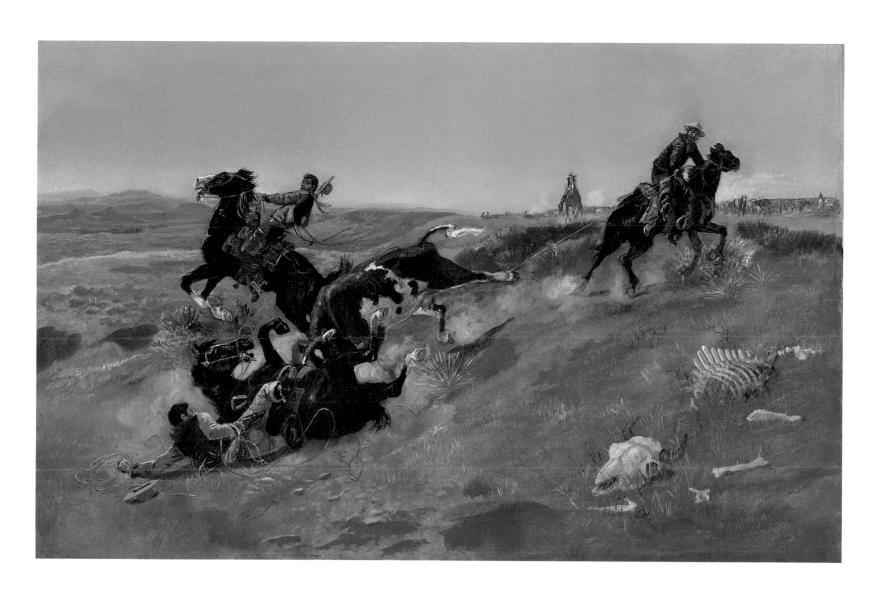

Cowboy Sport—Roping a Wolf

1890 Oil on canvas 20 x 35¾" (50.8 x 90.8 cm.) Signed lower left: (skull) / C M Russell / 1890

Wolves were a nuisance on the range during Russell's cowboy days. Deprived of game to eat, they preved on the cattle. Ranchers fought back against this cunning, fleet-footed menace as best they could. Bacon rind poisoned with strychnine was a common bait.1 Cowboys also did their bit and had a little fun in the bargain. Whenever they startled a wolf during their chores, they gave chase "at headlong speed, utterly regardless of the broken dangerous ground," Granville Stuart wrote about the time Russell painted Cowboy Sport—Roping a Wolf. "Loosing their lariats from their saddles as they run, the deadly noose is soon swinging swiftly around their heads as they close in on the frightened animal, who strains every nerve to escape. Often several misthrows are made, till some lucky fling catches it around the neck or body and it is dragged some distance till so exhausted that it cannot bite the rawhide lariat in two . . . Its career is then ended by a pistol shot . . . "2

Russell painted similar scenes many times over the years, but *Cowboy Sport—Roping a Wolf*, an early version, has remained a popular favorite. It is a crude effort in some respects and murky in color (browns, blacks, and greys predominate). "The coloring is not nearly so bright as that of Russells later works," the owner's daughter noted in 1938, but it is "redeemed by action and . . . a certain amount of humor; the coyote is winking when he sees that he is being chased by cowboys with *ropes* instead of pistols." Indeed, *Cowboy*

Ex-collection: Newhouse Galleries, New York City; Homer E. Britzman, Los Angeles; Eliza Carr Young, Geneseo, New York.

Sport—Roping a Wolf is bursting with energy and shows great care for detail. The faces of the riders are distinctive, no doubt because Russell, still a working cowboy in 1890, was portraying two friends. The lead rider appears a little grim, but his companion is evidently enjoying himself, while the wolf, with its sneaky, backward-glancing expression, is also clearly in the spirit of things.

- 1. Paul C. Phillips, ed., Forty Years on the Frontier: The Reminiscences and Journals of Granville Stuart 2: 171–172.
- 2. Granville Stuart, commentary for Cowboy Sport (Roping a Wolf), in Charles M. Russell, Studies of Western Life.
- 3. Katharine C. Young to Homer E. Britzman, September 6, 1938, in the Helen E. and Homer E. Britzman Collection, Taylor Museum of Southwestern Studies of the Colorado Springs Fine Arts Center.

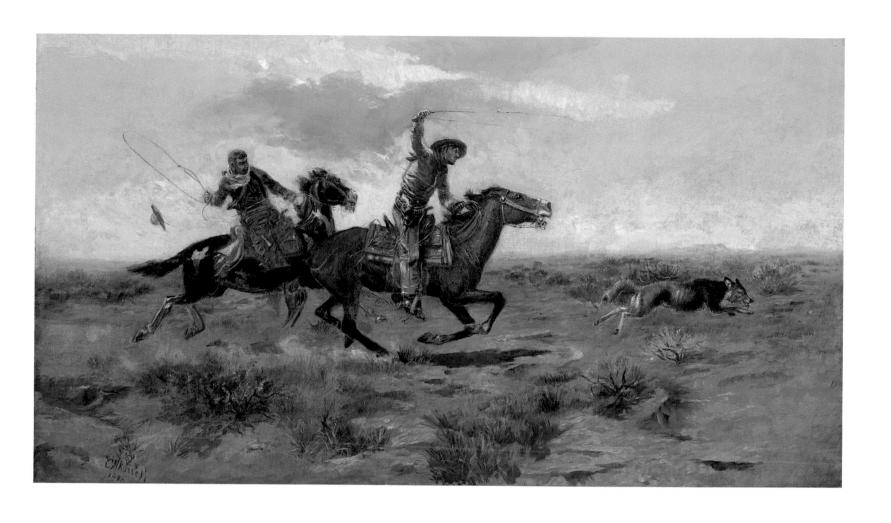

Grubpile [The Evening Pipe]

1890 Oil on canvas 95% x 163%" (24.4 x 41.6 cm.) Signed lower left: C M Russell / (skull) 1890

Day's end. A quiet time, a time for reflection, even brooding over an evening pipe. Europeans acquired the tobacco habit from America's natives and created a whole lore based on it. Smoking was a solace, a heart's balm, a source of individual contentment. With each puff on a pipe, one's worries were said to lift like the smoke and dissipate in the air. Indians made smoking into a ritual. In some cultures it was a part of religious practice as well as of ordinary social intercourse. Smoking the pipe could be an invocation to the gods, a test of integrity, or a sign of friendship.¹

The pensive Cree in *Grubpile* (a title deriving from the supper call on the roundup) appears oblivious to the activity behind him as a party of hunters wend their way home. The camp seems still. The pale moon, the pink glow on the distant bluffs, and the blanket-wrapped figure seated beside his temporary shelter, tobacco pouch and drum at hand, his small fire casting a reflection on the water, all convey a hushed, twilight mood. Russell was known as a painter of action, but in many of his Indian pictures he revealed a contemplative side.

Family tradition held that Grubpile was one of three oils (including Cowboy Sport-Roping a Wolf) that Russell painted for his cousin William Chiles Carr on Carr's horse ranch near Utica in the Judith Basin. Chiles, who also hailed from St. Louis, was described as "a good-looking young bachelor, nicely and neatly dressed,"2 but he has also been characterized as a spoiled man who "kept open house and lived and drank in a sort of feudal splendor, and had all kinds of friends until his money gave out." Reduced to working for a living, he was said to have been hired on as a cowboy through Charlie's influence, but quit because of rough joshing his first day on the job, got drunk, and rode off into the nightand disaster, when he tumbled over a cut bank and was crushed to death by his horse in the fall.3 Ex-collection: Newhouse Galleries, New York City; John Levy, New York City; Homer E. Britzman, Los Angeles; Eliza Carr Young, Geneseo, New York.

Since Carr died on October 11, 1889, family tradition is evidently in error about the paintings.4 Carr's sister Eliza recalled that Russell, eight years Carr's junior, was a frequent visitor at the ranch. "He painted when the spirit moved him, more often when the 'pot had to boil.'"5 She supposedly inherited the paintings at the time of her brother's death and had them shipped to St. Louis; since the family retained ownership of Carr's ranch it is possible that the paintings were indeed done there, but after his death. This much is certain: Russell cared enough about Chiles Carr to acquire the chaps he was wearing when he was killed, use them himself until he quit cowboying, and make them a permanent part of his studio collection.6

- 1. See J. C. H. King, Smoking Pipes of the North American Indian; Jordan Paper, Offering Smoke: The Sacred Pipe and Native American Religion.
 - 2. Mattie Phillips, quoted in Utica Book II, p. 153.
 - 3. Russell, C.M.R., pp. 77-78.
- 4. Carr's death date is in Taurman et al., *Utica*, *Montana*, p. 203; *Utica Book II*, p. 153.
- 5. Katharine C. Young to Homer E. Britzman, November 2, 1938; also Mary Paschall Young to Nancy C. Russell, April 21, 1929, and "Memorandum of Sale of Pictures by Charles M. Russell [owned by Eliza Carr Young]," undated, in the Helen E. and Homer E. Britzman Collection, Taylor Museum of Southwestern Studies of the Colorado Springs Fine Arts Center.
- 6. [Joe De Yong], "Mrs. Russell's list of Personal possessions from the C. M. Russell Studio" (notebook, 1927), item 19, in the Britzman Collection.

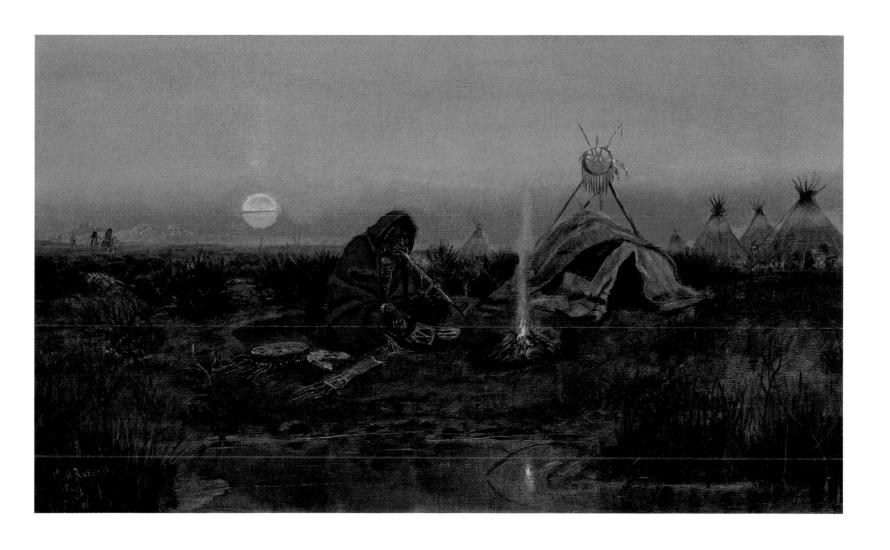

Seeking New Hunting Grounds [Breaking Camp; Indian Women and Children on the Trail]

C. 1891 Oil on canvas 23³/4 x 35⁷/8" (60.3 x 91.1 cm.) Signed lower left: C M Russell / (skull)

Russell loafed away the summer of 1888 on a ranch near High River, Alberta, in daily contact with Blood and Piegan Indians. A storied episode in his career, it changed his work forever. By 1890, the Cowboy Artist was recognized as much for his work on Indians as on cowboys. "In depicting American Indian life Mr. Russell excels," the Fort Benton Weekly River Press noted on March 5 that year. "He has a powerful grasp of nature. His Indians are Indians every inch . . ." Russell's earliest studies of Indian and cowboy life compensated for their artistic deficiencies with a freshness of observation that gives them a documentary quality lacking in his later, more polished work. His later Indian paintings are populated with heroic clusters of lean, muscular warriors astride splendid horses, clearly masters of their own domain. His paintings done in the 1880s and early 1890s, in contrast, show Indian raiding parties costumed in a crazy-quilt mixture of native and white fashions, riding tough, scrawny ponies. They are at once wary, dangerous, and utterly realistic. This excellent early oil, Seeking New Hunting Grounds, is another case in point. It is almost photographic in its precise detail. Moving camp, while not a theme as stirring as the buffalo hunt and one that Russell returned to less often, nevertheless was one of his favorites before the turn of the century. An 1892 painting, Indians on the Trail, brought the comment, "If Landseer is intitled to the honor of being the leading animal painter surely Montana's own Charlie Russell can well lay claim to the title of the truthful Indian painter of the

day."1 The reporter seemed most impressed by

But the real measure of his achievement was

noted the next year: Russell had captured "the

and the wondrous landscape of the mountains

the fact Russell did the painting in just two days.

cowboy, the Indian, the hunter, and the freighter,

and plains . . . with an artistic realism which was a revelation . . . The landscapes were photographic reproductions of the snow-wreathed and purple mountains, and the grand monotony of the plains, and the skies while sometimes boldly tinted, were always wondrous reflections for sunrise or sunset dyes, and the soft twilight shades and sombre shadows of night." That seems a fair comment on *Seeking New Hunting Grounds*.

Ex-collection: Newhouse Galleries, New York City; Findlay Galleries, New York City; Walter G. Kendall, Boston.

Russell was working his way towards the distinctive, lambent glow of his mature paintings. Detail still obsessed him. This painting could as well be titled "Families" in recognition of the mare and its gangly colt, the wolflike dog and its puppies peeping out of the cooking pot on the travois, and the Indian mother, baby wrapped in her blanket and her next youngest mounted in front of her. The travois appears to be made of lodge poles and secured to her saddle, which is held in place by the martingale and crupper. Ideally, a Blackfoot family on the move used three packhorses in transporting their tipi, two to pull the lodge poles and the third to carry the lodge cover.3 But reality was something else, and Russell here shows one packhorse doing double duty.

Walter G. Kendall, son of the man who discovered the Kendall mine near Lewistown in 1876 and cowboyed with Russell, wrote to Will Rogers in 1930: "When in Lewistown, about 1900, I was fortunate enough to secure an excellent example of his [Russell's] work that collectors have been trying to get away from me, but it shall be mine as long as I live and, then, I trust, will go to some museum." 4 It did.

- 1. "Indians on the Trail," Weekly River Press (Fort Benton), July 23, 1892; and, for an earlier work on the same theme, "By an Untutored Hand," Helena Independent, June 10, 1887.
- 2. "The Cowboy Artist," *Great Falls Tribune*, April 28, 1893.
- 3. John C. Ewers, *The Horse in Blackfoot Indian Culture, with Comparative Material from Other Western Tribes*, pp. 95–99, 103–105, 107–110, 132–139.
- 4. Walter G. Kendall to Will Rogers, [November 1930], in the Helen E. and Homer E. Britzman Collection, Taylor Museum of Southwestern Studies of the Colorado Springs Fine Arts Center.

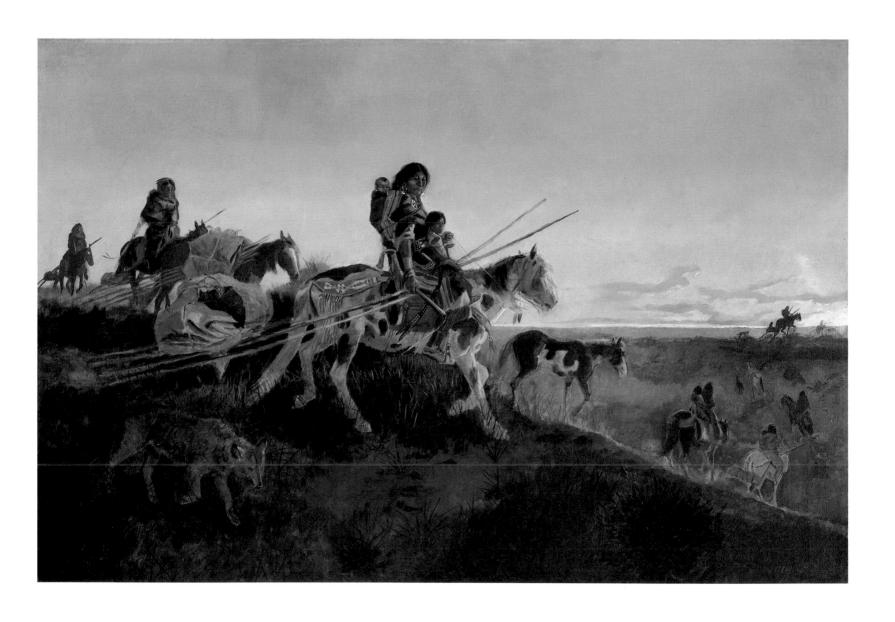

The Brave's Return

c. 1891 Pencil, watercolor, and gouache on paper 21½ x 31½ " (54 x 81 cm.)

Signed lower left: C M Russell / (skull)

Ex-collection: Newhouse Galleries, New York City; Paul Purdy, New York City.

In the 1890s, in particular, Russell gave free expression to his fondness for domestic scenes from Indian life. The Brave's Return records a tender moment as two women gaze up from their chores to find their warrior-husband returned safely from a raiding expedition or a hunting trip. There is no indication of what he has accomplished—no stolen horses, no scalps dangling from his belt, no fresh-killed game, just a tired man about to dismount from an equally tired horse. Through Russell's eyes we see the plains Indian in his family setting, a fully rounded individual; the wife's shy reaction in drawing her blanket around her bespeaks her affection and possibly the length of her husband's absence. The returned warrior will receive a properly respectful reception. "Men were the undisputed lords of their households," John Ewers has written of the Blackfeet. "They expected their wives to wait upon them hand and foot, to bring them food when they wanted it, to light their pipes and remove their moccasins."1 Among the Assiniboines, a successful hunter could anticipate an especially warm welcome: "He slid off his mount, and his wife led him into their lodge, where he lay down. She unpacked the horses, picketed them where the grass was good, ... then devoted all her time to him; first taking off his moccasins, washing his feet, and powdering them with dry vermillion-colored earth paint.

Then she removed all his clothing, and, while he wrapped himself in a robe and rested, she prepared hot food for him. As she waited on him, she carried on a pleasant conversation and talked of things agreeable to him. There was peace and contentment in the lodge." Russell's returned brave will receive similar attention, his wives gladly abandoning the task of scraping the buffalo hide in order to accommodate his wishes and make his homecoming a celebration.

This watercolor has faded over the years, explaining its rather washed-out appearance. But it exhibits the careful drawing characteristic of Russell's best work in this early period.

- I. John C. Ewers, *The Blackfeet: Raiders on the Northwestern Plains*, p. 100.
- 2. Michael S. Kennedy, ed., *The Assiniboines: From the Accounts of the Old Ones Told to First Boy (James Larpenteur Long)*, pp. 112–113.

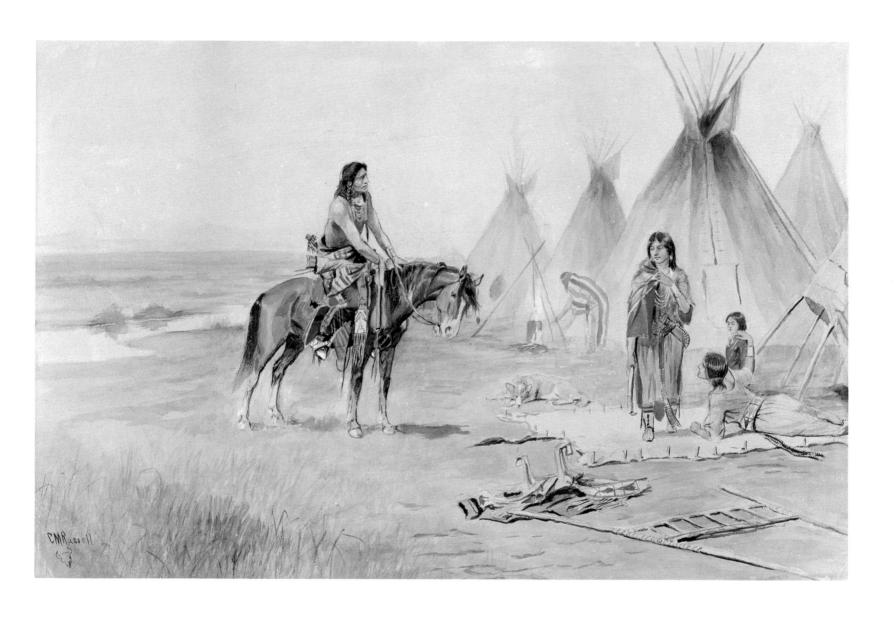

The Buffalo Runners

C. 1892 Oil on canvas 27⁵/₈ x 39³/₈" (70.2 x 100.0 cm.) Signed lower left: C M Russell

If the buffalo hunt is one of the supreme tests of a Western artist's abilities, few met it more successfully—or more often—than Russell, whose love of the old West found expression in dozens of paintings on this single theme. Indeed, he is now firmly identified with the buffalo hunt, though he never claimed to have seen one. Instead, he drew as he did in all of his paintings on memory buffalo, horses, and Indians he had seen-reading, the work of earlier artists, and that infatuation with the romantic that originally kindled his desire to go west.1 An item appeared in the Fort Benton, Montana, Weekly River Press on December 21, 1892, about two Russell paintings on display in the J. A. Graham saloon at Chinook (Russell's "headquarters" 2 in his last years as a cowboy). One showed an Indian camp, "and most naturally represents the squaws doing all the work, while the lazy bucks are lounging around, as is their wont. The other is a buffalo hunt, and is true to life." The Buffalo Runners is almost certainly the second painting meant, while an oil of identical size, The Silk Robe (c. 1892; Amon Carter Museum, Fort Worth), matches the newspaper description of a camp scene showing the hunters at ease while the women scrape a buffalo hide. Russell apparently intended the two paintings as a before-and-after pair, like the 1901 oils Buffalo Hunt and Returning to Camp (pp. 129, 131). The Buffalo Runners and The Silk Robe were both acquired about 1896 by Charles E. Conrad, a pioneer Montana entrepreneur who at one time commanded a vast mercantile and transportation empire based in Fort Benton before he relocated in 1891 to the new town of Kalispell at the head of Flathead Lake. There he built a mansion, raised buffalo as well as cattle, and formed a collection of four paintings by Charlie Russell, whom he knew. All four were on Indian themes.3

When Russell first tackled buffalo hunts he tended to isolate one mounted hunter and one buffalo, ordinarily shown broadside to minimize difficulties of perspective and to keep a complicated subject as simple as possible. *The Buffalo Runners* is unusually ambitious. It exhibits a fine feel for the terrain, especially the steep drop to the river where the herd is crossing in the distance. But the central action is less effective. The foreground bull is poorly articulated and seems much too long—a failure of foreshortening readily apparent when *The Buffalo Runners* is compared to

Ex-collection: Newhouse Galleries, New York City; John Douthitt, New York City; David Findlay Galleries, New York City;

a later painting like *Wild Man's Meat* (p. 117). The arrow in the bull also seems inappropriate. Normally the hunter would single out a cow, as he is shown doing, or would at least finish off the bull he has wounded. Similarly, the buffalo dropping to its knees behind the hunter is wounded on the left side, while a right-handed bowman almost always approached his target from the right. Finally, if the one hunter is responsible for all three wounded animals, as represented, then he is a phenomenal marksman, since the average Blackfoot required three or more arrows for a kill,⁴ and considered himself fortunate to down two buffalo during a prolonged chase.⁵

Russell did a close variation on the horse and rider in *The Buffalo Runners* in another undated oil executed in the same period, *Meat for the Tribe*. In it, he armed the hunter with a rifle instead of a bow, and had the bull charging horse and rider.⁶

Leonard Lopp, Kalispell, Montana; Agnes Conrad, Kalispell; Charles D. Conrad, Kalispell; Charles E. Conrad, Kalispell.

- I. See Brian W. Dippie, "Two Artists from St. Louis: The Wimar-Russell Connection," in *Charles M. Russell: American Artist*, ed. Janice K. Broderick, pp. 28–29.
- 2. Untitled item, *Livingston* [Montana] *Post*, June 30, 1892.
- 3. See James E. Murphy, *Half Interest in a Silver Dollar: The Saga of Charles E. Conrad;* Charles D. Conrad to James B. Rankin, February 13, 1937, in the James B. Rankin Papers, Montana Historical Society.
- 4. Ewers, The Horse in Blackfoot Indian Culture, p. 155.
- 5. Ewers, *The Blackfeet*, p. 80. Kennedy, ed., *The Assiniboines*, p. 109, notes that during the chase each Assiniboine hunter killed one or two buffalo "according to his needs."
- 6. Meat for the Tribe, formerly in the Amon Carter Museum Collection, is reproduced in Renner, Charles M. Russell, p. 29.

The Silk Robe (C. 1892) Amon Carter Museum, Fort Worth

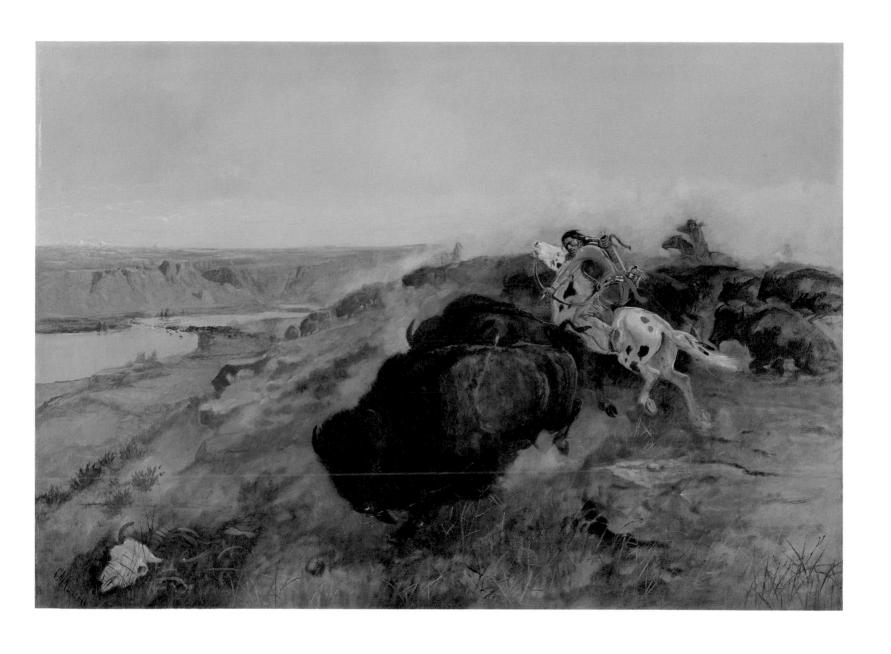

Caught in the Circle

C. 1892 Oil on canvas 261/8 x 357/8" (66.4 x 91.1 cm.) Signed lower left: C M Russell / (skull)

Frederic Remington frequently depicted what became a stock-in-trade for Western artists: the desperate stand of a small band of trappers, soldiers, or cowboys surrounded by circling Indians and resolved to sell their lives dearly. Russell did his share of such scenes in the 1890s, including one heroic-sized oil, before abandoning the subject for good after painting in 1903 an obligatory Custer's Last Stand on commission ("I no savy soldiers," he told his patron, who got Nancy to intercede 1) and a two-by-three-foot oil, Corralled [Caught in the Circle] (National Cowboy Hall of Fame and Western Heritage Center, Oklahoma City), that was at one time in Sid Richardson's possession.2 In his pictures of men under siege, Russell resorted to standard types—the boy, the grizzled old-timer, the intrepid, buckskin-clad frontiersman. The subject matter did not excite him, and the overblown and gory works that resulted came

Caught in the Circle is one of the earliest Russell surrounds, and resembles an illustration in Buffalo Bill Cody's 1879 autobiography. Less elaborate than those Russell painted near the end of the 1890s, its simplicity, the off-center arrangement of the cluster of men, and the fact that they are keeping their heads down and performing no suicidal heroics behind the barricade of dead horses add up to an effective storytelling picture full of the tension of the moment and the unanswered question: is this group of frontiersmen fated to stand off the foe and survive, or will they all die on the open plains, nameless martyrs to the cause of westering? The question itself seems ethnocentric and perhaps explains Russell's later preference for showing Indian-white encounters from the Indian perspective (see First Wagon Trail, p. 147).

as close to saloon art as anything he ever painted.3

Ex-collection: Newhouse Galleries, New York City; John Heckroth, Detroit.

- 1. William A. Allen to James B. Rankin, December 12, 1936, in the James B. Rankin Papers, Montana Historical Society. Custer's Last Battle, a black-and-white watercolor, illustrated Allen's Adventures with Indians and Game; or, Twenty Years in the Rocky Mountains, p. 63, and is now in the collection of the Gilcrease Museum, Tulsa, Oklahoma. Despite Russell's protestations, he had earlier done a pen and ink sketch, Death of General Custer (1896), that showed the traditional heroic cluster of troopers making their Last Stand. (Seventeenth Annual C. M. Russell Auction of Original Western Art, p. 56.)
- 2. A photograph of *Corralled* in the Sid Richardson Collection of Western Art files shows some puzzling variations in the painting as it now appears.
- 3. Russell's largest work on the theme, *The Trappers' Last Stand* (1899; The R. W. Norton Art Gallery, Shreveport), attracted contemporary notice partly because of its size (4 x 6 ft.); see "Russell's Latest," *Great Falls Daily Tribune*, March 28, 1899. But it and a similar work, *A Desperate Stand* (1898; Amon Carter Museum, Fort Worth), show a particular debt to Frederic Remington; see Dippie, *Looking at Russell*, pp. 20–25.

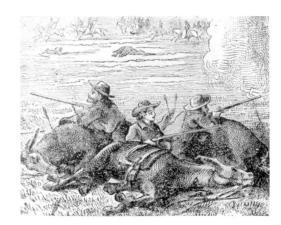

Holding the Fort (detail of engraving)
The Life of Hon. William F. Cody Known as Buffalo
Bill, the Famous Hunter, Scout and Guide (Hartford,
Conn.: Frank E. Bliss, 1879)

There May Be Danger Ahead [Hunting Party on Mountain Trail]

1893 Oil on canvas 36½ x 22" (92.1 x 55.9 cm.) Signed lower left: C M Russell / (skull) '93 Ex-collection: Newhouse Galleries, New York City; Elizabeth V. Sprague, Great Falls, Montana; Robert Vaughn, Great Falls.

Most plains Indian men aspired to be two things above all else in life: good hunters, and thus good providers, and bold warriors, thus enjoying both the material wealth acquired through horse raids and the social prestige that followed on war honors. No single subject engaged Russell more consistently than that of a small party of Indians on the prowl for game, horses, or scalps. He painted them in the 1880s and was still painting them the year he died.

This early oil bears the title There May Be Danger Ahead and appears to show a group of warriors descending a steep mountain trail en route to enemy country. Their purpose would be horse theft, by far the most common activity of such raiding parties, though it should be noted that horse-stealing expeditions usually set out on foot in order to travel inconspicuously and in the expectation there would be horses aplenty to ride on the return journey.1 It is possible that the men in this painting (which has also been called Hunting Party on the Mountain Trail) were merely looking for game, though naturally they would not pass up the chance to kill and butcher a stray cow or steal a few horses. Garbed in a mixture of white and traditional costume, armed with rifles, and riding scrub ponies, they are the very sort Russell encountered in Montana in the 1880s.

The colors used in *There May Be Danger Ahead*—drab browns and flat blues—are typical of Russell's work in this period, and there does appear to be too much foreground in the picture. But Russell wanted to indicate the precipitous nature of the incline, and so he showed the steep rocky ledge, the white horse gingerly picking its way down the trail, the tense expression on its rider's face, and the thread of river running through the valley below.

NOTE

1. See George Bird Grinnell, *Blackfoot Lodge Tales:* The Story of a Prairie People, p. 251; Kennedy, ed., The Assiniboines, p. 48; and David G. Mandelbaum, The Plains Cree: An Ethnographic, Historical, and Comparative Study, p. 241. However, Ewers, The Horse in Blackfoot Indian Culture, pp. 184–185, notes that "in the last decade of horse raiding the mounted party gained in popularity, especially in expeditions directed against the Crow. The mounted party could travel much faster and could more easily evade white authorities who at that time were seeking to put an end to inter-tribal horse raiding."

Plunder on the Horizon [Indians Discover Prospectors]

1893 Oil on canvas 24 x 36" (61.0 x 91.4 cm.) Signed lower left: C M Russell / (skull) '93 Ex-collection: Newhouse Galleries, New York City; Elizabeth V. Sprague, Great Falls; Robert Vaughn, Great Falls.

Russell occasionally painted companion pieces, even story sequences. Plunder on the Horizon and the following oil, Trouble on the Horizon, are a matched set. In the first, Indians emerge from a tangle of trees to spy on three prospectors panning for gold in the stream below; in the second, two prospectors on a mountain slope survey an Indian village nestled in a piney valley. Badly outnumbered, they will give the camp a wide berth; in contrast, the Indians are clearly calculating the odds and planning a surprise attack on the unwary prospectors, who are about to relax over a meal. While both oils are well painted, especially Plunder on the Horizon, their viewpoint seems surprising for Russell. The Indians are stealthy, skulking savages, pure products of the wilderness from which they emerge to spy on the men below. Russell often took this approach in the early 1890s, as a related work like The Way It Used to Be (c. 1892; The R. W. Norton Art Gallery, Shreveport) indicates. He had not yet fully developed that empathy for the natives that distinguished his work from Remington's, for example. But soon after he quit the range and settled down, Indians almost always appeared in his art in a sympathetic light, restored to their prereservation vigor, free-roaming and proud. They symbolized the fate of the West he loved, and he drew the moral that guided his later work when he related an anecdote to Great Falls' founding father, Paris Gibson, in 1902:

open I sat at a faryo layout in Chinook the hour was lat an the play light—a good deal of talk passed over the green bord the subject of conversation was the Indian question—the dealor Kicking George was an old time sport who spoke of cards as an industry . . . the Kicker alloud an Injun had no more right in this country than a Cyote—I told him what he said might be right but there were folks coming to the country on the new rail road that thaught the same way about gamblers an he wouldent winter maney times till hed find out the wild Indian would go but would onley brake the trail for the gambler

My prophecy came true we still have the gambler but like the cyote civilization has made him an outlaw . . . 1

At the time he painted *Plunder on the Horizon* and *Trouble on the Horizon*, Russell's loyalties were still mixed. If his Indians are dangerous savages, his white prospectors are upright pioneers with nothing to hide and interested only in avoiding confrontation. A possible explanation for this dramatic exercise in contrast is that Russell's patron, Montana pioneer Robert Vaughn, who wore a buckskin outfit much like that of one of the prospectors, suggested the subject matter *and* the treatment. The two paintings work nicely as a pair: they involve a reversal in perspective that Russell accomplishes by reversing the viewer's perspective as well.

NOTE

1. Charles M. Russell to Paris Gibson, February 4, 1902, in *Good Medicine: The Illustrated Letters of Charles M. Russell*, pp. 70–71.

The Way It Used to Be (C. 1892)
The R. W. Norton Art Gallery, Shreveport, La.

Trouble on the Horizon [Prospectors Discover an Indian Camp]

1893 Oil on canvas 261/8 x 34" (66.4 x 86.4 cm.) Signed lower left: C M Russell / (skull) '93 Ex-collection: Newhouse Galleries, New York City; Elizabeth V. Sprague, Great Falls; Robert Vaughn, Great Falls.

In both *Plunder on the Horizon* and *Trouble on the Horizon*, Russell employed a device that often appeared in his early paintings, a fallen tree separating foreground from background. Its use suggests a lack of confidence in his ability to convey the sensation of height and depth without some artificial line of demarcation. Fallen trees also serve as aids to perspective in *Attack on the Mule Train* (p. 93), *Big Nose George and the Road Agents* (p. 101), and *The Ambush* (p. 103). In *Plunder on the Horizon* and *Trouble on the Horizon*, the gnarled broken trunks carry an added symbolic import, running across the canvases like slash marks signifying the cultural barrier forever dividing red and white.

The prospectors rendered in profile, their costumes, and the pine-covered hills are all reminiscent of elements in the paintings by the pioneer Montana artist Edgar S. Paxson (see Indian Head, p. 137). Whether Russell had looked at much of Paxson's work at this early date is unclear, but Paxson had been active as a scenic artist and sign-painter in Butte since 1880, and his earliest Western subjects were bound to interest the Cowboy Artist. Russell liked Paxson, but recognized his artistic limitations—leaden coloring, awkward poses, scrambled compositions. "He dont look at things," Russell noted. "He has flat heads with travoys and I don[t] think they ever used them he dont study. . . . his cows have the same nose as a horse." Still, it is possible he was influenced by Paxson in a work like Trouble on the Horizon.2 As the packhorse shows, these are literally pick and shovel prospectors prepared to pan for their fortunes while not neglecting such creature comforts as a good pot of coffee.

- 1. Charles M. Russell notes [c. 1916] to Joe De Yong, in the Joe De Yong Papers, C. M. Russell Museum, Great Falls. De Yong, an aspiring artist who had seen examples of Paxson's work in Helena the previous year and been unimpressed, doubtless pressed Russell on the subject to get such a response; since De Yong was deaf, they communicated by notes. See De Yong to his parents, July 13, 1915, in the De Yong Papers, National Cowboy Hall of Fame and Western Heritage Center, Oklahoma City.
- 2. For a selection of Paxson's work, see William Edgar Paxson, Jr., E. S. Paxson: Frontier Artist. Unfortunately, few Paxsons antedating Russell's Trouble on the Horizon are extant, making any comparison speculative.

Indians Hunting Buffalo [Wild Men's Meat; Buffalo Hunt]

1894 Oil on canvas 24½ x 36½" (61.3 x 91.8 cm.) Signed lower left: C M Russell / (skull) 1894

Those familiar with Russell's work will immediately recognize this buffalo hunt as peculiar. Simply put, it is more a flight of fancy than the kind of realistic observation expected of Russell. The hunter's position is all wrong. His leaping steed has carried him past the buffalo, yet he remains intent on making the kill from an impossible angle. A right-handed hunter rode alongside the buffalo on its right and directed his arrows at the vital spot immediately behind the forelegs.1 The bow, rarely more than three feet in length, ordinarily was held slightly off vertical, or even horizontally.2 The buffalo here, huge as a locomotive and improbably long, is the incarnation of awesome, mindless power as it lowers its head and, mysteriously wounded on the side opposite the hunter, makes a last, convulsive charge. The Indian's horse, in turn, hardly resembles the average buffalo runner. These were all details Russell rendered accurately elsewhere. Why the discrepancies here? Indians Hunting Buffalo was long in the collection of Robert Vaughn. In his memoirs of life in early-day Montana it illustrated his recollections of his first buffalo hunt, in 1872, during which "a fat young cow," twice shot, whirled around "as quick as lightning," caught Vaughn's foot "with her crooked horn and came very near throwing me out of the saddle and as near goring the horse."3 Perhaps this experience gave Vaughn the idea for a buffalo-hunt picture and he instructed Russell accordingly. Certainly someone suggested Titian Ramsay Peale's 1832 lithograph American Buffaloe as a model.4 The composition of Indians Hunting Buffalo, especially the conventionalized white steed (admired by some as the best ever "off the Russell brush"),5 indicates that the Cowboy Artist worked directly from Peale's print, though he managed to include a few realistic touches of his own. The hunter is carefully modeled and convincing. He wears a wrist-guard as protection against the snap of his bow string and uses a pad saddle with stirrups for a firmer seat while guiding his buffalo horse with his knees and allowing the long bridle rope to trail behind.6 Nevertheless, no other Russell buffalo hunt ever looked more like the product of an Eastern studio.

Ex-collection: Newhouse Galleries, New York City; Elizabeth V. Sprague, Great Falls; Robert Vaughn, Great Falls.

- I. Ewers, The Horse in Blackfoot Indian Culture, p. 158; and The Blackfeet, p. 79.
- 2. Ewers, *The Horse in Blackfoot Indian Culture*, p. 158; Mandelbaum, *The Plains Cree*, pp. 94–95.
- 3. Robert Vaughn, Then and Now; or Thirty-Six Years in the Rockies, pp. 124–126.
- 4. See Jessie Poesch, *Titian Ramsay Peale and His Journals of the Wilkes Expedition*, 1799–1885, pp. 30–31. 45, 58–60.
- 5. "Vaughn Collection of Russell Paintings Sold to Newhouse Galleries of New York," *Great Falls Daily Tribune*, June 16, 1946. In this article, *Indians Hunting Buffalo* is simply titled *Buffalo Hunt*, the name under which it was copyrighted in 1944.
- 6. Ewers, *The Blackfeet*, p. 78, and *The Horse in Blackfoot Indian Culture*, pp. 76–77, 158; Edward Ahenakew, *Voices of the Plains Cree*, ed. Ruth M. Buck, p. 59.

American Buffaloe, by Titian Ramsay Peale (1832, lithograph) Amon Carter Museum, Fort Worth

Attack on the Mule Train [Mule Pack Train]

1894 Oil on canvas 23½ x 35½" (58.8 x 89.2 cm.) Signed lower left: C M Russell / (skull) 1894 Ex-collection: Newhouse Galleries, New York City; Elizabeth V. Sprague, Great Falls; Robert Vaughn, Great Falls.

Mules were not Russell's favorite animals judging from their infrequent appearance in his work. In fact, as an established artist he only twice made mule pack trains the subject of major paintings: Bell Mare (1920; Gilcrease Museum, Tulsa) and When Mules Wear Diamonds (1921; National Cowboy Hall of Fame and Western Heritage Center, Oklahoma City), similarly uneventful scenes of mule trains moving through spectacular mountain scenery. But in his younger days, Russell turned to mule trains for dramatic subject matter that elicited approving comment. Of four oils he exhibited early in 1894, a reporter favored one very similar in conception to Attack on the Mule Train. It showed three prospectors at the end of a long day "hurrying their train of pack mules toward a lake, which can be seen in the distance . . . They are congratulating themselves that camp and rest are so near, when suddenly a score of mounted Indians . . . sweep around a spur of a rocky bluff out of a deep canyon, which has heretofore concealed them and open fire on the unlucky prospectors, one of whom has received a fatal wound and throwing up his arms is about to fall from his horse. The pack mules are stampeded and running in every direction, but the other prospectors recovering from their surprise are preparing to give the advancing horde a warm reception."1 The success of this work must have inspired Russell to paint others like Attack on the Mule Train and Attack on Muleteers (c. 1895; Anschutz Collection, Denver).

Attack on the Mule Train is the kind of story-telling picture Russell favored at the time. Indians have opened fire with telling effect upon a pack train. The mule skinner riding the bell mare has been taken completely by surprise. Hit, he jerks back, reins slipping through his fingers, foot out of his stirrup, his rifle untouched. The high drama of the pose appealed to Russell—and he repeated it almost exactly in a celebrated 1911 action painting, Bushwhacked. While the wounded man's

horse rears in panic, the mules respond variously to the gunfire. One plunges forward, another is down and apparently about to topple over the precipice, and the rest in the line of fire mill about frantically. In sharp contrast is the calm procession still winding its way down the narrow trail and out of sight of the attacking Indians. The mule skinner trailing the pack train is just beginning to respond to the sound of firing ahead, while the mining camp nestled peacefully in the valley is unaware of the drama being enacted on the heights above. Though its parts do not add up to a coherent artistic whole and the Indian snipers appear to be stuck onto the background, Attack on the Mule Train tells a compelling story in which Russell displays dexterity and daring in handling complicated perspectives. The distant mountain range is well painted, and the foreground action convincing.

NOTE

I. "Russell's Work," Helena Weekly Herald, January II, 1894.

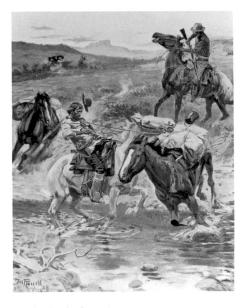

Bushwhacked (1911) Original unlocated; photograph © Brown & Bigelow 1918

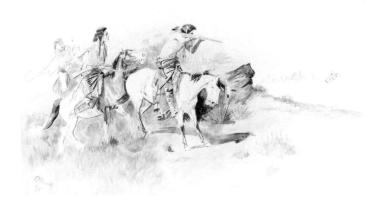

Attack on Muleteers (C. 1895) The Anschutz Collection, Denver

The Marriage Ceremony [Indian Love Call]

1894 Oil on cardboard 18½ x 245%" (47 x 62.5 cm.) Signed lower right: C M Russell / 94 (skull) *Ex-collection:* Newhouse Galleries, New York City; Charles L. Brown, Helena; Mrs. H. P. Brown, Great Falls; Matthew H. Brown, Great Falls; Frank Brown, Great Falls.

Indian courtship was a theme that especially intrigued Russell in the 1890s. It was common practice for an unmarried man to take his horse to water, then loiter by the stream to admire-and be admired by—a young woman who had caught his fancy. A Piegan Flirtation (c. 1896; Amon Carter Museum, Fort Worth) shows this stage in the courtship process. In one of his short stories, Russell recounted an old Blackfoot's courting days: ". . . he's 'bout nineteen—the age the Reds begin lookin' for a mate—when he starts ridin' 'round on a painted pony an' puttin' in his time lookin' pretty. When a bunch of young squaws is down gettin' water, he accidentally rides through the creek, givin' them a chance to admire him. He's ablaze with paint an' feathers—to hear him tell it he's rigged out so it hurts your eyes to look at him . . . "1 A humble lover might cajole and flatter the woman of his choice, wooing her with lines like: "Did you say something? Perhaps I am mistaken. You have been in my thoughts so much and I have imagined many times that you have spoken to me. Now that you are so near, I may seem to hear your voice. If you haven't said anything, it is well and good, for I am like dirt under your feet and why should you waste your kind voice on lowly things. See, I dare not touch you, lest I soil so beautiful a thing."2 Russell's bold suitor has obviously decided on the direct approach. During the day maidens were rigorously chaperoned as they went about their business picking berries, digging roots, gathering wood, and carrying water. For some reason the young woman in The Marriage Ceremony is unaccompanied—her chaperone, if such, is already well up the path back to the village. The startled expression on her face and the man's dramatic entry as he swoops down on her like some great bird of prey make this courtship appear more like an abduction. Indeed, among the Plains Cree and the Blackfeet, unescorted maidens were fair game for lurking males and had no recognized right of resistance or retaliation.3 This would make the title under which The Marriage Ceremony is commonly known, Indian Love Call, cruelly ironic.

But perhaps the young man's attentions are welcome. Sid Richardson, as a lifelong bachelor, found romance in the painting. It appealed to his sentimental side. He could be crusty in fending off the women attracted by his wealth and with marriage on their minds. "Do right and fear no man," he liked to say, "don't write and fear no woman." However, *The Marriage Ceremony* hung over his bed on San José Island, suggesting that beneath the gruff exterior was, as his nephew puts it, a "nice man—embarrassed to be found out." 5

- I. Charles M. Russell, "Finger-That-Kills Wins His Squaw," in *Trails Plowed Under*, p. 124.
 - 2. Kennedy, ed., The Assiniboines, p. 28.
- 3. Mandelbaum, *The Plains Cree*, p. 147; Ewers, *The Blackfeet*, p. 98.
- 4. Eleanor Harris, "The Case of the Billionaire Bachelor," *Look*, November 1954, copy in the Sid Richardson Collection of Western Art files.
 - 5. Interview with Perry Bass, July 15, 1992.

A Piegan Flirtation (C. 1896) Amon Carter Museum, Fort Worth

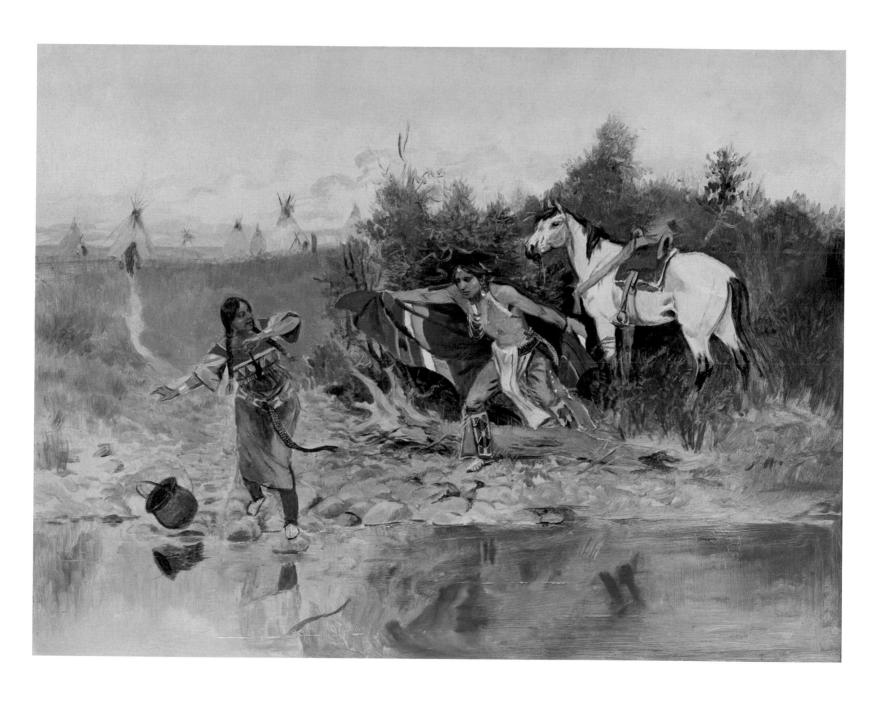

Bringing Up the Trail

1895 Oil on canvas 22⁷/8 x 35" (58.1 x 88.9 cm.) Signed lower left: C M Russell / (skull) 95

Usually an Indian band on the move would select its campsite by late afternoon to allow the women ample time to erect the lodges in daylight.1 Here, darkness is falling and the women and children bringing up the rear are anxiously scanning the horizon for sign of the men. Their concern is expressed by the woman shading her eyes against the setting sun, which casts an orange glow over the land, by the posture and look on the face of the boy watering his horse, and even by the dog's alert stance. The same theme subsequently inspired one of Russell's greatest paintings, In the Wake of the Buffalo Runners (1911; private collection, Minneapolis), but Bringing Up the Trail is impressive in its own right. The sense of movement is nicely carried through from the woman topping the rise on the right to the dog poised in the left corner. The strong evening light effects that Russell favored in his mature work are well handled here, though he did not utilize the entire pictorial space available to him, with the result that the lower-right quarter of Bringing Up the Trail offers little to the eye while the rest of the foreground is too busy with blades of grass.

Russell painted many scenes similar to *Bringing Up the Trail*, but one in particular, *Following the Buffalo Run* (1894; Amon Carter Museum, Fort Worth) could be a prelude to this version, so close are they in treatment.

NOTE

I. Ewers, *The Horse in Blackfoot Indian Culture*, p. 146.

Ex-collection: Newhouse Galleries, New York City; Gump Galleries, San Francisco; W. N. Corles, Santa Barbara; Treasure House Antiques (Susan E. MacGillivray), Spokane.

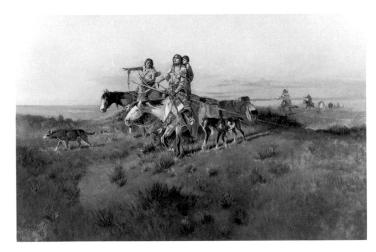

Following the Buffalo Run (1894) Amon Carter Museum, Fort Worth

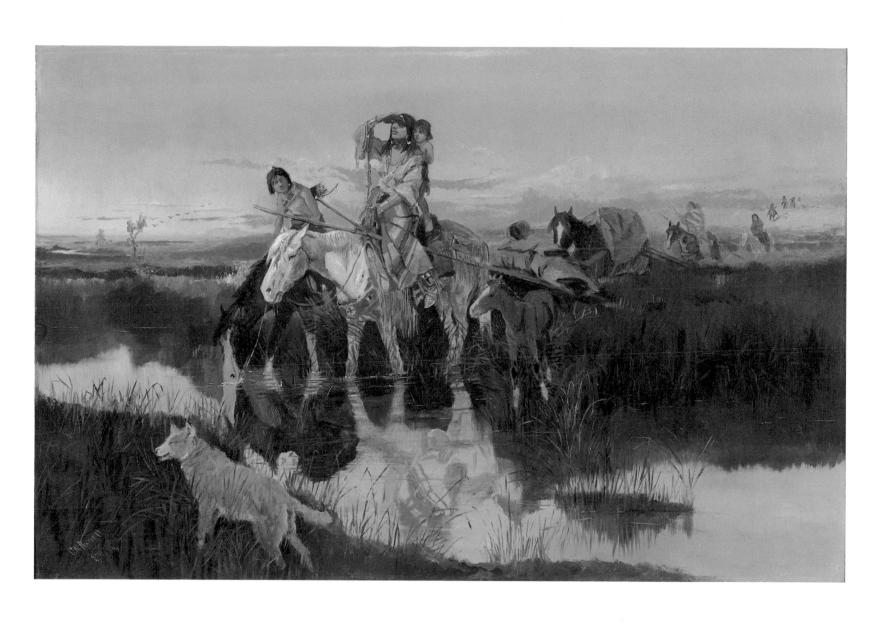

The Defiant Culprit

1895 Oil on masonite panel 18½ x 24¾" (47 x 61.9 cm.) Signed lower left: C M Russell / (skull) 1895 Ex-collection: Newhouse Galleries, New York City; W. Henderson, Buffalo; Emma M. Henderson, Buffalo; Milt F. Henderson, Great Falls.

Apart from a few wealthy individuals who took a shine to his work, Russell's main sources of patronage in Montana were the saloonkeepers he called friends. His first commission was from James R. Shelton, a Utica hotel and saloon operator (see Western Scene, p. 69), and Bill Rance and Sid Willis formed celebrated collections in their respective Great Falls emporiums, the Silver Dollar and The Mint.1 Russells graced the walls of bars scattered across Montana, but the city he eventually called home had most. Milt F. Henderson was co-owner of Great Falls's Milwaukee Beer Hall at the time Russell painted The Defiant Culprit, and it is just possible that he acquired the oil in settlement of one of those bar debts that became so much a part of the Charlie Russell legend.2

Lacking specific information on the incident portrayed here, it is a fair guess that the "defiant culprit" has been captured on a horse raid and is now about to pay the price of his temerity. Russell has underlined the melodramatic nature of the moment by throwing the tipi into deep shadow, allowing the flickering firelight to play over the stern features of the culprit's judges and the stooped figure of the cackling crone, who could have stepped out of the pages of Macbeth. Captor and captive also strike theatrical poses. The long arm of the law literally rests on the culprit's shoulder while he stands with his blanket dropped at his feet, vulnerable in his nakedness but arrogant in his pride. His stance, a classical pose that Russell may have borrowed from J. Steeple Davis's illustration of an unflinching Colonel Crawford awaiting torture at the hands of his Indian captors, expresses the culprit's contempt as he awaits his fate. "It's their religion to die without a whimper," Russell wrote in one of his Indian stories. "In olden times when a prisoner's took, there's no favors asked or given. He's up agin it. It's a sure case of cash in—skinned alive, cooked over a slow fire, or some such pleasant trail to the huntin'-ground—an' all Mister Prisoner does is to take his medicine without whinin'. If he makes any talk it's to tell ve you're a green hand at the business . . . "3 Such stoicism was a trait right out of the noble savage convention that Russell professed to disdain but could not resist, judging from The Defiant Culprit and a similar 1897 watercolor titled Sioux Torturing a Blackfoot Brave (Buffalo Bill Historical Center, Cody, Wyoming). Here, clothing and hair styles suggest that the situation is reversed and a Sioux is facing his Blackfoot captors.

Torture of Colonel Crawford by J. Steeple Davis Edward S. Ellis, *The Indian Wars of the United States* (Chicago: J. D. Kenyon & Co., 1892).

- 1. See Paul T. DeVore, "Saloon Entrepreneurs of Russell's Art and the Pilgrimage of One Collection," Montana, the Magazine of Western History 27 (Autumn 1977): 34–53
- 2. See Charles M. Russell to Milt F. Henderson [c. 1892], in Dippie, ed., *Charles M. Russell, Word Painter*, p. 27.
- 3. Charles M. Russell, "Finger-That-Kills Wins His Squaw," in *Trails Plowed Under*, p. 121.

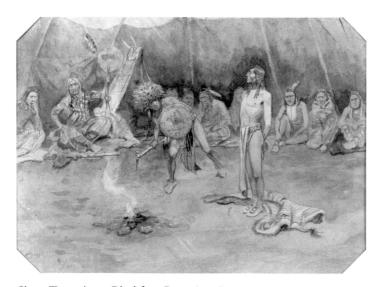

Sioux Torturing a Blackfoot Brave (1897) Buffalo Bill Historical Center, Cody, Wyoming

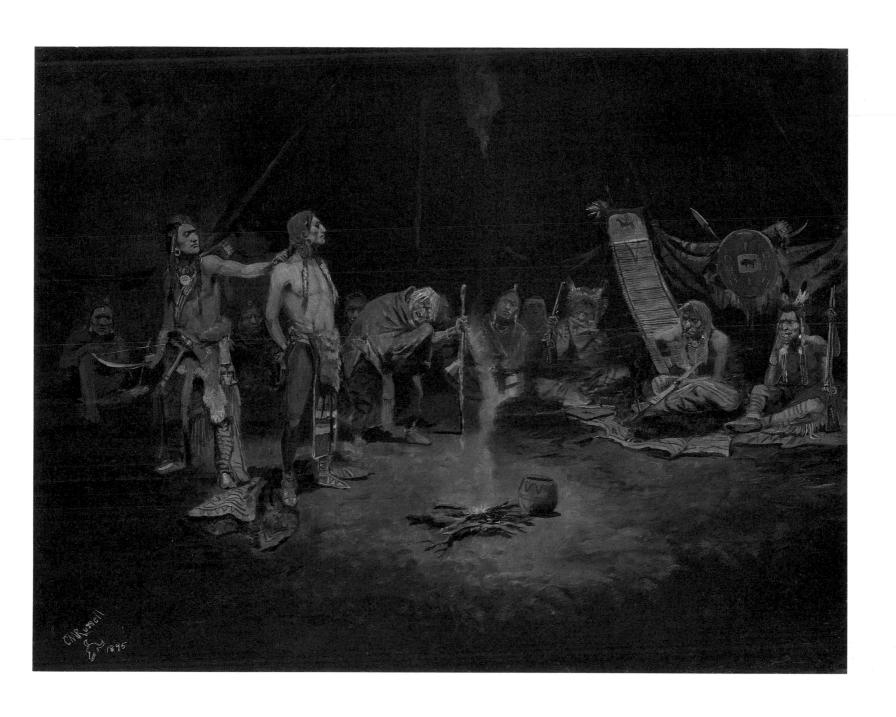

Big Nose George and the Road Agents

1895 Pencil, watercolor, and gouache on paper 14 x 20" (35.6 x 50.8 cm.)

Signed lower left: C M Russell / (skull) 1895

Ex-collection: Newhouse Galleries, New York City; Burr McGaughen, St. Louis.

Big Nose George and the Road Agents and the painting that follows, The Ambush, done a year apart but almost identical in composition, attest to Russell's continuing fascination with a gang of Black Hills holdup men active in the late 1870s. Their leader, "Big Nose George" Parrot, was arrested in Miles City, tried in Rawlins, Wyoming, and hanged by vigilantes in 1881—only a year after Russell arrived in Montana, an impressionable youth of sixteen.1 Not surprisingly, Big Nose George captured his imagination. Robert Vaughn, the Montana pioneer and good friend of Russell whose wall The Ambush graced for many years, described the activities of road agents in Montana "during the gold excitement of 1862-63":

The plan of operations of the road agents was to lie in wait at some secluded spot on the road for a coach, a party, or a single individual, of whom information was given by their confederates, and when near enough, [they] would spring from their cover with shotguns with the command, "Halt! throw up your hands!" And while a part of the gang kept their victims covered others would "go through" their effects. A failure to comply with the order or any hesitancy in obeying it, was sure to cause the death of the person so disobeying; and, indeed, if there was probability that any information which a victim might communicate would result in danger to themselves, he was shot, on the principle that "dead men tell no tales." 2

Despite this dark picture of road agents as coldblooded murderers, Russell included them in a toast "to all old-timers" that he addressed to Vaughn in 1911:

Here's to the holdup an' hoss thief
That loved stage roads an' hosses too well,
Who asked the stranglers [vigilantes] to hurry
Or he'd be late to breakfast in Hell.³

And when he went on to paint his popular 1899 oil *The Hold Up* (Amon Carter Museum, Fort Worth) showing an actual robbery in progress, Russell still managed to make Big Nose George's activities appear more comic than threatening. Realism simply lost out to his conviction that everything was better in the old days. "Even in my time Montana was a lawless land but seldom dangerous," he told an interviewer in 1921. "We had outlaws, but they were big like the country they lived in." ⁴ This was a sentiment that, in one shape or another, informed all of Russell's work.

- 1. For Big Nose George and his activities, see Agnes Wright Spring, *The Cheyenne and Black Hills Stage and Express Routes*, pp. 200, 252, 254, 285–287; Mark H. Brown and W. R. Felton, *The Frontier Years: L. A. Huffman, Photographer of the Plains*, pp. 157–158.
- 2. Vaughn, *Then and Now*, pp. 268–269. Granville Stuart, another pioneer Montanan, also provided a vivid description of the road agent's activities in a caption to an even earlier Russell painting, "*Hands Up*," in Russell's *Studies of Western Life*.
- 3. C. M. Russell to Robert Vaughn, [June 5] 1911, in Dippie, ed., *Charles M. Russell, Word Painter*, p. 156.
- 4. "Four Paintings by the Montana Artist, Charles M. Russell," *Scribner's Magazine* 70 (August 1921): 146; for a discussion of Russell's source for *The Hold Up*, see Hassrick, *Charles M. Russell*, pp. 62–67.

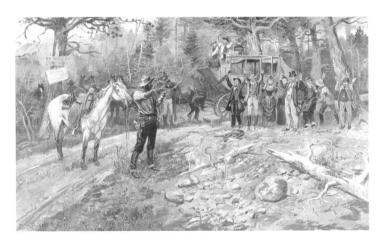

The Hold Up (1899) Amon Carter Museum, Fort Worth

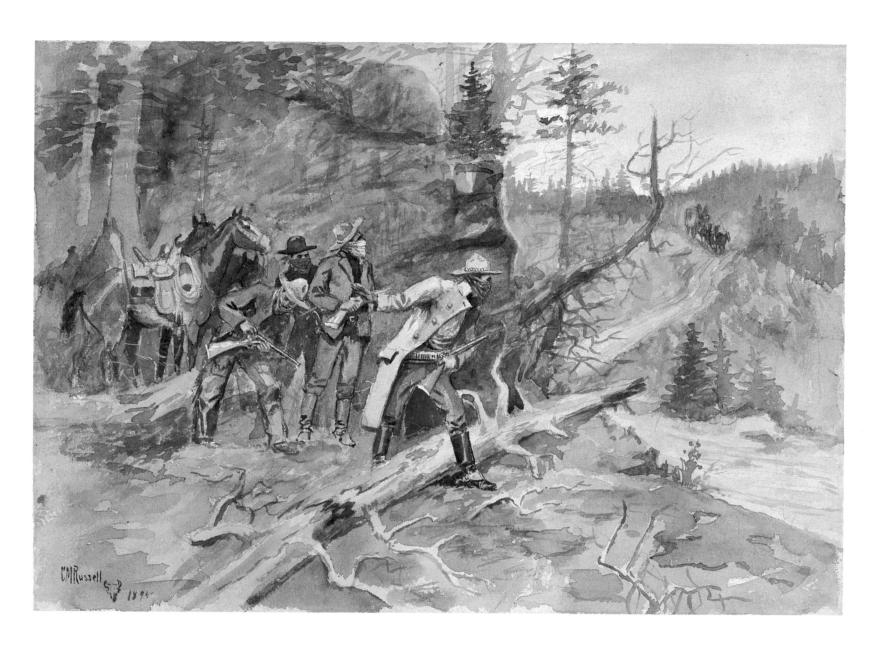

The Ambush [The Road Agents]

1896 Oil on canvas 261/8 x 35" (66.3 x 88.9 cm.) Signed lower left: C M Russell / (skull) 1896 Ex-collection: Newhouse Galleries, New York City; Elizabeth V. Sprague, Great Falls; Robert Vaughn, Great Falls.

What may be an anecdote about Big Nose George and the Road Agents or The Ambush was told by Russell's cowboy friend Con Price many years later. Con stayed with Charlie in Cascade in the period 1894-1895 and "just in fun," he remembered, posed for Russell "in a stage hold-up. I had a sawed-off shot-gun, big hat and my pants legs inside my boots. We found an old Prince Albert coat somewhere that I wore and a big handkerchief around my neck. I surely looked tough." Price went on to say that Russell "painted that picture in a rough way" and was flabbergasted a few years later when it fetched \$800 from a foreign nobleman visiting in New York.1 This part of the story sounds apocryphal, but the part about Con's services as a model was no doubt true.

Later, with the confidence maturity brought, and the refinement of his artistic skills, Russell would focus on the horses involved in the holdup. Left on their own while their masters went about the business of robbing a stagecoach, they grazed contentedly, indifferent to the drama taking place on the road below. Such was Russell's tack in the aptly titled painting *Innocent Allies* (1913; Gilcrease Museum, Tulsa), his most bemused take on Old West outlawry.

NOTE

1. Con Price, Memories of Old Montana, pp. 141-142.

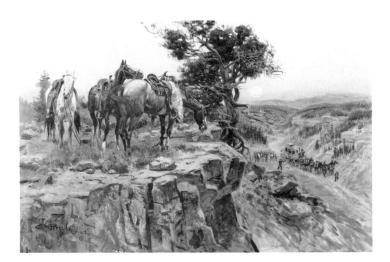

Innocent Allies (1913) Gilcrease Museum, Tulsa

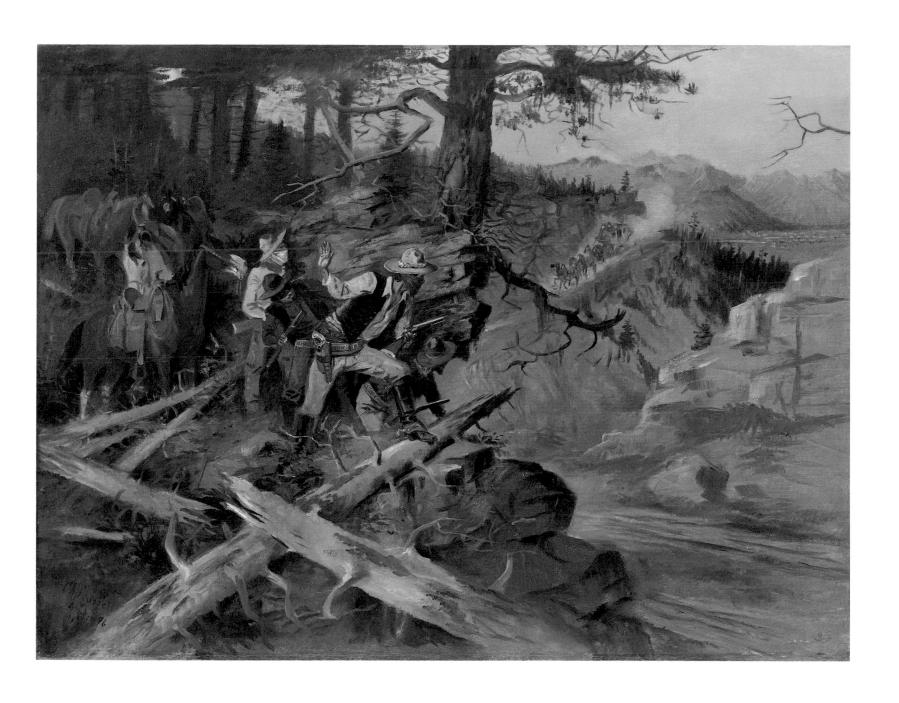

Sighting the Herd

1896 Oil on paper mounted on masonite $18\frac{1}{2}$ x $24\frac{1}{8}$ " (47.0 x 61.3 cm.) Signed lower left: C M Russell / 1896 (skull)

Ex-collection: Newhouse Galleries, New York City; John Levy, New York City.

A small party of hunters approaches a herd of buffalo grazing on the distant plain. Their position is favorable—they are out of view and doubtless downwind from the buffalo and so will have the necessary advantage of surprise when they begin the chase. Russell described the excitement and anticipation of a moment like this in one of his stories.

[The hunters] . . . ain't gone four miles when a scout looms up on a butte an' signs with his robe. This signal causes them all to spread out an' every Injun slides from his pony an' starts backin' out of his cowskin shirt an' skinnin' his leggin's. 'Tain't a minute till they're all stripped to the clout an' moccasins, forkin' their ponies naked like themselves, barrin' two half hitches of rawhide on the lower jaw. That sign means that the herd is in sight an' close. When they're all mounted, the scout on the butte swings his robe a couple of times around his head an' drops it. Before it hits the ground every pony's runnin', with a red rider quirtin' him down the hind leg . . . At the top of the ridge the herd shows—a couple of thousand, all spread out grazin'. But seein' these red hunters pilin' down on 'em, their heads leave the grass. One look's a plenty, an' with tails straightened, they start lumberin' together.1

The chase, which Russell portrayed so often elsewhere, was on.

Critics have noted Russell's fluency at spatial composition, evident even in a painting that exhibits as casual a disregard for polish as this one does. Russell virtually ignores a quarter of the canvas—the lower-right portion—but the rest of his composition is tightly structured. Russell did other early works in this vein, including *Piegan Indians Hunting Buffalo* and *The Returning*

Herd (both c. 1890; Gene Autry Western Heritage Museum, Los Angeles) and Buffalo Hunt (1891; Minneapolis Institute of Arts, Minnesota), but Sighting the Herd is the only one to show the hunters funneling up the slope, leading the viewer's eyes to the figure on the summit and to the buffalo herd grazing far below him.

NOTE

I. Charles M. Russell, "How Lindsay Turned Indian," in *Trails Plowed Under*, p. 143.

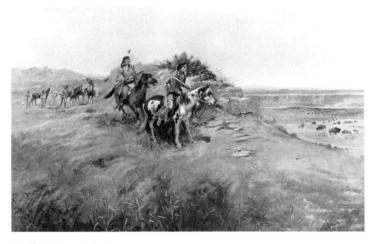

Buffalo Hunt (1891)
The Minneapolis Institute of Arts; gift of Mr. and Mrs.
George R. Steiner in memory of Frank M. Steiner, a
friend and admirer of Charles and Nancy Russell

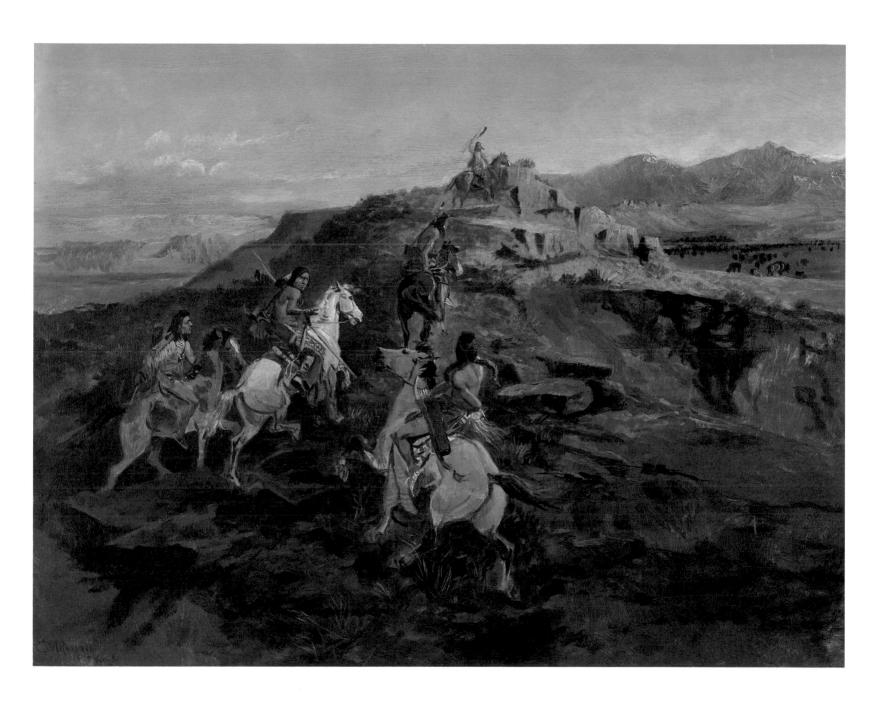

The Snow Trail

1897 Oil on canvas 18 x 253%" (45.7 x 64.5 cm.) Signed lower left: C M Russell (skull) 1897 *Ex-collection:* Newhouse Galleries, New York City; P. A. B. Franklin, Old Westbury, Long Island.

Russell's work did not progress evenly through the 1890s, and he did several oils around 1897-1898 that are crudely conceived and executed melodramatic pictures of hand-to-hand duels, cowboys shooting snakes or being dragged by their horses, buffalo trampling fallen Indians, and the like. Perhaps they were intended to attract buyers at a time when the newly married Russells were struggling to make ends meet. Certainly they indicate haste, an unwillingness to lavish time on careful finishing, and, in some respects, a decline in the standard Russell was attaining by 1896. But the slapdash quality of a surprising number of his paintings from the late 1890s may have represented a necessary transition in his artistic evolution. Russell was moving away from subjects closely based on personal experience as he accepted illustrating assignments that required him to draw as much upon imagination as memory.

The Snow Trail exhibits some of the weaknesses in Russell's oil paintings of this period. Apart from the central figure, the foreground group is indifferently modeled, especially the two horses on the right, and there is an impression of the figures' having been outlined and then painted in. But there are nice touches, too, including the light along the horizon under the leaden sky that casts pink highlights on the men, the white rime on the red blanket drawn up beneath the one brave's mouth, and the strong features of the

leader, who resembles the great Blackfoot chief Crowfoot. Russell's careful observation of detail is also evident in the Hudson's Bay Company blanket coats, or capotes, favored by the Blackfeet, the rifles in their cases indicating that no trouble is anticipated, the shaggy winter coats of the horses, and the typical quirting motion of plains Indian riders who rhythmically raised and lowered their whips with "every other jump of the horse." Indian bands preferred to winter in protected river bottoms away from the blizzards sweeping the plains. They moved only when necessity—scarcity of game, exhaustion of wood for fuel or grass for the horses—dictated.² Russell did a handful of fine paintings of Indian life during a season when the wolf was never far from the tipi door, nor the hunter's skills at a greater premium.

- 1. Ewers, *The Horse in Blackfoot Indian Culture*, pp. 181–183, 70.
 - 2. Ibid., pp. 124-136.

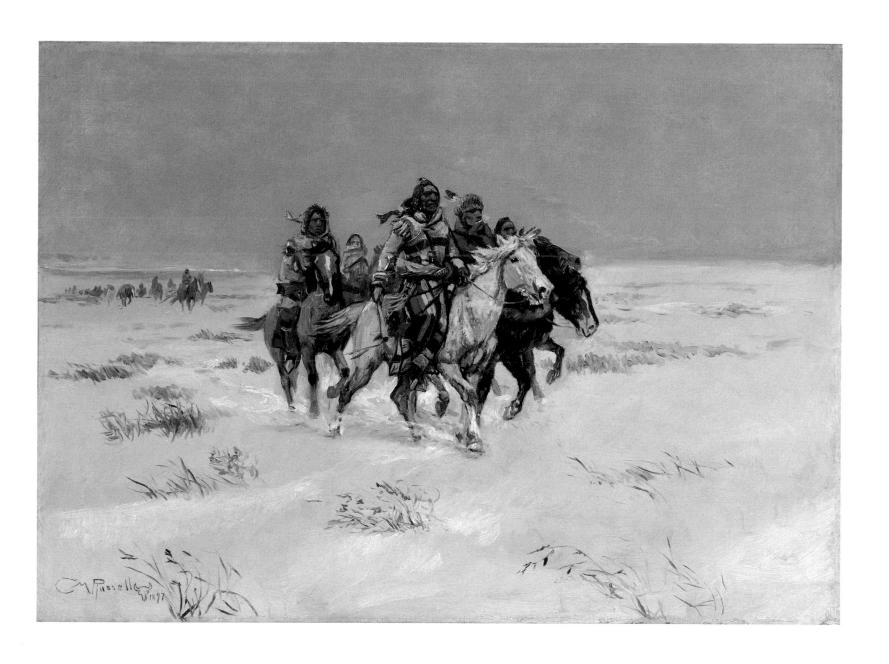

Three Generations

1897 Oil on canvas 17½ x 24¼" (43.5 x 61.6 cm.) Signed lower left: C M Russell / (skull) 1897 *Ex-collection:* Newhouse Galleries, New York City; Burr McGaughen, St. Louis.

Though the point has been much mooted, there is good reason to believe that, during his summer in Alberta in 1888, Russell seriously considered settling down with a Blood woman and becoming in fact what he often fancied himself, a white Indian. He wrote a humorous letter about the experience to a cowboy friend a few years after his return to Montana, noting:

I went out north a cross the line and lived six month with the Blackfeet . . . I was surprised to here that you were married but think it was the best thing you ever did and hope you will settel down and live like a whit man . . . I expect if I ever get married it will be to this kind [drawing of an Indian woman] as there is a grat many fo [of] them here and I seem to take well among them I had a chance to marry Young Louses daughter he is black foot Chief It was the only chance I ever had to marry into good famley but I did not like the way my intended cooked dog and we broke of our engagment.\(^1\)

Though he always treated it lightly, Russell again hinted strongly at the liaison in some of the stories he recorded in print years later. One is particularly revealing. Squaw Owens, a Russell persona, is speaking:

... I can talk some Blackfoot ... I get this talk from a "Live Dictionary" the year before, when I wintered up on Old Man River; that is, I marry a Blood woman. When I say marry, I traded her pa two ponies an' a Winchester, an' in accordance with all Injun's law we're necked all right. . . .

But our married life ain't joyful—I sure kick on that cookin', for there ain't enough Injun in me to like it.

Thinkin' to civilize her a little, I buy her a white woman's rig at [Fort] McLeod, an' when she slips this on I'm damned if you can tell which way she's travelin'.

We ain't been married a week till I've learned enough of the talk to call her all the names known to Blackfeet... When grass comes we separate; there's no divorce needed, as we're both willin', so we split the blankets; she pulls for camp, an' I drift south.²

Russell's fascination with Indian domestic life is undeniable. Camps on the move, women scraping buffalo hides, courtship, family life in the tipi, and lovely young Indian women were among his favorite subjects in the 1890s. But the conclusion he had reached that he was too white to be an Indian also found expression in works like *Three Generations*. On one level it is a straightforward family

portrait. On another, it can be seen as a statement on the toll that time took on the fair Indian maidens he had found so attractive. White observers commonly claimed that ceaseless drudgery quickly stripped Indian women (and, for that matter, pioneer white women) of their charms and made them old well beyond their years. "Their hands are large, coarse, and knotted by hard labor; and they early become wrinkled and careworn," George Bird Grinnell wrote of Blackfoot women in 1892.3 Much earlier, in the 1830s, George Back described "a poor old [Chippewayan] woman, bent double by age and infirmities," met on his explorations in the Canadian Northwest: "The ills that 'flesh is heir to' had been prodigally heaped on her, and a more hideous figure Dante himself has not conceived."4 In Russell's depiction of three generations is one of the concerns that may have haunted him when he contemplated staying with the Bloods. What would happen when youthful infatuation wore off, and the young mother sitting by the stream had aged into the stooped, toothless grandmother beaming down at her grandchild? The old crone, a ubiquitous presence in Russell's camp scenes, represents his vision of the last stage of Indian womanhood, and

it was not an alluring one.⁵ Nevertheless, she made a cameo appearance as a wise and benevolent character in a story he told—and illustrated—in 1898 of a discouraged young Indian man's vision quest. The composition of one illustration directly followed on that of *Three Generations*, showing how Russell could shuffle about the same imaginary ingredients.

- 1. Charles M. Russell to Friend Charly [Charles M. Joys], May 10, [1892], in Dippie, ed., *Charles M. Russell, Word Painter*, pp. 24–25.
- 2. Charles M. Russell, "Finger-That-Kills Wins His Squaw," in *Trails Plowed Under*, p. 122; also, "How Lindsay Turned Indian," p. 133, and "The War Scars of Medicine-Whip," p. 177. Two of these stories first appeared in *Outing Magazine* in the years 1907–1908.
- 3. Grinnell, Blackfoot Lodge Tales, p. 197.
- 4. George Back, Narrative of the Arctic Land Expedition . . . , p. 193.
- 5. For other crones in the Richardson Collection see The Defiant Culprit (p. 99), Captain William Clark of the Lewis and Clark Expedition Meeting with the Indians of the Northwest (p. 111), and Returning to Camp (p. 131).

The Medicine Arrow Sports Afield, January 1898, (cover illustration)

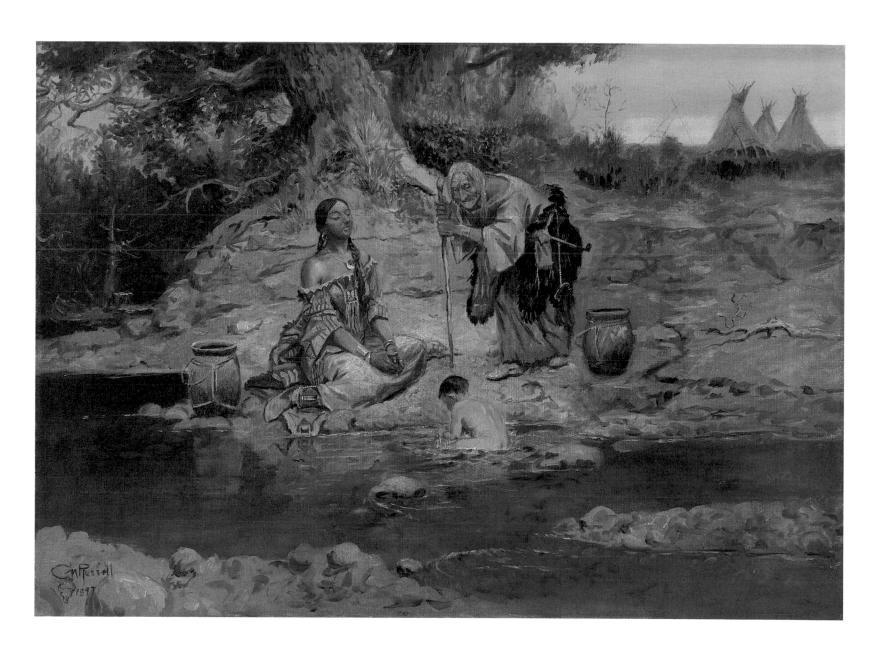

Captain William Clark of the Lewis and Clark Expedition Meeting with the Indians of the Northwest

1897 Oil on canvas 29½ x 41½" (75.0 x 105.4 cm.) Signed lower left: C M Russell (skull) 1897 Ex-collection: Newhouse Galleries, New York City; Elizabeth V. Sprague, Great Falls; Robert Vaughn, Great Falls.

The Lewis and Clark Expedition (1804–1806) stirred Russell's imagination like no other event in Montana's past. He returned to it for subject matter throughout his career, and it inspired some of his finest work, including two superb watercolors, Lewis and Clark on the Lower Columbia (1905; Amon Carter Museum, Fort Worth) and York (1908; see p. 146), and his celebrated mural for the Montana State Capitol in Helena, Lewis and Clark Meeting Indians at Ross' Hole (1912). Russell's fascination with Lewis and Clark extended to a 1913 boating trip down the Missouri retracing the portion of their route between Fort Benton and Fort Clagett at the mouth of the Judith River. A copy of their journals in hand, Russell responded with boyish enthusiasm to the adventure, occasionally reading "paragraphs aloud, particularly when they were about our surroundings," a companion on the trip recalled.1

Despite his personal interest in the subject and the fact that some of his paintings were directly based on passages in the explorers' journals, Russell's reconstructions of the Lewis and Clark Expedition were filled with anachronisms reflecting his tendency to depict Western Indians of whatever era in the costumes and with the accoutrements he saw and collected during his years on the range.2 This large oil is a case in point. The cradle boards, tipi designs, dress styles, and capote shown here all derive from a later period. The specific episode that Russell intended to depict is unclear. The painting was first published as Lewis and Clark Meeting the Mandan Indians, but when it was sold by its original owners in 1946 it was known as Captain William Clark of the Lewis and Clark Expedition Meeting with the Indians of the Northwest and was supposedly set on the Marias River near the Great Falls of the Missouri in mid-June 1805.3 The problem is compounded by the painting's similarity to a black-and-white oil done the same year for Western Field and Stream magazine, Lewis and Clark Meeting the Mandans (1897; Valley National Bank, Phoenix). Common elements in the two paintings include the costumes and hair styles of some of the Indians and the tipi village behind. But the black-and-white oil suggests that Russell had done additional research for what was intended to be a series of twenty historical pictures (he contracted with the magazine on September 30, 1897, and was to finish them, at a rate of fifteen dollars each, by the first of January, 1898, "if possible"!4). He introduced leggings, decorated robes, and a bull boat characteristic of the

Mandan, suggesting a source like George Catlin. Subsequently he repudiated the tipis behind, knowing that he should have shown an earth lodge village.5 The explorers in both paintings also form a similar grouping with the notable difference that the black-and-white oil includes both Lewis and Clark, while this painting shows only Clark stepping forward with aloof dignity to shake hands with the Indian headman while Charbonneau, husband of Sacajawea, interprets and Clark's black servant (here taking the place of Meriwether Lewis) looks on. Some of the poses seem stiff and conventionalized—which they were. Angela Miller observes that "in the midnineteenth century artists created a kind of regional gallery of originating myths, each visually recounting the moment when Europeans first entered a place or region or first established essential relations with the local Indians."6 Russell's painting is squarely within this earlier tradition. Its colors are "kind of stout," to use his own words,7 running to browns and greys. But Captain William Clark of the Lewis and Clark Expedition Meeting with the Indians of the Northwest is an impressive, large-scale performance at this stage of the Cowboy Artist's career, and a touchstone work in defining his local reputation in the year the Russells took up permanent residence in Great Falls. As a writer noted after seeing the painting in 1902, "Aside from its historical interest, the grouping, coloring, clear atmosphere and fine perspective make it an admirable composition."8

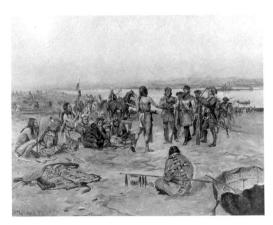

Lewis and Clark Meeting the Mandans (1897) Valley National Bank of Arizona, Phoenix

One puzzle remains: Why two such similar paintings, and why the change from Lewis and Clark to just Clark? It seems logical that the larger oil in color (nearly 21/2 by 31/2 feet) was painted after the smaller (21 x 27 inch) black-and-white. And an intriguing possibility suggests itself. Russell's father wrote the artist on March 12, 1898, that "a son of Genl Clark wants to know if your original painting of the meeting with the Mandan Indians a copy of which appears in the Field & Stream is for sale and the price If it belongs to the Field & Stream can't you find out if they will sell and the price in making the sale I hope you will get something for your self let me know the size of the picture and whether it is an oil painting or water color I would like to know as soon as possible."9 Did Russell by chance respond to his father's query with this handsome painting of just Captain William Clark and for whatever reason backdate it to 1897?

- I. Linderman, Recollections of Charley Russell, p. 66.
- 2. See John C. Ewers, Artists of the Old West, pp. 230–232, and "Charlie Russell's Indians," Montana, the Magazine of Western History 37 (Summer 1987): 36–53.
- 3. "Vaughn Collection of Russell Paintings Sold to Newhouse Galleries of New York," *Great Falls Daily Tribune*, June 16, 1946.
- 4. "Contract and Agreement" (between Charles Marion Russell and William Bleasdell Cameron, September 30, 1897), in the Montana Historical Society, Helena; and Wm. Bleasdell Cameron, "The Old West Lives through Russell's Brush," *Canadian Cattlemen* 13 (January 1950): 11, 26; and "Russell's Oils Eye-Opener to the East," ibid. (February 1950): 26–27, 34.
- 5. O. D. Wheeler to Nancy C. Russell, March 24, 1903, in the Helen E. and Homer E. Britzman Collection, Taylor Museum of Southwestern Studies of the Colorado Springs Fine Arts Center.
- 6. Angela L. Miller, "A Muralist of Civic Ambitions," in Rick Stewart, Joseph D. Ketner II, and Angela L. Miller, Carl Wimar: Chronicler of the Missouri River Frontier, p. 197; and see William H. Truettner, "Prelude to Expansion: Repainting the Past," in The West as America: Reinterpreting Images of the Frontier, 1820–1920, ed. William H. Truettner, pp. 55–95.
- 7. "Cowboy Artist Paints as He Talks, Lives," Minneapolis Journal, December 14, 1919.
- 8. Ruby Danenbaum, "Charles M. Russell, The Cow Boy Artist" (1902), typescript copy in the Britzman Collection.
- 9. C. S. Russell to Charles M. Russell, March 12, 1898, in the Britzman Collection; *Lewis and Clark Meeting the Mandans* was reproduced in the January 1898 number of *Western Field and Stream*.

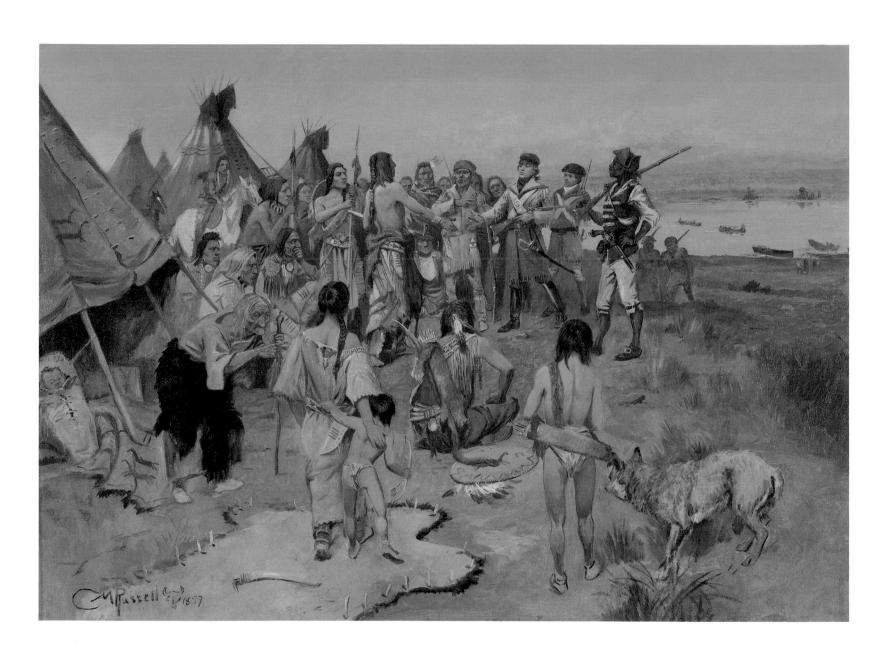

Guardian of the Herd

[Nature's Cattle; Buffalo Herd; Before the White Man Came]

1899 Pencil, watercolor, and gouache on paper 20% x 291/8" (52.4 x 74.0 cm.)

Signed lower left: C M Russell (skull) 1899

No one who saw the great herds of buffalo drifting down to the river to drink ever forgot the sight. George Bird Grinnell, who witnessed such scenes in the 1870s, wrote in 1892: "From the high prairie on every side they stream into the valley, stringing along in single file, each band following the deep trail worn in the parched soil by the tireless feet of generations of their kind. At a quick walk they swing along, their heads held low. The long beards of the bulls sweep the ground; the shuffling tread of many hoofs marks their passing, and above each long line rises a cloud of dust that sometimes obscures the westering sun."1 Russell had arrived in Montana just in time to see the remnants of the awesome multitudes of the recent past still roaming at large. Ten years before, a Montanan recalled, "I rode from Sun River to Milk River, and from there to Fort Benton, about 210 miles, and during the whole journey I was constantly surrounded by the animals, and never for a moment out of sight of them."2 Russell witnessed no such spectacle in 1880, but had he come even a few years later he would have seen no wild buffalo at all. By 1885 the herds had vanished, leaving tribes like the Blackfeet desolate. "The buffalo were their main dependence," a Canadian anthropologist wrote at the time. "Suddenly, almost without warning, they found themselves stripped of nearly every necessary of life. The change was one of the greatest that could well befall a community."3

No wonder Russell made a buffalo skull his personal insignia, for the buffalo's fate was that of the whole West that he knew so briefly and loved so well. On Thanksgiving Day in 1925, a year before he died, he penned a warm tribute to the buffalo:

turkey is the emblem of this day and it should be in the east but the west owes nothing to that bird but it owes much to the humped backed beef...

the nickle weares his picture dam small money for so much meat he was one of natures bigest gift and this country owes him thanks ⁴

Russell's own gratitude found expression in paintings, sketches, and sculpture featuring buffalo, and *The Guardian of the Herd* represents one of his favorite themes, the herd on the move. It anticipates an oil like *The West* (1913; Rockwell Museum, Corning, New York) and his major achievement on this theme, *When the Land Belonged to God* (1915; Montana Historical Society, Helena). Success did not come easily. The lead bull in *When the Land Belonged to God* gave

Ex-collection: Newhouse Galleries, New York City; Guido Nelli, Los Angeles; C. Bland Jamison, Beverly Hills; Nancy C. Russell, Pasadena, California.

him no end of trouble. He painted and repainted it, unable to make the animal "stand still," before he was satisfied. The Guardian of the Herd, done sixteen years earlier, does not meet such a high standard. Russell conveys the undulating motion of the herd descending in the distance and topping the rise in the foreground, and the ruts establish an effective diagonal that brings bull and coyote into line. But the bull himself is less successful. Heavy shadows make his hindquarters appear detached from the rest of his body, while his head is awkwardly proportioned.

- I. George Bird Grinnell, "The Last of the Buffalo," *Scribner's Magazine* 12 (September 1892): 267.
- 2. Hamlin Russell, "The Story of the Buffalo," Harper's New Monthly Magazine 86 (April 1893): 796.
- 3. Horatio Hale, "Report on the Blackfoot Tribes," in *Report on the North-Western Tribes of Canada*, pp. 3–4.
- 4. Charles M. Russell to Ralph Budd, November 26, 1925, in *Good Medicine*, p. 37.
- 5. Linderman, Recollections of Charley Russell, p. 95.

The West (1913)
Rockwell Museum, Corning, New York

When the Land Belonged to God (1915) Montana Historical Society, Helena

The Buffalo Hunt [Wild Meat for Wild Men]

1899 Oil on canvas 24½ x 36½" (61.3 x 91.7 cm.) Signed lower left: C M Russell / (skull) 1899 *Ex-collection:* Newhouse Galleries, New York City; Helen Card, Woonsocket, Rhode Island.

This painting, approximately 2 x 3 feet in size, shows the remarkable development in Russell's ability to portray Indians hunting buffalo. He was in complete command of the subject by 1899. That same year he painted another major buffalo hunt, 21/2 x 4' (Amon Carter Museum, Fort Worth), and the next, a similar, even larger (4 x 6') oil (Gilcrease Museum, Tulsa). All three paintings were called simply The Buffalo Hunt, and in order to differentiate among them and the many other identically titled Russell paintings, Frederic G. Renner assigned each one a number This is The Buffalo Hunt No. 25. It exhibits Russell's ease not only in handling buffalo on the run but also in seeing the subject from any perspective. No longer did he stick to broadside views; rather, in the paintings he executed in 1899 and 1900 he ran the buffalo and their pursuers toward the viewer. His bowmen are convincing. Here, as in most of his buffalo hunts, one of the background figures sports a headband—a detail that not only serves as a color highlight but also represents the custom of, for example, the Assiniboines, who before the chase stripped to their moccasins and breech clouts "and tied their hair with bands on top of their heads." Russell frequently showed one of the hunters carrying an extra arrow or two in his bow hand or, as here where the rather odd absence of a quiver would make it necessary, in his mouth.2 The sense of verisimilitude is wonderful. Only the choking cloud of dust that would obscure such a scene from view is lacking. By 1899, no other artist could touch Russell when it came to conveying the wild excitement of a buffalo chase.

- I. Kennedy, ed., The Assiniboines, p. 112.
- 2. In "How Lindsay Turned Indian," Russell told how an Indian hunter would pull "five or six arrows at a draw, holdin' the extras in his mouth an' bow-hand . . ." (*Trails Plowed Under*, p. 143). An 1836 lithograph based on Titian R. Peale's *Buffaloe Hunt on The River Platte* showed one Indian with an arrow in his mouth, a second with a spare arrow in his bow hand. See Poesch, *Titian Ramsay Peale*, p. 59.

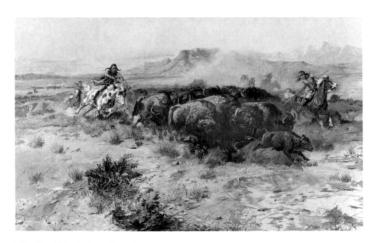

The Buffalo Hunt (1899) Amon Carter Museum, Fort Worth

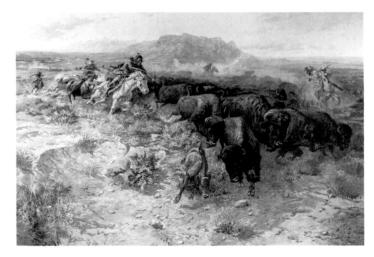

The Buffalo Hunt (1900) Gilcrease Museum, Tulsa

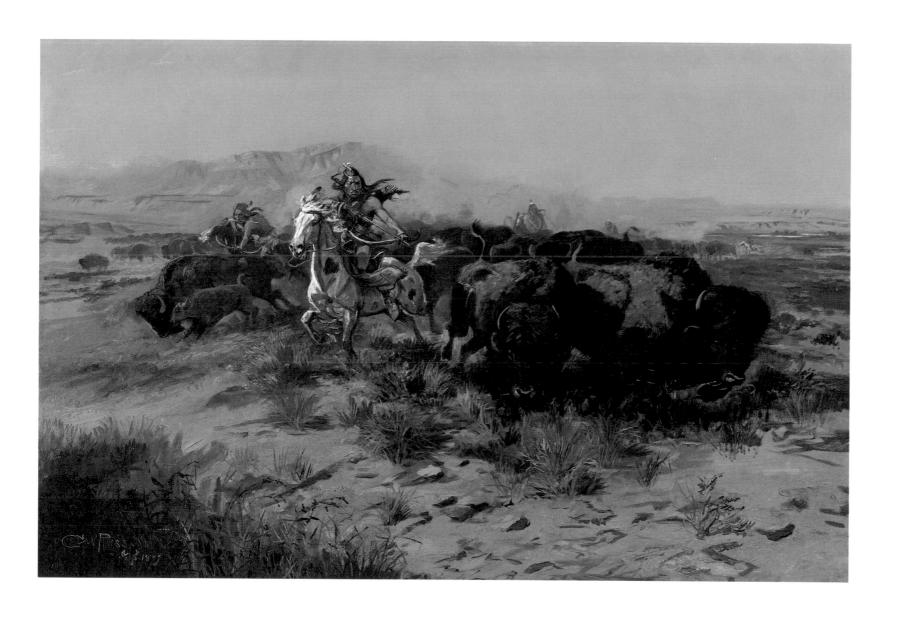

Wild Man's Meat [Redman's Meat]

1899 Pencil, watercolor, and gouache on paper 21 x 30" (53.3 x 76.2 cm.)

Signed lower left: C M Russell / (skull) 1899

Ex-collection: Provenance unknown.

In his buffalo hunt paintings Russell made no concession to delicacy. Terrified calves, cows, and bulls jam together, saliva streaming from their mouths, tongues lolling as they run for life. When an offended patron demanded that Russell alter such realistic details in an oil he had commissioned, Russell refused on the sensible grounds that, when buffalo run, they slobber.1 Anyway, there was nothing very sportsmanlike or elevated about the chase. The white trophy hunter might single out a magnificent bull as his target, but the Indian hunter was after meat, and his techniques were designed accordingly. Russell often showed an Indian crowding a cow into a calf to slow it down and give him a better shot, though during any extended run the cows usually outdistanced the bulls while the calves were left far behind, prey to Indian boys who honed their hunting skills on them.

So natural is the action in Wild Man's Meat, and so effortlessly is it portrayed, that one must be reminded just how difficult the subject is in order to appreciate Russell's skill. His buffalo are

the real thing. Here one particularly notices the foreground bull lumbering along, his "hoofs flying out below," as Francis Parkman observed, and his short tail "held rigidly erect." If there is a defect in this watercolor, it would be the proportions of the main hunter. In his early work Russell, who was large-headed himself, sometimes painted figures with oversized heads. Since he sometimes posed before a mirror and had photographs taken of himself in Indian costume, it is not surprising that more than a few of his "wild men" bear a family resemblance to the Cowboy Artist. (See *Maney Snows Have Fallen* . . . , p. 153.)

- 1. Nancy C. Russell to Thomas F. Cole, July 17, 1918, in Adams and Britzman, *Charles M. Russell, the Cowboy Artist* p. 282
 - 2. Parkman, The Oregon Trail, p. 363.

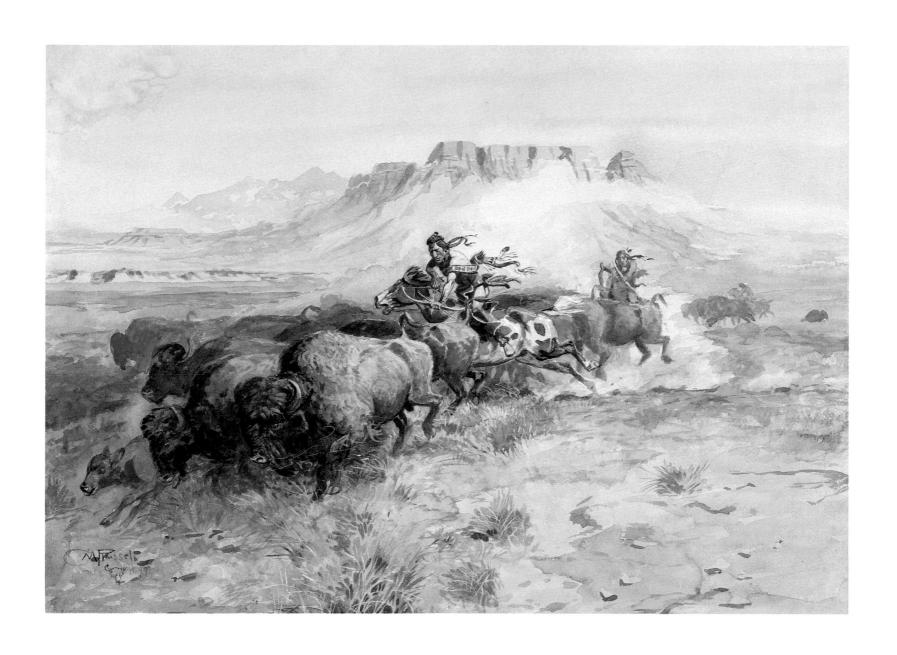

When Cowboys Get in Trouble [The Mad Cow]

1899 Oil on canvas 24 x 36" (61.0 x 91.5 cm.) Signed lower left: C M Russell (skull) 1899 *Ex-collection:* Newhouse Galleries, New York City; George J. Heckroth, Detroit.

Most cow work was routine. "Occasionally an animal would get on 'the fight' and make things interesting," the pioneer Montana cattleman Granville Stuart remembered, "but the rope horses were as clever as the men about keeping out of danger and rarely did we have a serious accident."1 However, there were perilous moments in cowboying, and the incident shown here was one Russell painted several times, both before (A Dangerous Situation [1897; Stark Museum of Art, Orange, Texas]) and after (A Moment of Great Peril in a Cowboy's Career [c. 1904; Amon Carter Museum, Fort Worth]) doing this elaborate treatment. The cow, roped by the heel, has lunged at a horse and rider, backing them against the side of a cutbank. A toss of its head and the horse will be gored. The cowboy reaches for his revolver as he scrambles out of the saddle to avoid himself being gored in the leg or crushed by his rearing mount. Russell implies more trouble ahead for the cowboy, since his gun hand is about to be snagged in the loop of his rope. The third rider, preoccupied with controlling his horse, is effectively hors de combat. The action is tense, the composition tight. The dust cloud raised by the herd grazing calmly in the distance sets off the figure of the cowboy on the right. It has been pointed out many times that in scenes like these Russell did not generalize. The men were individuals, and so were the horses and cows. The brands tell the names of the outfits represented at the roundup and place this scene in the Big Dry country west of the Musselshell and below the Missouri.

NOTE

I. Phillips, ed., Forty Years on the Frontier 2: 179–180.

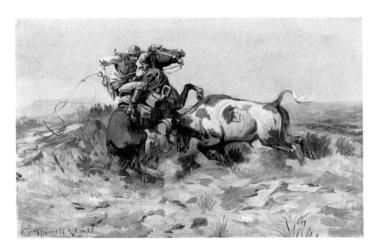

A Dangerous Situation (1897) Stark Museum of Art, Orange, Texas

A Moment of Great Peril in a Cowboy's Career (C. 1904) Amon Carter Museum, Fort Worth

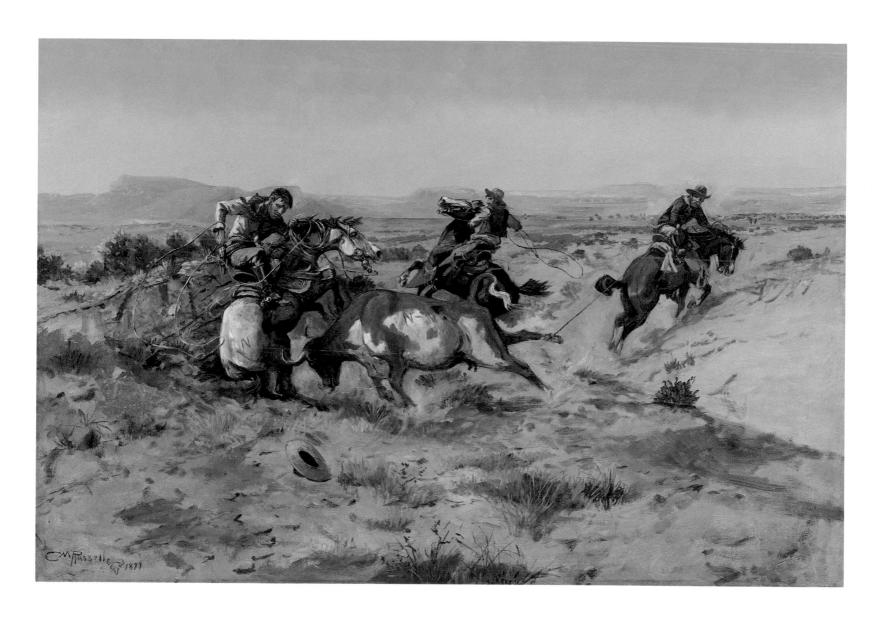

Bear Claw [Chief Bear Claw]

C. 1900 Pencil, watercolor, and gouache on paper 105/8 x 9" (27 x 22.9 cm.)

Signed lower left: C M R (skull)

Ex-collection: Newhouse Galleries, New York City; Earl C. Adams, Pasadena, California; Nancy C. Russell, Pasadena.

A student of Russell's work would be hard pressed to think of a single portrait he did of a white man, yet he painted many individual Indians. A few of his portraits were of celebrated leaders he had never met—Chief Joseph and Sitting Bull, for example—and thus were derived from photographs. Most were of Indians of his own acquaintance. Russell often went on sketching trips to the Montana reservations and attended rodeos and stampedes where Indian delegations were part of the show. Some Cree friends—notably John Young Boy—posed for him in his Great Falls studio.

This little watercolor, done basically in brown with the earrings providing a yellow highlight, was possibly intended for use as an illustration. It also may be a composite portrait rather than an individual likeness. The face bears a family resemblance to Sleeping Thunder, the subject of a bronze. But the features are distinct enough to suggest that Russell had someone else in mind. Nancy Russell identified Bear Claw as a Piegan or Blackfoot, and there is another portrait of Chief Bear Claw (1900; Rockwell Museum, Corning, New York) in which the subject actually wears a bearclaw necklace.2 Similar facial features, hairstyle, and earrings suggest two versions of the same man, as well as a 1900 date for this watercolor. It is a straight-on, unembellished portrait, powerful in its simplicity.

- 1. Nancy C. Russell, "Price List" (c. 1927–1929), in the Helen E. and Homer E. Britzman Collection, Taylor Museum of Southwestern Studies of the Colorado Springs Fine Arts Center.
 - 2. Renner, A Limitless Sky, pp. 88-89.

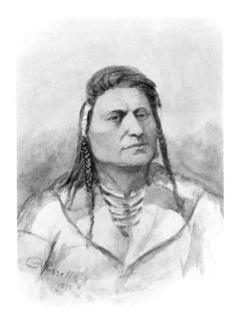

Chief Joseph (1898) The R. W. Norton Art Gallery, Shreveport, LA

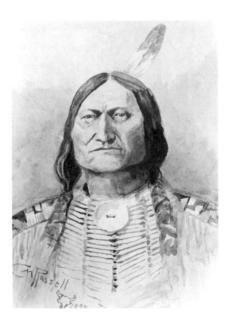

Chief Sitting Bull (1898)
The R. W. Norton Art Gallery, Shreveport, LA

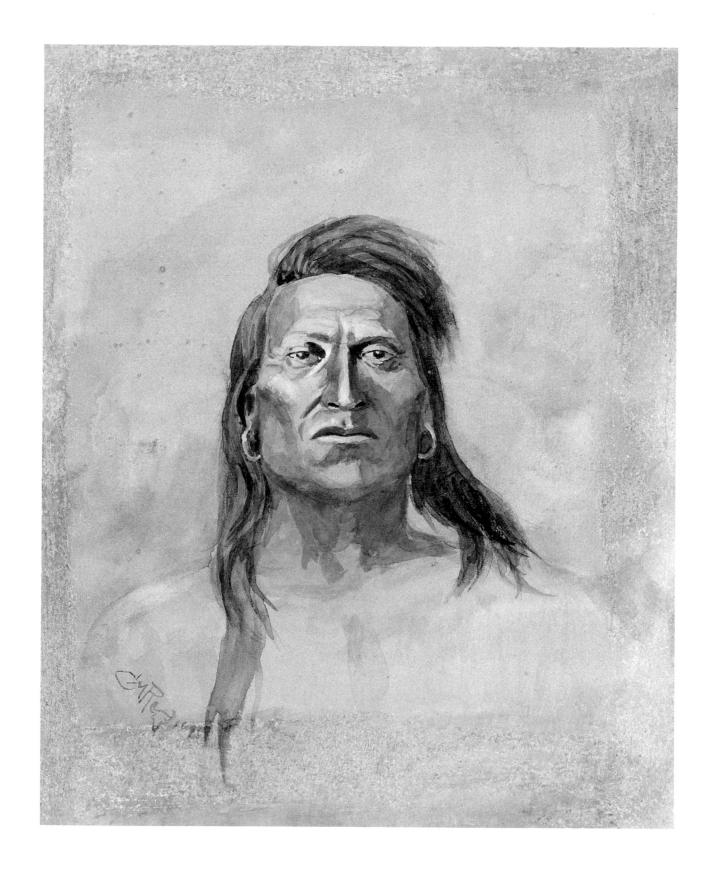

Breaking Up the Ring [Breaking Up the Circle]

1900 Pencil, watercolor, and gouache on paper 19½ x 29¾" (49.5 x 74.6 cm.)

Signed lower left: C M Russell (skull) 1900

Ex-collection: Newhouse Galleries, New York City; H. Alexander, Detroit.

Breaking Up the Ring is so loosely sketched and painted that it appears to have been tossed off casually.1 But it is pleasingly colored, full of dash and verve, and serves as an introduction to the composition Russell favored in his more elaborate paintings of Indians attacking stagecoaches, wagon trains, and the like. Jumped (1914; Amon Carter Museum, Fort Worth) is his summation of the theme, a fully resolved work of art that effectively plays off light and shadow and makes the terrain itself part of the action as a wagon train, caught strung out, finds its vanguard trapped in a gully by charging Indians. In each of Russell's related paintings a prominent warrior armed with a rifle serves as the centerpiece set off by two or three others clustered behind him. The action moves from left to right, the circling braves approaching and receding on the sides of the picture; often one or more on the left fall wounded, while on the right one rides away bent low over his pony as he releases an arrow toward the embattled whites, whose individuality is lost in the dust and the distance. A critic in 1904 contended that Russell's "chief fault is a tendency to neglect portions of his picture that he considers of too little importance, and the result is often an unfinished work whose imperfections show up glaringly in a reproduction. This fact lays him liable to an accusation (that may seem partly justifiable) of carelessness . . . "2 Breaking Up the Ring obviously evidences haste. At the same time, by downplaying distracting elements it successfully focuses attention on the principal figures, and it departs from form by introducing a fallen horse into the foreground.

- 1. Breaking Up the Ring is especially close to another, more finished watercolor painted the same year, Gun Powder and Arrows (Gilcrease Museum, Tulsa).
- 2. Kathryne Wilson, "An Artist of the Plains," *Pacific Monthly* 12 (December 1904): 343.

Jumped (1914) Amon Carter Museum, Fort Worth

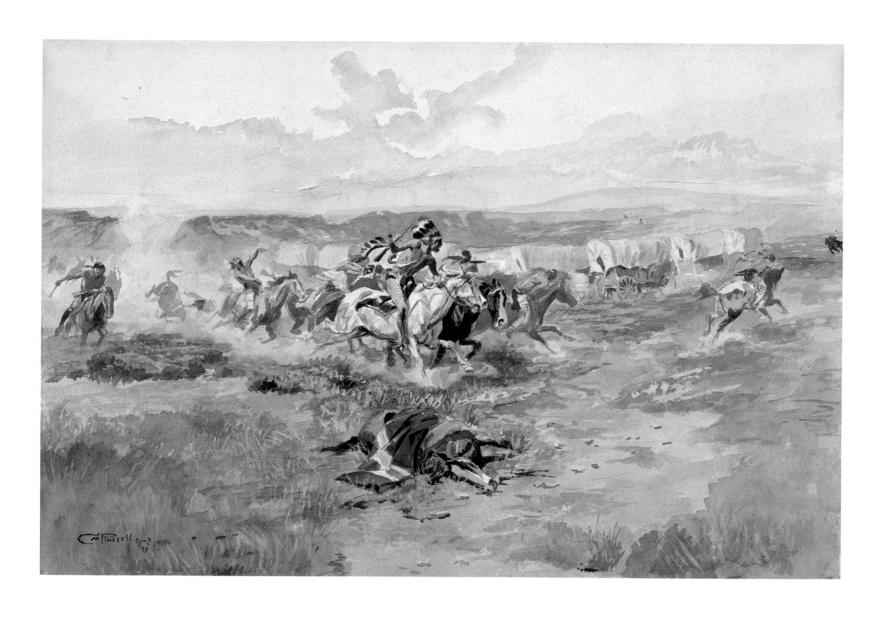

The Tenderfoot

1900 Oil on canvas 14½ x 20½" (35.9 x 51.1 cm.) Signed lower left: C M Russell (skull) / 1900 Ex-collection: Newhouse Galleries, New York City; Homer E. Britzman, Los Angeles.

If ever there was a touch of malice lurking in Charlie Russell's genial heart, it found expression in a work like this. He sketched, painted, and modeled other versions of "cowboy fun," but when it was a tenderfoot doing the dancing to the tune of a .45 he obviously took extra delight in the performance. For, unfair as the odds seem and deplorable as such bullying might be, it had the ring of an initiation rite—the West introducing itself to the East. Presumably, if the dude in The Tenderfoot proves himself a good sport there will be slaps on the back and a convivial round of drinks afterward. But no matter what the immediate outcome, the tenderfoot is the future, and he and his ilk will one day displace his tormentors as surely as the sun is setting behind the stage stop in Russell's painting. If the old West chose to go out with a bang and a roar of laughter, Russell as its greatest eulogist was not about to shed tears over the discomfiture of a tenderfoot or two.

Patrick T. Tucker, who actually rode the range with Kid Russell in the early 1880s and years later wrote a thoroughly unreliable book about their escapades together, told an anecdote that might be apocryphal but was obviously meant to describe *The Tenderfoot*. One quiet Sunday afternoon, Pat O'Hara, owner of the stage station at Geyser on Arrow Creek, decided to stir up some excitement by introducing a young English guest "looking for adventure" to a bunch of thirsty cowboys who had just ridden up "to the door branded SALOON." The Englishman

gave them all the gladhand. Pat was wiping off the bar, getting ready for business. The dude's invitation is accepted, and the boys all take a drink. Bill Bullard, a big long-legged cowpoke, pats the man with the silver on the back. That makes the Englishman feel brave, and he tells the barkeeper to fill them up again.

We all take another drink, and hurrah for the Queen.

"Give the lads another drink," the tenderfoot says.

By this time the pilgrim [traveler] is a hoss man, and steps outside to look the hosses over. Bill Bullard is trailing the dude, pulling his shooting iron as he goes. They are both walking crooked. A lone Indian buck is standing by the log shack. He can't move—too much firewater. . . . but he is still standing up and his eyes are working.

The pilgrim is traveling slow. He sees a lot of saddle hosses. Bullard is making eyes at the boys, and walking tiptoe. His legs are shaky but his aim is still good. He takes a crack at Johnny Bull's feet with his six-gun. That raised a dust. The pilgrim crowhops. Bill makes him dance the cancan while he shoots at his feet. . . .

Russell was sitting in the shade of his cow hoss on the side of a hill, taking it all in. . . . He told me afterward that this was the first time he had ever seen a man dance to the music of a six-gun.¹

The Tenderfoot is what it appears to be, a joke, not a deathless work of art. It draws its principal figures from a Frederic Remington sketch published in 1888 as "Dance Higher—Dance Faster," and is populated with Russell's stock Western types: the Indian, the saloonkeeper, the gambler, the Chinese cook, the stagedriver, and, sitting at the end of the bench watching intently, the Cowboy Artist himself. Arresting touches include the skillful way the setting sun is implied by the streak of light along the saloon roof and on the distant bluff, and the deep shadow cast over the foreground figures. There is also artfulness in the composition as the frightened, rearing horse carries the action from right to left, along the path of the bullet to the dude's dancing feet. Since the other horses are so nonchalant about the gunfire, one can assume that the skittish animal is the dude's own mount.

NOTE

1. Patrick T. Tucker, *Riding the High Country*, ed. Grace Stone Coates, pp. 52–55. Tucker comments on the cowboy propensity, in swapping yarns, to tell "more lies than truth" (p. 69), and his book certainly proves the point. See Raphael Cristy, "Discredited Memoirs Resurrected," *Montana, the Magazine of Western History* 38 (Summer 1988): 84–86.

"Dance Higher—Dance Faster" by Frederic Remington Century Magazine, October 1888

On the Attack

1901 Pencil, watercolor, and gouache on paper 115/8 x 175/8" (26.5 x 44.8 cm.)

Signed lower left: C M Russell (skull) 1901

Ex-collection: Newhouse Galleries, New York City.

In 1889, Frederic Remington painted a mammoth (4 x 8') oil titled A Dash for the Timber (Amon Carter Museum, Fort Worth) showing a band of cowboys racing pellmell for safety with Apaches hot on their heels. The painting is a dazzling exercise in Wild West theatrics, and Remington drove home the point by having all the onrushing cowboys part around the viewer except one who, coming hell bent for leather, is shown straight on. Russell occasionally painted similar groups of trappers or cowboys in full flight from pursuing warriors, the action sweeping across the picture at an angle, usually from right to left. On the Attack is a carefully painted and vigorous version; its riderless horses and desperate faces tell a dramatic tale. But none of Russell's paintings on the theme remotely rivals A Dash for the Timber. Suffice it to say, Remington owned the subject.

A Dash for the Timber (1889) by Frederic Remington Amon Carter Museum, Fort Worth

Buffalo Hunt

1901 Oil on canvas 24½ x 36½" (61.3 x 91.8 cm.) Signed lower left: C M Russell (skull) 1901 Ex-collection: Maurice S. Weiss, Helena.

The buffalo hunt shown here has elements of the traditional surround—wherein hunters circled the herd and forced it to mill—though this is essentially a parallel chase, with the bowman and the lancer pressuring the opposite flanks. Few plains Indians actually used a lance in buffalo hunting. The Plains Cree may never have used it, while the Blackfeet had virtually abandoned it by 1870.1 John Ewers notes that, when a Blackfoot hunter did wield a spear, he grasped it with two hands and holding it overhead, thrust downward.2 Russell's lancer looks ready to enter a jousting match and would seem to be at a decided disadvantage in trying to bring down a buffalo with his spear held as shown.

The composition of *Buffalo Hunt* (No. 30, to employ Frederic Renner's numbering system) is distinctive among Russell's many related works. Here the surging herd has been bunched so tightly by the pressure of the hunters on the flanks and at the rear that it forms a triangular mass moving directly at the viewer like an arrow in flight.

Buffalo Hunt and the following painting, Returning to Camp, constitute a matched set. Both were bought from Russell by his friend Maurice S. Weiss, a saloonkeeper who worked the legendary Mint in Great Falls, which under its proprietor Sid Willis would form a matchless Russell collection. When Weiss moved to Helena he took his Russells with him, and they graced the Old Stand Saloon, the Weiss Cafe, and the Placer Hotel. When he relocated in Butte in 1924 to manage the Finlon Hotel, his oils and models moved again. Buffalo Hunt and Returning to

Camp decorated the lobby during his long tenure there.⁴ After retiring in 1941, Weiss returned to Helena and took quarters in the Placer Hotel. He no longer had room for his Russells. "I have no home now and they are just in my way," he explained in February 1942 to Sid Richardson, whose acquaintance he had made by mail through two interesting intermediaries—John B. Ritch, an old friend of Russell and Weiss, and J. Frank Dobie, a Russell admirer who was seriously contemplating a biography of the Cowboy Artist.⁵ So Weiss sold his prize possessions to Richardson, and in transferring title wrote, "I hope that you will enjoy them as much as I have for many years to come."

- I. Mandelbaum, *The Plains Cree*, p. 95; Ewers, *The Horse in Blackfoot Indian Culture*, pp. 156–157.
- 2. Ewers, *The Horse in Blackfoot Indian Culture*, pp. 158, 200–201.
- 3. Maurice S. Weiss to Mr. Sheriff, July 18, 1944 ("Story of 'The Russell Stage Coach"), in the Helen E. and Homer E. Britzman Collection, Taylor Museum for Southwestern Studies of the Colorado Springs Fine Arts Center.
- 4. James B. Rankin to his mother, July 10, 1937, in the James B. Rankin Papers, Montana Historical Society, Helena.
- 5. Maurice S. Weiss to Sid W. Richardson, February 5, 1942, in the Sid Richardson Collection of Western Art files
- 6. Weiss to Richardson, March 3, 1942, in the Sid Richardson Collection of Western Art files.

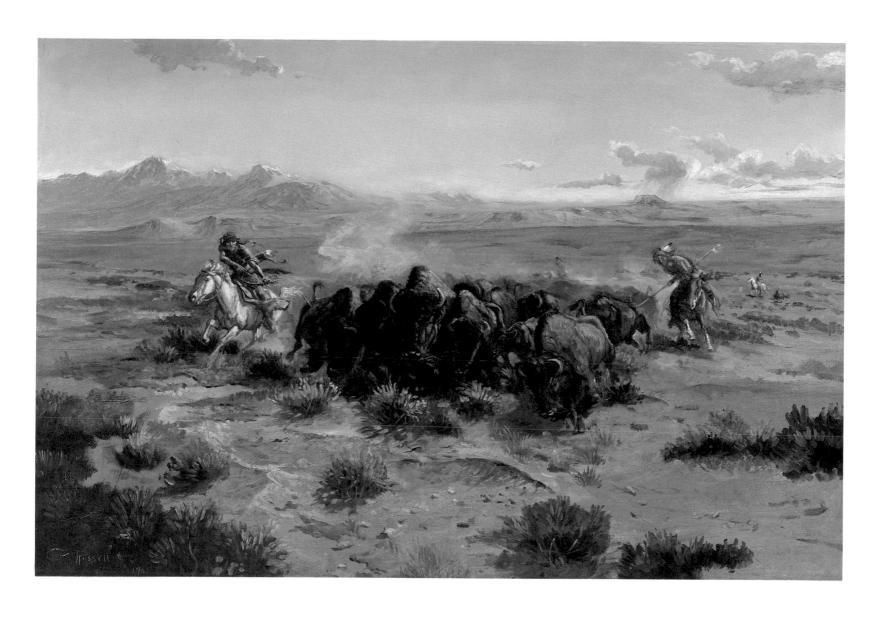

Returning to Camp

1901 Oil on canvas 241/8 x 36" (61.3 x 91.5 cm.) Signed lower left: C M Russell / (skull) 1901 Ex-collection: Maurice S. Weiss, Helena.

In Buffalo Hunt, Russell ran the action right at the viewer; in this sequel, Returning to Camp, the viewer trails after the women and boys transporting the spoils of the chase back to the village. The reversal in perspective complements the before-and-after story Russell set out to tell and results in another strikingly different oil. The men, who may have assisted with the butchering (about an hour per animal) have ridden off ahead on their buffalo horses, leaving the women to bring home the meat and hides by travois or slung over the backs of the pack horses.1 Full of the kind of detail admired in Russell's work, Returning to Camp is also rich in human interest, some of it possibly derived from a plate in George Catlin's popular Letters and Notes on the Manners, Customs, and Conditions of the North American Indians (1841) showing a Comanche camp on the move. In Russell's painting, a mother glances over at her young son proudly displaying the trophy of his chase; soon he too will hunt the mighty buffalo. An old woman drives off one of the wolflike dogs frustrated in its bid to partake of the feast so tantalizingly near.

The buffalo was always referred to as the plains Indians' staff of life. "It was their food, clothing, dwelling, tools," George Bird Grinnell wrote. "The needs of savage people are not many, perhaps, but whatever the Indians of the plains had, that the buffalo gave them." In *Returning to Camp* Russell makes the same point visually.

Comanche Moving Camp: Dog Fight en Route by George Catlin George Catlin, Letters and Notes on the Manners, Customs, and Conditions of the North American Indians (London: The Author, 1841)

- 1. See Ewers, *The Horse in Blackfoot Indian Culture*, pp. 160–161; Mandelbaum, *The Plains Cree*, p. 58.
- 2. George Bird Grinnell, "The Last of the Buffalo," Scribner's Magazine 12 (September 1892): 278.

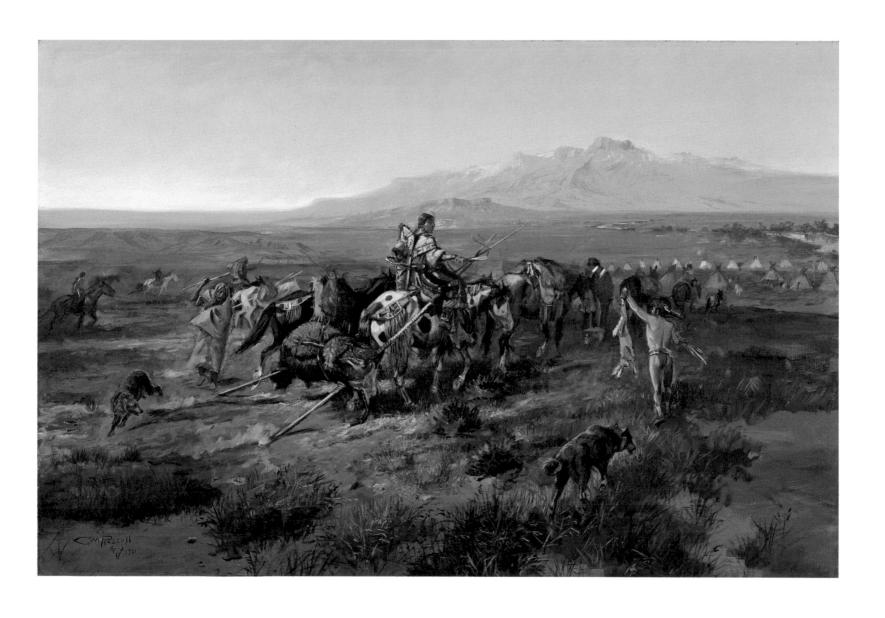

Counting Coup [Medicine Whip]

1902 Oil on canvas 18½ x 30½" (46 x 76.5 cm.) Signed lower left: C M Russell / (skull) 1902

Few Russell paintings are as well documented as this stirring depiction of intertribal warfare and the counting of a coup. "The basis of the [plains Indian] war honor system was the coup—originally awarded for the striking of an enemy," a student of the Sioux explained:

A system of graduated points was evolved wherein the first man to touch an enemy was awarded a first coup or "direct hit" . . . Credit was given for touching, not killing, an adversary, except in hand-to-hand combat. It was the daring required of close contact for which the honor was given To count coup, one might use his hand, his bow, his lance, or certain societal paraphernalia like rattles or whips. 1

Russell painted *Counting Coup* for a distant relative in St. Louis, George W. Kerr, and sent along a detailed description. While he was visiting with the Bloods in Alberta in 1888, Russell wrote, he sat in the lodge of Medicine Whip, a man of some eighty years, and listened while he told the story of his greatest war exploit:

My son he said fifty snows behind me the Sioux were verry bad... we had out maney scouts but the Sioux were like ghosts we could not see them at last in the moon of the painted leaves a scout came in with a sioux arrow and said he had seen maney tracks and the poney sighn were still warm it was not long till maney Bloods were on their war poneys on the track of the Sioux the sun was not yet in the middle when we sighted them. It was a running fight until we killed the horse of their medicine man then his braves gathered about him and faught so strong we could not reach them our arrows were nearly all gon, the Sioux had been wise and saved theirs

Now every time a Sioux bow string spoke a Blood brave was sent to shadow land there was but one way, charge and scatter them. but we had no leader they had killed our Chief and our harts were on the ground the Sioux now called us maney bad names. they said we were people with moss on our backs from hiding in the woods and harts cold like the snake one young man called to me saying, You with the pritty poney, that is not a squaw poney, see he hangs his head with shame, he has the Coup paint on his hip but no man on his back . . . come poney I will wash the maggot from your back his words were like hot irons in my hart Has the liar spoken I called if so let him sing his death song for in less time than it takes to smoke the warr pipe his scalp will

Ex-collection: Newhouse Galleries, New York City; Samuel H. Rosenthal, Jr., Los Angeles; Jack C. Russell, Pasadena, California;

For Supremacy (1895) Amon Carter Museum, Fort Worth

hand [hang] in the belt of him you called the maggot and throwing down my bow and now empty quiver I shouted come brothers we will show them how the Bloods kill lice I will whip their medicine man like I would a camp dog my pony was strong and in a fiew jumps he was among them he with the bad tounge ran in frount of the Medicine man I made a falce thrust with my lance at his throat and as he raised his shield drove under stopping his hart crying this from the Magaot you dog eater . . . then quickly changing my shield to the string hand I struck the medicine man across the face with my qurit [quirt]. then the sioux crouded about me and left their war pictures on me a [as] you see to day this scar on my face was from the tomahawk which stuned and blinged [blinded] me I rembmber twisting my fingers in my poneys mane then it was night verry dark when I awoke my people were about me the sioux were dead all still thir harts slept they were all scalped, except Bad tongue and the Medicine man which were left for me the scars on my legs are where the arrows went under my shield that was long ago My son.2

Russell loved this tale of valor from the olden days on the plains. He retold it with some embellishments in "The War Scars of Medicine-Whip" ³ and based two other striking oils on it: For Supremacy (1895; Amon Carter Museum, Fort Worth) and *The Making of a Warrior* (1898; present location unknown). In the related paintings and pen sketches that Russell did, he invariably placed a corpse in the foreground—a grim reminder of the cost of valor.

Nancy C. Russell, Pasadena, California; Mrs. Silas Bent Russell, St. Louis; George W. Kerr, St. Louis.

Russell obviously lavished care on Counting Coup. In its time it was hailed as a "master piece"his best work to date in "grouping, action and technic [technique]."4 Every figure in it is well painted. But the color scheme, with its predominance of pinks and blues ("very soft and pearly," Nancy Russell wrote),5 does not do justice to the furious action, and for all the fine detail the composition seems cluttery in comparison to Russell's brilliant 1908 painting When Blackfeet and Sioux Meet (p. 149). It is a comparison that establishes just how much Russell's work improved over six years during this dynamic period in his career. Nancy Russell offered both oils to a client in 1929 and thoroughly approved when he chose the later work. "There is," she said of When Blackfeet and Sioux Meet, "one thing,-marvelous action and drawing—that few people are able to put on canvas."6

- 1. Royal B. Hassrick, *The Sioux: Life and Customs of a Warrior Society*, p. 90.
- 2. Charles M. Russell to George W. Kerr, September 29, 1902, private collection. Russell's format in recording the old Indian's story was anticipated in two legendary accounts he illustrated in the 1890s: John H. Beacom, How the Buffalo Lost His Crown, and Anna P. Nelson (as told to by C. M. Russell), "The Medicine Arrow," Sports Afield 20 (January 1898): 20–21.
- 3. Trails Plowed Under, pp. 177-186.
- 4. Ruby Danenbaum, "Charles M. Russell, The Cow Boy Artist" (1902), typescript copy, and William Macbeth to Ruby Danenbaum, November 28, 1902, in the Helen E. and Homer E. Britzman Collection, Taylor Museum for Southwestern Studies of the Colorado Springs Fine Arts Center.
- 5. Nancy C. Russell to Ernest Quantrelle, May 15, 1929, in the Britzman Collection.
- 6. Nancy C. Russell to Alex. Simpson, Jr., July 2, October 2, 1929, in the Britzman Collection.

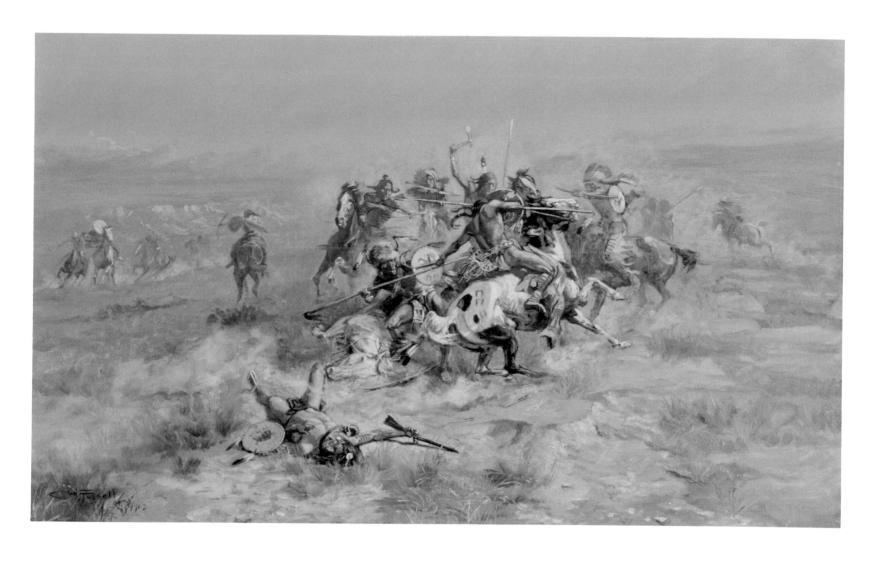

Trouble Hunters

1902 Oil on canvas 22 x 29½" (55.9 x 74.0 cm.) Signed lower left: C M Russell (skull) 1902 Ex-collection: Alice P. Biggs, Helena.

Plains Indian warfare ordinarily was an individual, volunteer activity, unsystematic and unrelated to larger tribal goals. Young men followed an experienced warrior in hopes of stealing horses and, should the need arise, winning war honors, or coups, in combat with the enemy. Raiding parties tended to be small—a dozen men or lessand since the object was horses, not battle, the ideal raid was one in which the horses were taken without even arousing the owners. The party in Trouble Hunters, however, appears very much on the prod. The men bristle with weapons—shields and lances, bows and arrows, rifle and knivessuggesting that they are out for blood and would welcome a fight. Such scalp parties were usually fairly large in size. Two or three scouts moved ahead of the main body, as Russell has shown. Apparently they have spotted something and are waiting for the others to catch up.

Russell liked the theme of Trouble Hunters. Eight years later he painted an oil with the identical title that could be taken as another view of the same three warriors. He often set scenes like this at day's end, and in his later work the Indians became almost unthreatening as they basked in the sun's fading warmth—perfect symbols of Russell's own nostalgia over the vanished West. This version, painted in 1902 with the artist in command of his medium, has a different aura. The sky is roseate, and the setting sun washes the men in pinks and reds, but they exude menace. They are lean, tough, and full of fight. The figure of the mounted warrior in the foreground with the distinctive fur cap obviously appealed to Russell. With minor variations it appeared in a succession of paintings from 1899 to 1903.

Nancy Russell wrote the owner, Alice P. Biggs, in 1929 to see if she wished to sell *Trouble Hunters*. Proud of her painting, Mrs. Biggs declined, and Nancy replied, "I am glad that you are keeping your Russell picture. . . . they are going to be more precious as time goes on." 2 *Trouble Hunters* came into Sid Richardson's possession in 1945 only after Alice Biggs was enfeebled by age and her possessions were sold off by her guardian. 3

- 1. Grinnell, *Blackfoot Lodge Tales*, p. 250; Ewers, *The Blackfeet*, pp. 126–129; Kennedy, ed., *The Assiniboines*, p. 48; Mandelbaum, *The Plains Cree*, pp. 239–247.
- 2. Nancy C. Russell to Alice P. Biggs, June 18, 1929, in the Helen E. and Homer E. Britzman Collection, Taylor Museum for Southwestern Studies of the Colorado Springs Fine Arts Center. It was Alice Biggs (then Alice Chadwick) who helped Nancy, fourteen at the time of her mother's death in Helena in 1894, by lining up a place for her with the Robertses in the little town of Cascade. There Nancy met and, in 1896, wed Charles M. Russell.
- 3. "Guardian's Bill of Sale" (July 10, 1945), in the Sid Richardson Collection of Western Art files.

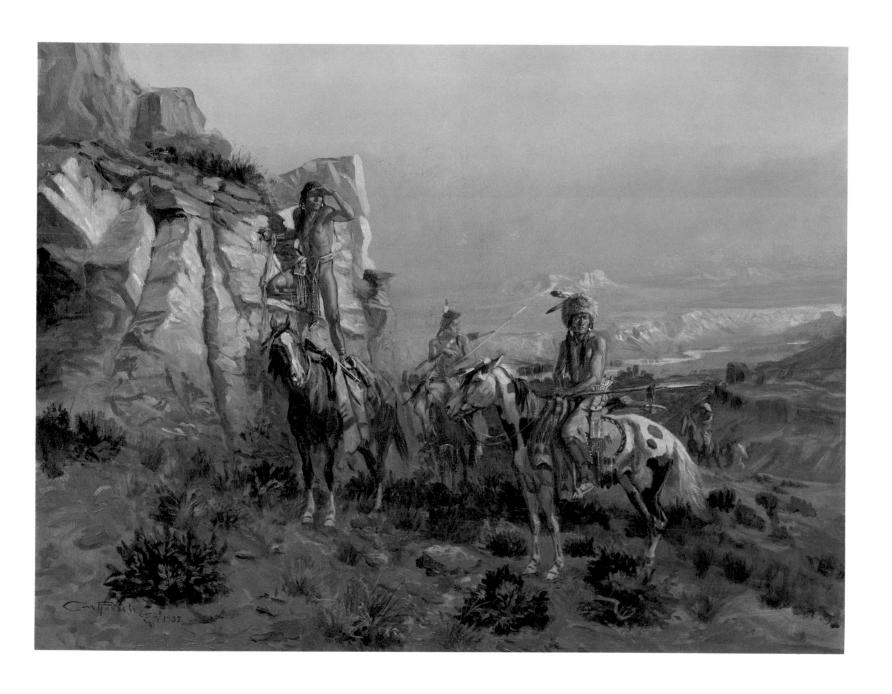

Indian Head

1904 Pencil, watercolor, and gouache on paper 15½ x 9½" (38.7 x 23.5 cm.)

Signed lower right: C M Russell (skull) / by E. S. Paxson—/ Chas. Schatzlein / 1904

Ex-collection: Newhouse Galleries, New York City; F. Leonard, Great Falls.

This Indian head is the work of three Montanans: Russell, his close friend and first serious dealer Charles "Dutch" Schatzlein, owner of the Schatzlein Paint Company in Butte, and Edgar S. Paxson (1852-1919), an artist also resident in Butte at the time. Judging from the end result, Paxson was the guiding spirit behind this joint endeavor. His reputation rested on a few large historical oil paintings and numerous watercolor Indian portraits, of which this one is typical. Russell respected Paxson, who arrived in Montana three years before him (in 1877), as Montana's pioneer painter. He had his reservations—see the commentary with Trouble on the Horizon, p. 88 but was generous in his praise. "I can't paint an Indian head with Ed Paxon [sic], nor can I mix his colors," he told an interviewer in 1917.1 And when Paxson died two years later Russell commented: "Paxson has gone, but his pictures will not allow us to forget him. His work tells me that he loved the Old West, and those who love her I count as friends. Paxson was my friend . . . I am a painter, too, but Paxson has done some things that I cannot do. He was a pioneer and a pioneer painter."2

The circumstances under which *Indian Head* was painted in 1904 are unknown, but the same threesome collaborated again in 1906 on a mural that decorated Schatzlein's dining room.³ Russell visited Paxson's studio two years later,⁴ exhibited in Helena at the Montana State Fair with him in 1909,⁵ and rode beside him in a Missoula parade celebrating Montana's past in 1915.⁶ Their mutual respect adequately accounts for this 1904 collaboration, then, though Russell's contribution to it is

difficult to ascertain since the pose, drawing (especially the rendering of eyes, ears, and mouth), and greenish coloration are all so characteristic of Paxson's work while nothing distinctively Russell's is evident.

It is worth noting that Russell's personal collection of paintings—a small sampling of the work of his friends—included Indian heads by both Paxson and Schatzlein.⁷

- I. Noyes, In the Land of Chinook, p. 126.
- 2. C. M. Russell, November 1919, quoted in Michael Kennedy, "Frontier Vermeer," *Montana Magazine of History* 4 (Spring 1954): 38; Franz R. Stenzel, "E. S. Paxson—Montana Artist," *Montana, the Magazine of Western History* 13 (Autumn 1963): 76; and see Paxson, E. S. Paxson.
- 3. The section of the mural painted by Russell, *The Indian War Dance*, is in the collection of the Amon Carter Museum, Fort Worth; see Renner, *Charles M. Russell*, p. 60.
- 4. Albert J. Partoll, "Paxson and Russell Close Friends; Led Parade at Missoula," *Great Falls Daily Tribune*, January 15, 1933.
- 5. "Montana Fine Art," *Treasure State*, June 26, 1909, p. 5; "Best Art Exhibit Ever Collected in the West," *Great Falls Daily Tribune*, October 1, 1909.
- 6. "Russell's Art in Park," Great Falls Daily Tribune, July 2, 1915.
- 7. E. W. Latendorf Catalogue No. 27: C M Russell, #37–38.

The Bucker

1904 Pencil, watercolor, and gouache on paper 16½ x 12½" (41.3 x 31.1 cm.)

Signed lower left: C M Russell / (skull) 1904

Charlie Russell had no problem accounting for his aversion to bronc busting. It was a specialist's job during his days on the range. The average cowboy did not tackle the half-wild horses in the rough string, and those who did usually paid the price.1 "I never got to be a bronk rider but in my youthfull days wanted to be," Russell recalled, "and while that want lasted I had a fine chance to study hoss enatimy from under and over the under was the view a taripan gits The over while I hoverd ont the end of a Macarty rope was like the eagle sees grand but dam scary for folks without wings."2 Elsewhere he quipped, "never did take kindly to broncos as my mind and theirs did not seem to work in unison," 3 but there is no denying his uncanny feel for horse anatomy, however he came to observe it. Russell could twist man and animal anyway he wanted for purposes of action, yet, since he visualized the figures in the round, always make his distortions seem natural—a trick

that Frederic Remington and other artists influ-

enced by stop-action photography did not master. Russell painted three similar watercolors in 1904: A Bad Hoss [Bronc Buster] (Buffalo Bill Historical Center, Cody, Wyoming), Powder River, Let'er Buck [The Bucking Bronco] (Gilcrease Museum, Tulsa), and this painting, The Bucker. All three are virtuoso performances, and the praise that a New York critic at the time heaped on one applies to the others as well: "The artist shows here his thorough knowledge of both man and beast. The ugly temper and viciousness of the bronco is splendidly done, and all details such as trappings on the saddle, swinging of the quirt or lash by the loop instead of the handle and the dress of the cowboy are perfect."4 Comments like these helped establish Russell's reputation in the East as a gifted painter of the West. In particular, he was praised for his realism. But the three watercolors are also artistic successes. The vertical composition of each augments its visual impact, emphasizing the towering height of the bucking horse and the rider on its back as they crowd the edges of the painting and, in their violent exertions, threaten to explode right out of it.

Ex-collection: Newhouse Galleries, New York City; Earl C. Adams, Pasadena, California; Nancy C. Russell, Pasadena, California.

A Bad Hoss (1904) Buffalo Bill Historical Center, Cody, Wyoming; collection of Mr. and Mrs. W. D. Weiss

Powder River, Let'er Buck (1904) Gilcrease Museum, Tulsa

- 1. E. C. Abbott and Helena Huntington Smith, We Pointed Them North: Recollections of a Cow-puncher, p. 230; Jeff C. Dykes, ed., The West of the Texas Kid, 1881–1910: Recollections of Thomas Edgar Crawford, Cowboy, Gun Fighter, Rancher, Hunter, Miner, p. 122; Ramon F. Adams, The Old-time Cowhand, Chapter 36.
- 2. Charles M. Russell to Will James, May 12, 1920, in Good Medicine, p. 68.
 - 3. Noyes, In the Land of Chinook, p. 120.
- 4. "Smart Set Lionizing a Cowboy Artist," New York Press, January 31, 1904.

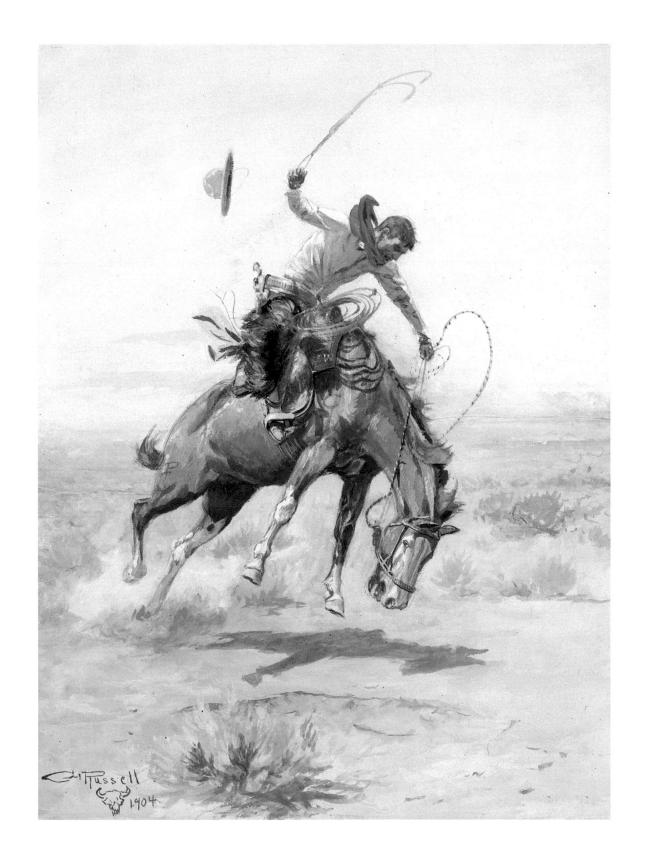

He Snaked Old Texas Pete Right Out of His Wicky-up, Gun and All

1905 Pencil, watercolor, and gouache on paper 123/8 x 173/8" (31.4 x 45.4 cm.)

Signed lower left: C M Russell / (skull) 1905

Ex-collection: Newhouse Galleries, New York City; E. J. Rodlein, Great Falls.

With the encouragement of John N. Marchand (1875-1921), a New York illustrator he had met the previous summer in Montana, Russell spent January and part of February 1904 in New York City, passing much of his time there in the studio Marchand shared with two others. During his stay, he told a reporter, he did "considerable work and more than 'broke even' on expenses. I did some illustrations for Scribner's, Outing, Mc-Clure's and Leslie's magazines, and some of it will be published in a short time. . . . My friend, Marchand, took me around and introduced me to the art editors of the big publishing houses, which was mighty fine for me. Many of the editors promised me work in the future in illustrating western stories."1

He Snaked Old Texas Pete Right Out of His Wicky-up, Gun and All was one of the pictures that Russell painted for McClure's Magazine to illustrate the first two installments of Stewart Edward White's Arizona Nights. It is faithful to White's story about a tough named Texas Pete, "about as broad as he was long," with "big whiskers and black eyebrows," who discovered a waterhole in the middle of the Arizona desert, set up shop, and began gouging the emigrant traffic en route to California "two bits a head—man or beast" for a drink of water. Texas Pete sat outside his canvas shack, Winchester across his lap, and let a crude sign speak for him. One day two goodhearted cowboys chanced by when an emigrant, denied water because he could not meet the price, bent down to scoop up a drink for his sick child from an overflow puddle. His thirsty horses chose the same moment to dip into the trough. Texas Pete, nursing a hangover and in an uglier mood than ever, jumped up and fired, killing one of the horses. Instantly, a cowboy grabbed his rope and "with one of the prettiest twenty-foot flip throws I ever see done he snaked old Texas Pete right out of his wicky-up, gun and all. The old renegade did his best to twist around for a shot at us; but it was no go; and I never enjoyed hog-tying a critter more in my life than I enjoyed hog-tying Texas Pete."2 Action abounded, in short, and Russell put it all into his painting, which appeared in the February 1906 McClure's.

N. C. Wyeth (1882–1945) was subsequently assigned to illustrate the remaining installments of White's story, indicating dissatisfaction with Russell's work. Wyeth's mentor, the great illustrator Howard Pyle, had begun a brief, unhappy stint as *McClure's* art director in early March 1906, and it may have been his personal preference to bring in Wyeth. The next year Edgar Beecher Bronson mentioned he had written a story he was urging *McClure's* "to send to Charlie, but they are stuck on Wyeth & so far I have not won my point." Nancy Russell replied:

We appreciate what you have done in trying to get McClure to have Chas. illustrate for them, but the art editor and I had a disagreement about some pictures about two years ago and I can understand how he would dislike to ask any favors or even to give work to Mr. Russell. We appreciate your efforts but don't try to have Chas. illustrate anything for McClure because I know the present art editor will not have him if he can help himself.³

When White's book *Arizona Nights* appeared in 1907, Russell's illustrations were all dropped and only Wyeth's were used.

- 1. "Prefers Ulm to New York as Place of Residence," Great Falls Daily Tribune, February 16, 1904.
- 2. Stewart Edward White, "Arizona Nights," *Mc-Clure's Magazine* 26 (February 1906): 412–419.
- 3. Edgar B. Bronson to Nancy C. Russell, October 9, 1907, and Nancy Russell to Bronson, October 23, 1907, in the Helen E. and Homer E. Britzman Collection, Taylor Museum for Southwestern Studies of the Colorado Springs Fine Arts Center.

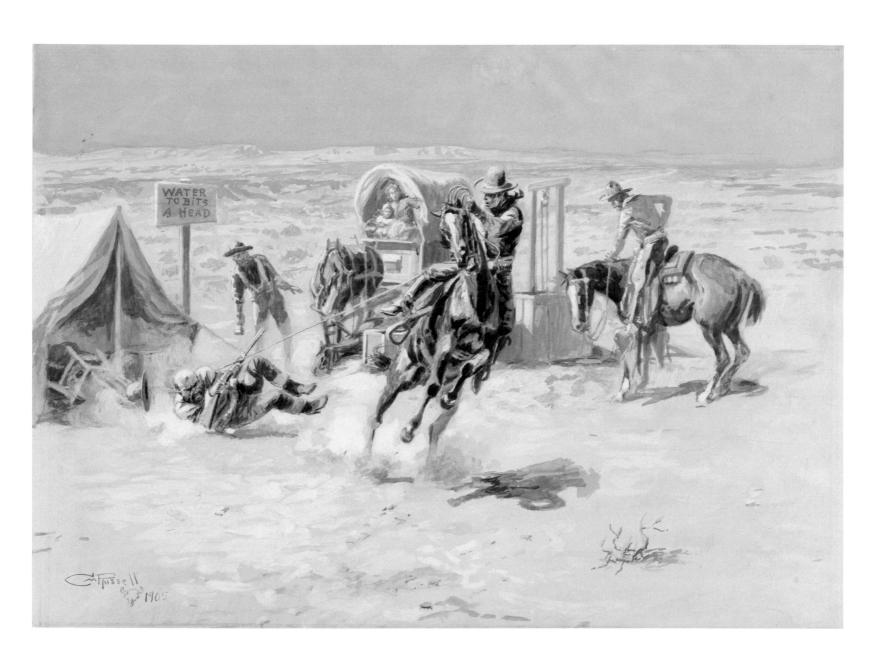

Utica [A Quiet Day in Utica]

1907 Oil on canvas 24½ x 36½" (61.3 x 91.8 cm.) Signed lower left: C M Russell / (skull) 1907

Utica was a commissioned work, which accounts for its precise detail. Charles Lehman, a Lewistown merchant, had purchased Utica's original mercantile store in 1886 and operated it in the 1890s before selling out. In 1907 it occurred to one of his sons that it would be a fine idea to have an old customer, the now nationally prominent Cowboy Artist Charles M. Russell, paint a picture that could be used on a calendar to advertise the family store in Lewistown. None of the Lehmans inquired into price before ordering what they thought would be a watercolor. When the bill came for what turned out to be an oil painting, the Lehman boys hid it from their father, assuring him the painting had cost just "a hundred smacks."2 They paid off the actual figure in installments.3

Utica shows the skills of a seasoned professional, though it also shows the strong continuities in Russell's work. Twenty years earlier he had painted Cowboy Camp during the Roundup (Amon Carter Museum, Fort Worth) on commission for another Utica businessman, saloonkeeper James R. Shelton. Its busy activity included a group in the foreground just right of center that closely anticipates the cluster of three cowboys in Utica. Every figure in both paintings was said to be identifiable. The cowboys providing the entertainment in Utica are, from the left, Bill Quigley, Bull Nose Sullivan, and, on the bucking horse, Frank Hartzell. If the picture has a contrived quality, it is because Russell wanted to create a portrait gallery for the enjoyment of the Lehmans and their customers. Charlie called the painting Tin Canning a Dog, and the culprit responsible for the prank was apparently Breathitt Gray, proprietor of the hotel and saloon just up the street from the Lehman store. He can be seen standing in front of the other spectators relishing the commotion he has caused. Charles Lehman is in the doorway of his establishment, and to his right are Millie Ringgold, a black woman prospector in the area, an oldtimer who has been identified as Jake Hoover, Russell's first mentor in Montana, and then Charlie Russell himself, leaning on the hitching post and taking everything in.4 His stance, revealing the sash he wore about his waist, is reminiscent of a photograph taken in the same period showing him outside his log cabin studio talking to John Matheson, a pioneer freighter who hauled between Great Falls and the Judith Basin for years. Indeed, Russell accompanied him on a trip to Utica to gather material for his painting.5 Though its colors run to pinks and blues, the picture holds together nicely, and precisely

Ex-collection: Newhouse Galleries, New York City; Burr McGaughen, St. Louis; Walter Lehman, Lewistown, Montana; Charles Lehman, Lewistown.

Cowboy Camp during the Roundup (C. 1887) Amon Carter Museum, Fort Worth; photograph by Linda Lorenz

because Russell introduced the contrived action, Utica is more than a painted advertisement. Even if the Greek chorus (witnessing a comedy in this case) is a bit static, Russell's critters occupying center stage are lively enough as the collie dragging a five-gallon oil can rattles the horses and scatters the chickens—as well as one hapless dude who is shown in the background abandoning ship, his derby hat flying, while the stagecoach driver struggles to control his plunging team. That tin-canned dog has caused just enough excitement to bring a little wild to the West and enliven what would otherwise be a dull day in Utica, and an even duller picture.

- I. Taurman et al., *Utica*, *Montana*, p. 10; and see p. 14 for a photograph of the Lehman store.
- 2. Walter Lehman to James B. Rankin, November 25, 1936, in the James B. Rankin Papers, Montana Historical Society, Helena.
- 3. Harold McCracken, *The Charles M. Russell Book:* The Life and Work of the Cowboy Artist, pp. 204–205.
- 4. Identifications are in Lehman to Rankin, November 25, 1936, Rankin Papers; McCracken, *The Charles M. Russell Book*, p. 95; Taurman et al., *Utica, Montana*, p. 97. For Millie Ringgold, see Kenneth W. Hay, "I Remember Old Yogo and the Weatherwax," *Montana, the Magazine of Western History* 25 (Spring 1975): 66–67 (her photograph shows that Russell's likeness was not entirely a racial caricature); for Jake Hoover, Earl L. Jensen, "Russell's First Friend in Montana," *Montana, the Magazine of Western History* 34 (Summer 1984): 24–33; and for Breathitt Gray, Taurman et al., *Utica, Montana*, pp. 53–54.
- 5. "Passing of Johnny Matheson," *Montana Newspaper Association Insert*, June 25, 1917; Lehman to Rankin, November 25, 1936, Rankin Papers.

John Matheson and Charlie Russell Helen E. and Homer E. Britzman Collection, Taylor Museum for Southwestern Studies of the Colorado Springs Fine Arts Center

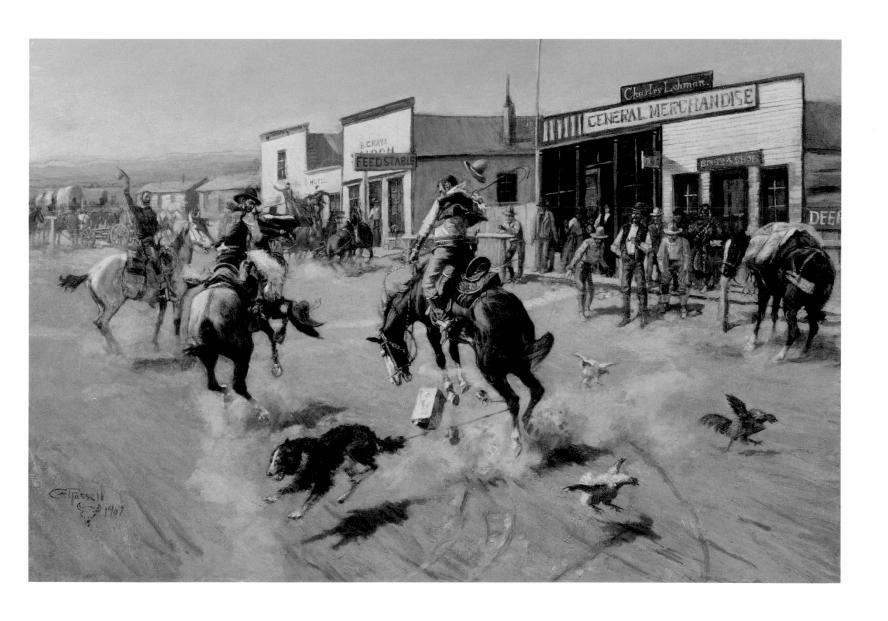

The Scout

1907 Pencil, watercolor, and gouache on paper 16¾ x 115/8" (42.6 x 29.5 cm.)

Signed lower left: C M Russell / (skull) 1907

Ex-collection: Newhouse Galleries, New York City; Mr. Heines, New York City.

Russell painted the Pawnees infrequently, but when he did he made them easily identifiable by showing the distinctive roach hair style favored by Pawnee men in the buffalo hunting days. Indeed, a writer in 1880 maintained that the tribe's name derived from the word for "horn" and referred to the scalp lock, which was "dressed to stand nearly erect or curving slightly backward, somewhat like a horn."1 George Bird Grinnell, a close student of several Western tribes—notably the Pawnee, Blackfoot, and Cheyenne—hypothesized that the Pawnees were known to their enemies as "wolves" in grudging recognition of their superior ability as scouts, or "prowlers." They cemented this reputation in the period 1864-1876 when, under the command of Frank and Luther North, they distinguished themselves as scouts in the service of the U.S. Army. Years later, Luther North recalled the appearance of a Pawnee fighting man: "On their old Nebraska reservation in 1861-62, I saw some of the great Pawnee warriors paint their horses, particularly if they were white or had white spots on them, which would make them better marks for their enemies. They would also braid the tails of their horses, and fasten colored feathers in the tails and manes. I have known them to take at least two hours to paint their faces, tie colored feathers in their scalp locks and prepare themselves and horses for a fight. That was in the tribal battles between the Sioux and Pawnees . . . "3 Russell painted many solitary warriors, mounted and poised for action, including a similar watercolor also done in 1907, Pawnee Chief (C. M. Russell Museum, Great Falls). But this fine study, bearing the less descriptive title The Scout, shows him at the top of his form.4

Pawnee Chief (1907)
C. M. Russell Museum, Great Falls, Montana

- 1. John B. Dunbar, 1880, quoted in Robert Bruce, The Fighting Norths and Pawnee Scouts: Narratives and Reminiscences of Military Service on the Old Frontier, p. 16.
- 2. George Bird Grinnell, Pawnee Hero Stories and Folk-Tales, with Notes on the Origin, Customs and Character of the Pawnee People, pp. 244–246.
- 3. L. H. North (c. 1929–1932), in Bruce, *The Fighting Norths and Pawnee Scouts*, p. 71.
- 4. The Scout appeared on the cover of Popular Magazine 9 (August 1907).

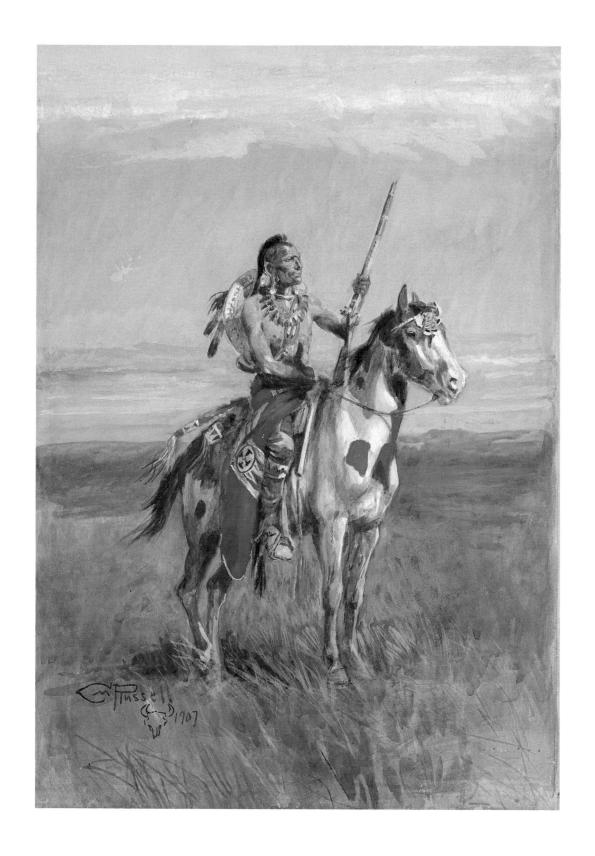

First Wagon Trail [First Wagon Tracks]

1908 Pencil, watercolor, and gouache on paper 181/4 x 27" (46.4 x 68.6 cm.)

Signed lower right: Copyright by / C M Russell (skull) 1908

Ex-collection: Newhouse Galleries, New York City; William L. Moody III, San Antonio.

1908 was a banner year for Russell. During it he painted three of his finest watercolors—York, Bronc to Breakfast, and this beautiful study, First Wagon Trail1—as well as two superb oils of Indian life, The Medicine Man (Amon Carter Museum, Fort Worth), and When Blackfeet and Sioux Meet (p. 149). The level of Russell's achievement is obvious in First Wagon Trail. The colors are warm, creating a perfect twilight mood. All the figures are meticulously painted, and every aspect of the picture exhibits a mastery of the medium and care for detail and finishing. The composition is completely satisfying, with the pronounced diagonal carried through by the wagon trail itself, and the theme an interesting one. As the West of Russell's personal experience receded into memory, he responded by going back in his imagination to an even earlier era when the Indians were in their prime and the whites were intruders on the buffalo range. "You know I have always studied the wild man from his picture side," he noted in 1918, and explained his meaning a month later when he advised a writer to "sinch your saddle on romance hes a high headed hoss with plenty of blemishes but . . . most folks like prancers."2 First Wagon Trail would be set in the 1840s, when wagon trains heading to Oregon first cut paths across the plains. Apart from the Hudson's Bay Company blanket coat draped over one saddle, these warriors show little evidence of contact with whites. Indeed, they are puzzling over the ruts and wondering what manner of beast has left the hoofprints. The squatting warrior on the left gives the sign for buffalo, but his companion, concealing his amazement behind his hand, looks dubious. The painting's theme is carried off by the other warriors trailing in from the right, each obviously absorbed in his own thoughts about what has left these strange markings on the ground. Red man and white usually regarded one another across a formidable cultural barrier. In paintings like *First Wagon Trail*, Russell chose to view things from the Indian side, where it was the whites' ways that appeared peculiar, not the Indians'.

NOTES

1. Bronc to Breakfast and First Wagon Trail were exhibited together in the window of the Como Company in Great Falls, where Russell had them framed, in

March 1908. Accurately described in the local paper as "excellent specimens of Russell's work," they were said to be "attracting a great deal of attention" ("More Work by C. M. Russell," *Great Falls Daily Tribune*, March 26, 1908). *York*, in turn, was deemed important enough for Russell to deed it in 1909 to the Historical Society of Montana, where *Bronc to Breakfast* has also found a permanent home ("Russel Donates Valuable Canvas," *Helena Daily Independent*, October 8, 1909). Russell painted other exceptional works in 1908, including the popular watercolor *A Disputed Trail* (Joseph T. O'Connor, Vancouver, British Columbia) showing an unexpected confrontation between a lone hunter and a grizzly bear.

2. Charles M. Russell to Harry Stanford, December 13, 1918, private collection; Russell to Frank B. Linderman, January 18, 1919, in Dippie, ed., *Charles M. Russell, Word Painter*, p. 269.

The Medicine Man (1908) Amon Carter Museum, Fort Worth

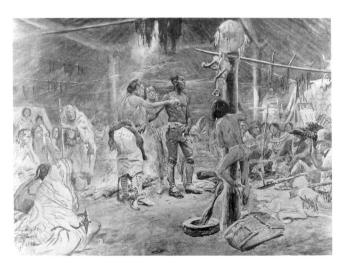

York (1908) Montana Historical Society, Helena; Gift of the Artist

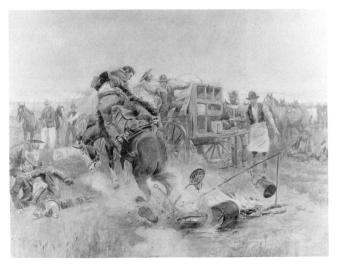

Bronc to Breakfast (1908) Montana Historical Society, Helena; Mackay Collection

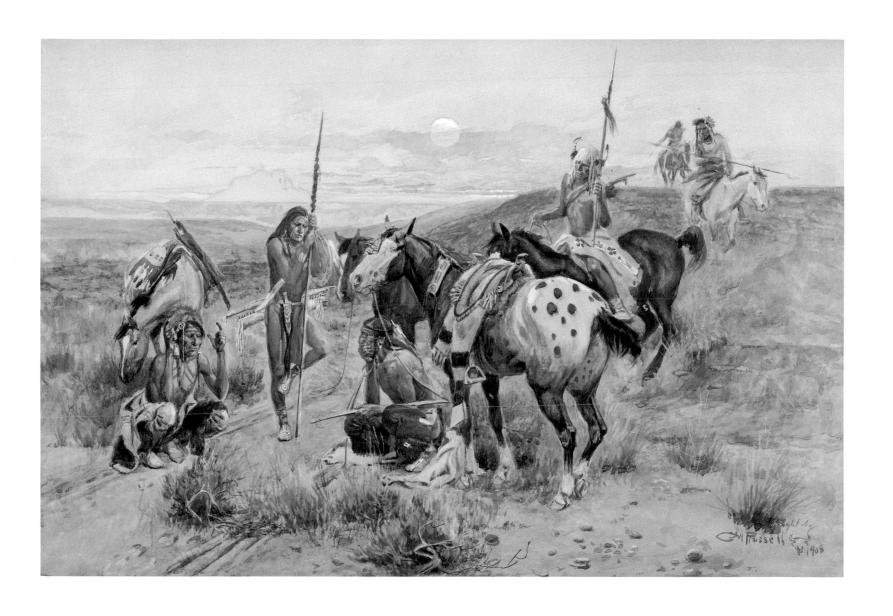

When Blackfeet and Sioux Meet

1908 Oil on canvas 20½ x 29¾" (51.1 x 75.9 cm.) Signed lower left: C M Russell / (skull) 1908

When Blackfeet and Sioux Meet is another great Russell, the summation of his work on a theme he handled often in the 1890s but rarely after executing this masterpiece in 1908, the clash of enemy tribes. In this perfectly integrated action painting he has stripped his story down to the essentials. A moment of furious fighting involving three individuals becomes in microcosm the clash between the two most feared tribes on the plains, and the whole history of war at close quarters. The outcome is uncertain as a Sioux, tomahawk upraised, attempts to intercede on behalf of his dismounted tribesman who has avoided the charging Blackfoot and now, shield raised to ward off the thrusting lance, has a chance to fire into his enemy's unprotected midriff. For the Blackfoot this is a moment of grand heroism. He has already earned a coup for striking an armed enemy with his lance, and should he ride away safely will receive high acclaim for his deed. The wounded pony resting on its haunches is an essential ingredient in this tale of war, while the red hand print slapped on its neck tells us something more: this dismounted warrior, now on the defensive and fighting for his life, has himself killed an enemy in hand-to-hand combat, perhaps by riding him down in battle.1 The tables have been turned, and he is calling upon all his martial prowess to avoid the same fate.

Ex-collection: Newhouse Galleries, New York City; T. Carson Simpson, Philadelphia; Alex. Simpson, Jr., Philadelphia; Nancy C. Russell, Pasadena, California.

Of Russell's related paintings, the one most similar to When Blackfeet and Sioux Meet is a large 1903 watercolor showing two mounted warriors dueling at full gallop. Titled Running Fight, it is also known, confusingly, as When Sioux and Blackfeet Meet (Gilcrease Museum, Tulsa). Russell's direct inspiration for his oil was his 1905 bronze Counting Coup, which explains the sculpturesque unity of the grouping and the smooth flow of the action in When Blackfeet and Sioux Meet. In the bronze the Blackfoot simultaneously fends off the mounted Sioux with his shield while thrusting at the dismounted Sioux with his lance, thus scoring a double coup. A final point of interest worth noting in When Blackfeet and Sioux Meet is the figure of the downed warrior as he both eludes and responds to his enemy's charge by twisting at the waist, his right knee bent almost to the ground, his left leg kicked out in a whirling motion. Russell worked variations on this pose in many of his action pictures. See, for example, the figure of Buffalo Bill Cody in Buffalo Bill's Duel with Yellowhand (p. 165).

NOTE

I. R. Hassrick, *The Sioux*, p. 91; Ewers, *The Horse in Blackfoot Indian Culture*, p. 100.

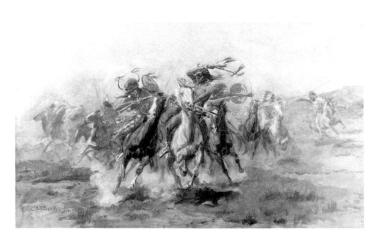

Running Fight (1903) Gilcrease Museum, Tulsa

Counting Coup (1905; bronze) Amon Carter Museum, Fort Worth

Wounded [The Wounded Buffalo]

1909 Oil on canvas 1978 x 301/8" (50.5 x 76.5 cm.) Signed lower left: C M Russell (skull) 1909; and below: Copyright by C M Russell Ex-collection: Newhouse Galleries, New York City; Peter Hasse, Philadelphia.

In one of his short stories Russell wrote of that most prized possession of the plains Indian hunter, his buffalo horse: "In them days buffalo hosses was worth plenty of robes. This animal had to be sure-footed, long-winded, an' quick as a cat. It's no bench of a hoss that'll lay alongside of a buffalo cow, while you're droppin' arrows or lead in her. He's got to be a dodger . . . 'cause a wounded cow's liable to get ringy or on the fight, an' when she does, she's mighty handy with them black horns." 1 Wounded illustrates the point. It also shows Russell's fluency in painting the subject. This is not his most elaborate buffalo hunt by any means, but the snow-patched landscape, the receding flow of the chase, the frosty bite of the air, and the action—especially the aggressive charge of the cow and the frantic leap of the horse—are all expertly portrayed. (There is also a treat tucked into the foreground—a rabbit hunkered in the grass. As Russell took more care with finish, he often added such touches to delight alert viewers; Deer in Forest [p. 163] is a good example.)

Wounded has an immediacy deriving from Russell's observation of in October 1908, and participation in the following spring, a roundup of buffalo on the Flathead Reservation in Montana. The privately owned herd had been purchased by the Canadian government and had to be corralled and shipped north by boxcar.2 Russell's stint as a rider on the roundup involved a close brush with an angry bull. "Suddenly you hear a pistol shot," an eye-witness reported, "and, turning your eyes quickly towards the middle of the field, you see Charlie Russell's pony swinging about and young Pablo [son of the herd's owner] leaning from his saddle, smoking pistol in hand, over a big bull that stands quivering as if about to fall. Charlie and Young Pablo had undertaken to head-off this bull, which was running away. Charlie must have run too close, for, as you learn later, the bull suddenly turned and charged. Had Young Pablo not been ready, having anticipated the move, Charlie's cayuse at least would have been a victim."3 Charlie remembered the incident differently. "We were on a side hill," he wrote in January 1910, "when a bull about the size of a Murphy wagon with tassels all over him an black tung out . . . charged almost getting Pebloes horse. who had bumped into mine Peblos gun slowed him up enough so we could side step the gentelman. I dont think the led hert the bull aney as him an his bunch swam the river an were runing the last we saw of them. but I tell you for a second or two my hair dident lay good."4 Whoever did what,

this recent, exhilarating exposure to the wild side of the buffalo obviously stimulated Russell's artistry, and he translated his own experience into this dramatic painting of a wounded cow defending its calf.⁵

- I. Charles M. Russell, "How Lindsay Turned Indian," in *Trails Plowed Under*, p. 142.
- 2. See John Kidder, "Montana Miracle: It Saved the Buffalo," *Montana, the Magazine of Western History* 15(Spring 1965): 52–67; for more on Russell's involvement in the roundups, see Dippie, ed., *Charles M. Russell, Word Painter*, pp. 109–116, 128–131.
- 3. Newton MacTavish, "The Last Great Round-up," Canadian Magazine 34 (November 1909): 33.
- 4. Charles M. Russell to Friend Fiddel back [Bertrand W. Sinclair], January 12, 1910, in Dippie, ed., Charles M. Russell, Word Painter, pp. 130–131.
- 5. Nancy Russell wrote a few years later: "Mr. Russell rode as one of the men [on the buffalo roundup] and in that way saw a great deal that was priceless. . . . You must know what all this meant to the artist. I think he rejoiced when outwitted by these grass-eaters . . ." ("Close View of Artist Russell," *Great Falls Daily Tribune*, March 1, 1914).

Charles M. Russell to Friend Fiddel back [Bertrand W. Sinclair], January 12, 1910 Stark Museum of Art, Orange, Texas

Maney Snows Have Fallen

(Letter from Ah-Wa-Cous [Charles M. Russell] to Short Bull)

c. 1909-1910 Pen & ink and watercolor on paper 8 x 10" (20.3 x 25.4 cm.)

Signed lower right: AH-WA-COUS (antelope skull)

Ex-collection: Anderson Galleries, New York City.

Contemporaries often remarked on Russell's Indian-like features, and he was not averse to accentuating them on occasion by dressing up in wig, feathers, and a blanket. He also impressed others as Indian-like because of the stern set of his mouth, his taciturnity when working, and his engagingly expressive storytelling style, sign language and all, when at ease. The body of his work stands as a permanent testament to his deep respect for the Indian as "the onley real American." 1 Though Russell hewed to the doctrine of live and let live and deplored reformers and moralists of every stripe, he spoke out publicly in support of Indian rights even when his position was unpopular. In his letters to his many friends he reserved for a special few the compliment that they were pure "Injun" beneath the skin, though he frequently wrote as one Indian to another, signing off with his Blood name Ah-Wa-Cous, the Antelope. When he invited an Easterner to come visit, he might depict himself as a plains Indian and his correspondent as a woodlands Indian, while a Southwesterner would appear as a Navajo.

In this letter to Short Bull, Russell has shown himself and his wife Nancy as Blackfeet extending the welcoming pipe to two Sioux visitors. It is possible that Short Bull was Jim Gabriel who, as a performer with Buffalo Bill's Wild West when Russell saw him in 1907, was "fighting Sioux every day."2 This letter and another addressed to Jim Gabriel were sold together in 1933, suggesting the possibility. But whoever Short Bull was, this much is certain: he would receive a very different reception from Mr. and Mrs. Antelope than the one portrayed in When Blackfeet and Sioux Meet.

Russell in His Indian wig, c. 1916 Photograph by A. J. Thiri Helen E. and Homer E. Britzman Collection, Taylor Museum for Southwestern Studies of the Colorado Springs Fine Arts Center

- 1. Charles M. Russell to Charles N. Pray, January 5, 1914, in Dippie, ed., Charles M. Russell, Word Painter,
- 2. Charles M. Russell to Kid Gabriel, 1909, in Good Medicine, p. 83.

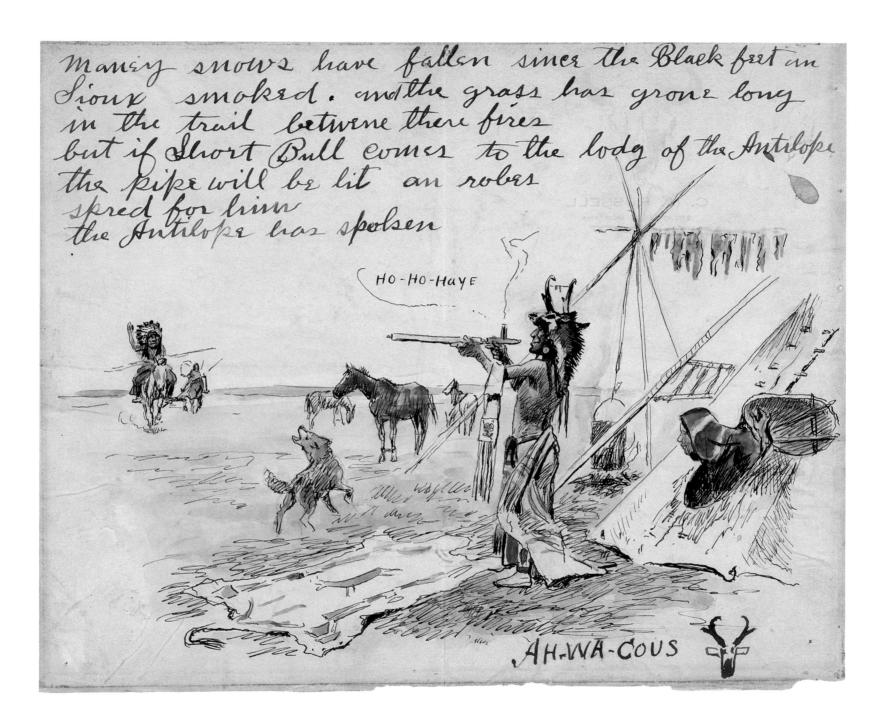

He Tripped and Fell into a Den on a Mother Bear and Her Cubs

1910 Pencil, watercolor, and gouache on paper 17 x 14" (43.2 x 35.6 cm.) Signed lower left: C M Russell / (skull) Ex-collection: Newhouse Galleries, New York City; Homer E. Britzman, Los Angeles; Gump Galleries, San Francisco (?); Treasure House Antiques (Susan E. MacGillivray), Spokane; Robert Strahorn, Boise

In 1910 Russell accepted a commission he came to regret. He agreed to illustrate Mrs. Carrie Adell Strahorn's book Fifteen Thousand Miles by Stage: A Woman's Unique Experience during Thirty Years of Path Finding and Pioneering from the Missouri to the Pacific and from Alaska to Mexico. Mrs. Strahorn's stagecoaching days with her husband qualified her as a bona fide pioneer since they stretched back to 1871. They also endowed her with an imperious manner, and in 1910 she set up camp near the Cowboy Artist's summer retreat on Lake McDonald to give him the benefit of her advice. Russell grumbled, but he also completed the sizable assignment, which involved four paintings in color, another thirteen in monochrome, and sixty-eight pen and inks.1

He Tripped and Fell into a Den on a Mother Bear and Her Cubs illustrated a story Mrs. Strahorn told at second hand about a man from Challis, Idaho, who set out one afternoon for a few hours of hunting with his dog and inadvertently stumbled into a bear's den. He was badly mauled by the protective mother before his faithful dog distracted her long enough to allow him to crawl away. At last the bear ambled off to rejoin her cubs, and the dog, in the best tradition of Lassie,

ran to town and brought back help. Russell has graphically depicted the moment when the man, both arms broken, lies helpless while his dog comes to the rescue. Bears fascinated Russell. He incorporated them in several large action paintings, sculpted them frequently, and obviously found this incident congenial enough to kindle more enthusiasm in him than most of the others he was required to illustrate for Mrs. Strahorn.²

- 1. See Austin Russell, *C.M.R.* pp. 154–155. Sometime in November 1910, Russell wrote to fellow artist Philip R. Goodwin: "I have been mighty bussy with that book of Mrs. Strayhorns but am about through." This suggests a 1910 date for *He Tripped and Fell into a Den on a Mother Bear and Her Cubs*; letter in Dippie, ed., *Charles M. Russell, Word Painter*, p. 141.
- 2. Carrie Adell Strahorn, Fifteen Thousand Miles by Stage: A Woman's Unique Experience during Thirty Years of Path Finding and Pioneering from the Missouri to the Pacific and from Alaska to Mexico, pp. 156–157.

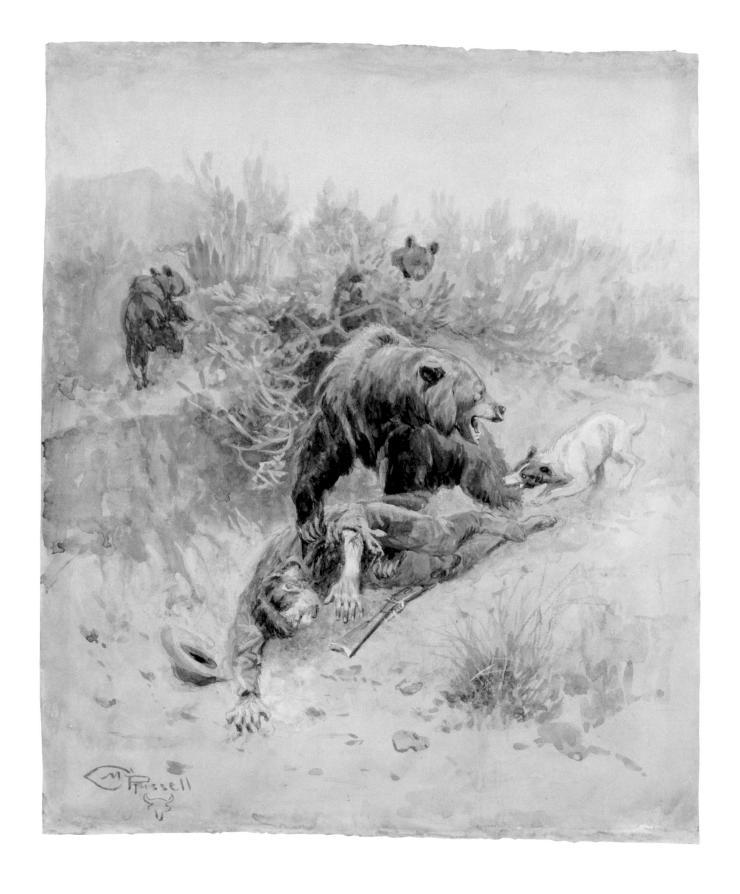

His Wealth [Braves on the March]

c. 1910 Pencil, watercolor, and gouache on paper 6¼ x 9¾" (15.9 x 23.5 cm.)

Signed lower left: C M R (skull)

Ex-collection: Provenance unknown.

Before the whites came and, to Russell's way of thinking, despoiled the land, the Western Indians lived a life that was simple, even spartan, yet rich beyond reckoning. "While the buffalo lasted, the Injuns counted their wealth in hosses," Russell observed.¹ Horse wealth varied from tribe to tribe—a rich Plains Cree might own five horses, a rich Blackfoot forty or fifty.² Another measure of status was the number of wives a man supported. Among the old-time Blackfeet it was "a very poor man" who did not claim three, George Bird Grinnell wrote in 1892. "Many had six, eight, and some more than a dozen. I have heard of one who had sixteen."³

In this quick sketch, with the self-explanatory title *His Wealth*, ⁴ Russell shows the plains warrior at his peak. Independent, fearless, and self-sufficient, he rode with the haughty dignity befitting his station as "nature's nobleman," lord and master of a vast domain that provided his every want. After his first, fumbling campaign against plains Indians in 1867, George A. Custer offered a heartfelt tribute:

The Indian, born and bred to his prairie home, accustomed to look to it for his subsistence as well as his shelter, is never at a loss for either, let him be where he may. The buffalo supplies him with food; no bread is required; his pony, like himself, a stranger to the luxuries of civilization, seeks no better food than the wild prairie grass. . . . In addition to [the pony's] transporting the lodgepoles, which one would imagine to constitute a sufficient load, there is not unfrequently added a squaw, and from one to three pappooses, depending entirely upon the extent of the family and the wealth of the paternal head, the latter being most usually estimated by the numbers of his ponies or buffalo robes. That a small, half-starved pony, supporting such an immense load, should outmatch a large American horse with a lighter burden seems improbable, yet such is the case.5

Estimated according to his needs, then, the wealth of the plains warrior portrayed by Russell was substantial indeed.

- I. Charles M. Russell, "Injuns," in *Trails Plowed Under*, p. 27.
- 2. Ewers, The Horse in Blackfoot Indian Culture, pp. 30−32.
- 3. Grinnell, Blackfoot Lodge Tales, p. 218.
- 4. His Wealth is also the title of a magisterial 1915 Russell oil; for a reproduction, see Lee Silliman, "CMR: The Cowboy on Canvas," Montana, the Magazine of Western History 21 (Winter 1971): 46.
- 5. George A. Custer letter, November 11, 1867, in Brian W. Dippie, ed., *Nomad: George A. Custer in "Turf, Field and Farm,"* pp. 28–30.

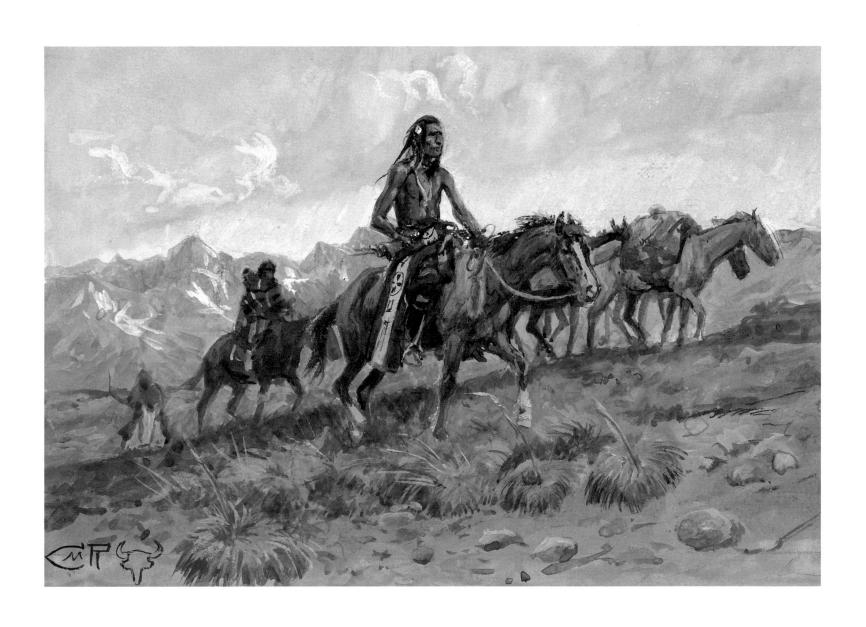

A Bad One

1912 Pencil, watercolor, and gouache on paper 19¾ x 285%" (50.2 x 72.7 cm.)

Signed lower left: C M Russell / © (skull) 1912

Ex-collection: Provenance unknown.

"An Injun once told me that bravery came from the hart not the head," Charlie Russell observed in 1916. "If my red brother is right Bronk riders and bull dogers are all hart above the wast band but its a good bet theres nothing under there hat but hair." Russell's closest friend from his rangeland days, Con Price, was the genuine article—a first-class bronc buster. Price began cowboying in 1885 and did not retire until a kick from a horse disabled him in 1943. Shortly before his death in 1958 he told a reporter a delightful tale:

Charlie exaggerated me, he painted me riding a horse lots of times, but he never did paint me getting bucked off. I was always riding 'em in Charlie's pictures.

It reminds me of a time Charlie and me was in a saloon. There was a bunch of cowboys there, all talking about what they did after a bronc made the first jump. They asked a tough looking little guy from Texas what he did after the first jump.

"Me, why I don't do nothing, unless the horse tries to step on me," the Texan said.³

Russell painted some pretty snaky broncs over the years. The one in this watercolor, despite its title, would appear to be an honest bucker, the kind that gave the buster a jolting ride without resorting to tricks. In such horizontal compositions Russell often included other figures watching the action, with the occasional infuriated camp cook waving his fist and cursing the cowboy whose bucking horse has just carried him through the campfire and the morning's breakfast. The composition of this 1912 painting is a model of sim-

plicity. The plain sky and unfenced prairie set off the solitary competition between horse and rider, lending the scene a timeless quality. It may have been painted as a gift for Sir Henry Mill Pellatt, who purchased four oils and a watercolor at the 1912 Calgary Stampede, and was presented with *The Bucking Horse*, a watercolor of the same dimensions as *A Bad One*, in gratitude for his patronage.⁴

- I. Charles M. Russell to Guy Weadick, January 28, 1916, in Dippie, ed., *Charles M. Russell, Word Painter*, p. 223.
- 2. Con Price, Memories of Old Montana and Trails I Rode; Con Price to Joe Scheuerle, December 28, 1943, photocopy in my possession; Jack O'Reilly, "Con Price, Cowboy: A Personal Tribute," Montana, the Magazine of Western History 8 (Summer 1958); 50–53.
- 3. "Con Price Missed Gathering of Cowhands, but Not in Spirit; Tells Russell Stories," *Great Falls Daily Tribune*, [c. February 1958], clipping in author's pos-
- 4. See the exchange between Nancy C. Russell and Henry M. Pellatt, November 13–December 18, 1912, in the Helen E. and Homer E. Britzman Collection, Taylor Museum for Southwestern Studies of the Colorado Springs Fine Arts Center.

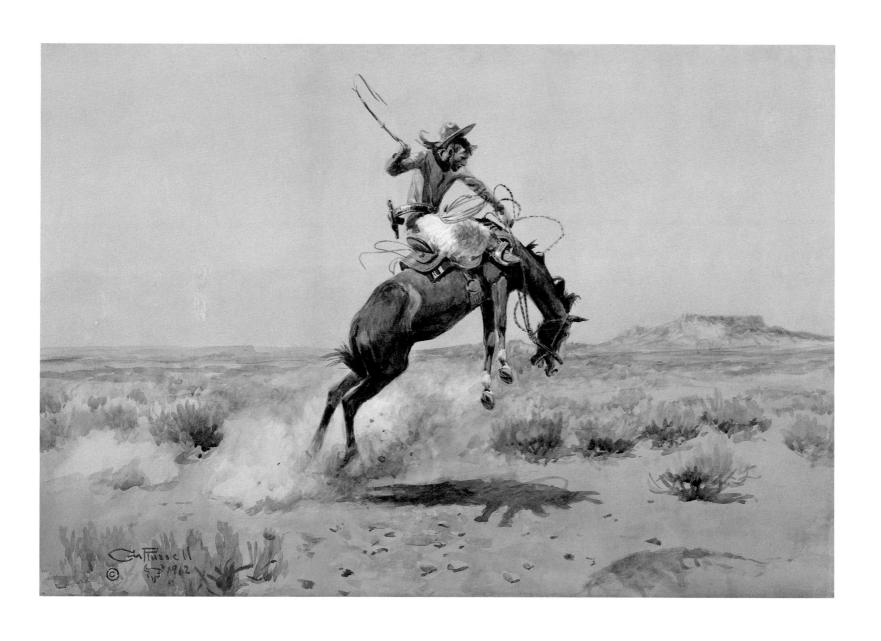

Man's Weapons Are Useless When Nature Goes Armed

[Weapons of the Weak; Two of a Kind Win]

1916 Oil on canvas 30 x 481/8" (76.2 x 122.2 cm.) Signed lower left: C M Russell / © (skull) 1916; inscription: To Howard Eaton / From His friend / C M Russell

This amusing painting was given by Russell to his good friend Howard Eaton, a pioneer dude rancher who hailed from Pittsburgh, settled near Medora in North Dakota in 1882, and then, with his dude wrangling business well established, relocated permanently on the eastern side of the Big Horn Mountains, near Wolf, Wyoming. Eaton expanded his operation to include trail rides through Glacier and Yellowstone parks and the Grand Canyon country of the Southwest, and by the time of his death in 1922 his name was synonymous with western tourism. Russell was an honored guest on several Eaton trail rides. He accompanied camping trips through Glacier in 1915 and 1916 and made a particularly memorable excursion with an Eaton party through Arizona and along the Grand Canyon in October 1916. "In the city men shake hands and call each other friends but its the lonsome places that ties their harts together and harts do not forget," Russell wrote to one of his companions on that excursion, and in gratitude presented this large oil to Eaton.1

Russell painted buffalo and bear in profusion; they were mighty symbols of the untamed West. But he also loved nature's smaller creatures, from the prairie dog to the field mouse, and, as this wry tribute suggests, had nothing but respect for the lowly skunk. Two hunters return at dusk after a day in the field to find their camp ransacked and their evening meal of pork and beans partially devoured by an invading force that they can repel only at the risk of having their nest fouled. The

Ex-collection: Newhouse Galleries, New York City; William Eaton, Wolf, Wyoming;

Mary B. Eaton, Wolf; Howard Eaton, Wolf.

extravagant scale of Russell's thank you is evident when one remembers that he made the same idea the subject of a modest sketch back in 1907, "All Who Know Me—Respect Me," for use on a postcard.

NOTE

I. Charles M. Russell to Santa Fe [Tom Conway], March 24, 1917, in Dippie, ed., Charles M. Russell, Word Painter, pp. 233-234. On Eaton, see Jerome L. Rodnitzky, "Recapturing the West: The Dude Ranch in American Life," Arizona and the West 10 (Summer 1968): 113-114. A photograph of the painting in one of Nancy Russell's albums in the Helen E. and Homer E. Britzman Collection, Taylor Museum for Southwestern Studies of the Colorado Springs Fine Arts Center, indicates that the inscription to Howard Eaton was added some time after the oil was finished, thus raising the possibility it was not intended as a gift for Eaton. Russell began the painting in 1915 and Joe De Yong admired it in his studio on June 30. It was Russell's usual method to work on several paintings at a time, going from one to another as inspiration struck (Joe De Yong to his parents, July 2, 1915, in the Joe De Yong Collection, National Cowboy Hall of Fame and Western Heritage Center).

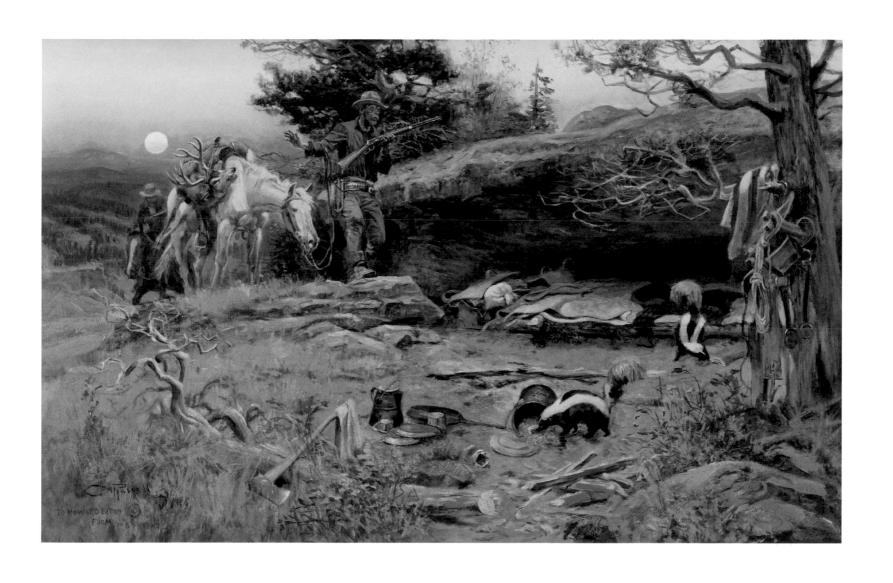

Deer in Forest [White Tailed Deer]

1917 Oil on canvasboard 14 x 97/8" (35.9 x 25.3 cm.)

Signed lower left: C M Russell / (skull) 1917

The woods around Lake McDonald, where the Russells built a cabin in 1905 and spent every summer, were magic to Charlie. He fashioned figures of moss and bark and twigs and created his own enchanted forest outside Bull Head Lodge, as their cabin was known. And always he delighted in the wildlife that abounded in the area once it became part of Glacier National Park in 1910, fulfilling his prediction that "in a fiew years . . . it will be one of the gratest game country in the west."1 The white-tailed deer in Russell's 1917 painting Deer in Forest frolic in the open, unafraid, though nature always held secrets to delight the observant—the barely visible deer just emerging from the woods on the right, for example. The partridge watching the deer leap the fallen log is clearly visible, but the rabbit hunkered down in the undergrowth below is an unexpected bonus—Russell's gift of the sort the woods yield up only to the patient looker.

Ex-collection: Newhouse Galleries, New York City; Earl C. Adams, Pasadena, California; Nancy C. Russell, Pasadena.

In many of his wildlife paintings Russell used an unfamiliar palette to convey a woodsy atmosphere—dimmer light, deeper shadow, mossy greens. Even a sunlit scene like Deer in Forest is distinctive in its coloration, and a virtually identical oil has been reproduced as Montana's Majesty.2 But this is the genuine article, with an impeccable pedigree tracing it back to Nancy Russell's collection, and with the inimitable touches—including that hunkered-down rabbit—that brand it as Charlie's own.

- 1. Charles M. Russell to Philip R. Goodwin, May 26, [1908], in Dippie, ed., Charles M. Russell, Word Painter, p. 98.
- 2. Back cover, Montana, the Magazine of Western History 10 (Spring 1960). Sid Richardson acquired Deer in Forest in 1942; since then the painting has been known as White Tailed Deer.

Buffalo Bill's Duel with Yellowhand

1917 Oil on canvas 297/s x 477/s" (75.9 x 121.6 cm.) Signed lower left: C M Russell (skull) 1917 / © *Ex-collection:* C. Bland Jamison, Los Angeles; Thomas F. Cole, Duluth, Minnesota.

As a boy, Charlie Russell's head was stuffed full of the kind of Wild West heroics personified for almost fifty years by William F. (Buffalo Bill) Cody (1846-1917). A drawing of "Bufalow Bill" stands out among the Indian and cowboy scenes Russell sketched in a notebook during his last year at school,1 and in the Judith Basin in the early 1880s he was sometimes referred to as the "Buckskin Kid" because of the Buffalo Bill-style jacket he affected. When he saw Buffalo Bill's Wild West in New York in 1907, Russell could not suppress a note of disappointment. Cody had "lost most of his hair in the London fog," Russell wrote, and while the "show was good real cow boys an Indians," authenticity had been sacrificed to audience appeal: "I learn here that punchers wore red shirts an indians go to ware strung with slay bells . . . "2

But several years after he saw his balding boyhood hero in the artificial light of Madison Square Gardens, Russell honored him in two fine oils depicting incidents in Cody's career in the 1870s at a time when he was still more plainsman than performer, Buffalo Bill's Duel with Yellowhand and Running Buffalo (1918; Gilcrease Museum, Tulsa). Russell was originally commissioned to paint a third oil showing Buffalo Bill scouting a Cheyenne camp, but his patron, Thomas F. Cole, a mining magnate with properties in Montana, may have canceled it because of Russell's refusal to make requested changes in the 1918 oil.3 Both Running Buffalo, showing Cody selecting a buffalo for the Grand Duke Alexis of Russia to kill on their hunt together in 1872,4 and Buffalo Bill's Duel with Yellowhand re-create legendary episodes in the scout's career. The duel occurred in 1876 when Cody, already an established stage performer, served as a scout with the Fifth Cavalry in the Sioux campaign that saw Custer fall on the Little Big Horn. Not only was he closely connected with the storied events of that summer's fighting, but Cody was also with the Fifth when they met a party of warlike Cheyennes on July 17 and was involved in a skirmish during which he killed a Chevenne named Yellow Hair or, as it has been erroneously rendered through the years, Yellow Hand, in an exchange of rifle shots. When Russell went to portray the scene in 1917, the year Cody died, he undoubtedly relied on the old scout's account of what had become through many tellings a personal duel between two warrior heroes:

... One of the Indians, who was handsomely decorated with all the ornaments usually worn by a war chief when engaged in a fight, sang out to me, in his own tongue:

"I know you, Pa-he-haska; if you want to fight, come ahead and fight me."

The chief was riding his horse back and forth in front of his men, as if to banter me, and I concluded to accept the challenge. I galloped towards him for fifty yards and he advanced towards me about the same distance, both of us riding at full speed, and then, when we were only about thirty yards apart, I raised my rifle and fired; his horse fell to the ground, having been killed by my bullet.

Almost at the same instant my own horse went down, he having stepped into a hole. The fall did not hurt me much, and I instantly sprang to my feet. The Indian had also recovered himself, and we were now both on foot, and not more than twenty paces apart. We fired at each other simultaneously. My usual luck did not desert me on this occasion, for his bullet missed me, while mine struck him in the breast. He reeled and fell . . .

Just so did Russell show the duel, with its grisly sequel implied by the knife riding prominently on Cody's hip. Having finished off Yellow Hair, Cody "scientifically scalped him in about five seconds" and, waving the trophy over his head, called out for the benefit of the approaching troopers, "The first scalp for Custer." 5

The Duel with Yellow Hand (engraving)
Life and Adventures of "Buffalo Bill" (Colonel
William F. Cody) (Chicago: Charles C. Thompson
Company, c. 1917)

In Buffalo Bill's Duel with Yellowhand (and, for that matter, in Running Buffalo) Russell worked closely with the illustrations in a popular edition of Cody's autobiography. The plate The Duel with Yellow Hand showed Cody and Yellow Hair in matching poses firing simultaneously. Russell retained specifics such as the men's horses, the cavalry and Indians witnessing the duel from a distance, and Cody's costume.6 He also matched the poses of the two combatants: Cody, having discharged his rifle, and Yellow Hair, reeling from the impact of Cody's bullet as he drops his stillsmoking weapon and crumples to the ground, both pivot on their right legs. This mirroring creates a unity of movement that effectively locks the two adversaries, across the dry wash separating them, in a dance of death.

- I. R. D. Warden, C M Russell Boyhood Sketchbook, p. 26.
- 2. Charles M. Russell to H. Percy Raban, May 3, 1907, in Dippie, ed., *Charles M. Russell, Word Painter*, p. 86
- 3. For the Cole commission, see Thomas F. Cole to Charles M. Russell, September 7, 1916, in the Helen E. and Homer E. Britzman Collection, Taylor Museum for Southwestern Studies of the Colorado Springs Fine Arts Center; Noyes, *In the Land of Chinook*, p. 122 (Russell was working on the "Yellow Hand" painting while Noyes interviewed him); for their disagreement, see Adams and Britzman, *Charles M. Russell, the Cowboy Artist*, pp. 279–280, 282. Russell did two other oils for Cole: *Watching for Wagons* (1917) and *Lewis and Clark Reach Shoshone Camp, Led by Sacajawea, the "Bird Woman"* (1918; also known as *Sacajawea Meeting Her People*), both in the Gilcrease Museum, Tulsa.
- 4. See Suzanne Massie, "The Grand Duke Alexis in the U.S.A.," *Gilcrease* 6 (July 1984): 1–24, for the painting and the history behind it.
- 5. Buffalo Bill (Hon. W. F. Cody), The Life of Hon. William F. Cody Known as Buffalo Bill the Famous Hunter, Scout and Guide: An Autobiography, pp. 343–344.
- 6. Buffalo Bill that day was actually wearing a Mexican-style outfit of black velvet agleam with silver buttons and ornamented with lace and scarlet piping, while the Cheyenne sported a feather bonnet that Cody took, along with his shield, weapons, and scalp. For the best accounts of the affair, see Don Russell, *The Lives and Legends of Buffalo Bill*, Chapter 17, and Paul L. Hedren, *First Scalp for Custer: The Skirmish at Warbonnet Creek*, *Nebraska*, *July 17*, 1876.

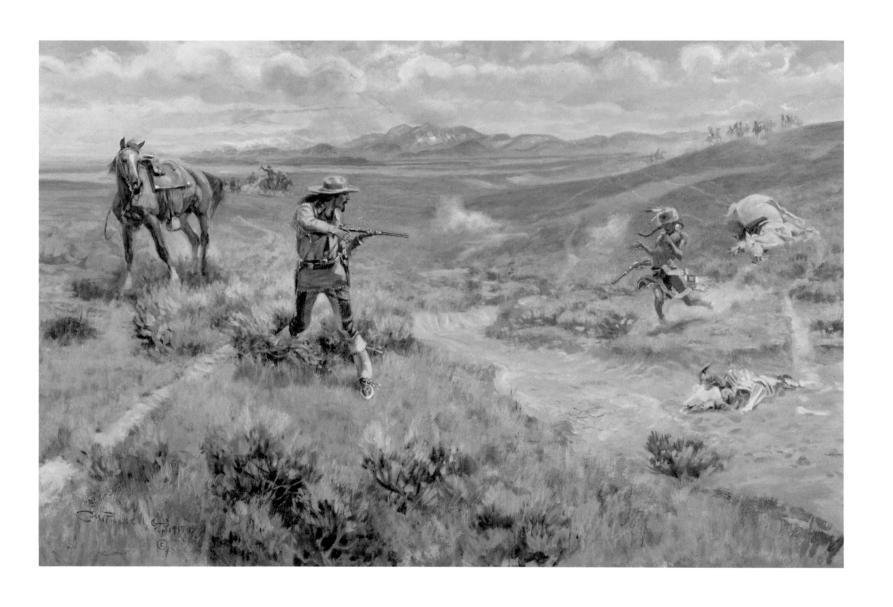

When White Men Turn Red

1922 Oil on canvas 24 x 36¹/4" (63.0 x 92.1 cm.) Signed lower left: C M Russell / (skull) ©; dated lower right: 1922

Russell's compassionate affection for the old-time Westerners left stranded by civilization's advance extended to the so-called "squawmen," objects of ridicule and contempt with the passing of the frontier period when red-white unions were common. Russell himself had felt the lure of Indian life and knew that he, like several of his cowboy friends, would have been quick to take an Indian wife had the right woman come along. In his story "How Lindsay Turned Indian" he told the tale of a fur trapper who explained his reasons for "going Indian" in these words:

In early times when white men mixed with Injuns away from their own kind, these wild women in their paint an' beads looked mighty enticin', but to stand in with a squaw you had to turn Injun. She'd ask were your relations all dead that you cut your hair? or was you afraid the enemy'd get a hold an' lift it?—at the same time givin' you the sign for raisin' the scalp. The white man, if he liked the squaw, wouldn't stand this joshin' long till he throwed the shears away, an' by the time the hair reached his shoulders he could live without salt. He ain't long forgettin' civilization. Livin' with Nature an' her people this way, he goes backwards till he's a raw man, without any flavorin'.

When White Men Turn Red, with the longhaired trapper and his wives, horses, dogs, and all trailing down from the hills to join their kinfolk camped in the valley below, could be an illustration for Russell's text.

Painted in 1922, When White Men Turn Red is the only example in the Richardson Collection of Russell's later work in oils. Its vibrant colors are Ex-collection: Newhouse Galleries, New York City; Burr McGaughen, St. Louis; Kansas City Art Institute, Missouri; Howard M. Vanderslice, Los Angeles.

typical of his palette after 1919, while the composition is the same as that of two great Russells from the same period, Salute of the Robe Trade (1920; Gilcrease Museum, Tulsa) and Men of the Open Range (1923; Montana Historical Society, Helena). Though Russell's draftsmanship remained solid till the end, his line became increasingly disjointed and tentative, while his colors ran riot.2 Why the sudden and pronounced change in his work, particularly his oils? Some critics think that his eyes and his color sense betrayed him. Russell himself expressed an interest in the vivid hues of Maxfield Parrish and may have felt at this late juncture in his career that he could experiment freely with his own color range.3 Certainly the plague of minor ailments and the serious bout of sciatic rheumatism that put him on crutches in 1923 startled him into an acute awareness of his advancing age, accompanied by an almost unbearable longing for olden times that found expression in the gaudy, flaming oils of his sunset years.

They struck the right note at the time. Good press agentry got a story planted in the *Los Angeles Sunday Times* in 1923 that told of the recent run on Russells at Earl Stendahl's downtown gallery:

Los Angeles leaped abreast of London as a purchasing center for fine paintings, . . . and went very far toward establishing itself as the art center of Western America . . .

It all began when the Prince of Wales recently purchased one of the paintings [Salute of the Robe Trade] of Charles M. Russell, noted Montana cowboy, for \$10,000.

Now H. M. Vanderslice, retired Kansas City capitalist residing in Los Angeles, and a patron of

the fine arts, came glowering into the Stendahl Art Gallery . . .

"This is a fine how d'ye do! What's the matter with us Americans? Why can't you find a Russell canvas in an American gallery? We're all a fine bunch of pikers if we let that little shrimp of a prince . . . take our most distinctive American art away from us!"

Stendahl motioned the financier to a chair and drew out of a drawer in his desk a Russell water-color, "People of the Desert." Then he smiled slily at Vanderslice.

"All right, I'll take it! Yes, price is all right—send it out today—but, d—n it, I've been trying for years to land a Russell oil! . . . you'll wire Russell tonight? . . . alright . . . "Vanderslice said he'd be back in three days.

Stendahl, knowing that Russell had painted just one picture this year, wired for it—to Santa Barbara. Five minutes after he saw it, H. M. Vanderslice became the owner of "When White Men Turn Red," one of Russell's oil masterpieces.⁴

In fact, some of Russell's patrons were not so smitten with his late-life paintings and preferred what they regarded as his earlier style.⁵ But such stories did create a welcome demand for Russell's work in his last few years.

- 1. Trails Plowed Under, p. 135.
- 2. See Dippie, Looking at Russell, pp. 120-128.
- 3. "Cowboy Artist Paints as He Talks, Lives," *Minneapolis Journal*, December 14, 1919; "'Just Kinda Natural to Draw Pictures, I Guess,' Says Cowboy Artist in Denver to Exhibit Work," *Rocky Mountain News* (Denver), November 27, 1921.
- 4. "Home Artists Appreciated," Los Angeles Sunday Times, March 18, 1923.
- 5. Malcolm S. Mackay to Nancy C. Russell, August 25, 1926, noted that "in some ways" he liked a 1907 oil "better than some of Charlie's later works where he has used a somewhat free-er brush" (Helen E. and Homer E. Britzman Collection, Taylor Museum for Southwestern Studies of the Colorado Springs Fine Arts Center).

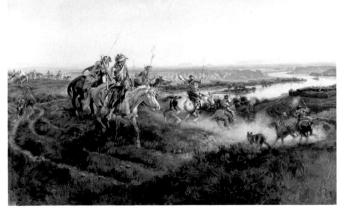

Salute of the Robe Trade (1920) Gilcrease Museum, Tulsa

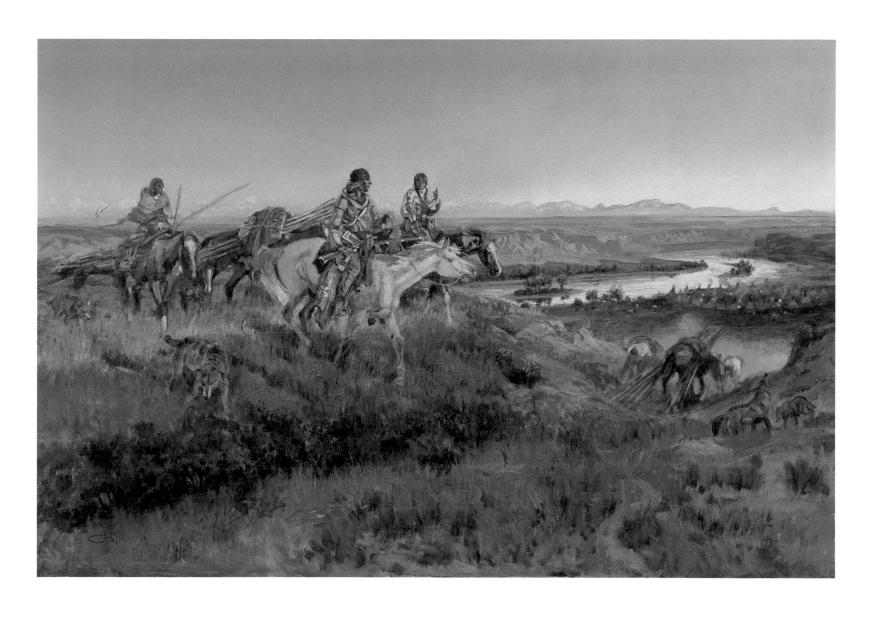

Roping

C. 1925–1926 Gouache on paper 15 x 19¹/₄" (38.1 x 48.9 cm.) Unsigned

This painting, probably done around 1925–1926, takes us back to Russell's years as a cowboy and his watercolor Roping the Renegade (p. 67) the first and the last works by Russell in the Richardson Collection. Both show a cowboy taking his "dally welts" while his partner attempts to drop a second loop on the cow. "Judgment of time and distance was half the battle in good ropin'," Ramon F. Adams has written. "Top ropers seemed to know by intuition the proper time to throw. They were experts who went 'bout the business without any fancy flourishes. In heelin' he seemed to know jes' when the loop reached the animal's feet at the split second they'd be off the ground."1 Here the roper's problems are compounded since the cow has already been caught and is struggling to pull free. But the throw is accurate and the animal is about to have its hind feet pulled out from under it. This was a nifty piece of cow work that Russell also recorded around the turn of the century in *Throwing on* the Heel Rope,2 in a pen-and-ink sketch, Work on the Roundup (1922; Amon Carter Museum, Fort Worth); and in one of his last major watercolors, When Cows Were Wild (c. 1926; Montana Historical Society, Helena).

Ex-collection: Newhouse Galleries, New York City; Earl C. Adams, Pasadena, California; Nancy C. Russell, Pasadena.

As was common in his work, Russell has "sized" the cow's head by painting around it, correcting defects in his drawing as he went along. The same kind of correction is evident even in his major oils, and testifies to his spontaneity as well as his lack of formal training.

- 1. Adams, The Old-Time Cowhand, p. 230.
- 2. Rocky Mountain Magazine I (December 1900): 221.

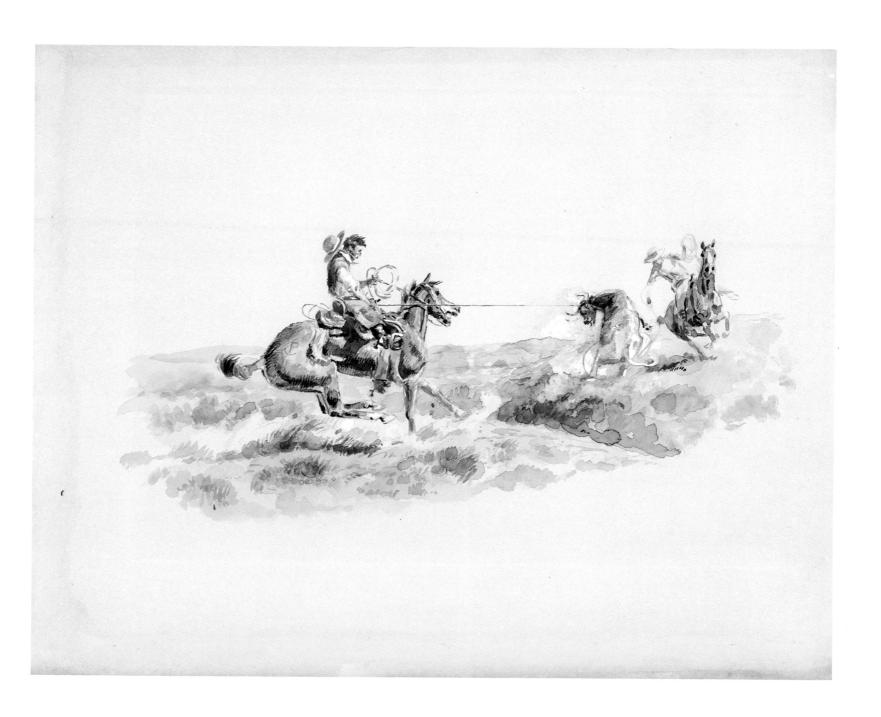

•	

OTHER WESTERN PAINTERS

Indian Encampment

C. 1880–1881 Oil on panel 127/8 x 31" (32.7 x 78.7 cm.) Signed lower right: P. Moran

Compared to his long-lived brother Thomas, one of America's foremost landscape painters, Peter Moran is positively obscure.1 The Moran family emigrated from England in 1844 and settled in Philadelphia the next year. After a brief apprenticeship as a printer, Peter followed in his brother's footsteps and turned to the study of art, eventually establishing a reputation as an accomplished etcher of animals.² Both Morans were drawn to the West, and Peter accompanied Thomas on a sketching trip to the Teton range in 1879. On his own two years later he made a tour of the pueblos in Arizona and New Mexico.3 Along with four other painters (including Gilbert Gaul, who is also represented in the Richardson Collection [p. 175]), Moran served as a special agent for the Eleventh Census in 1890. His published report on the Wind River Reservation in Wyoming was illustrated with three of his paintings. One in particular, a study of the slaughterhouse at the Shoshone agency on beef issue day, provides a striking contrast to Indian Encampment.4 The title of this painting tells us little, but its details tell much. The Indians that Moran saw in 1890 had lost all vestiges of independence and were reduced to living on government handouts. But the natives in Indian Encampment were still armed, rich in horses, and living in the traditional way, suggesting that Moran completed the painting a decade before, following his trip to the Tetons.5

Ex-collection: Newhouse Galleries, New York City; David David, Philadelphia.

- 1. Scattered information about Peter Moran can be found in three books on his brother's work: Fritiof Fryxell, ed., *Thomas Moran: Explorer in Search of Beauty;* Thurman Wilkins, *Thomas Moran: Artist of the Mountains;* and Carol Clark, *Thomas Moran: Water-colors of the American West.* Also see Rick Stewart with Don Hedgpeth, *The American West: Legendary Artists of the Frontier,* pp. 54–55; and Joseph C. Porter, *Paper Medicine Man: John Gregory Bourke and His American West,* passim.
- 2. W[illiam] H[owe] D[ownes], "Peter Moran," Dictionary of American Biography 7: 152.
- 3. Wilkins, *Thomas Moran*, pp. 123–128; and Robert Taft, *Artists and Illustrators of the Old West*, 1850–1900, p. 216.
- 4. "Report of Special Agent Peter Moran on the Indians of the Wind River Reservation, Shoshone Agency, Wyoming, July and August, 1890," in *Report on Indians Taxed and Indians Not Taxed in the United States (Except Alaska) at the Eleventh Census: 1890, H. of R. Misc. Doc. No. 340, Pt. 15*, 52 cong., 1 sess. (Washington, D.C.: Government Printing Office, 1894), pp. 629–634.
- 5. See Taft, Artists and Illustrators of the Old West, p. 366n.13.

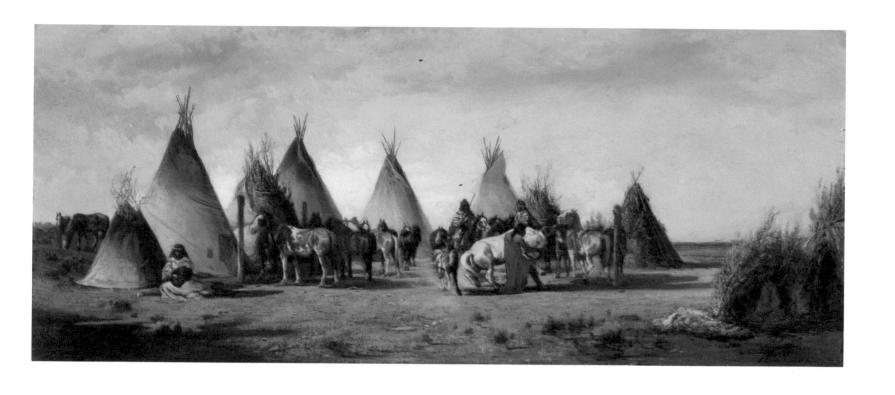

The Pow-Wow

C. 1890 Oil on canvas 18½ x 24½" (46.0 x 61.3 cm.) Signed lower right: GILBERT GAUL Ex-collection: Newhouse Galleries, New York City; Jerry Beekman, New York City.

Gilbert Gaul, a New York-based artist, was once described as "the most capable of American military painters." His reputation in his day was sufficient to earn him election as a National Academician in 1882. A busy illustrator and a friend of Frederic Remington, Gaul specialized in western subjects too. He traveled extensively, gathering impressions firsthand, and in 1890 offered an unvarnished picture of life on the Sioux reservation in the oils he prepared while serving as a special agent for the Eleventh Census. He did not dress up his Indians or show them engaged in the activities of an earlier day. Rather, exhibiting the concern for detailed accuracy characteristic of military artists, Gaul recorded exactly what he saw. "None of Mr. Gaul's pictures are 'studio' pictures," a contemporary noted. "All his sketches are made from life out on the frontier . . . Of course he does not paint his pictures out in the open; he uses a camera and a color-box, and makes his notes from life, but paints his picture in his studio . . . "2

The Pow-Wow resembles photographs taken at the Sioux agencies in the same period—John A. Anderson's picture of women hitching up a team on the Rosebud Reservation, for example.³ But what makes Gaul's oil more than a painted photograph is his distinctive, loose brushwork and his sensitivity to color effects, evident here in the treatment of the early evening light. The tone of The Pow-Wow gives it a dimension beyond the literal, making it a statement on the plains Indian in transition. "The appearance of the Indian is fast changing," Gaul observed in his report on his visit to the Standing Rock Reservation in North

Dakota in August 1890. "The day of buffalo robes and buckskins is passing away. With the Sioux breechcloths are no more. The Indian is no longer a gaily bedecked individual. Most of his furs and feathers have disappeared simultaneously with the deerskin. When he lost his picturesque buckskins he had to make his leggings of army blankets, red and blue." Most of the Sioux men that Gaul saw were dressed in military clothing and sported felt hats with a decorative feather or two and red handkerchiefs knotted about their necks. They exhibited some sartorial variety, unlike the women who were "very uniform" in dress. "Invariably the shawl is worn, which is made to answer the purpose of head covering . . . They wear loose robes to the ankles, with flowing sleeves. . . . The dresses are usually of bright colors, red being greatly worn, and of the brightest kind. . . . As ornaments they wear brass bands at the wrists, earrings, strings of beads, necklaces of calves' teeth, supposed to be of the elk, and painted porcupine quills."4 Gaul's comment on the ersatz elks' teeth necklaces makes a point expressed graphically in The Pow-Wow, where elements of the old and the new stand in uneasy juxtaposition. The tipis ("now all of canvas or muslin") with the meat (beef, not buffalo) drying on the rack contrast with the wagon, the coffee pot, the kettle, and the clothing worn by the huddled men. There is a fine feeling for the expanse of the Dakotas here, but also a sense of confinement, a realization that the horizon has permanently shrunk for the buffalo-hunting warriors of yesteryear who now listlessly wait at the agency to receive their beef rations on issue day.5

- 1. W[illiam] H[owe] D[ownes], "William Gilbert Gaul," *Dictionary of American Biography* 4: 193.
- 2. Jeannette L. Gilder, "A Painter of Soldiers," Outlook, July 2, 1898, p. 570.
- 3. See Paul Dyck, Brulé: The Sioux People of the Rosebud; Henry W. Hamilton and Jean Tyree Hamilton, The Sioux of the Rosebud: A History in Pictures; and also Richard H. Saunders, Collecting the West: The C. R. Smith Collection of Western American Art, pp. 112–113.
- 4. "Report of Special Agent Gilbert Gaul on the Indians of Standing Rock Reservation, Standing Rock Agency, Fort Yates, North Dakota, August, 1890," in Report on Indians Taxed and Indians Not Taxed in the United States (Except Alaska) at the Eleventh Census: 1890, H. of R. Misc. Doc. No. 340, Pt. 15, 52 Cong., I sess. (Washington, D.C.: Government Printing Office, 1804), p. 526.
- 5. Ibid., p. 524; and "Report of Special Agent Gilbert Gaul, on the Indians of the Cheyenne River Reservation, Cheyenne River Agency, South Dakota, July and August, 1890," in *Report on Indians Taxed and Not Taxed*, p. 585.

The Sioux of the Rosebud John A. Anderson, photographer South Dakota State Historical Society

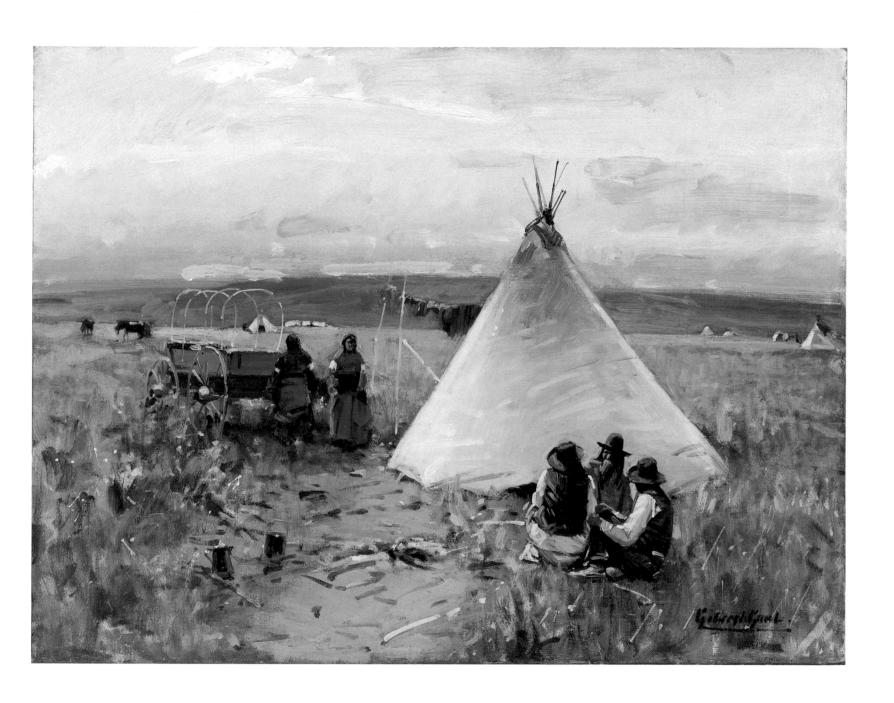

Naí-U-Chi: Chief of the Bow, Zuni 1895

1895 Oil on canvas 18½ x 12¾" (47.0 x 32.4 cm.) Signed lower left: C. F. Browne / 1895; inscription upper left: NAÍ-U-CHI / CHIEF OF THE BOW / ZUNI 1805

In the summer of 1895 three friends from Chicago writer Hamlin Garland, sculptor Hermon A. MacNeil, and his studio mate, painter Charles Francis Browne—embarked on an adventure in the West, a tour of the Indian country of Colorado, Arizona, and New Mexico.1 At Walpi on the Hopi reservation, they witnessed the snake dance—"without doubt the strangest, most weird and perhaps most ancient ceremonial dancedrama in all our American domain," according to Browne—before going on to Zuñi, "the largest native city under our flag, and . . . now, practically, what it was when the first white man saw it over three centuries ago."2 The tour "profoundly influenced" Garland's subsequent career, marking a turning point in his writing from prairie tales to stories of the high country. "In truth every page of my work thereafter was colored by the experiences of this glorious savage splendid summer," he recalled.3 MacNeil was similarly affected. Over the next decade, following his return to Chicago, he devoted himself to Indian subjects, including two much-admired sculptures inspired by the Hopi snake dance.4 While Browne also was attracted "by the strangeness, picturesqueness and real interest" of the Indians, he was least influenced by the tour.5 Landscape, not genre painting or portraiture, was his teaching specialty at the Chicago Art Institute, and it was his work in this field that earned him election as an associate in the National Academy of Design in 1913. Nevertheless, Browne did paint Indians in 1895, including this creditable likeness of the Zuñi notable Naiuchi, elder brother in the most prestigious and secretive of the Zuñi esoteric orders, the priesthood of the Bow. Naiuchi held this office until 1903, the year before his death.6

Ex-collection: Charles P. Everitt, New York City.

- 1. Lonnie E. Underhill and Daniel F. Littlefield, Jr., eds., *Hamlin Garland's Observations on the American Indian*, 1895–1905, pp. 12–18.
- 2. Charles Francis Browne, "Elbridge Ayer Burbank: A Painter of Indian Portraits," *Brush and Pencil* 3 (October 1898): 33.
- 3. Hamlin Garland, A Daughter of the Middle Border, pp. 29, 31.
- 4. Jean Stansbury Holden, "The Sculptors MacNeil," World's Work 14 (October 1907): 9408–9417; "Notes," Craftsman 16 (September 1909): 710; and J. Walker McSpadden, Famous Sculptors of America, pp. 311–317.
- 5. Browne, "Elbridge Ayer Burbank," p. 16.
- 6. Matilda Coxe Stevenson, "The Zuni Indians," in Twenty-Third Annual Report, Bureau of American Ethnology, pp. 20, 576–577. Also see Jesse Green, ed., Zuni: Selected Writings of Frank Hamilton Cushing, esp. pp. 96–98, 149–150; the illustrations include (p. 79) Henry F. Farny's 1882 portrait Chief Priest of the Bow. Taft, Artists and Illustrators of the Old West, pp. 368–369n.37, confirms that this was a likeness of Naiuchi, though a comparison between it and Browne's portrait of thirteen years later is sufficient to establish the fact. Also see Porter, Paper Medicine Man, pp. 121–123, 130, for additional information on Nayuchi (as he renders the name).

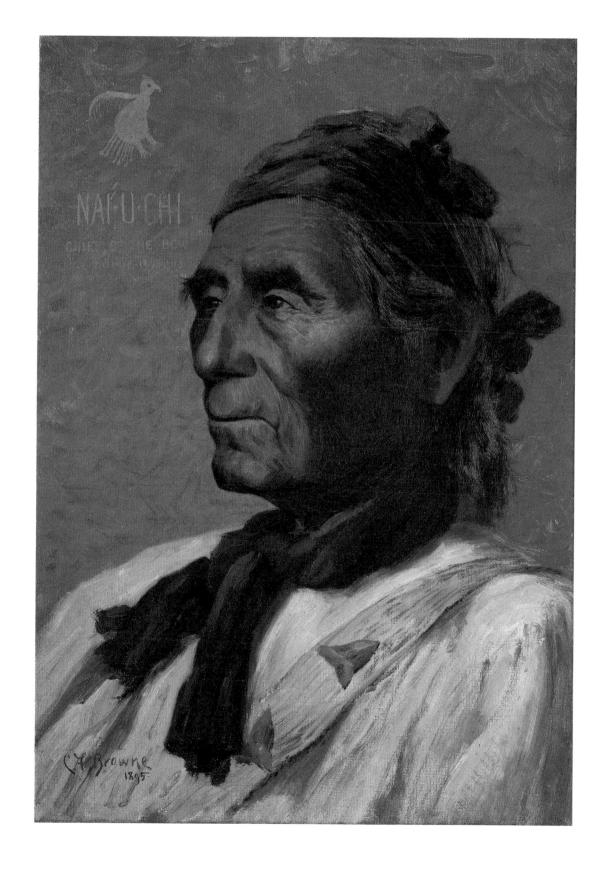

Indians [Indian Attack]

C. 1910 Oil on canvas 201/s x 281/s" (51.1 x 71.4 cm.) Signed lower left: (shield) E W DEMING *Ex-collection:* Newhouse Galleries, New York City; S. Joseph, Boston.

Edwin Willard Deming enjoyed a long, productive career as artist and illustrator. He was best known as a muralist. "I haven't a bit of that decorative feeling and must go on doing easel pictures," Frederic Remington wrote him in 1909 in a letter stating his intention to have Deming do "a panel or two" for the dining room of the Remingtons' new house in Connecticut.1 But in the same period Deming's smaller canvases were also winning recognition for their evocation of the spiritual side of Indian life.2 Raised on a homestead in Illinois, Deming had traveled extensively among the Western tribes in the late 1880s and through the 1890s before turning to a study of the Eastern tribes.3 His contemporaries thought that he had managed to penetrate the mystery of the Indian mind and could present the world through their eyes. It was a judgment that Deming happily accepted. He saw himself as the interpreter of the Indian's soul and was given to quoting Remington to the effect, "Deming, the difference between your Indians and mine is that I saw my Indians through the sights of a rifle and you saw yours from inside his blanket in his tipi."4

Indians differs from the stylized, allegorical studies, rich in folkloric elements, upon which Deming's reputation rested. As an action picture, it exhibits some of his limitations—despite formal training in New York and Paris, Deming was not always a careful draftsman, and his running horses tended to float through the air. Indians also indicates a sizable debt to Remington's great oil Ridden Down (1905; Amon Carter Museum, Fort Worth). The situations are identical. A brave, pursued by an enemy war party, can run no further. Dismounted, he braces for his last stand. Club in hand, imperturbable in the face of death,

he is the model of the stoical warrior. While Remington showed a meeting between hostile plains tribes, Deming chose to underline the clash of different Indian cultures by giving his lone warrior the roach cut usually associated with the woodland tribes, though he could be thinking of a Pawnee—see Russell's *The Scout* (p. 145).

NOTES

- 1. Frederic Remington to E. W. Deming [1907], in Therese O. Deming, comp., Edwin Willard Deming, ed. Henry Collins Walsh, p. 25; and see William Walton, "Mural Painting in This Country since 1898," Scribner's Magazine 40 (November 1906): 639.
- 2. See "Folk-lore of a Vanishing Race Preserved in the Paintings of Edwin Willard Deming—Artist-Historian of the American Indian," *Craftsman* 10 (May 1906): 150–167.
- 3. With artist DeCost Smith, Deming coauthored three articles recounting Western experiences in *Outing* 23–25 (October 1893, May 1894, February 1895): "Sketch-

ing among the Sioux," "Sketching among the Crow Indians," and "With Gun and Palette among the Redskins." Also see Deming's "Custer's Last Stand: The Indians' Version of the Massacre," *Mentor* 14 (July 1926): 56–57. His pretension to having been present when Sitting Bull was killed in 1890 was dismissed by the frontier photographer David F. Barry in letters casting doubts on Deming's reliability: Barry to Joe Scheuerle, August 12, 14, 1914, photocopies in the author's possession.

4. Quoted in Thomas G. Lamb, *Eight Bears: A Biography of E. W. Deming, 1860–1942*, p. 28. Since the same remark appeared in a piece by a journalist in the *New York Post*, one wonders if the words that Deming recalled were his rather than Remington's (see Deming, *Edwin Willard Deming*, p. 43). Either way, the description is apt. Deming also knew Russell and may have influenced his late-life allegorical sculptures *Secrets of the Night* and *The Spirit of Winter*. For their relationship, see E. W. Deming to James B. Rankin, November 2, 1936, in the James B. Rankin Papers, Montana Historical Society, Helena.

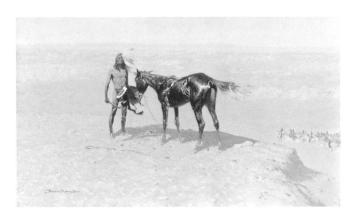

Ridden Down (1905) by Frederic Remington Amon Carter Museum, Fort Worth

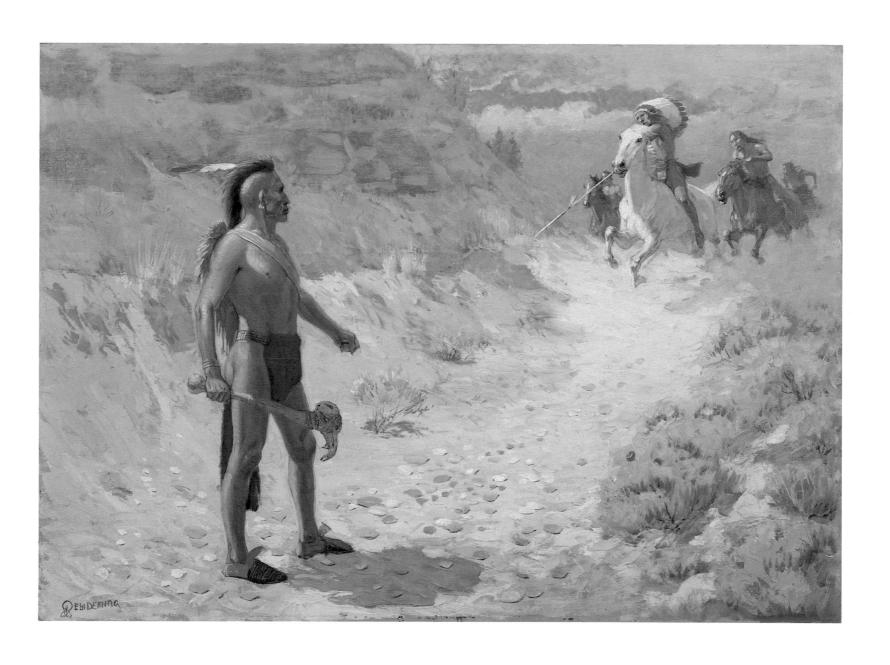

Attack on the Herd [Close Call]

c. 1907 Oil on canvas 25¹/₈ x 34¹/₄" (63.8 x 87.0 cm.) Signed lower left: Chas Schreyvogel

Charles Schreyvogel's work, apart from a scattering of portraits and a few tranquil scenes, constitutes a sustained tribute to the Wild West. In his paintings, troopers charge, Indians dodge and whoop, rifles and pistols discharge, sabres swing, bodies crash to the ground, and horses are always at full gallop. Though others—notably Rufus F. Zogbaum—portrayed the Indian-fighting army, only Schreyvogel rivaled Frederic Remington in the public's esteem, and only that duo tried to elevate the subject from illustration to art. Indeed, the introduction to a collection of Schreyvogel reproductions, My Bunkie, stressed that he "has never been an illustrator in the restricted sense of that term; that is, he has never drawn his pictures purely for reproduction in magazines and books." To Remington, immensely sensitive about his stature as a pure artist, those were fighting words. Because he thought that Schreyvogel was poaching on his turf—and in the oil that first brought him critical recognition, My Bunkie (1899), was directly stealing his ideas—he launched an attack on Schreyvogel's work in 1903 on the grounds of historical inaccuracy.2 Typically, Remington was talking about details of dress and accoutrements in a Schreyvogel cavalry scene, with the result that his criticisms seemed petty and his motive in making them mere envy. Had he not been so committed to Wild West action himself, he might more pertinently have charged Schreyvogel with misrepresenting what life in the Indianfighting army was all about, for, based on his own experience, it had precious little to do with fighting and a great deal to do with boredom and drudgery. Schreyvogel simply eliminated the greater part of reality from his work and presented an unadulterated vision of constant, violent action. His contemporaries loved it. Even as Remington was growing moody and introspective, there was Schreyvogel still doing the Wild West. William Jones accompanied Edwin W. Deming on a visit to Schreyvogel's studio in 1902 and came away impressed: "he does things western, especially where Indians and soldiers are fighting. . . . His pictures are like Remington's, only far better. This statement has reference only to the pictures in action. In atmosphere and cowboys and ponies Remington is king . . . "3 Elizabeth Custer, the General's widow, was equally

Ex-collection: Newhouse Galleries, New York City; Albert Milch, New York City; Jacob Ullrich, Hoboken, New Jersey (?).

smitten with Schreyvogel's work. "He represents action so splendidly, and he does horses that are so alive and full of spirit," she wrote William F. (Buffalo Bill) Cody. "The souls of those officers that he so admires seems to have entered into him." That was high praise indeed for a life-long Easterner.

Born, like Remington, in New York state in 1861, Schreyvogel trained in Munich (1886–1890) and lived in Hoboken, New Jersey, until his death in 1912. Beginning in 1893 he made regular visits to the West, gathering impressions and satisfying an obsession with accuracy of detail equal to Remington's own. His concern with verisimilitude has even persuaded his biographer that his work was historically realistic despite its obvious devotion to the fantasy West served up by that master showman, Buffalo Bill.5 A nice man, lacking Remington's bombastic streak, Schrevvogel won people over easily. Like Charles Russell, he made clay models of horses in action and then painted from them; it was appropriate that Schreyvogel was the one who referred Russell on an early trip to New York to the foundry responsible for some of Remington's most notable bronzes, thus helping launch the Cowboy Artist's distinguished career as a sculptor.6

Attack on the Herd is distinctive among Schreyvogel's paintings in that its white protagonist is a cowboy rather than a cavalryman. The only comparable Schreyvogel is a 1907 oil, Hard Pushed, showing a cowboy in identical costume—red shirt, chaps, and a hat with the rim rolled backtrying to elude two Indians armed with bow and spear. In other respects, Attack on the Herd is a typical Schreyvogel, isolating a few figures in a life-or-death struggle. This one combines a figure seen in side view and another charging toward the viewer, a favorite Schreyvogel motif. It is possible that Attack on the Herd was originally known as Close Call, though the present title is more descriptive. The Indians have successfully separated the cowboy from the herd, while another warrior can be seen in the background stampeding the cattle by flapping a blanket.

- I. Charles Schreyvogel, My Bunkie and Other Pictures of Western Frontier Life.
- 2. See Frederic Remington Notebook (New Rochelle), 71.812.6, Frederic Remington Art Museum, Ogdensburg, New York, entry under "Schreyvogel / Custer's Demand"; Horan, *The Life and Art of Charles Schreyvogel*, pp. 31–40; R. C. Wilson, "The Great Custer Battle of 1903," *Mankind* 5 (February 1976): 52–59; and Dippie, "Frederic Remington's West: Where History Mccts Myth," in Bruce, et al., *Myth of the West*, p. 119. Interestingly, the painting that Remington chose to attack, *Custer's Demand* (1903; Gilcrease Museum, Tulsa), was one Schreyvogel *not* concerned with an Indian-white skirmish.
- 3. Henry Milner Rideout, William Jones: Indian, Cowboy, American Scholar, and Anthropologist in the Field, p. 81.
- 4. Elizabeth B. Custer to William F. Cody, August 13, 1907, in the William C. Garlow Collection, Buffalo Bill Historical Center, Cody, Wyoming.
- 5. See Horan, *The Life and Art of Charles Schreyvogel*, pp. 40, 49–50, 56, and for Schreyvogel and Cody, pp. 46–57; and William F. Cody to R. Farrington Elwell, July 18, [1907], August 31 [1911], in the William F. Cody Collection, Buffalo Bill Historical Center, Cody, Wyoming. Cody told Elwell, an artist himself, of the interest in his show indicated by Remington and Russell as well as Schreyvogel.
- 6. "The West's Painter-Laureate," *Harper's Weekly*, November 15, 1902, p. 1668; Charles Schreyvogel calling card, in the Jack "Doe" Sahr Collection, Montana Historical Society, Helena, directing Russell to R. Bertelli.

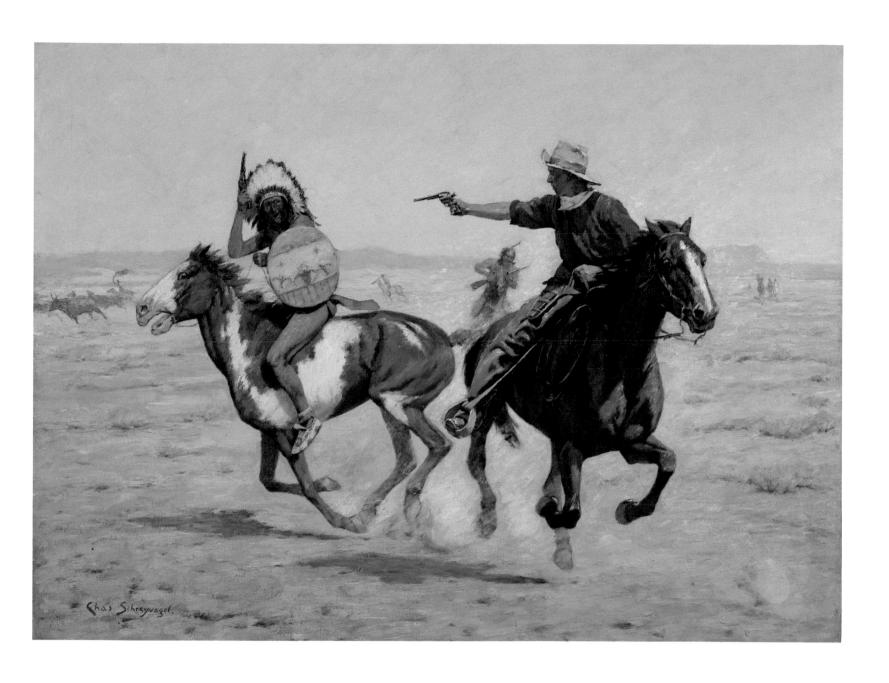

The Hold Up [The Ambush]

1903 Oil on canvas 32¾ x 22¾" (83.2 x 57.8 cm.) Signed lower right: W. R. LEIGH / 1903;

Of the painters who gained fame as delineators of the American West around the turn of the century, William Robinson Leigh is routinely cited as the most thoroughly trained.1 A native of West Virginia, he spent fifteen years studying drawing, painting, and composition in Baltimore and Munich and apprenticing as a mural painter before establishing himself as an artist and illustrator in New York City in 1896. A decade later, fulfilling "a desire that has been in me since boyhood," Leigh went west and fell in love with the desert country.2 "I saw Acoma and the Grand Canyon," he recalled years later. "I knew that some of the most distinctive—characteristic—dramatic poetic-unique motives in the world were here in this virgin country waiting an adequate hand to do them justice."3 Leigh never doubted that his was the hand adequate to the task, and while he would venture into other areas over the next halfcentury, he was primarily a Western artist. A crusty, opinionated man, he occasionally painted allegorical pieces intended to embody his views. They were, with few exceptions, disasters. For all his technical sophistication, Leigh displayed a pedestrian imagination and abysmal taste in his allegories, and they principally serve to foster a renewed appreciation for less pretentious, more successful Western oils like The Hold Up.4

inscription lower left: Copyright 1904 / By Am. Litho Co. N.Y.

Ex-collection: Newhouse Galleries, New York City; Karl Loevenich.

- I. Remington was proud to say that he was a dropout from Yale's School of Fine Arts, while Russell may have enrolled in a St. Louis art school but stayed only long enough to realize he could learn nothing drawing from a plaster cast of a foot.
- 2. Mentor, June 15, 1915, notes on the back of plate 6, An Argument with the Sheriff by William R. Leigh.
- 3. W. R. Leigh, "My America," *Arizona Highways* 24 (February 1948): 25.
- 4. Examples of Leigh's allegorical work are reproduced in June DuBois, W. R. Leigh: The Definitive Illustrated Biography, and D. Duane Cummins, William Robinson Leigh: Western Artist. Cummins provides a more critical, searching treatment of Leigh's views, but neither biographer comments extensively on artistic merit.

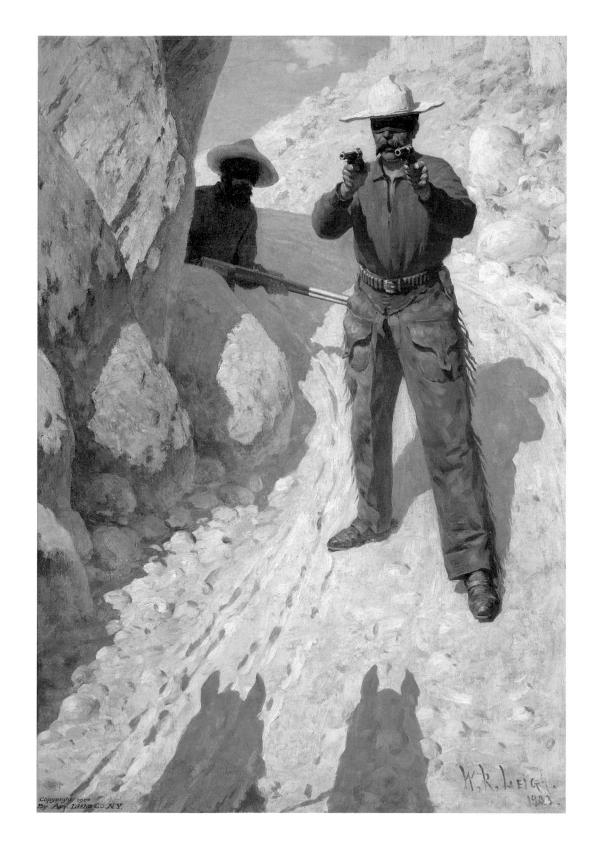

Bears in the Path [Surprise]

1904 Oil on canvas 21½ x 33½" (53.7 x 84.2 cm.) Signed lower left: W. R. LEIGH / 1904 Ex-collection: Newhouse Galleries, New York City; Karl Loevenich.

In preparing for a major painting, Leigh worked out each compositional element separately in meticulous drawings. Then he laboriously transferred them to canvas to produce finished works short on spontaneity but notable for their polish, vibrant colors, and aura of make-believe. Leigh never permitted factual considerations to dim "the sunlight and thrill of the glorious West." But he bristled at the charge that his Western paintings were merely gaudy illustrations, and he waged a passionate war against what he deemed the scandal of modern art without ever recognizing that his own old-fashioned approach clashed with the subject matter of many of his oils, particularly the astonishing action scenes he executed in his seventies and eighties in which he sent men and horses flying about the canvas with little regard for probability but with an unflagging sense of the dramatic.

Bears in the Path, like The Hold Up, is interesting as a Western subject done before Leigh ever saw the West of his childhood dreams. Both paintings capture moments of suspense, anticipating rather than showing the violence that might momentarily occur. And both confront the viewer face on. In The Hold Up an outlaw costumed in a red shirt, chaps, white hat, and an unlikely Lone Ranger-style mask trains his revolvers on the stagecoach indicated by the shadows cast by the horses. The viewer's angle of vision is that of the driver. In Bears in the Path, Leigh depicts another confrontation much favored by Western painters—Russell did several—though none took more pride in his rendering of bears than Leigh, who painted them often and was not about to leave them to the viewer's imagination here. Like the bandit, the surprised man stands with left leg extended, his weight planted on the right, poised for swift action, another study in suspense. Since he is also decked out in a red shirt

and chaps, it would appear that these were props in Leigh's New York studio. Of course, it is just as likely that Leigh had been doing research at Buffalo Bill's Wild West and had reached the same conclusions as Schreyvogel about what the average westerner wore. Charlie Russell remarked on the omnipresent red cowboy shirts when he attended a performance of Buffalo Bill's show in 1907,² and his friend Philip R. Goodwin (1882-1935), a gifted wildlife and outdoor illustrator, told him in 1920: "If you see any works of mine with red shirted cow boys don't blame me. it is as the man who pays for it would have it. some of them won't give me an order unless I make a red shirt and yellow sky."3 Once established, the convention was inescapable!

- I. W. R. Leigh, "My America," *Arizona Highways* 24 (February 1948): 26.
- 2. See the commentary with Russell's *Buffalo Bill's Duel with Yellowhand*, p. 164.
- 3. Philip R. Goodwin to Charles M. Russell, May 25, 1920, in the Earl Adams Inventory, Buffalo Bill Historical Center, Cody, Wyoming.

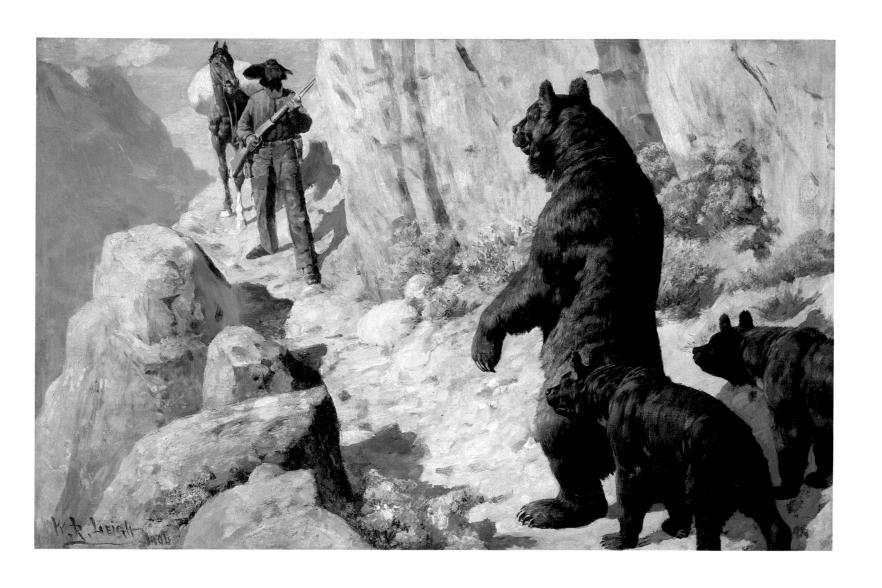

Trouble on the Pony Express

C. 1910–1920 Oil on canvas 36½ x 28½" (92.1 x 71.8 cm.)

Signed lower left: Frank Tenney Johnson

Frank Tenney Johnson was born in 1874 on a farm in Iowa. Later press accounts described it as a "cattle ranch" and told how as a boy he watched "the last of the 'prairie schooners' lurch and rumble" westward—a distortion not unlike that which turned Remington's brief stint as a Kansas sheepman into an adventurous career as a freeroaming cowboy.1 The Johnsons moved to Milwaukee in 1888, and Frank studied art there and in New York City until 1904, when he realized his youthful ambition to see the far West. Five months in Colorado, Wyoming, and the desert Southwest filled his reference files with oil sketches and hundreds of photographs of the subjects that would preoccupy him—cowboys, Mexicans, and Southwestern Indians. (Predictably, press accounts had him spending "most of his summers" in Colorado, "where he rode with the 'Lazy Seven' cattle outfit."2) Subsequent excursions expanded Johnson's repertoire. In 1912, for example, he joined Charles Russell on a sketching expedition to the Blackfoot Reservation east of Glacier National Park in Montana, and fondly recalled camping with him "in Joe Kipp's buffalo-skin tepee . . . We sketched Indians together . . . Charley was sure a white Indian, and every one liked him." (Nancy Russell was another matter. Johnson remembered her coolness—she did not cotton to competitors—but Charlie "liked my work and said so emphatically."3 At the time, Russell's most vivid impression of Johnson was of his eagerness to gather Indian souvenirs for his studio collection.4) Ex-collection: Newhouse Galleries, New York City; B. C. Claes, New York City.

Johnson's considerable reputation was based on his fluid, painterly oils and his dramatic use of color. He favored nocturnes and sun-splashed scenes capturing the light early in the morning and late in the day when shadows and warm orange tones soften the floodlit clarity of mid-day.

- I. "F. T. Johnson, Noted Painter of West, Dies," Los Angeles Times, undated clipping (January 1939), in the Helen E. and Homer E. Britzman Collection, Taylor Museum for Southwestern Studies of the Colorado Springs Fine Arts Center; also, Babcock Galleries, "Paintings of the West," El Palacio 8 (July 1920): 237.
- 2. "F. T. Johnson, Noted Painter of West, Dies" (1939).
- 3. Frank Tenney Johnson to James B. Rankin, November 19, 1936, in the James B. Rankin Papers, Montana Historical Society, Helena.
- 4. Charles M. Russell to Joe Scheuerle, August 11, 1912, in *Good Medicine*, p. 55.

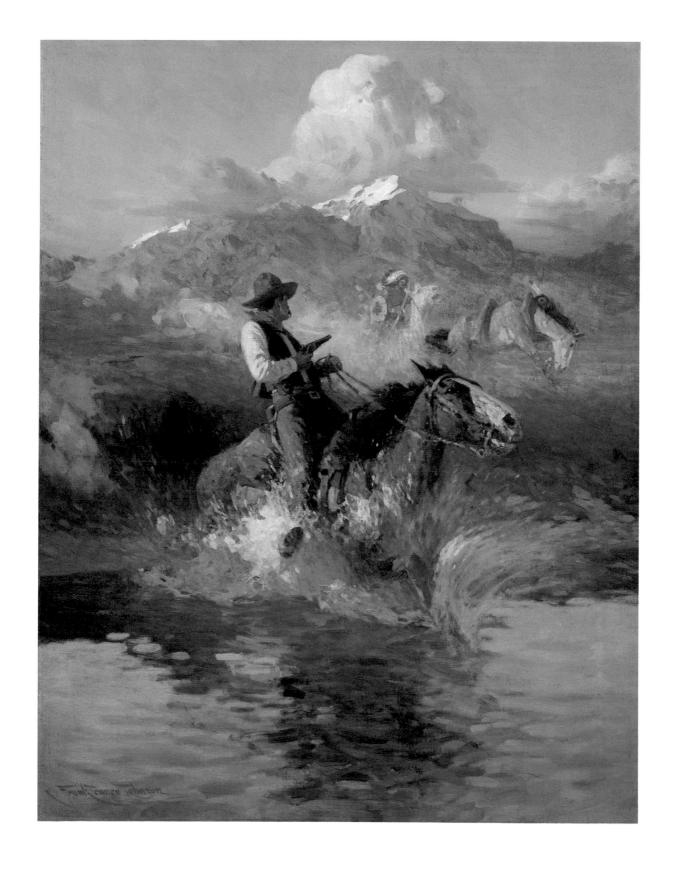

Contrabandista a la Frontera

1925 Oil on canvas 361/8 x 451/8" (91.7 x 114.6 cm.)

Signed lower right: F. Tenney Johnson—1925

Ex-collection: Provenance unknown.

Contrabandista a la Frontera and Trouble on the Pony Express are unusual in portraying gunfire—a point made by Johnson's biographer1 but representative in showing his two favorite color schemes. They suggest why Johnson's reputation as a pure painter—that is, to adopt the terminology of the times, as an artist rather than an illustrator—was sufficiently elevated to secure his election as an associate in the National Academy of Design in 1929 and as a full member eight years later, a distinction conferred upon only three other artists represented in the Richardson collection, Gilbert Gaul, William R. Leigh, and Peter Hurd. Nevertheless, Johnson's paintings, individually so striking, collectively exhibit limitations. There is a vague, generalized quality to his work—too much striving after a few patented effects, too many scenes with clouds piled column high over the central figure, too many night scenes of a solitary cowboy, head bent, hands cupped, lighting up a cigarette. All Western artists repeat themes and figures, but the best do not copy themselves. In this respect, Johnson is kin to another, much-admired Western painter, Henry F. Farny (1847-1916); both seemed better before their works were brought together between two covers, where the redundancies become glaringly

apparent. The figure on the left of Contrabandista a la Frontera, for example, is lifted straight out of Johnson's 1924 oil Cattle Rustlers.2 Many of Johnson's paintings also indicate a deep, unacknowledged debt to Remington. The composition of Contrabandista a la Frontera is reminiscent of Remington's great oil Fired On (1908; see p. 58), while the figure on the right could have ridden straight out of Remington's painting The Scout (1902). Similarly, the rider in Trouble on the Pony Express seems to have stolen his costume and pose from the foreground figure in Remington's His Last Stand (p. 27), while the color scheme owes much to the work of one of Johnson's first instructors in Milwaukee, Richard Lorenz (1858-1915).

Sid W. Richardson owned four Frank Tenney Johnson oils at one time but traded two of them for William R. Leigh's *The Hold Up* and *Bears in the Path*.

- I. Harold McCracken, *The Frank Tenney Johnson Book: A Master Painter of the Old West*, p. 12.
- 2. Ibid., p. 125.

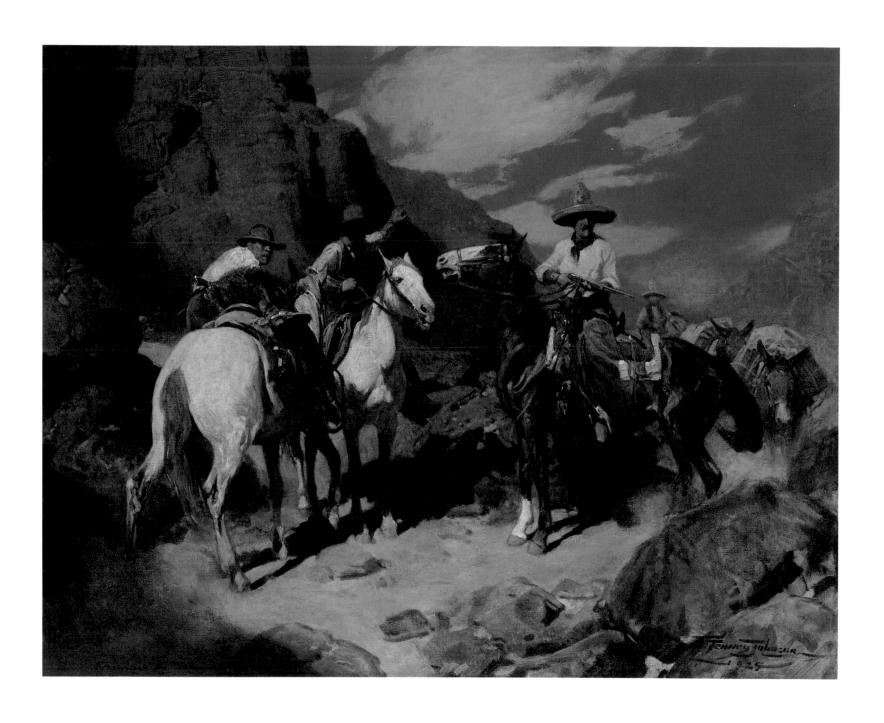

The Forty-niners

Before 1942 Oil on canvas 26¹/₄ x 36¹/₄" (66.7 x 92.1 cm.) Signed lower left: O E BERNINGHAUS

Oscar E. Berninghaus is the only member of the famous Taos artists' colony represented in the Sid Richardson Collection of Western Art. St. Louis born and raised, Berninghaus was an established commercial artist when he visited New Mexico in 1899 and became "infected with the Taos germ." 1 He established a pattern: winters in St. Louis, summers in Taos, and though a charter member of the Taos Society of Artists (1912), he did not move permanently to Taos until 1925. A generous, popular man, Berninghaus was also a diligent professional. "Painting," his biographer notes, "was his life—his business—his reason for being."2 He exhibited regularly, won major prizes, held office in such organizations as the Society of Western Artists (serving as secretary during one year of Charles F. Browne's presidential term³), and in 1926 was elected an associate of the National Academy of Design.

Like such Taos friends as Ernest L. Blumenschein and Victor Higgins, Berninghaus is known for his strong sense of place. He painted many Indian subjects, giving them the full Taos treatment, but also works in which horses and humans were reduced to inconspicuous elements in the spectacular mountainous landscape that lured painters to northern New Mexico.4 In addition, Berninghaus painted Western historical picturesnotably five murals for the Missouri State Capitol at Jefferson City⁵ and a series of oils for the Anheuser-Busch Brewing Company of St. Louis on the theme of early western transportation. (He also painted an advertisement showing a packtrain carrying a precious cargo—beer.) 6 The Fortyniners, in subject matter and style, forms part of this less familiar body of his work. The conjunction of stagecoach, covered wagons, and prospectors west of the Sierra Nevada range give it an allegorical quality. It is an unapologetic tribute to

Ex-collection: Newhouse Galleries, New York City; John Levy, New York City.

Anglo pioneering and a celebration of civilization's advance westward. Similarities in composition to a painting done on commission for the De Lore Baryta Company in 1920 suggest a date for *The Forty-niners* as early as the 1920s, though both treatment and theme also resemble an oil of a stagecoach passing through the Missouri Hills that Berninghaus painted in 1938. What is certain is that it was done before 1942, when Sid Richardson acquired it as one of his very first Western paintings.

- I. Oscar E. Berninghaus letter, April 12, 1950, in Laura M. Bickerstaff, *Pioneer Artists of Taos*, p. 9.
- 2. Gordon E. Sanders, Oscar E. Berninghaus, Taos, New Mexico: Master Painter of American Indians and the Frontier West, p. 1.
- 3. Seventeenth Annual Exhibition of The Society of Western Artists, December 11 to December 29, 1912 (Chicago: Art Institute of Chicago, 1912).
- 4. For a representative sampling of Berninghaus's work, see Mary Carroll Nelson, "Oscar E. Berninghaus: Modesty and Expertise," *American Artist* 42 (January 1978): 42–47; for an intelligent appraisal of his artistry, see Van Deren Coke, *Taos and Santa Fe: The Artist's Environment*, 1882–1942, p. 18; for his art in context, Charles C. Eldredge, Julie Schimmel, and William H. Truettner, *Art in New Mexico*, 1900–1945: *Paths to Taos and Santa Fe*; and for a biography with a large selection of his work, Sanders, *Oscar E. Berninghaus*, *Taos, New Mexico*.
- 5. Sanders, Oscar E. Berninghaus, Taos, New Mexico, pp. 40–45.
- 6. Roland Krebs and Percy J. Orthwein, *Making Friends Is Our Business: 100 Years of Anheuser-Busch*, pp. 337, 341–342; and Sanders, *Oscar E. Berninghaus*, *Taos, New Mexico*, pp. 27–28.
- 7. See Sanders, Oscar E. Berninghaus, Taos, New Mexico, pp. 38, 92.

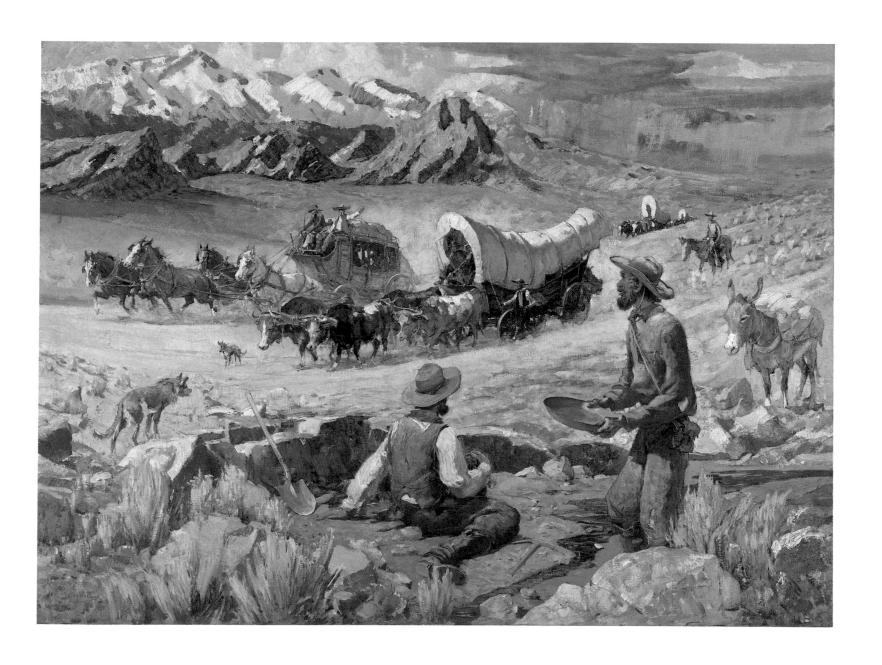

Ten Indian Studies

cut and patterned shirt.

C. 1930 Watercolor and gouache on paper Each 1778 x 12½" (45.8 x 32.1 cm.) Each signed lower left: H M HERGET (except Seminole and Siksika, signed lower right)

These ten brightly colored Indian studies in sometimes borrowed poses (George Catlin, Carl Wimar, and N. C. Wyeth deserve a nod of thanks) were probably intended for classroom use to illustrate variety in tribal costume. All the Indian types represented are Western save for the Seminole from Florida, though the Apache man looks like an Eastern woodland Indian with his roach

The artist, Herbert M. Herget of St. Louis, painted detailed, ethnologically sophisticated illustrations of life in the Ancient and New World civilizations for the National Geographic Society in the 1930s and 1940s. Little is known about him apart from his work. His series on the Mayas, Aztecs, and Incas appeared in the National Geographic Magazine between 1935 and 1938, and included individual studies of priests, warriors, artisans, laborers, and rulers rendered in the same linear style as this set of North American types acquired by Sid Richardson in 1943.

NOTE

I. Mary B. Palmer, Research Correspondence, National Geographic Society, to the author, August 15, 1980.

Ex-collection: Newhouse Galleries, New York City; Burr McGaughen, St. Louis.

APACHE ARAPAHOE

ASSINIBOINE CHEYENNE

194

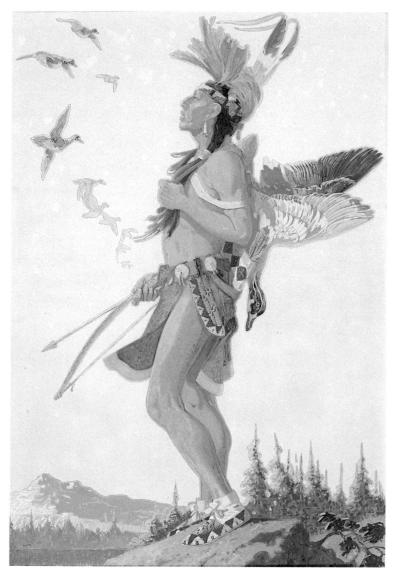

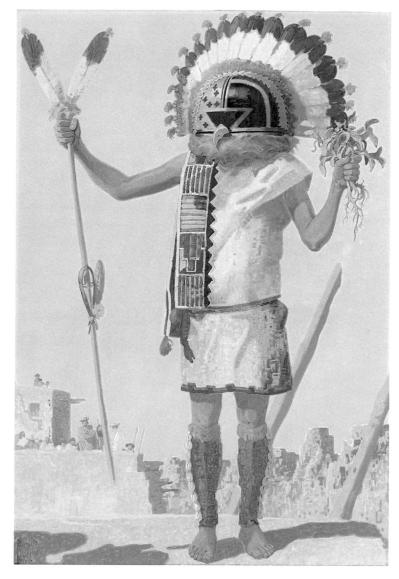

CROW HOPI

195

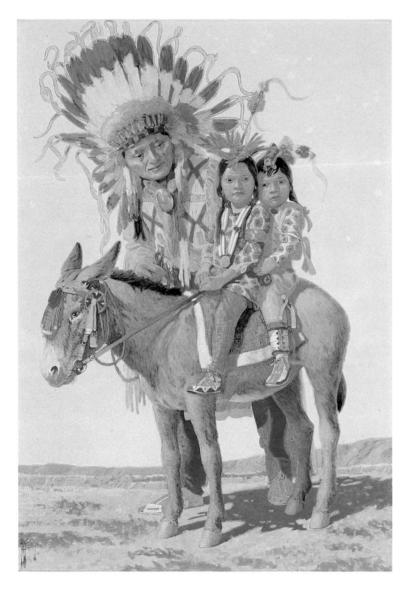

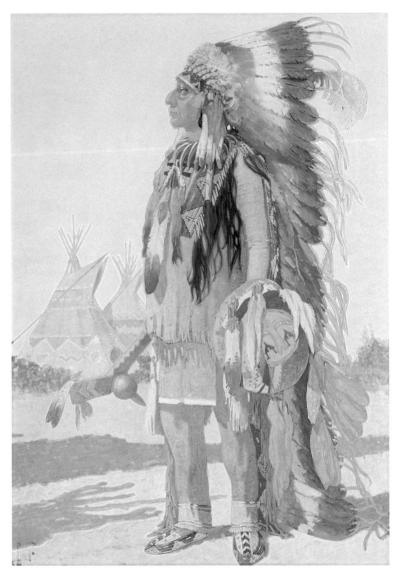

OGALALLA SIOUX PONKA

SEMINOLE

SIKSIKA [BLACKFOOT]

Portrait of Sid Richardson

1958 Oil on panel 32 x 48" (81.3 x 121.9 cm.) Signed lower left: PETER HURD

Peter Hurd, a native of New Mexico, ventured from his home state in 1921 to attend West Point but resigned to study art instead. In 1924 he became a pupil of the renowned illustrator N. C. Wyeth at Chadds Ford, Pennsylvania, and five years later a member of the Wyeth family circle when he married his mentor's daughter Henriette. The Hurds, both artists, lived on at Chadds Ford until 1939, then settled in New Mexico, where Peter Hurd earned distinction as one of the outstanding painters of the Southwest. Though his watercolors and etchings are much admired, his reputation rests on his work in egg tempera, an exacting medium perfectly suited to his tight, precise brushstroking since it allows his heavily reworked surface to retain an airy glow. While best known for his spare, evocative studies of the light, the landscape, the people, and the quiet charm of his native state, Hurd was also an accomplished portraitist.1

This painting of Sid W. Richardson was executed in 1958, in Palm Springs, though the carefully wrought background shows the palm trees of San José Island, off Rockport, Texas.² The herds of cattle and horses tell us something about the subject—who this man is—while the likeness speaks volumes about character. Hurd considered Richardson "an old friend" and described him as both colorful and amusing.³ His affectionate likeness also reveals a man of substance and vision. At sixty-seven, Richardson sits, self-assured and comfortable. His warmth comes through, though there is a pensive quality to this portrait made the year before he died.

- 1. For a brief overview of Hurd's career, see Susan E. Myer, "Peter Hurd," *American Artist* 39 (February 1975): 46–51, 100, 104; for Hurd and the Wyeth family circle, see Henry C. Pitz, "N. C. Wyeth," *American Heritage* 16 (October 1965): 52–54; for a personal statement on Hurd's relationship to New Mexico, see his "A Southwestern Heritage," *Arizona Highways* 29 (November 1953): 14–27; for a biography written by a friend, see Paul Horgan, *Peter Hurd: A Portrait Sketch from Life*.
- 2. Although San José was the name given to this island by the Spanish, it was long known as St. Joseph Island. In 1973 the Texas Legislature restored the original name.
- 3. Peter Hurd to Ann Wyeth McCoy, March 14, 1958, in Robert Metzger, ed., My Land Is the Southwest: Peter Hurd Letters and Journals, p. 380.

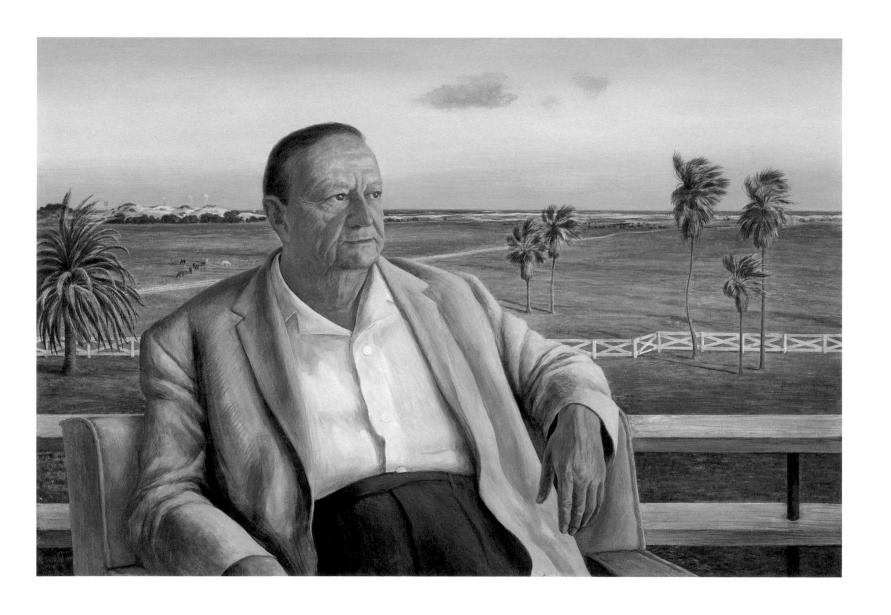

SELECTED BIBLIOGRAPHY

- Abbott, E. C., and Helena Huntington Smith. We Pointed Them North: Recollections of a Cowpuncher. Norman: University of Oklahoma Press, 1955; reprint of 1939 edition.
- Adams, Ramon F. *The Old-time Cowhand.* New York: Macmillan, 1961.
- ———, and Homer E. Britzman. *Charles M. Russell, the Cowboy Artist: A Biography.* Pasadena, Calif.: Trail's End Publishing Co., 1948.
- Ahenakew, Edward. *Voices of the Plains Cree*. Edited by Ruth M. Buck. Toronto: McClelland and Stewart, 1973.
- Allen, William A. Adventures with Indians and Game; or, Twenty Years in the Rocky Mountains. Chicago: A. W. Bowen & Co., 1903.
- Back, George. *Narrative of the Arctic Land Expedition* . . . London: John Murray, 1836.
- Ballinger, James K. Frederic Remington. New York: Harry N. Abrams, in association with the National Museum of American Art, Smithsonian Institution, Washington, D.C., 1989.
- ——. Frederic Remington's Southwest. Phoenix: Phoenix Art Museum, 1992.
- Beacom, John H. How the Buffalo Lost His Crown. New York: Forest and Stream Publishing Co., 1894.
- Bickerstaff, Laura M. *Pioneer Artists of Taos.* Denver: Sage Books, 1955.
- Bold, Christine. Selling the Wild West: Popular Western Fiction, 1860–1960. Bloomington: Indiana University Press, 1987.
- Bollinger, James W. Old Montana and Her Cowboy Artist: A Paper Read before the Contemporary Club, Davenport, Iowa, January Thirtieth, Nineteen Hundred Fifty. Shenandoah, Iowa: World Publishing Co., 1963.
- Brown, Mark H., and W. R. Felton. *The Frontier Years: L. A. Huffman, Photographer of the Plains.* New York: Henry Holt and Co., 1955.
- Bruce, Robert. The Fighting Norths and Pawnee Scouts: Narratives and Reminiscences of Military Service on the Old Frontier. New York: Robert Bruce, 1932.
- Buffalo Bill (Hon. W. F. Cody). The Life of Hon. William F. Cody Known as Buffalo Bill the Famous Hunter, Scout and Guide: An Autobiography. Hartford: Frank E. Bliss, 1879.
- ——. Story of the Wild West and Camp-Fire Chats. N.p., 1888.
- Burnside, Wesley M. Maynard Dixon: Artist of the West. Provo: Brigham Young University Press, 1974.

- Clark, Carol. *Thomas Moran: Watercolors of the American West.* Austin: University of Texas Press for the Amon Carter Museum of Western Art, Fort Worth, 1980.
- Coke, Van Deren. *Taos and Santa Fe; The Artist's Environment, 1882–1942.* Albuquerque: University of New Mexico Press for the Amon Carter Museum of Western Art, Fort Worth, and the Art Gallery, University of New Mexico, Albuquerque, 1963.
- Cummins, D. Duane. William Robinson Leigh: Western Artist. Norman: University of Oklahoma Press and Thomas Gilcrease Institute, Tulsa, 1980.
- Deming, Therese O., comp. *Edwin Willard Deming*. Edited by Henry Collins Walsh. New York: Privately printed, 1925.
- Dippie, Brian W. "Frederic Remington's West: Where History Meets Myth." In *Myth of the West*, by Chris Bruce et al. Seattle: The Henry Art Gallery, University of Washington, 1990.
- ——. Looking at Russell. Fort Worth: Amon Carter Museum, 1987.
- ——. "Two Artists from St. Louis: The Wimar-Russell Connection." In *Charles M. Russell: American Artist*, edited by Janice K. Broderick. St. Louis: Jefferson National Expansion Historical Association, 1982.
- ——, ed. Nomad: George A. Custer in "Turf, Field and Farm." Austin: University of Texas Press, 1980.
- ——, ed. Charles M. Russell, Word Painter: Letters, 1887–1926. Fort Worth: Amon Carter Museum, with Harry N. Abrams, New York,
- Dobie, J. Frank. "A Summary Introduction to Frederic Remington." In *Pony Tracks*, by Frederic Remington. Norman: University of Oklahoma Press, 1961; reprint of 1895 edition.
- DuBois, June. W. R. Leigh: The Definitive Illustrated Biography. Kansas City: Lowell Press, 1977.
- Dyck, Paul. *Brulé: The Sioux People of the Rose-bud.* Flagstaff: Northland Press, 1971.
- Dykes, Jeff C., ed. The West of the Texas Kid, 1881–1910: Recollections of Thomas Edgar Crawford, Cowboy, Gun Fighter, Rancher, Hunter, Miner. Norman: University of Oklahoma Press, 1962.
- Eldredge, Charles C., Julie Schimmel, and William H. Truettner. Art in New Mexico, 1900–1945: Paths to Taos and Santa Fe. New York: Abbeville Press, for the National Museum of American Art, Smithsonian Institution, Washington, D.C., 1986.

- Ewers, John C. *Artist of the Old West*. Garden City, N.Y.: Doubleday and Co., 1965.
- western Plains. Norman: University of Oklahoma Press, 1958.
- ——. "Fact and Fiction in the Documentary Art of the American West." In *The Frontier Re-examined*, edited by John Francis McDermott. Urbana: University of Illinois Press, 1967.
- ——. The Horse in Blackfoot Indian Culture, with Comparative Material from Other Western Tribes. Smithsonian Institution, Bureau of American Ethnology Bulletin 159. Washington, D.C.: Government Printing Office, 1955.
- E. W. Latendorf Catalogue No. 27: C M Russell. New York: E. W. Latendorf, n.d. [1957].
- Frederic Remington. Santa Fe: Gerald Peters Gallery, in association with Mongerson-Wunderlich, Chicago, 1991.
- Frederic Remington: The Soldier Artist. West Point: The United States Military Academy— The Cadet Fine Arts Forum, 1979.
- Frederic Remington (1861–1909): Paintings, Drawings, and Sculpture in the Collection of the R. W. Norton Art Gallery, Shreveport, Louisiana. Shreveport: R. W. Norton Art Gallery, 1979.
- Fryxell, Fritiof, ed. *Thomas Moran: Explorer in Search of Beauty.* East Hampton, Long Island: East Hampton Free Library, 1958.
- Garland, Hamlin. *A Daughter of the Middle Border.* New York: Grosset and Dunlap, 1921.
- ------. Roadside Meetings. New York: Macmillan, 1930.
- Green, Jesse, ed. *Zuñi: Selected Writings of Frank Hamilton Cushing.* Lincoln: University of Nebraska Press, 1979.
- Grinnell, George Bird. *Blackfoot Lodge Tales:* The Story of a Prairie People. New York: Charles Scribner's Sons, 1892.
- ——. Pawnee Hero Stories and Folk-Tales, with Notes on the Origin, Customs and Character of the Pawnee People. New York: Forest and Stream Publishing Co., 1889.
- Hale, Horatio. "Report on the Blackfoot Tribes." In *Report on the North-Western Tribes of Canada.* London: Office of the British Association for the Advancement of Science, 1885.
- Hamilton, Henry W., and Jean Tyree Hamilton. *The Sioux of the Rosebud: A History in Pictures.* Norman: University of Oklahoma Press, 1971.

- Hasrick, Peter H. Charles M. Russell. New York: Harry N. Abrams, in association with the National Museum of American Art, Smithsonian Institution, Washington, D.C., 1989.
- ——. Frederic Remington: The Late Years.
 Denver: Denver Art Museum, 1981.
- ——. The Way West: Art of Frontier America. New York: Harry N. Abrams, 1977.
- Hassrick, Royal B. *The Sioux: Life and Customs of a Warrior Society.* Norman: University of Oklahoma Press, 1964.
- Hedren, Paul L. First Scalp for Custer: The Skirmish at Warbonnet Creek, Nebraska, July 17, 1876. Glendale: Arthur H. Clark Co., 1980.
- Horan, James D. *The Life and Art of Charles Schreyvogel: Painter-Historian of the Indian-Fighting Army of the American West.* New York: Crown Publishers, 1969.
- Horgan, Paul. Peter Hurd: A Portrait Sketch from Life. Austin: University of Texas Press for the Amon Carter Museum of Western Art, Fort Worth, 1965.
- "How the West Was Won": Paintings, Watercolors, Bronzes by Frederic Remington and Charles M. Russell, for the Benefit of the Hospital for Special Surgery. New York: Wildenstein, 1968.
- Jacobs, Wilbur R., ed. Letters of Francis Parkman. 2 vols. Norman: University of Oklahoma Press, 1960.
- Jussim, Estelle. Frederic Remington, the Camera & the Old West. Fort Worth: Amon Carter Museum, 1983.
- ——. Visual Communication and the Graphic Arts: Photographic Technologies in the Nineteenth Century. New York: R. R. Bowker Co., 1974.
- Kennedy, Michael S., ed. *The Assiniboines: From* the Accounts of the Old Ones Told to First Boy (James Larpenteur Long). Norman: University of Oklahoma Press, 1961.
- King, J. C. H. Smoking Pipes of the North American Indian. London: British Museum Publications Ltd., 1977.
- Krebs, Roland, and Percy J. Orthwein. Making Friends Is Our Business: 100 Years of Anheuser-Busch. St. Louis: Anheuser-Busch, 1953.

- Ladner, Mildred D. William de la Montagne Cary: Artist on the Missouri River. Norman: University of Oklahoma Press and Thomas Gilcrease Institute, Tulsa, 1984.
- Lamb, Thomas G. Eight Bears: A Biography of E. W. Deming, 1860–1942. Oklahoma City: Griffin Books, 1978.
- Linderman, Frank Bird. *Recollections of Charley Russell*. Edited by H. G. Meriam. Norman: University of Oklahoma Press, 1963.
- McCracken, Harold. *The Charles M. Russell Book: The Life and Work of the Cowboy Artist.* Garden City, N.Y.: Doubleday and Co., 1957.
- ——. The Frank Tenney Johnson Book: A Master Painter of the Old West. Garden City, N.Y.: Doubleday and Co., 1974.
- McSpadden, J. Walker. Famous Sculptors of America. Freeport: Books for Libraries Press, 1968.
- Mandelbaum, David G. *The Plains Cree: An Eth-nographic, Historical, and Comparative Study.*Canadian Plains Studies, 9. Regina: Canadian Plains Research Center, University of Regina, 1979.
- Manley, Atwood. Some of Frederic Remington's North Country Associations. Ogdensburg: Northern New York Publishing Co., 1961.
- ——, and Margaret Manley Mangum. Frederic Remington and the North Country. New York: E. P. Dutton, 1988.
- Marlin Guns for 1963. New Haven: Marlin Firearms Co., 1963.
- Metzger, Robert, ed. My Land Is the Southwest: Peter Hurd Letters and Journals. College Station: Texas A&M University Press, 1983.
- Miller, Angela L. "A Muralist of Civic Ambitions." In *Carl Wimar: Chronicler of the Missouri River Frontier*, by Rick Stewart, Joseph D. Ketner II, and Angela L. Miller. Fort Worth: Amon Carter Museum, 1991.
- Murphy, James E. Half Interest in a Silver Dollar: The Saga of Charles E. Conrad. Missoula: Mountain Press Publishing Company, 1983.
- The North Country Art of Frederic Remington: Artist in Residence. Ogdensburg: The Frederic Remington Art Museum and the Adirondack Museum, 1985.
- Noyes, Al. J. (Ajax). In the Land of Chinook; or, the Story of Blaine County. Helena: State Publishing Co., 1917.

- Paper, Jordan. Offering Smoke: The Sacred Pipe and Native American Religion. Edmonton: University of Alberta Press, 1989.
- Parkman, Francis. *The Oregon Trail: Sketches of Prairie and Rocky-Mountain Life.* Boston: Little, Brown, and Company, 1892.
- Paxson, William Edgar, Jr. E. S. Paxson: Frontier Artist. Boulder: Pruett Publishing Company, 1984.
- Phillips, Paul C., ed. Forty Years on the Frontier: The Reminiscences and Journals of Granville Stuart. 2 vols. Cleveland: Arthur H. Clark Co., 1925.
- Poesch, Jessie. *Titian Ramsay Peale and His Journals of the Wilkes Expedition*, 1799—1885. American Philosophical Society Memoirs, 52. Philadelphia, 1961.
- Porter, Joseph C. Paper Medicine Man: John Gregory Bourke and His American West. Norman: University of Oklahoma Press, 1986.
- Price, Con. *Memories of Old Montana*. Hollywood: Highland Press, 1945.
- ——. *Trails I Rode*. Pasadena, Calif.: Trail's End Publishing Co., 1947.
- Recent Paintings by Frederic Remington and Portraits by A. de Ferraris of Vienna. Chicago: Reinhardt's Annex Gallery, 1908.
- Renner, Frederic G. Charles M. Russell: Paintings, Drawings, and Sculpture in the Amon G. Carter Collection. Austin: University of Texas Press for the Amon Carter Museum of Western Art, Fort Worth, 1966.
- Renner, Ginger. A Limitless Sky: The Work of Charles M. Russell in the Collection of the Rockwell Museum, Corning, New York. Flagstaff: Northland Press, 1986.
- Rideout, Henry Milner. William Jones: Indian, Cowboy, American Scholar, and Anthropologist in the Field. New York: Frederick A. Stokes, 1912.
- Russell, Austin. C.M.R.: Charles M. Russell, Cowboy Artist. New York: Twayne Publishers, 1956.
- Russell, Charles M. Good Medicine: The Illustrated Letters of Charles M. Russell. Garden City, N.Y.: Doubleday, Doran, and Co., 1929.
- ——. Studies of Western Life. 2d ed. New York: Albertype Co., 1890.
- ——. *Trails Plowed Under.* Garden City, N.Y.: Doubleday, Page and Co., 1927.
- Russell, Don. *The Lives and Legends of Buffalo Bill.* Norman: University of Oklahoma Press, 1960.

- Samuels, Peggy, and Harold Samuels. Frederic Remington: A Biography. Garden City, N.Y.: Doubleday & Company, 1982.
- ——. Remington: The Complete Prints. New York: Crown Publishers, 1990.
- ———, eds. *The Collected Writings of Frederic Remington*. Garden City, N.Y.: Doubleday and Co., 1979.
- Sanders, Gordon E. Oscar E. Berninghaus, Taos, New Mexico: Master Painter of American Indians and the Frontier West. Taos: Heritage Publishing Company, 1985.
- Saunders, Richard H. Collecting the West: The C. R. Smith Collection of Western American Art. Austin: University of Texas Press for the Archer M. Huntington Art Gallery, College of Fine Arts, University of Texas at Austin, 1988.
- Schreyvogel, Charles. My Bunkie and Other Pictures of Western Frontier Life. New York: Moffat, Yard & Company, 1909.
- Seventeenth Annual C. M. Russell Auction of Original Western Art. Great Falls: Great Falls Advertising Federation, 1985.
- Shapiro, Michael Edward. Cast and Recast: The Sculpture of Frederic Remington. Washington, D.C.: Smithsonian Institution Press for the National Museum of American Art, 1981.
- ——, Peter H. Hassrick, et al. *Frederic Remington: The Masterworks.* New York: Harry N. Abrams for the St. Louis Art Museum in conjunction with the Buffalo Bill Historical Center, Cody, 1988.
- Splete, Allen P., and Marilyn D. Splete, eds. Frederic Remington—Selected Letters. New York: Abbeville Press, 1988.
- Spring, Agnes Wright. *The Cheyenne and Black Hills Stage and Express Routes*. Glendale: Arthur H. Clark Co., 1949.
- Stewart, Rick. Charles M. Russell: Masterpieces from the Amon Carter Museum. Fort Worth: Amon Carter Museum, 1992.
- ——, with Don Hedgpeth. *The American West: Legendary Artists of the Frontier.* Dallas: Hawthorne Publishing Company, 1986.
- Strahorn, Carrie Adell. Fifteen Thousand Miles by Stage: A Woman's Unique Experience during Thirty Years of Path Finding and Pioneering from the Missouri to the Pacific and from Alaska to Mexico. New York: G. P. Putnam's Sons, 1911.

- Taft, Robert. Artists and Illustrators of the Old West, 1850–1900. New York: Charles Scribner's Sons. 1953.
- Tatham, David. "Frederic Remington: North Country Artist." In *The North Country Art of Frederic Remington: Artist in Residence*. Ogdensburg: The Frederic Remington Art Museum and the Adirondack Museum, 1985.
- Taurman, Mildred, et al. *Utica*, *Montana*. N.p., 1968.
- Truettner, William H. "Prelude to Expansion: Repainting the Past." In *The West as America:* Reinterpreting Images of the Frontier, 1820— 1920, edited by William H. Truettner. Washington, D.C.: Smithsonian Institution Press for the National Museum of American Art, 1991.
- Tucker, Patrick T. *Riding the High Country*. Edited by Grace Stone Coates. Caldwell, Idaho: Caxton Printers, 1933.
- Underhill, Lonnie E., and Daniel F. Littlefield, Jr., eds. *Hamlin Garland's Observations on the American Indian*, 1895–1905. Tucson: University of Arizona Press, 1976.
- Utica Book II. N.p., n.d. (c. 1980).
- Vaughn, Robert. *Then and Now; or, Thirty-Six Years in the Rockies*. Minneapolis: Tribune Printing Company, 1900.
- Vorpahl, Ben Merchant. Frederic Remington and the West: With the Eye of the Mind. Austin: University of Texas Press, 1978.
- ——. My Dear Wister—: The Frederic Remington—Owen Wister Letters. Palo Alto, Calif.: American West Publishing Co., 1972.
- Warden, R. D. C M Russell Boyhood Sketchbook. Bozeman: Treasure Products, 1972.
- Wilkins, Thurman. *Thomas Moran: Artist of the Mountains*. Norman: University of Oklahoma Press, 1966.
- Wyeth, Betsy James, ed. *The Wyeths: The Letters of N. C. Wyeth*, 1901–1945. Boston: Gambit, 1971.

Bronco Buster (Remington), 4

Bronc to Breakfast (Russell), 146, 146, 146n

Adams, Ramon F., 168 Bronson, Edgar Beecher, 140 Advance-Guard, or the Military Sacrifice, The Browne, Charles Francis, 2, 176, 190; Naí-U-Chi: (Remington), 20 Chief of the Bow, Zuni 1895, 176, 177 Allen, William A., 82n Bucker, The (Russell), 138, 139 Ambush, The (Leigh), 182, 183 Bucking Horse, The (Russell), 158 Ambush, The (Russell), 88, 100, 102, 103 Buffalo and buffalo hunts, 80, 90, 104, 112-117, Ambushed Picket, The (Remington), 46 128, 130, 150 American Buffaloe (Peale), 90, 90 Buffalo Bill. See Cody, William F. Among the Led Horses (Remington), 11-12, 58, 59 Buffalo Bill's Duel with Yellowhand (Russell), 11, Anderson, John A., 174, 174 148, 164, 165 Apache (Herget), 193 Buffaloe Hunt on The River Platte (Peale), 114 n Apache Medicine Song (Remington), 11 Buffalo Herd (Russell), 112, 113 Buffalo Hunt (Russell, 1891), 104, 104 Apaches, 22, 38, 56 Buffalo Hunt (Russell, 1894), 90, 91 Apache Signal Fire (Remington), 56n Apache's Medicine Song (Remington), 56, 57 Buffalo Hunt, The (Russell, 1900), 114 Buffalo Hunt No. 25, The (Russell, 1899), 80, 114, Arapahoe (Herget), 193 Arizona Cow-puncher, An (Remington), 34 n Arizona Nights (White), 140 Buffalo Hunt No. 30 (Russell, 1901), 128, 129, 130 Assiniboine (Herget), 194 Buffalo Runners, The (Russell), 80, 81 Assiniboines, 78, 114 Buffalo Runners—Big Horn Basin (Remington), Attack on Muleteers (Russell), 92, 92 Attack on the Herd (Schreyvogel), 180, 181 Bunch of Buckskins, A (Remington), 34n, 44 Bushwhacked (Russell), 92, 92 Attack on the Mule Train (Russell), 88, 92, 93 Back, George, 108 Canadian Northwest, 28, 32, 108 Bad Hoss, A (Russell), 138, 138 Canoeing, 32, 32n Bad One, A (Russell), 158, 159 Captain William Clark of the Lewis and Clark Baker, Jim, 54n Expedition Meeting with the Indians of the Barry, David F., 178n Northwest (Russell), 108n, 110, 111 Beacom, John H., 132n Captive, The (Farny), 36, 36 Bear Claw (Russell), 120, 121 Captured (Remington), 36, 37 Bears, 26, 154, 184 Carr, Eliza, 74 Bears in the Path (Leigh), 184, 185, 188 Carr, William Chiles, 74 Before the White Man Came (Russell), 112, 113 Carson, Kit, 54n Bell Mare (Russell), 92 Carter, Amon, I, II Benighted for a Dry Camp (Remington), 48 Cary, William de la Montagne, 16 Berninghaus, Oscar E., 2, 190; The Forty-niners, Catlin, George, 130, 192; Comanche Moving Camp: Dog Fight en Route, 130, 130 190, 191 Biggs, Alice P., 134, 134n Cattle Rustlers (Johnson), 188 Big Nose George and the Road Agents (Russell), Caught in the Circle (Remington), 40n 88, 100, 101, 102 Caught in the Circle (Russell), 82, 83 Cavalry. See Soldiers Blackfoot (Herget), 197 Blackfoot Indians, 98, 106, 120, 128, 144, 148, 156 Charbonneau, 110 Blood Indians, 76, 108, 132 Chatillon, Henry, 54, 54n Blumenschein, Ernest L., 190 Chevenne (Herget), 194 Braves on the March (Russell), 156, 157 Cheyenne Indians, 38, 144, 164 Brave's Return, The (Russell), 78, 79 Chief Bear Claw (Russell), 120, 121 Breaking Camp (Russell), 76, 77 Chief Joseph (Russell), 120 Breaking Up the Circle (Russell), 122, 123 Chief Priest of the Bow (Farny), 176n Breaking Up the Ring (Russell), 122, 123 Chief Sitting Bull (Russell), 120 Bridger, Jim, 54, 54n Clark, William, 110 Bringing Up the Trail (Russell), 96, 97 Close Call (Schreyvogel), 180, 181

Cody, William F. (Buffalo Bill), 82, 148, 164, 164 n,

180, 180n

Colton, John B., 54n Comanche Moving Camp: Dog Fight en Route (Catlin), 130, 130 Connally, John, 2 Conrad, Charles E., 80 Contrabandista a la Frontera (Johnson), 188, 189 Cooper, Nancy. See Russell, Nancy Cooper Corralled (Russell), 82 Cortissoz, Royal, 58 Counting Coup (Russell, painting), 132, 133 Counting Coup (Russell, sculpture), 148, 148 Courrier du Bois and the Savage, The (Remington), 28, 29 Cowan, Zella, 68n Cowboy Camp during the Roundup (Russell), 142, 142 Cowboys: Remington on, 24, 24n, 34, 42; Russell as, 6, 66, 70, 124; in Russell's paintings, 66, 70, 72, 118, 124, 126, 138-143, 158, 168; Wister's poem Cowboy Sport—Roping a Wolf (Russell), 72, 73, 74 Cow Puncher, The (Remington), 42, 43 Cowpunching Sometimes Spells Trouble (Russell), 11, 70, 71 Cree Indians, 120, 128, 156 Crow (Herget), 195 Crowfoot, 106 Cuban war, 18, 20 n, 34, 40, 62 Custer, Elizabeth, 180 Custer, George Armstrong, 2, 16, 40, 82, 82n, Custer's Demand (Schrevvogel), 180n Custer's Last Battle (Russell), 82, 82n "Dance Higher—Dance Faster" (Remington), 124, 124 Danger Ahead (Scott), 26 Dangerous Situation, A (Russell), 118, 118 Dash for the Timber, A (Remington), 50, 126, 126 Davis, J. Steeple: Torture of Colonel Crawford, Death of General Custer (Russell), 82n Deer in Forest (Russell), 150, 162, 163 Defiant Culprit, The (Russell), 98, 99, 108n

Deming, Edwin Willard, 2, 178, 180; Indians,

Dry Camp, The (Remington), 11, 48, 49 Duel with Yellow Hand, The, 164, 164

Desperate Stand, A (Russell), 82n

Detaille, Edouard, 10n

De Yong, Joe, 88n, 160n

Dobie, J. Frank, 8, 8n, 128

Cole, Thomas F., 164

Elwell, R. Farrington, 180n Evening Pipe, The (Russell), 74, 75 Ewers, John C., 11, 78, 128 Exalted Ruler, The (Russell), 68 Farny, Henry F., 188; Chief Priest of the Bow, 176n; The Captive, 36, 36 Fifteen Thousand Miles by Stage (Strahorn), 154 Figure of the Night, A (Remington), 50, 51 Fired On (Remington), 58, 58, 188 First Wagon Tracks (Russell), 146, 146n, 147 First Wagon Trail (Russell), 82, 146, 146n, 147 Following the Buffalo Run (Russell), 96, 96 For Supremacy (Russell), 132, 132 Forty-niners, The (Berninghaus), 190, 191 Gabriel, Jim, 152 Garland, Hamlin, 54, 176 Gaul, William Gilbert, 2, 172, 174, 188; The Pow-Wow, 174, 175 Geronimo campaign, 18 Gibson, Paris, 86 Gilcrease, Thomas, 1 Gold prospectors, 86, 88, 92 Goodell, Mrs. M. C., 68n Goodwin, Philip R., 154n, 184 Gray, Breathitt, 142 Grinnell, George Bird, 108, 112, 130, 144, 156 Grubpile (Russell), 74, 75 Guardian of the Herd (Russell), 112, 113 Guard of the Rancheria, The (Remington), 22 Halt—Dismount! (Remington), 40 Hard Pushed (Schreyvogel), 180 Hartzell, Frank, 142 Hassrick, Peter, 11, 42, 52 Henderson, Milt F., 98 Herget, Herbert M.: Ten Indian Studies, 192, 193-197 He Rushed the Pony Right to the Barricade (Remington), 38, 38, 39 He Snaked Old Texas Pete Right Out of His Wicky-up, Gun and All (Russell), 140, 141 He Tripped and Fell into a Den on a Mother Bear and Her Cubs (Russell), 154, 155 Hiawatha (Longfellow), 28 Higgins, Victor, 190 His First Lesson (Remington), 50 His Last Stand (Remington), 26, 27, 188 His Wealth (Russell), 156, 157 Holding the Fort (Russell), 82 Hold Up, The (Leigh), 182, 183, 184, 188

Hold-Up, The (Remington), 46

Eaton, Howard, 160, 160n

178, 179

Hold Up, The (Russell), 100, 100 Hoover, Jake, 142 Hopi (Herget), 195 Hopi Indians, 176 Hough, Emerson, 5 Hudson's Bay Company, 28, 32, 106, 146 Hungry Moon, The (Remington), 62, 62 Hunting Party on Mountain Trail (Russell), Hurd, Henriette Wyeth, 198 Hurd, Peter, 188, 198; Portrait of Sid Richardson, 198, 199 Impressionism, 10 In a Stiff Current (Remington), 32, 33 Indian Attack (Deming), 178, 179 Indian Encampment (Moran), 172, 173 Indian Head (Russell, Schatzlein, and Paxson), Indian Love Call (Russell), 94, 95 Indian Trapper, An (Remington), 44 Indian Women and Children on the Trail (Rus-Indians: and buffalo hunts, 80, 90, 104, 114, 116, 128, 130; capture by, 36; Cavalry campaigns against, 18, 20, 24, 40, 44, 164; and counting coup, 132; courtship of, 94; in Deming's painting, 178; domestic life of, 76, 78, 94, 96, 108, 130; in Gaul's painting, 174; and gold prospectors, 86, 88; in Herget's paintings, 192-197; in Moran's painting, 172; raiding parties of, 84, 84n, 98, 134; in Remington's fiction, 38; as Remington's subjects, 9, 28, 30, 36, 38, 44, 50, 56, 62, 178; as Russell's subjects, 9, 74-79, 84-89, 94-99, 104-117, 120, 122, 128-137, 144-153, 156, 164; in Schreyvogel's painting, 180; smoking of pipe by, 74; white men's marriage to Indian women, 166. See also specific Indian tribes Indians (Deming), 178, 179 Indians Discover Prospectors (Russell), 86, 87 Indians Hunting Buffalo (Russell), 90, 91 Indians on the Trail (Russell), 76 Innocent Allies (Russell), 102, 102 In the Wake of the Buffalo Runners (Russell), 96 Jedediah Smith (Remington), 54 n John Ermine of the Yellowstone (Remington), 46, 48

Johnson, Frank Tenney, 2, 186, 188; Cattle

188, 189; Trouble on the Pony Express,

186, 187, 188

Jones, William, 180

Joseph, Chief, 120

Rustlers, 188; Contrabandista a la Frontera,

Judith Basin Roundup, The (Russell), 66 Jumped (Russell), 122, 122 Kendall, Walter G., 76 Kerr, George W., 132 Last Stand, The (Remington), 40, 40 Lehman, Charles, 142 Leigh, William Robinson, 2, 182, 184, 188; Bears in the Path, 184, 185, 188; The Hold Up, 182, 183, 184, 188 Lewis, Meriwether, 110 Lewis and Clark Expedition, 110 Lewis and Clark Meeting Indians at Ross' Hole (Russell), 110 Lewis and Clark Meeting the Mandan Indians (Russell), 110, 110 Lewis and Clark on the Lower Columbia (Russell), 110 Longfellow, Henry Wadsworth, 28 Long Horn Cattle Sign, The (Remington), 48n Lorenz, Richard, 188 Luckless Hunter, The (Remington), 11, 62, 63 McFry, Jasper, 66n Mackay, Malcolm S., 166n MacNeil, Hermon A., 176 Mad Cow, The (Russell), 118, 119 Making of a Warrior The (Russell), 132 Mandan Indians, 110 Maney Snows Have Fallen (Russell), 116, 152, 153 Man's Weapons Are Useless When Nature Goes Armed (Russell), 1, 2, 11, 160, 161 Marchand, John N., 140 Marlin Fire Arms Company, 26 Marriage Ceremony, The (Russell), 2, 94, 95 Matheson, John, 142, 142 Meat for the Tribe (Russell), 80 Medicine Arrow, The (Russell), 108 Medicine Man, The (Russell), 146, 146 Medicine Whip (Russell), 132, 133 Men of the Open Range (Russell), 166 Messner, Martin, 68n Miles, Nelson A., 18n Miller, Angela, 110 Missing (Remington), 36, 36 Moment of Great Peril in a Cowboy's Career, A (Russell), 118, 118 Monet, Claude, 10 Montana's Majesty (Russell), 162 Moran, Peter, 2, 172; Indian Encampment, 172, 173 Moran, Thomas, 172 Mountain men, 54

Mule Pack Train (Russell), 92, 93

Mule pack trains, 92

My Bunkie (Schreyvogel), 180

Naí-U-Chi: Chief of the Bow, Zuni 1895 (Browne), 176, 177 Nature's Cattle (Russell), 112, 113 Nelson, Anna P., 132n Neuville, Alphonse de, 10n Newhouse, Bertram M., 1 Newhouse, Clyde, 1 Newhouse Galleries, 1 North, Frank, 144 North, Luther, 144 Norton, R. W., 1

Ogalalla Sioux (Herget), 196 O'Hara, Pat, 124 On the Attack (Russell), 126, 127 Oregon Trail, The (Parkman), 28, 30, 30, 54 Outlier, The (Remington), 50, 50, 50n

Papagos, 22 Parkman, Francis, 28, 30, 38, 54, 54n, 116 Parrish, Maxfield, 166 Parrot, "Big Nose George," 100 Pawnee Chief (Russell), 144, 144 Pawnees, 144 Paxson, Edgar S., 88, 136; Indian Head, 88, 136, Peale, Titian Ramsay: American Buffaloe, 90, 90; Buffaloe Hunt on The River Platte, 114n Pellatt, Sir Henry Mill, 158 Phillips, Frank, 1 Piegan Flirtation, A (Russell), 94, 94 Piegan Indians, 76, 94, 120 Piegan Indians Hunting Buffalo (Russell), 104 Pirates Used to Do That to Their Captains Now and Then (Pyle), 34, 34n Plunder on the Horizon (Russell), 86, 87, 88 Ponka (Herget), 196 Portrait of Sid Richardson (Hurd), 198, 199 Powder River, Let'er Buck (Russell), 138, 138 Pow-Wow, The (Gaul), 174, 175 Price, Con, 102, 158 Prospectors, 86, 88, 92 Prospectors Discover an Indian Camp (Russell), 88, 89 Puncher, The (Remington), 34, 34 n, 35 Pyle, Howard, 34, 34n, 140; Pirates Used to Do That to Their Captains Now and Then, 34, 34 n

Quiet Day in Utica, A (Russell), 142, 143 Quigley, Bill, 142 Ralph, Julian, 28, 32 Rance, Bill, 98 Redman's Meat (Russell), 116, 117 Refractory Steer, A (Zogbaum), 66, 66 Reinhardt, Henry, 50 Remington, Eva, 6 Remington, Frederic Sackrider: animals as subjects of, 26; biographies of, 12, 12n; on canoeing, 32, 32n; color in paintings by, 60, 60n; compared with Russell, 7-10; on cowboys, 24, 24n, 34, 42; in Cuban war, 18, 20n, 34, 40, 62; death of, 5, 62; and Deming, 178; dramatization of novel by, 46, 48; European influences on, 10, 10n; fiction written by, 38, 38n, 46, 48; first trip west to Montana, 3, 16; and Gaul, 174; as illustrator for periodicals, 3-4, 8, 34n, 36n; on Impressionist painting, 10; Indian campaign assignments of, 18, 20, 24, 44; Indians as subjects of, 9, 28, 30, 36, 44, 50, 56, 62, 178; Indians in fiction by, 38; landscapes of, 5, 7; light in paintings by, 48, 56; meeting with Russell, 9; night scenes of, 46, 50, 52, 58; as painter, 4-5, 8, 9-11, 12, 60, 60n; on painting pueblos, 2; on passing of the West, 4, 7, 34, 42, 62; photograph of, 24; scholarship on, 12-13; and Schreyvogel, 46, 180; as sculptor, 4, 60; soldiers as subjects of, 18-25, 40; trip to Mexico, 22; on varnishing of paintings, 22; as Westerner, 3, 24, 24; on winning of the West, 3-5, 12-13; works in Richardson Collection, 11-12; at Yale's School of Fine Arts, 3, 182n; youth and family of, 2-3 -works: The Advance-Guard, or the Military Sacrifice, 20; The Ambushed Picket, 46; Among the Led Horses, 11−12, 58, 59; Apache Medicine Song, 11; Apache Signal Fire, 56n; Apache's Medicine Song, 56, 57; Bronco Buster, 4; Buffalo Runners—Big Horn Basin, 11, 60, 61; An Arizona Cow-puncher, 34n; A Bunch of Buckskins, An Arizona Cowboy, 34n, 44; Captured, 36, 37; Caught in the Circle, 40n; The Courrier du Bois and the Savage, 28, 29; The Cow Puncher, 42, 43; "Dance Higher—Dance Faster," 124, 124; A Dash for the Timber, 50, 126, 126; The Dry Camp, 11, 48, 49; A Figure of the Night, 50, 51; Fired On, 58, 58, 188; Halt—Dismount!, 40; He Rushed the Pony Right to the Barricade, 38, 38, 39; His First Lesson, 50; His Last Stand, 26, 27, 188; The Hold-Up, 46; The Hungry Moon, 62, 62; In a Stiff Current, 32, 33; An Indian Trapper, 44; Jedediah Smith, 54n; The Last Stand, 40, 40; The Long Horn Cattle Sign, 48n; The Luckless Hunter, 11, 62, 63; Missing, 36, 36; The Outlier,

50, 50, 50n; The Puncher, 34, 34n, 35; Return

178, 178; The Riderless Horse, 18, 19, 20, 46; The Right of the Road, 46; Rounded-Up, 40, 41; Scare in a Pack Train, 11, 52, 53, 58; The Scout, 188; Self-Portrait on a Horse, 24, 25; The Sentinel (1889), 1, 22, 23; The Sentinel (1907), 48, 48; The Sign of the Buffalo Scouts, 48n; A Sioux Chief, 44, 45; Sketches among the Papagos of San Xavier, 22, 22; The Storm Medicine, 30; A Taint on the Wind, 11, 46, 47; The Thunder-Fighters Would Take Their Bows and Arrows, Their Guns, Their Magic Drum, 30, 30, 31; Troopers Singing the Indian Medicine Song, 56, 56; Types from Arizona, 18, 18; The Unknown Explorers, 11, 54, 54, 55; The Way Post, 16, 17 Remington's Four Best Paintings, 48 Renner, Frederic G., 68 Reno, Marcus, 40 Renoir, Pierre Auguste, 60 Returning Herd, The (Russell), 104 Returning to Camp (Russell), 80, 108n, 128, 130, 131 Return of a Blackfoot War Party (Remington), 30 Richardson, Sid Williams: birth date of, I; business successes of, 1; as collector, 1-2; death of, 2; as horseman and outdoorsman, 2; portrait of, 198, 199; Remingtons owned by, I, II-I2; Russells owned by, I-2, II, 82, 94, I28, I34; Western art owned by, in addition to Remingtons and Russells, 12, 188, 190, 192 Richardson Collection, 11-12 Riderless Horse, The (Remington), 18, 19, 20, 46 Right of the Road, The (Remington), 46 Ringgold, Millie, 142 Ritch, John B., 128 Road agents, 100, 102 Road Agents, The (Russell), 102, 103 Robbery, 100, 102 Roberts, May Fanton, 50, 54, 56 Rogers, Will, 76 Roosevelt, Theodore, 26, 38 Roping (Russell), 168, 169 Roping 'Em (Russell), 66, 66 Roping the Renegade (Russell), 66, 67, 68, 168 Rounded-Up (Remington), 40, 41 Rungius, Carl, 60 Running Buffalo (Russell), 164 Running Fight (Russell), 148, 148 Russell, Charles M.: biographies of, 12, 12n; on buffalo hunt, 150, 150n; business manager of, 6, 7; compared with Remington, 7–10; cowboy life of, 6, 66, 70, 124; cowboys as subjects of, 66, 70, 72, 118, 124, 126, 138-143, 158, 168; on

of a Blackfoot War Party, 30; Ridden Down,

cowboys' red shirts, 184; death of, 7; and Deming, 178n; fiction by, 94, 104, 108, 114n, 132, 150; as illustrator for periodicals, 140; on Impressionist painting, 10; Indian-like features of, 116, 152, 152; Indians as subjects of, 9, 74-79, 84-89, 94-99, 104-117, 120, 122, 128-137, 144-153, 156, 164; and Johnson, 186; marriage of, 6; meeting with Remington, 9; in New York City, 140; on inaccuracies in Remington's paintings, 9, 42; as painter, 6-11; on passing of the West, 7, 13; patronage for, 68, 98, 142, 164; photographs of, 142, 152; relationship of, with Indian woman, 108; at St. Louis art school, 182n; scholarship on, 12-13; sciatic rheumatism of, 166; as sculptor, 180; setting in paintings of, 7, 8-9, 76; wildlife paintings of, 162; works in Richardson Collection, 11; youth and family of, 6

-works: The Ambush, 88, 100, 102, 103; Attack on Muleteers, 92, 92; Attack on the Mule Train, 88, 92, 93; A Bad Hoss, 138, 138; A Bad One, 158, 159; Bear Claw, 120, 121; Bell Mare, 92; Big Nose George and the Road Agents, 88, 100, 101, 102; The Brave's Return, 78, 79; Breaking Up the Ring, 122, 123; Bringing Up the Trail, 96, **97**; Bronc to Breakfast, 146, 146, 146n; The Bucker, 138, 139; The Bucking Horse, 158; Buffalo Bill's Duel with Yellowhand, 11, 148, 164, 165; The Buffalo Hunt (1891), 104, 104; Buffalo Hunt (1894), 90, 91; The Buffalo Hunt (1900), 114; The Buffalo Hunt No. 25 (1899), 80, 114, 115; Buffalo Hunt No. 30 (1901), 128, 129, 130; The Buffalo Runners, 80, 81; Bushwhacked, 92, 92; Captain William Clark of the Lewis and Clark Expedition Meeting with the Indians of the Northwest, 108n, 110, 111; Caught in the Circle, 82, 83; Chief Joseph, 120; Chief Sitting Bull, 120; Corralled, 82; Counting Coup (painting), 132, 133; Counting Coup (sculpture), 148, 148; Cowboy Camp during the Roundup, 142, 142; Cowboy Sport—Roping a Wolf, 72, 73, 74; Cowpunching Sometimes Spells Trouble, II, 70, 71; Custer's Last Battle, 82, 82n; A Dangerous Situation, 118, 118; Death of General Custer, 82n; Deer in Forest, 150, 162, 163; The Defiant Culprit, 98, 99, 108n; A Desperate Stand, 82n; The Exalted Ruler, 68; First Wagon Trail, 82, 146, 146n, 147; Following the Buffalo Run, 96, 96; For Supremacy, 132, 132; Grubpile, 74, 75; Guardian of the Herd, 112, 113; He Snaked Old Texas Pete Right Out of His Wicky-up, Gun and All, 140, 141; He Tripped and Fell into a Den on a Mother Bear and Her Cubs, 154, 155; His Wealth, 156, 157; The Hold

Up, 100, 100; Holding the Fort, 82; In the Wake of the Buffalo Runners, 96; Indian Head, 136, 137; Indians Hunting Buffalo, 90, 91; Indians on the Trail, 76; Innocent Allies, 102, 102; The Judith Basin Roundup, 66; Jumped, 122, 122; Lewis and Clark Meeting Indians at Ross' Hole, 110; Lewis and Clark Meeting the Mandan Indians, 110, 110; Lewis and Clark on the Lower Columbia, 110; The Making of a Warrior, 132; Maney Snows Have Fallen, 116, 152, 153; Man's Weapons Are Useless When Nature Goes Armed, 1, 2, 11, 160, 161; The Marriage Ceremony, 2, 94, 95; Meat for the Tribe, 80; The Medicine Arrow, 108; The Medicine Man, 146, 146; Men of the Open Range, 166; A Moment of Great Peril in a Cowboy's Career, 118, 118; Montana's Majesty, 162; On the Attack, 126, 127; Pawnee Chief, 144, 144; A Piegan Flirtation, 94, 94; Piegan Indians Hunting Buffalo, 104; Plunder on the Horizon, 86, 87, 88; Powder River, Let'er Buck, 138, 138; The Returning Herd, 104; Returning to Camp, 80, 108n, 128, 130, 131; Roping, 168, 169; Roping 'Em, 66, 66; Roping the Renegade, 66, 67, 68, 168; Running Buffalo, 164; Running Fight, 148, 148; Salute of the Robe Trade, 166, 166; The Scout, 144, 145, 178; Secrets and the Night, 178n; Seeking New Hunting Grounds, 76, 77; Sighting the Herd, 104, 105; The Silk Robe, 80, 80; Sioux Torturing a Blackfoot Brave, 98, 98; The Snow Trail, 106, 107; The Spirit of Winter, 178n; The Strenuous Life, 70, 70; The Tenderfoot, 1, 2, 124, 125; There May Be Danger Ahead, 84, 85; Three Generations, 108, 109; Throwing on the Heel Rope, 168; Tin Canning a Dog, 142; The Trappers' Last Stand, 82n; Trouble Hunters, 134, 135; Trouble on the Horizon, 86, 88, 89, 136; Utica, 2, 142, 143; Waiting for a Chinook, 6; The Way It Used to Be, 86, 86; The West, 112, 112; Western Scene, 68, 68n, 69, 98; When Blackfeet and Sioux Meet, 11, 132, 146, 148, 149; When Cowbovs Get in Trouble, 118, 119; When Cows Were Wild, 168; When Mules Wear Diamonds, 92; When the Land Belonged to God, 112, 112; When White Men Turn Red, 11, 166, 167; Wild Man's Meat, 80, 116, 117; Wild Men's Meat, 90, 91; Work on the Roundup, 168; Wounded, 150, 151; York, 110, 146, 146, 146n Russell, Nancy Cooper: and Bear Claw, 120; and Biggs, 134, 134n; as business manager for Russell, 6, 7, 82, 140; on Counting Coup, 132; and Johnson, 186; marriage of, 6, 134n; Russell's illustration of, as Indian, 152; on Russell's partici-

pation in buffalo roundup, 150n; summers on

Lake McDonald, 162

Sacajawea, 110 Salute of the Robe Trade (Russell), 166, 166 Samuels, Harold, 38n Samuels, Peggy, 38n Scare in a Pack Train (Remington), 11, 52, 53, 58 Schatzlein, Charles "Dutch," 136 Schreyvogel, Charles, 2, 46, 180; Attack on the Herd, 180, 181; Custer's Demand, 180n; Hard Pushed, 180 Scott, John, 26 Scout, The (Remington), 188 Scout, The (Russell), 144, 145, 178 Secrets and the Night (Russell), 178 n Seeking New Hunting Grounds (Russell), 76, 77 Self-Portrait on a Horse (Remington), 24, 25 Seminole (Herget), 197 Sentinel, The (Remington, 1889), 1, 22, 23 Sentinel, The (Remington, 1907), 48, 48 Shelton, James R., 68, 98, 142 Shelton Saloon Painting, The (Russell), 68, 68n, **69** Short Bull, 152 Shot on Picket (Thulstrup), 20, 20 Sid Richardson Collection. See Richardson Sighting the Herd (Russell), 104, 105 Sign of the Buffalo Scouts, The (Remington), 48 n Siksika (Herget), 197 Silk Robe, The (Russell), 80, 80 Sioux, 30, 44, 98, 132, 144, 148, 164, 174 Sioux Chief, A (Remington), 44, 45 Sioux of the Rosebud, The (Anderson), 174 Sioux Torturing a Blackfoot Brave (Russell), Sitting Bull, 120, 178n Sketches among the Papagos of San Xavier (Remington), 22, 22 Sleeping Thunder, 120 Smith, DeCost, 178n Smith, Jedediah, 54, 54 n Smoking, 74 Snow Trail, The (Russell), 106, 107 Soldiers: as Remington's subjects, 18-25, 40; Russell on, 82 Spirit of Winter, The (Russell), 178n Stendahl, Earl, 166 Storm Medicine, The (Remington), 30 Strahorn, Mrs. Carrie Adell, 154 Strenuous Life, The (Russell), 70, 70 Stuart, Granville, 72, 118 Sullivan, Bull Nose, 142 Surprise (Leigh), 184, 185

Taint on the Wind, A (Remington), 11, 46, 47 Tenderfoot, The (Russell), 1, 2, 124, 125 Ten Indian Studies (Herget), 192, 193-197 There May Be Danger Ahead (Russell), 84, 85 Thiri, A. J., 152 Three Generations (Russell), 108, 109 Thrill That Comes Once in a Lifetime, The (Web-Throwing on the Heel Rope (Russell), 168 Thulstrup, Thure de: Shot on Picket, 20, 20 Thunder-Fighters Would Take Their Bows and Arrows, Their Guns, Their Magic Drum, The (Remington), 30, 30, 31 Tin Canning a Dog (Russell), 142 Tobacco smoking, 74 Torture of Colonel Crawford (Davis), 98, 98 Trappers' Last Stand, The (Russell), 82n Troopers Singing the Indian Medicine Song (Remington), 56, 56 Trouble Hunters (Russell), 134, 135 Trouble on the Horizon (Russell), 86, 88, 89, 136 Trouble on the Pony Express (Johnson), 186, 187, 188 Tucker, Patrick T., 124, 124n Two of a Kind Win (Russell), 160, 161 Types from Arizona (Remington), 18, 18 Unknown Explorers, The (Remington), 11, 54,

54, 55 *Utica* (Russell), 2, 142, 143

Vanderslice, H. M., 166 Vaughn, Robert, 11, 86, 90, 100

Waiting for a Chinook (Russell), 6 Way It Used to Be, The (Russell), 86, 86 Way of an Indian, The (Remington), 38, 38, 38 n Way Post, The (Remington), 16, 17 Weapons of the Weak (Russell), 160, 161

Webster, H. P.: The Thrill That Comes Once in a Lifetime, 44 Weiss, Maurice S., 128 West, The (Russell), 112, 112 Western Scene (Russell), 68, 68n, 69, 98 When Blackfeet and Sioux Meet (Russell), 11, 132, 146, 148, 149 When Cowboys Get in Trouble (Russell), 118, 119 When Cows Were Wild (Russell), 168 When Mules Wear Diamonds (Russell), 92 When Sioux and Blackfeet Meet (Russell), 148, 148 When the Land Belonged to God (Russell), 112, 112 When White Men Turn Red (Russell), 11, 166, 167 White, Stewart Edward, 140 White Tailed Deer (Russell), 162, 163 Wild Man's Meat (Russell), 80, 116, 117 Wild Meat for Wild Men (Russell), 114, 115 Wild Men's Meat (Russell), 90, 91 Willis, Sid, 98, 128 Wimar, Carl, 192 Winthrop (Robert) collection, II Wister, Owen, 26, 42, 60n Wolves, 72 Work on the Roundup (Russell), 168 Wounded (Russell), 150, 151 Wounded Buffalo, The (Russell), 150, 151 Wounded Knee, battle of, 18 Wyeth, N. C., 40, 140, 192, 198

Yellow Hair, 164 Yellow Hand, 164 *York* (Russell), 110, 146, **146**, 146 n Young Boy, John, 120

Zogbaum, Rufus F., 180; *A Refractory Steer*, 66, **66** Zuñi Indians, 176

×				

		,			

•			